W9-BXD-179

ART FUNDAMENTALS

NINTH EDITION

THEORY AND PRACTICE

ART FUNDAMENTALS

NINTH EDITION

THEORY AND PRACTICE

Pat Steir, *Inner Sanctum Waterfall*, 1992.

OTTO G. | ROBERT E. | PHILIP R. | ROBERT O. | DAVID L.
OCVIRK | STINSON | WIGG | BONE | CAYTON

SCHOOL OF ART / BOWLING GREEN STATE UNIVERSITY

Mc Graw Hill

Boston Burr Ridge, IL Dubuque, IA Madison, WI New York San Francisco St. Louis
Bangkok Bogotá Caracas Kuala Lumpur Lisbon London Madrid Mexico City
Milan Montreal New Delhi Santiago Seoul Singapore Sydney Taipei Toronto

McGraw-Hill Higher Education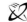
*A Division of The **McGraw-Hill** Companies*

ART FUNDAMENTALS: THEORY AND PRACTICE

Published by McGraw-Hill, an imprint of The McGraw-Hill Companies, Inc., 1221 Avenue of the Americas, New York, NY 10020. Copyright 2002, 1998 by The McGraw-Hill Companies, Inc. All rights reserved. No part of this publication may be reproduced or distributed in any form or by any means, or stored in a data base or retrieval system, without the prior written consent of The McGraw-Hill Companies, Inc., including, but not limited to, in any network or other electronic storage or transmission, or broadcast for distance learning.
Some ancillaries, including electronic and print components, may not be available to customers outside the United States.

This book is printed on acid-free paper.

1 2 3 4 5 6 7 8 9 0 QPD/QPD 0 9 8 7 6 5 4 3 2 1

ISBN 0-07-240700-X

Editorial director: *Phillip A. Butcher*
Sponsoring editor: *Joe Hanson*
Senior marketing manager: *David Patterson*
Senior production supervisor: *Michael R. McCormick*
Managing editor: *Jane Lightell*
Media producer: *Shannon Rider*
Freelance design coordinator: *Laurie J. Entringer*
Lead supplement producer: *Cathy L. Tepper*
Photo research coordinator: *David A. Tietz*
Cover design: *Laurie J. Entringer*
Typeface: *11/13 Bembo*
Compositor: *GTS Graphics, Inc.*
Printer: *Quebecor World Dubuque Inc.*

Library of Congress Cataloging-in-Publication Data

Art fundamentals : theory & practice / Otto G. Ocvirk ... [et al.].—9th ed.
 p. cm.
 Includes bibliographical references and index.
 ISBN 0-07-240700-X (pbk.)
 1. Art—Technique. 2. Art. I. Ocvirk, Otto G.

N7430 .A697 2001
701′.8—dc21 2001034257

Cover and title page:
Pat Steir, *Inner Sanctum Waterfall,* 1992. Oil on linen, 104 × 136.4 in. (246.4 × 346.7 cm). Courtesy of Ani and David Kasparian, New Jersey. See also fig. 3.1, p. 77.

www.mhhe.com

Contents

Preface

Why Was *Art Fundamentals* Written?

The foundations or fundamentals course presents a unique challenge to the instructor. It is a course profoundly based in *doing*—in the experience of exploring art elements and media on a level of practical curiosity. At the same time, foundations has a history and language that successful students will learn and master—as a way of avoiding common pitfalls, if nothing else.

The ninth edition of *Art Fundamentals* is a watershed for the book; at no time in its history have there been so many improvements incorporated into it. Despite our appreciation of these changes our greater concern, as always, is for our examination of the character of art, which is largely dependent on its elements and principles. This inquiry has again been fortified by a great number of historical art examples, as well as contemporary art. We believe the display and examination of these works will benefit all who are interested in art, be they students, instructors, or artists.

That *Art Fundamentals* enters its fifth decade as the best-selling foundations text is an indication that we in some small way achieved our goal.

What Was Improved?

Art Fundamentals has always been the most colorful book for foundations courses, and rest assured that this remains unchanged. In fact, the ninth edition is in full color throughout, for the first time in its history.

In addition to the color, *Art Fundamentals*, Ninth Edition, incorporates more contemporary and women artists, and the computer-aided designs have been rendered using the most current software.

The ninth edition breaks new ground with an auxiliary *Core Concepts in Art* CD-ROM. Art concerns are explained and demonstrated with brief video segments. Although many items are interactive, others allow us to show sequential steps in the development of an idea or image. In the past these have been rendered in the text as a single image; however, with advanced technology we are able to present them in real time. In addition, *Core Concepts* will help the student prepare with a second approach to the presentation of terminologies, important biographies, and compositional explanations. Chapter summaries, lists of key terms, multiple-choice practice quizzes, and review sections, which reference the text, are also part of the CD-ROM.

Finally, rounding out the instructional program, are: the *Art Fundamentals'* Web site <www.mhhe.com/ocvirk>, *A Guide to Electronic Research in Art, A Museum Goer's Guide,* and a slide set for qualifying adopters. For more information, please contact your local McGraw-Hill sales representative or visit McGraw-Hill's Web page <www.mhhe.com>.

Acknowledgments

It is an important tradition that plaudits be distributed among those who have been of help. Our publisher McGraw-Hill and its Higher Education staff has given excellent support and the necessary "prodding." The reviewers—from longtime devotees to instructors who had never before used the text—can never be adequately thanked; their comments and observations allowed us to see the text with new eyes and to better understand the way the book is used in classrooms and studios across North America. We would especially like to express our deep appreciation to the many artists, museums, galleries, and art owners for providing us with permissions and materials, which have enabled us to photographically reproduce their highly valued art. Finally, we express our thanks to the many readers who have persisted in their support over the years; may their ranks increase!

Reviewers

Cortlandt Bellavance
Atlantic Cape Community College

Cynthia Bickley-Green
East Carolina University

Dwaine Crigger
Southwest Missouri State University

Lori Ellis
Louisiana State University

Virginia Jenkins
University of Northern Colorado

Marie Louden-Hanes
University of Findlay

Sean O'Meallie
Colorado University at Colorado Springs

Phil E. Phillips
East Carolina University

Edward Pramuk
Louisiana State University

Robert Repinski
University of Minnesota

Donna Stackhouse
Raritan Valley Community College

ART FUNDAMENTALS

NINTH EDITION

THEORY AND PRACTICE

Introduction

THE VOCABULARY OF INTRODUCTORY TERMS

THE NEED AND SEARCH FOR ART

THE INGREDIENTS OF ART

The Three Basic Components of a Work of Art
Subject
Form
Content
Savoring the Ingredients

THE INGREDIENTS ASSEMBLED

Two-Dimensional Media and Techniques
The Two-Dimensional Picture Plane
The Picture Frame
Positive and Negative Areas
The Art Elements

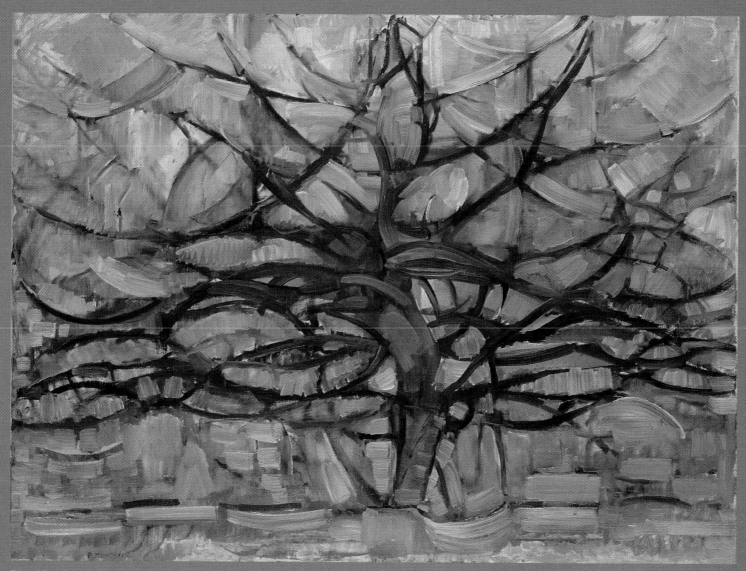

Piet Mondrian, *The Grey Tree*, 1912. Oil on canvas, $30\frac{7}{8} \times 42\frac{1}{2}$ in. (76.4 × 107.9 cm).

THE VOCABULARY OF INTRODUCTORY TERMS

Art The formal expression of a conceived image or imagined conception in terms of a given medium. (Sheldon Cheney)

abstraction
A term for the visual effects derived by the simplification and/or rearrangement of the appearance of natural objects, or nonrepresentational work arranged simply to satisfy artists' needs for organization or expression. Abstraction is present in varying degrees in all works of art, from full representation to complete nonobjectivity.

aesthetic, aesthetics
The theory of the artistic or the "beautiful"; traditionally a branch of philosophy, but now a compound of the philosophy, psychology, and sociology of art. As such, aesthetics is no longer solely confined to determining what is beautiful in art, but attempts to discover the origins of sensitivity to art forms and the relationship between art and other aspects of culture (such as science, industry, morality, philosophy, and religion). Frequently, aesthetics is used in this book to mean concern with artistic qualities of form, as opposed to descriptive form or the mere recording of facts in visual form. (See **objective.**)

conceptual perception
Creative vision derived from the imagination.

content
The expression, essential meaning, significance, or aesthetic value of a work of art. Content refers to the sensory, subjective, psychological, or emotional properties we feel in a work of art, as opposed to our perception of its descriptive aspects alone.

craftsmanship
Aptitude, skill, or quality workmanship in the use of tools and materials.

decorative (art, line, shape, color, etc.)
Ornamenting or enriching but, more importantly in art, emphasizing the two-dimensional nature of an artwork or any of its elements. Decorative art emphasizes the essential flatness of a surface.

descriptive (art)
A type of art that is based upon adherence to actual appearances.

design
The underlying plan on which artists base their total work. In a broader sense, design may be considered synonymous with the term **form.**

elements of art
Line, shape, value, texture, and color—the basic ingredients the artist uses separately or in combination to produce artistic imagery. Their use produces the visual language of art.

expression
1. The manifestation through artistic form of thought, emotion, or quality of meaning. 2. In art, expression is synonymous with the term **content.**

form
1. The organization or inventive arrangement of all the visual elements according to the principles that will develop unity in the artwork. 2. The total appearance or organization.

graphic art
1. Two-dimensional art forms, such as drawing, painting, making prints, etc.
2. The two-dimensional use of the elements of art. 3. May also refer to the techniques of printing as used in newspapers, books, magazines, etc.

mass
1. In graphic art, a shape that appears to stand out three-dimensionally from the space surrounding it, or appears to create the illusion of a solid body of material.
2. In the plastic arts, the physical bulk of a solid body of material. (See **plastic.**)

medium, media (pl.)
The material(s) and tool(s) used by the artist to create the visual elements perceived by the viewer.

naturalism
The approach to art that is essentially a description of things visually experienced. Pure naturalism would contain no personal interpretation introduced by the artist.

negative area(s)
The unoccupied or empty space left after the positive elements have been created by the artist. However, when these areas have boundaries, they also function as design shapes in the total structure. (See **positive area.**)

nonobjective, nonrepresentational (art)
A type of art that is entirely imaginative and not derived from anything visually perceived by the artist. The elements, their organization, and their treatment by the artist are entirely personalized and, consequently, not associated by the observer with any previously experienced natural objects.

objective (art, shape)
A type of art that is based, as near as possible, on physical actuality or optical perception. Such art tends to appear natural or real.

optical perception
A way of seeing in which the mind has no other function than the natural one of providing the visual sensation of object recognition.

organic unity
A condition in which the components of art—that is, subject, form, and content—are so vital and interdependent that they may be likened to a living organism. A work having "organic unity" is not guaranteed to have "greatness" or unusual merit.

picture frame
The outermost limits or boundary of the picture plane.

picture plane
The actual flat surface on which the artist executes a pictorial image. In some cases, the picture plane acts merely as a transparent plane of reference to establish the illusion of forms existing in a three-dimensional space.

plane
1. An area that is essentially two-dimensional, having height and width. 2. A flat or level surface. 3. A two-dimensional surface having a positive extension and spatial direction or position.

plastic (art)
1. The use of the elements of art to create the illusion of the third dimension on a two-dimensional surface. 2. Three-dimensional art forms, such as architecture, sculpture, ceramics, etc.

positive area(s)
The state in the artwork in which the art elements (shape, line, etc.), or their combination, produce the subject—nonrepresentational or recognizable images. (See **negative area.**)

realism, Realism (art movement)
A style of art that retains the basic impression of visual actuality without going to extremes of detail. In addition, realism attempts to relate and interpret the universal meanings that lie beneath surface appearances. As a movement, it relates to painters like Honoré Daumier in nineteenth-century France and Winslow Homer in the United States in the 1850s.

representation(al) (art)
A type of art in which the subject is presented through the visual art elements so that the observer is reminded of actual objects. (See **naturalism** and **realism.**)

space
The interval, or measurable distance, between points or images.

style
The specific artistic character and dominant trends of form noted during periods of history and art movements. Style may also refer to artists' expressive use of media to give their works individual character.

subject
1. In a descriptive approach to art, subject refers to the persons or things represented, as well as the artists' experiences, that serve as inspiration.

2. In abstract or nonobjective forms of art, subject refers merely to the visual signs used by the artist. In this case, the subject has little to do with anything experienced in the natural environment.

subjective (art, shape, color, etc.)
That which is derived from the mind reflecting a personal viewpoint, bias, or emotion.

technique
The manner and skill with which artists use their tools and materials to achieve an expressive effect. The ways of using media can have a strong effect on the aesthetic quality of an artist's total concept.

three-dimensional
Possessing the illusion of possessing the dimension of depth, in addition to having the dimensions of height and width.

two-dimensional
Possessing the dimensions of height and width, especially when considering the flat surface, or picture plane.

unity
The result of bringing the elements of art into the appropriate ratio between harmony and variety to achieve a sense of oneness.

volume
A measurable area of defined or occupied space.

THE NEED AND SEARCH FOR ART

ART FUNDAMENTALS: The two words that form the title of this book should make our purpose fairly clear. We will probably think we know what is meant by the word "art," but, as will be seen later, there are many interpretations.

As to "fundamentals," we mean the basic fabric of art, even though this definition is sometimes in dispute today. The word could legitimately be applied to the fundamental urge to create art objects that has persisted in humans back to the earliest recesses of history. Witness the cave paintings and carvings of prehistory (figs. 1.1 and 1. 2). The cave paintings may have been done to assure success in hunting—a form of magic. But why the figure carvings? Perhaps to serve as fertility fetishes. In any case, and whatever the motivation, this is surely a preeminent form of magic—the magic of the ability to create art.

Since those remote artistic eras, techniques and ambitions have enlarged exponentially, and today we have an array of different approaches to art. These "styles" have proliferated boundlessly and have provoked many definitions of art. A few of these follow; please note that all of them have been challenged, but each one probably has some essence of what may be thought of as art: The formal expression of a conceived image in terms of a given medium (Cheney), the making of a form produced by the cooperation of all the faculties of the mind (Longman), significant form (Bell), eloquence (Burke), the unexpected inevitability of formal relations (Fry), a unified manifold which is pleasure-giving (Mather), a diagram or paradigm with a meaning that gives pleasure (Lostowel), that which gives pleasure apart from desire (Thomas Aquinas), objectified pleasure (Santayana), imitation (what is imitation?), propaganda (emphasis on communication rather than expression; implies an effort to influence conduct).

▼ 1 • 1
Running Horse Attacked by Arrows.
Paleolithic cave painting, c.15,000–10,000 B.C., Lascaux, France.
One meaning of the word "fundamental" is the essential or basic urge to create art, as seen in this prehistoric cave painting.
Erich Lessing/Art Resource, NY.

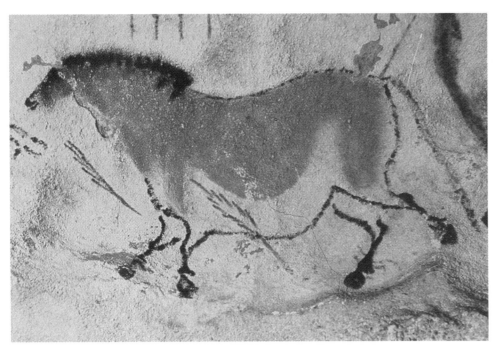

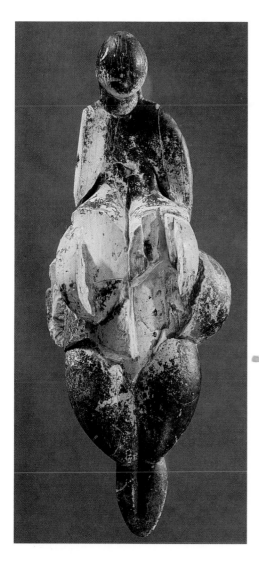

▲ 1 • 2

Venus of Lespugue, **carving from the Aurignacian Period.**

Possibly used as a magical fertility fetish, the *Venus of Lespugue* was carved from a mammoth tusk during the Aurignacian Period.

Scala/Art Resource, NY.

Notice that several of these definitions stress "pleasure" as a component of art, although some art seems to have no intention of provoking pleasure. Nevertheless, attempts at definition exemplify a constant effort to decipher the real nature of art and suggest that it is a different thing for different people. If a definition is attempted today, it would need to be awkwardly all-encompassing. Whatever it is, art can be a relaxant or stimulant. For the artist, it can also produce frustration—but in most cases, finally, a sense of achievement.

Before investigating the ingredients of art in the next section, let's consider some historical attitudes toward art. One such area deals with the appreciation of the "beautiful." Known as **aesthetics**, this complex area of study has never been totally resolved, particularly as it relates to the definition of beauty. Definitions of that troublesome word have changed with the times, even radically over the course of the last several generations. In some art circles today, beauty is considered obsolete. Historical cultures have had their own concepts of beauty, many of which would not correspond to contemporary tastes, and in the nineteenth and twentieth centuries, changes in the arts have confounded the public. What does the public often like and expect in art? Three things: the familiar subject, the recognizable subject, and the sentimental or "pleasant" subject. For many people, those criteria constitute beauty in art. But what if a work meets all three guidelines but is poorly executed? What if a work lacks the expected criteria but is expertly executed? Many great artists have created great works on gross subjects, and many inferior artists have produced inferior works on cherished subjects. Certainly not all people, even of similar backgrounds, would agree on the "beauty" of a given subject, much less its interpretation.

Beauty, whatever it is, is not universally sought in today's art. Process or Conceptual artists are much more concerned with the "how" (the **technique** used to create the work) than the "what" (the final product). Although such artists might consider their art beautiful (though they would probably not use the word), many would find it to be an alien and unacceptable kind of beauty. Perhaps "beauty" is due for a new definition—if one can be found!

An artwork's "fingerprint," or recognizability, usually exists in its style. Some styles are individual and unique, while others have been adopted by generations of artists. Regardless of style and the time or place of its creation, art has always been produced because an artist has wanted to say something and has chosen a particular way of saying it. Over the years, artists have been variously praised, neglected, misunderstood, and criticized. The amount of art being created today is unrivaled. In an attempt to provide some insight into the subject, many books have been written. Some have been intended for casual, enjoyable viewing; some for the general artistic enlightenment of the layperson; some for passive coffee table display; and some for an introduction to the practice of art. Apparently many people want to be actively engaged in art but find that much of what they see is not meaningful to them. This may add to their inhibitions. One reason for the inability to understand much of the art being created may be the enormous diversity of our world. Sophisticated printing and distribution techniques have made most of the art of the past and present available to us. In addition, television, the Internet with its instant global interactive communications, radio, and air travel have contributed to a great cultural mixing. This is a far cry from the insularity of the periods before the twentieth century; in those days, people often had a better understanding and greater acceptance of what they saw because they saw so little.

▶ 1•3
**Piet Mondrian, *The Grey Tree*, 1912.
Oil on canvas, 30⅞ × 42½ in. (76.4 ×
107.9 cm).**
In this work, we see the beginnings of
abstraction that marked Mondrian's progress
through figs. 1.4 and 1.5 to the purity of his
mature style (see fig. 1.6).
Gemeentemuseum, The Hague.

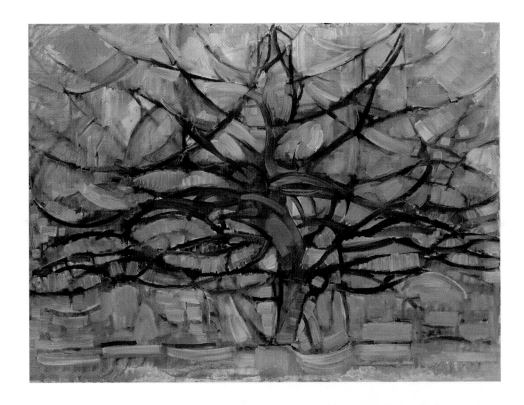

▶ 1•4
**Piet Mondrian, *Tree*, 1912.
Oil on canvas, 37 × 27⅞ in. (94 × 70.8
cm).**
This painting is another in Mondrian's gradual
abstract progression in the tree series to his
final classical purism in fig. 1.6. It is a step
away from the greater realism of fig. 1.3 to the
greater abstraction of fig. 1.5.
Museum of Art, Carnegie Institute, Pittsburgh, PA,
Patron's Art Fund, 61.1.

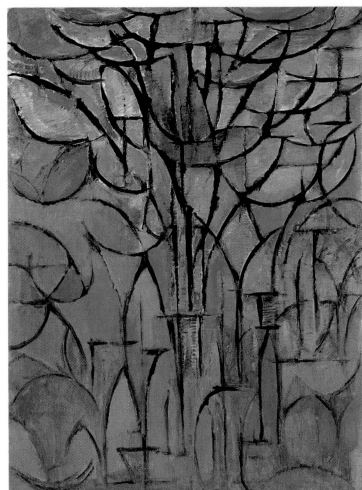

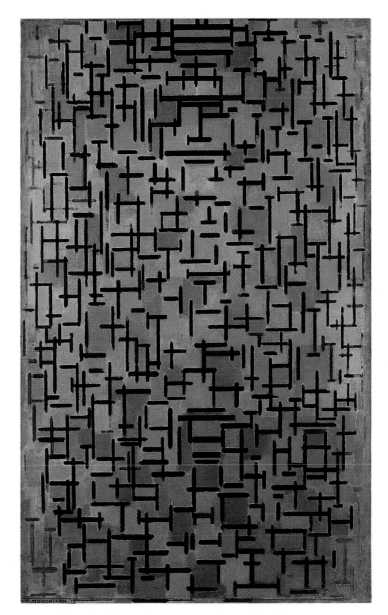

◀ **1•5**
Piet Mondrian, *Composition, 1916*, c. 1916.
Oil on canvas and wood strip, 47¼ ×
29½ in. (120 × 74.9 cm).
As a follow-up to figs. 1.3 and 1.4, this later work can be seen to be even closer to the severity of Mondrian's final style in fig. 1.6.
Solomon R. Guggenheim Foundation, New York (FN 4\9.1229).

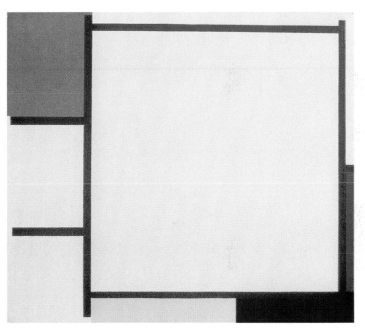

Throughout history, the fine arts of drawing, painting, printing, sculpture, and so forth, have been the fountainhead of significant artistic change and discovery, with a great potential for proliferation. One prime example is the paintings of Piet Mondrian. The development of his distinctive mature style can be traced easily by an examination of his works (figs. 1.3, 1.4, 1.5, and 1.6). The final style, the one best known, continues to be extremely influential in a very wide variety of applications (figs. 1.7, 1.8, and 1.9). It has, in fact, seeped into the subconscious

attitudes of us all—despite the fact that we may have little taste for the paintings themselves. Similarly, other significant artists, those whom we would deem "fine" artists, have subtly and involuntarily altered our vision. Many of those included in this book could be counted among them.

In order to gain some appreciation for the many forms of art to which we have access today, we must understand the basics from which they have grown. This book seeks to provide an understanding by examining the nature of the many factors involved in producing artworks, including

▲ **1•6**
Piet Mondrian, *Composition with Red,*
***Blue, Yellow, Black, and Gray*, 1922. Oil on**
canvas, 16½ × 19⅛ in. (41.9 × 48.6 cm).
The primary colors divided by block lines, all in a two-dimensional grid, are typical of Mondrian's later work. This is the style that has generated so much influence through the years.
Toledo Museum of Art. Toledo. OH. Purchased with funds from the Libbey Endowment, Gift of Edward Drummond Libbey. (1978.44) © Mondrian Estate/Holtzman Trust.

▶ 1 • 7
Gerrit Rietveld and Truus Schröder,
Rietveld-Schröder House, **1920–24.**
Rietveld (architect and designer) and Schröder (client and codesigner) were members, along with Mondrian, of the de Stijl group in Holland—a fact that probably accounts for the similarities in style.
© Nathan Willock/Architectural Association Slide Library, London.

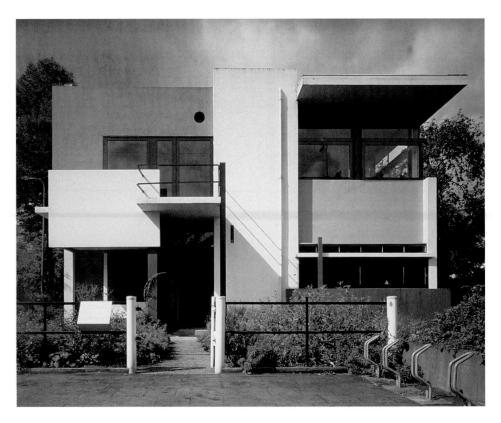

▶ 1 • 8
Gerrit Rietveld, *Red/Blue Chair,* **designed 1918 (made c. 1950 by G. van de Groenekan). Pine, ebonized and painted, $34\frac{7}{8} \times 23\frac{5}{8} \times 29\frac{3}{4}$ in. ($88.4 \times 60 \times 75.5$ cm).**
The relationships between horizontals and verticals and the juxtapositions of color within an asymmetrical grid are features shared by this chair and the paintings of Piet Mondrian.
Toledo Museum of Art, Toledo, OH. Purchased with funds from the Florence Scott Libbey Bequest, in memory of her father, Maurice A. Scott (1985.48)
© 1998 Beeldricht, Amsterdam.

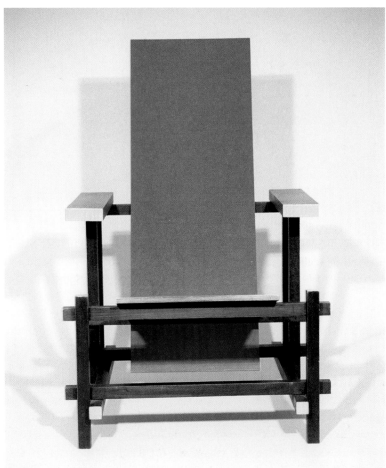

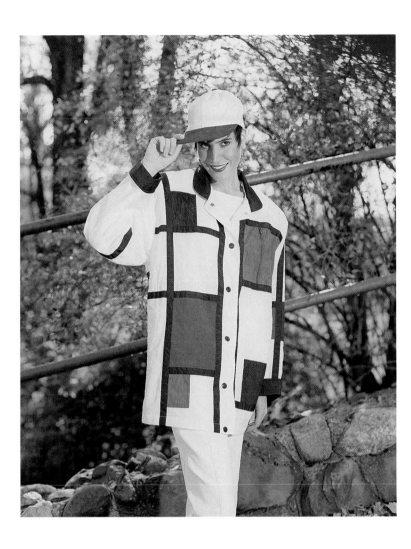

1 • 9
From the Deerskin catalog, a lightweight color block jacket.
The influence of Mondrian on commercial products is clearly evident in this design.
Courtesy of Deerskin Trading Post, North Bergen, NJ.

the principles that govern those factors. The authors have tried to avoid the pitfalls of stylistic favoritism by presenting a system for evaluating the structure of a work of art. Analyzing structure may seem a bit cold when applied to a creative field, but structure is necessary to all artistic areas, including music, dance, and literature. Without structure the expression would not come through, and the work would lack interest.

THE INGREDIENTS OF ART

Subject, form, and content have always been the three basic components of a work of art. In recent years, however, these components are often difficult to identify, differentiate, and define in certain works.

Traditionally, the subject of a work of art has been a person, object, or theme. Today, with the advent of the abstract age, subject can also refer to a particular configuration of the art elements and sometimes to a record of the energy and movement of the artist. The subject, in turn, can collide with an artwork's form, which is commonly understood as the work's appearance or organization. This can create confusion, indeed, for someone who is trying to write about art!

The definition of content, too, has been lost or altered from its original meaning. Conventionally, content refers to a work's total message as developed by the artist and interpreted by the viewer. Today, however, we find that the content

▲ 1 • 10

Barbara Chase-Riboud, *Bathers*, 1973. Floor relief, cast aluminum and silk in 16 pieces, 400 × 400 × 12 cm.

Barbara Chase-Riboud does not limit her image to a superficial presentation of subject, bathers. She reveals deeper formal meanings with the repitition of cast undulating surface folds and the contrast of metal against flowing silk coils.

Courtesy of the artist and Jernigan Wicker Fine Arts, CA.

often derives from an artist's private experiences. These experiences are so personal that it is sometimes difficult for an observer to understand the message unless he or she has had the same kind of experiences as the artist. The definitions of subject, form, and content that follow below are traditional. However, as we look at the illustrations in the book, we will recognize the contemporary blurring of these definitions. With that in mind, it may be easier to cope with works that defy our usual understanding of art.

Beyond art's three basic components, there are certain principles of organization—harmony, variety, balance, movement, proportion, dominance, and economy—that contemporary artworks may not always follow. Although some may quarrel with the observance of these principles in certain works, no one can argue with their constituent basics: the elements of line, shape, value, texture, and color. All artists must deal with these elements either alone or in combination. They may be the guiding forces for organization and interpretation. As a consequence, content may have an opportunity to appear. Thus, to summarize, in art we have the motivation (subject), the substantiation (form), and communication (content).

THE THREE BASIC COMPONENTS OF A WORK OF ART

Subject

A ▇ **subject** is a person, a thing, or an idea. The person or thing will be pretty clear to the average observer, but the idea may not be. In ▇ **abstract** or semi-abstract works, the subject may be somewhat perceivable, but in ▇ **nonobjective** works, the subject is the idea behind the form of the work, and it communicates with those who can read the language of form (fig. 1.10). Whether

recognized or not, the subject is important only to the degree that the artist is motivated by it. Thus, subject is just a starting point; the way it is presented or formed to give it **expression** is the important consideration.

Music, like any area of art, deals with subjects and makes an interesting comparison with the visual arts. In the latter, the subject is frequently the particular thing(s) viewed and reproduced by the artist. But at other times, art parallels music in presenting a "nonrecognizable" subject; the subject is, of course, an idea rather than a thing. Music sometimes deals with recognizable sounds—thunderstorms and bird songs in Beethoven's *Pastoral Symphony* or taxi horns in Gershwin's *An American in Paris.* Although rather abstractly treated, these may be the musical equivalents of recognizable subjects in an artwork. By way of contrast, Beethoven's *Fifth Symphony* or Gershwin's *Concerto in F* are strictly collections of musical ideas. In the dance medium, choreography often has no specific subject, but dancing in Copland's ballet *Rodeo* is, to a degree, subject-oriented. All of the arts have subjects that obviously should not be judged alone, but by what is done with them (fig. 1.11).

Form

The term **form** is used in various ways when referring to art objects. When applied to sculpture, form refers to the

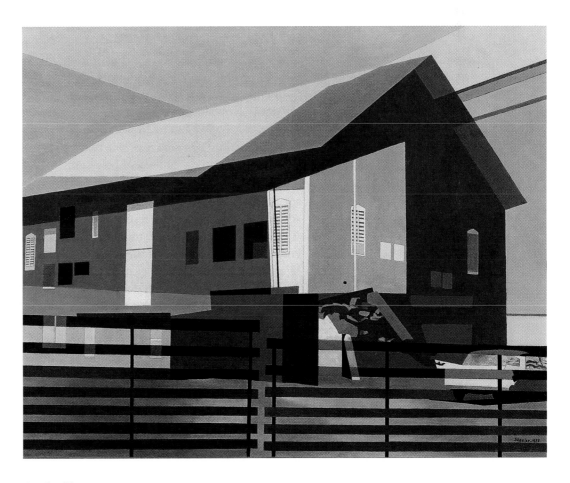

▲ 1 • 11

Charles Sheeler, *Composition around Red (Pennsylvania)*, 1958. Oil on canvas, 26 × 33 in.
The subject—a man-made structure—is clear enough. However, a work of art should not be judged by its subject alone but rather by how that subject is treated.
Montgomery Museum of Fine Arts. The Blount Collection of American Art.

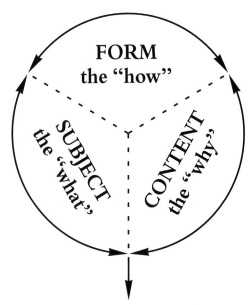

combining to produce ORGANIC UNITY

1 • 15
This diagram illustrates the interrelationship of subject, form, and concept as described on pages 12–16. Subject is not always the starting point. In some instances, artists start by exploring color or shape (the elements), and discover meaning as they work. The positions on the diagram and their degree of importance may be changed. And, though the content is revealed by the form, it might, in some instances, be the motivating force. Whatever the evolution, progression, or emphasis of the components—subject, form, and content—organic unity is the desired end.

representational likeness. The artist then manipulates the artistic elements (line, shape, etc.) to create the kind of form (the "how") that will result in the desired content (the "why"). The content expresses the artist's feelings (fig. 1.15). In this process, the artist attempts to make all parts of the work mutually interactive and interrelated—as they are in a living organism. If this is achieved, we can call it **organic unity**, containing nothing that is unnecessary or distracting, with relationships that seem inevitable.

A television set might be used as an illustration of organic unity because it has a complex of parts intended to function together, like the organs in the human body. A TV contains the minimum number of parts necessary to function, and these parts work only when properly assembled with respect to each other. When all the parts are activated, they become organically unified. As in the case of sophisticated engineering, this sense of reciprocal "wholeness" is also sought in art.

Wholeness is difficult to detect in the works of some contemporary artists who challenge tradition. In their works, the distinctions between subject, form, and content are blurred, lost, or "muddied" because these components are sometimes treated as identical. This break with tradition requires a shift of gears in our thinking. In **Conceptual art** (a style; most art is conceptual, to some degree), the concept is foremost, the product is considered negligible, and the concept and subject seem to be one. In Process art (another style), the act of producing

is the only significant aspect of the artwork, thereby reducing form and content to one entity. (See the Process and Conceptual Art section in Chapter 10.) Styles that embrace such goals can be quite puzzling if the aims of the artist are not understood by the viewer.

Even conventional art forms sometimes scramble the roles of the components. Although content results from form, content sometimes functions as the precipitating force, thereby placing it prior to the subject in the scheme of things. Also, in some cases, the developing form may mutate into a subject and/or content altogether different from that originally conceived.

As previously suggested, many people expect visual art to be recognizable, representing such familiar items as houses, flowers, people, trees, and so on. When the artist reproduces such things faithfully, the vision may be thought of as the "real" world. The artist who works in this manner could be called a "perceptual" artist because he or she records only what is perceived. But in art, the "real" can supersede mere optics; reality in art does often include things seen but, more importantly, includes our reactions to those things (fig. 1.16). Artists who are more concerned with responses than with commonplace perceptions are legitimately called "conceptual" because they are idea-oriented.

Creativity emanates from ideas. Generally speaking, an idea is born in the mind. For the artist, it may be an all-encompassing plan, a unique or particularly suitable set of relationships

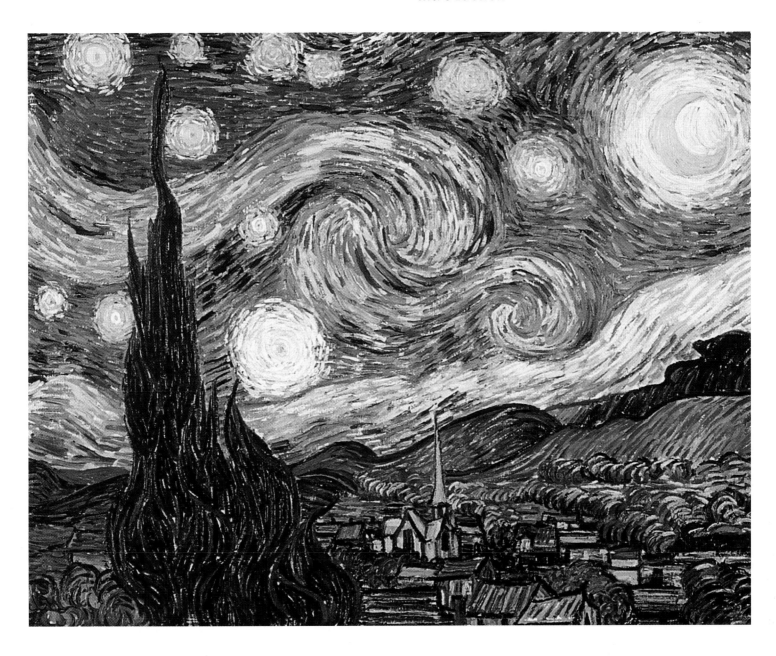

(however broad the scope), an attitude that could be conveyed or a way of conveying an attitude, or a solution to a visual problem. In the artist's mind, the idea occurs as mental imagery and may be a "bolt from the blue" (inspiration?) or the end product of much thoughtful searching, some of which may be reflected in numerous notes, sketches, or repeated overhauling of the artwork.

All such creative enterprises are occasionally plagued by mental blocks, but they seem to afflict the fledgling artist most often. For the beginner, the idea is conceived at a more pedestrian level, being equated with subject ("I don't know what to do!"). In such situations, a familiar object or experience is the best bet as a starter, supplemented by the brainstorming of anything remotely related. In art, an idea is of value only when converted into visual reality; sometimes this is the more difficult problem, sometimes not, depending on the fertility of one's imagination.

▲ 1 • 16

Vincent van Gogh, *The Starry Night*, 1889. Oil on canvas, 29 × 36¼ in. (73.7 × 92.1 cm).

Surveying the landscape is a fairly common experience, but few (if any) of us see landscapes with the perception and intensity of van Gogh.

The Museum of Modern Art, New York. Acquired through the Lillie P. Bliss Bequest. Photograph © 1998 the Museum of Modern Art, New York.

SAVORING THE INGREDIENTS

All art is illusory to some extent, and some artworks are more successful than others at drawing us out of our standard existence into a more meaningful state. Artists achieve some of this by the use of frames, stages, exaggerated costumes and gestures, cosmetics, concert halls, and galleries. All of these emphasize the idea that in seeing and hearing the arts, we are not in the everyday world, but rather a hypersensitized world of "greater" values. By strengthening this illusion, art enlarges our awareness.

When, in being ▩ **subjective**, the artist reaches below surface appearances and uses unfamiliar ways to find unexpected truths, the results can often be distressing for many observers. Such distress frequently follows changes in art styles. The artist is sometimes accused of being incompetent or a charlatan. Much of what we value in art today was once fought for, tooth and nail. General acceptance of the new comes about only when enough time has passed for it to be reevaluated. At this point, the new begins to lose its abrasiveness. Thus, there is no need for embarrassment at feeling confused or defiant about an artwork that seems "far out"; instead, we need to strive for continued exposure, thought, and study (fig 1.17). We all have the capacity to appreciate the beautiful or expressive, as evidenced by the aesthetic choices we make every day. But we must enlarge our sensitivity and taste, making them more inclusive.

One way to extend our responses to art is by attempting to see the uniqueness in things. The author Gertrude Stein wrote, "A is a rose is a rose is a rose." A literal interpretation would lead us to expect all roses to be identical, but we know that every rose has a different character, even with identical breeding and grooming. Every object is ultimately unique, be it a chair, a tree, or a person. One of the major characteristics that sets the artist apart is the ability to see (and experience) the subtle differences in things. By exposing those differences, the artist can make the ordinary seem distinctive, the humdrum exciting (fig. 1.18).

Perception is the key. When an artist views an object—a tree branch, for example—and is inspired to try to reproduce the original as seen, he or she is using and drawing inspiration from ▩ **optical perception**. However, another artist seeing the same branch may find it evokes a crying child or a rearing horse. When the imagination triggers this creative vision and additional images are suggested, the artist is using ▩ **conceptual perception**.

Leonardo da Vinci, in his *Treatise on Painting,* recorded an experience with conceptual perception while studying clouds. "On one occasion above Milan, over in the direction of Lake Maggiore, I saw a cloud shaped like a huge mountain made up of banks of fire. . . ." Elsewhere, he recommends staring at stains on walls as a source of inspiration. Following Leonardo, author and painter Victor Hugo found many of his ideas for drawings by studying the blots made by coffee stains on tablecloths.

Another way to enlarge our sensitivity to the visual arts is by ridding ourselves of the expectation that all forms of art should follow the same rules. Photography might serve as an example. We know that many people judge a work of art by how closely it can be made to look like something. It is true that skillful artists can create amazing resemblances, but the camera can win this game! The artist fights a losing battle with the camera if he or she plays by photography's rules. Artists are often proud of their ability to reproduce appearances, but most artists regard this skill as less important. If making look-alikes is the key to art, it is strange that the best photographers are not content simply to point and shoot. Instead, they look for the best view, blur the focus,

The Wrapping Up

Here's what it takes to wrap the German Reichstag as Christo and Jeanne-Claude did:

The German Reichstag
Total perimeter: 1,520.3 feet
Width (north-south): 314.9 feet
Length (east-west): 445.2 feet
Height of the four towers: 139.4 feet
Height at roof: 105.5 feet

The Materials
Yarn for weaving: 43,836 miles
Silver polypropylene fabric: 119,603 square yards
Width of the original woven fabric: 5 feet
Number of fabric panels: 70
Length of thread: 807.8 miles
Window anchors: 110
Roof anchors: 270

Visits to Germany by the Christos:
1976-95: 54
Members of Parliament visited: 352
Number of presidents of the Bundestag involved: 6

The Workforce
Monitors: 1,200 in four 6-hour shifts
Professional climbers: 90
Professional helpers: 120 in two shifts
Office staff (Berlin): 17
Office staff (New York): 2

The Costs
Rope: $72,000
Fabric metalization: $72,000
Sewing: $1,080,000

Structural engineering and construction: $1,080,000
Documentation of building condition: $72,000
Air cushions and covering of cages: $216, 000
Steel construction: $2,160,000
Steel weights: $180,000
Insulation and dismantling: $1,368,000
Monitors and security: $1,296,000
Rents, further wages, transportation: $324,000
Total cost to Christo and Jeanne-Claude: $13,000,000 of their own money. The work of art was entirely financed by the artists, as they have done for all their projects, through the sale of preparatory studies, drawings, collages, scale models as well as early works and original lithographs. The artists do not accept sponsorship of any kind.

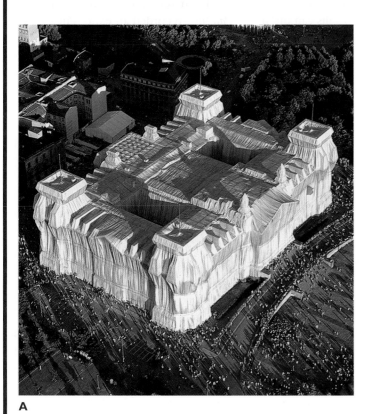

A

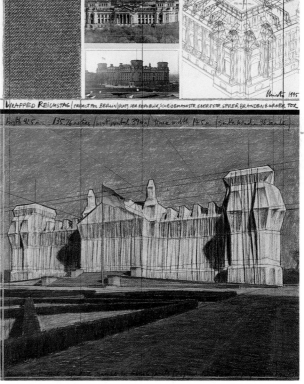

B

▲ 1 • 17
(A) The realized work: Christo and Jeanne-Claude, *Wrapped Reichstag, Berlin,* 1971–95.
(B) Preparation work (drawings) before the project was realized: Christo, *Wrapped Reichstag, Project for Berlin.*
Wrapping the Reichstag in aluminum coate fabric and rope was the culmination of Christo's and Jeanne-Claude's long-held dream.
© Christo and Jeanne-Claude, 1998. Photographs: Wolfgang Volz.

◀ **1 • 18**
Patricia Nix, *La Primavera*, 1992–94.
Mixed media on canvas, 72 × 80 in.
Patricia Nix's *La Primavera* presents roses as a repeated theme, but subtle differences in texture, color, and treatment keep them fresh and unique.
From the collection of Ivan Blinoff, London.

use filters, alter lighting, and make adjustments in developing (fig. 1.19). Photographers become artists when they are not satisfied with obvious appearances. So, too, do ▪ **plastic** and ▪ **graphic** artists.

People also tend to associate visual art with literature, hoping it will tell a story in a ▪ **descriptive** manner. Many fine works contain elements of story-telling, but artists have no need or obligation to narrate. "Picture-stories" succeed as art only when influenced by formal considerations (fig. 1.20). The visual arts and literature share certain elements. For the author, objects or things are nouns; for the visual artist, representational subjects are nouns. Nouns are informative, but provide nothing poetic for the author; there is always a need for verbs, adjectives, and so on to establish action, moods, and meanings. Similarly, the visual artist's

"subject-nouns" rarely inspire, except occasionally by association. For the visual artist, the "verbs" are the combined effect of the elements and their principles; by manipulating these, a poetic effect very like that found in literature can be achieved.

In adapting ourselves to the rules peculiar to art, we must also place our own taste on trial. This means accepting the possibility that what is unfamiliar or disliked may not necessarily be badly executed or devoid of meaning. Of course, one should not automatically accept what one is expected to like; instead, open-mindedness is required. Even artists and critics rarely agree unanimously about artists or their works. Fortunately, the authors of this book are generally of the same mind regarding art, with some exceptions. Even with training, people's tastes, like Stein's roses, do not turn out to be

identical. The quality of art is always questionable. Perhaps the most reliable proof of quality comes only with time and the eventual consensus of sensitive people.

Aside from satisfaction, one of the dividends gained by a better understanding of the visual arts is that it puts us in touch with some remarkably perceptive people. We always benefit from contact, however indirect, with the creations of great geniuses. Einstein exposed relationships that have reshaped our view of the universe. Mozart created sounds that, in an abstract way, summed up the experiences and feelings of humankind. Though not always of this same magnitude, artists, too, expand our frames of reference, revealing new ways of seeing and responding to our surroundings. When we view artworks knowledgeably, we can be on the same wavelength with the artist's finely tuned emotions.

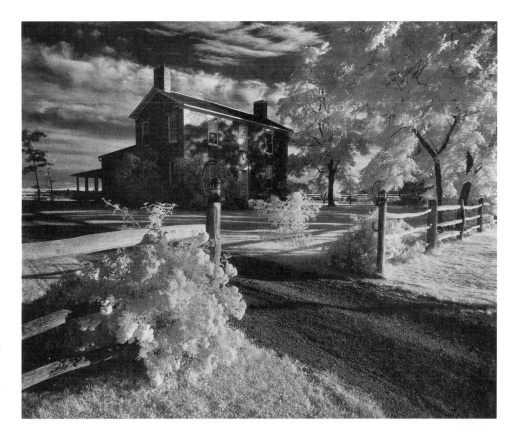

▷ 1 • 19
Minor White, *Cobblestone House, Avon, New York,* 1958. Gelatin silver print.
Photographers may have the edge on other visual artists when it comes to recording objective reality, but photographer-artists are not satisfied with obvious appearances and use complex technical strategies to achieve their goals.

The Art Museum, Princeton University, Princeton, NJ. The Minor White Archive. (© 1982 Trustees of Princeton University.)

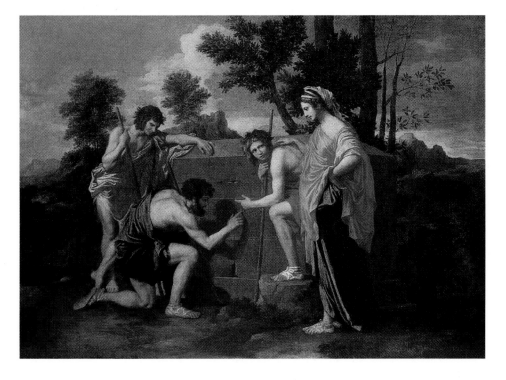

◁ 1 • 20
Nicolas Poussin, *et in Arcadia Ego (Shepherds of Arcadia),* c. 1650–65.
This painting could be called a "picture story" because it derives from a classical mythological tale. It could have been merely a factual statement about a moment in that myth, but Poussin's concern for design enhances the meaning of the tale.

Louvre, Paris, France/The Bridgeman Art Library.

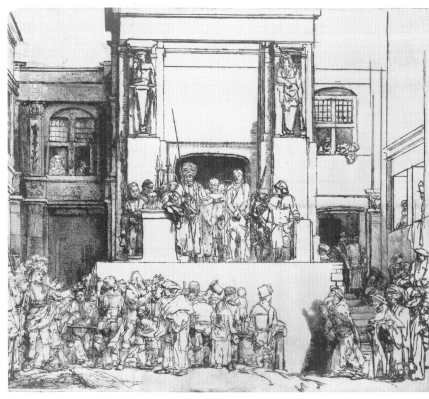

A

THE INGREDIENTS ASSEMBLED

We have mentioned some of the means by which an artist's emotions may be brought to the surface. You have been introduced to the components, elements, and principles involved in making visual art. You now have an idea of how all these factors enter into the expression of the artist's feelings. You have been given some advice on the attitudes to develop in order to share the artist's feelings. Now, let's consider how these matters fit into developing a hypothetical work of art.

Any construction project requires structural elements. Under the supervision of the contractor, these are assembled and put together until an edifice of some kind results. The corresponding structural **elements of art** are **line, shape, value, texture,** and **color.** In making a work of art, the artist is not only

the contractor but also the architect; he or she has the vision, which is given shape by the way the elements are brought together. Whereas a building contractor is limited by adherence to blueprints, an artist has the advantage of constant flexibility in the structuring of the work. For example, the raw elements can be manipulated to produce either a **two-dimensional** effect (circle, triangle, or square) or a **three-dimensional** effect (sphere, pyramid, or cube). In a two-dimensional work, the elements and whatever they produce seem to lie flat on the **picture plane,** but when the elements are three-dimensional, penetration of that **plane** is implied.

Other terms are used in art circles to describe the conditions found in any consideration of dimensionality. **Decorative** is a term we usually associate with ornamentation, but it is also used to describe the effect produced when the elements of art cling rather

closely to the artistic surface. We can say that line (which can decorate in the familiar sense) is decorative if it does not leap toward or away from the viewer dramatically in the format. The same is true of the other art elements. When they are of this nature collectively, we can say that the space created by them is decorative, or relatively flat. On the other hand, if the elements make us feel that we could dive into the picture and weave our way around and behind the art elements, the space is said to be plastic.

Thus defined, the term plastic has clear implications for **sculpture,** because we can (we must!) move about the piece. Any **mass,** whether actual (as in a statue) or implied (as portrayed in drawing or painting), can be called plastic. Mass is anything that has cohesive, homogeneous bulk, implying a degree of weightiness. **Volume,** on the other hand, is an area of defined containment. An empty living room has volume in its

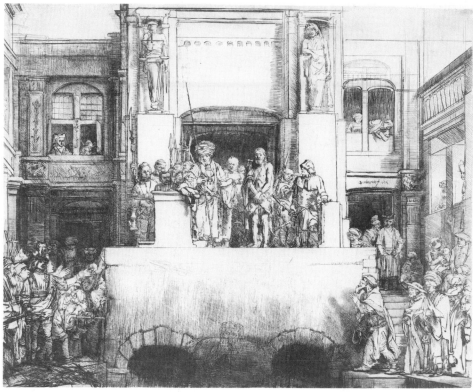

B

◀ 1•21

Rembrandt Harmenszoon van Rijn, *Christ Presented to the People,* **last state 1606–09, print (etching).**

Rembrandt searched for the most interesting and communicative presentation of his idea. In doing so, he made dramatic deletions and changes, which in this case involved scraping out a portion of the copper plate. Figure 1.21A is the first version of the work, and Figure 1.21B is the last.

Metropolitan Museum of Art, New York. Gift of Felix M. Warburg and his family, 1941.

dimensions, but no mass. A brick has mass within its volume. Mass and volume indicate the presence of three-dimensionality in art.

A distinction must be made between plastic art and graphic art. The graphic arts—drawing, painting, printmaking, photography, and so on—generally exist on a flat surface and rely on the illusion of the third dimension. By contrast, the plastic arts—sculpture, ceramics, architecture, and so on—are tangible and palpable, occupying and encompassed by their own space. Stated another way, graphic art may have two-dimensional, decorative effects defined by art elements, and plastic art has a three-dimensional reality created by art elements that share the same properties.

An artist must begin with an idea, or germ, that will eventually develop into the concept of the finished artwork. The idea may be the result of aimless doodling, a thought that has suddenly struck the artist,

or a notion that has been growing in his or her mind for a long time. If this idea is to become tangible, it must be developed in a ▪ **medium** selected by the artist (clay, oil paint, watercolor, etc.). The artist not only controls, but is controlled by, the medium. Through the medium the elements of form emerge, with their intrinsic meanings. These meanings may be allied with a nonobjective or, to different degrees, objective image; in either case, the bulk of the meaning will lie in the form created by the elements.

While developing the artwork, the artist will be concerned with composition, or formal structure, as he or she explores the most interesting and communicative presentation of an idea. During this process, ▪ **abstraction** will inevitably occur, even if the work is broadly realistic—elements will be simplified, changed, added, eliminated, or generally edited (fig. 1.21). The abstraction happens with an awareness,

and within the parameters, of the principles of the artwork.

As the creative process unfolds (not always directly, neatly, or without stress or anguish), the artist fervently hopes that its result will be organic unity. As stated earlier, this all-inclusive term refers to the culmination of everything that is being sought in the work. Put simply, it means that every part not only fits, but that each one contributes to the overall content, or meaning. At this point, however arduous or circuitous the artist's route, the work is finished—or is it? Having given the best of themselves, artists are never sure of this! Perhaps the perspective of a few days, months, or even years will give the answer. And if the work is finished, and it has organic unity, is it guaranteed to be judged a "great work of art"? The ingredients assembled in organic unity do not guarantee "greatness" or immortality, but they do help give the work a vital completeness.

▲ 1 • 22
Thomas Hilty, *Meditation*, 1996. Charcoal, pastel, and conté on museum board, 28 × 40 in. (71.12 × 101.6 cm).
This drawing shows the artist's characteristic use of mixed media. He has skillfully blended and rubbed the materials to produce the effect of expressive and varied surfaces.
Courtesy of the artist.

TWO-DIMENSIONAL MEDIA AND TECHNIQUES

Media are the materials used in making an artwork, and techniques control their application. Artists derive much stimulation for creative expression from their interaction with the media and the various techniques. In each area of the graphic arts, certain successful processes, many of them developed over the centuries, have become common or traditional. Painters are attracted by the smell and feel of fresh plaster resisting the brush in fresco and secco painting. Oils and watercolors provide a different tactile excitement from gouache and tempera, as do wet or dry surfaces. For the draftsman, the difference between a heavy pressure or a light touch can be just as compelling as the textural quality of the drawing surface. Graphite, charcoal, colored pencils, pastels, and chalk can all be blended or erased (fig 1.22). Inks, whether applied by brush, crow quill, speedball steel

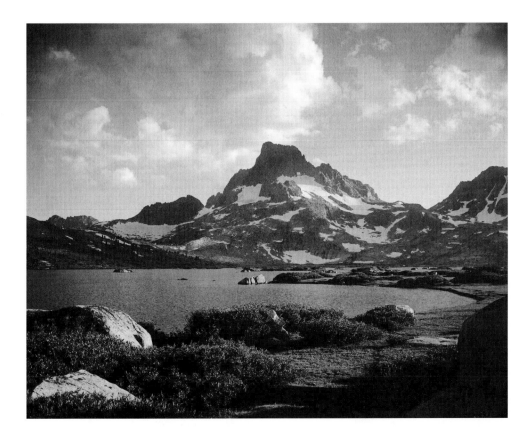

1 • 23

Ansel Adams, *Banner Peak and Thousand Island Lake, Sierra Nevada, California,* 1923. Panchromatic glass.

The invention and development of photography added an important new medium to the repertoire of artists. The accomplishments of such photographers as Ansel Adams rank with those of well-known painters, sculptors, and architects.

Courtesy of the Ansel Adams Publishing Rights Trust.

point, bamboo/sharpened stick, or cardboard can be exciting because of how they react to dry or dampened surfaces.

For printmakers (see Chapter 5), watching the physical surface change is intriguing. In lithography, the drawing comes to life as water magically resists the application of ink; intaglio plates are etched in acid until the topography reveals the image below the plate's surface. In wood or linoleum cuts and wood engraving, the resistance of the wood provides a unique texture. Serigraphic images can be flat in decorative color and surface quality or resolve into transparency and overlapping texture.

Nineteenth- and twentieth-century artists benefited from numerous advances in scientific technology. One of the great visual breakthroughs was the development of photography.

Although a camera is not as flexible as a paintbrush (for example), photographic innovations can broaden the artist's vision. The creative efforts of such photographic artists as Edward Steichen, Alfred Stieglitz, and Ansel Adams (fig. 1.23) are as well known today as the works of many of our important painters and sculptors. From the photographic experiments of such people have come creative filmmaking, xerography, and the artistic employment of other photographically related media. All have been absorbed into the artist's repertoire.

Today there is a deluge of new media and techniques. Some are extensions of traditional approaches, while others, like digital generated imagery, are without precedent. Traditional painting media have been augmented by acrylics, enamels, lacquers, preliquified watercolors, and

roplex. Drawing media include new forms of chalk, pastels, crayons, inks, and drawing pens. The sculptor's arsenal has been augmented by welding, plastics, composition board, aluminum, and stainless steel. Printmakers now use paper, light-sensitive polymer plates, and presensitized metal. Although most of the artworks with which we are familiar are static (lacking movement), except for mobiles, today new art forms produce actual movement in their imagery; think of video, holography, virtual reality, computer-generated action, and performances that mix dance, drama, sound, and light, and even include the audience. Very often, traditional and nontraditional media and techniques are combined.

For illustrations and more specific information on artists' tools, equipment, and working surfaces, see the accompanying CD-ROM. 💿

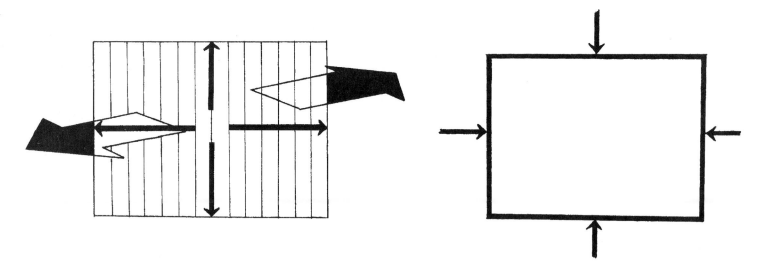

▲ 1•24A

The picture plane.
Movement can take place on a flat surface, as indicated by the vertical and horizontal arrows. The vertical lines represent an imaginary plane through which a picture is seen. The artist can also give the illusion of advancing and receding movement in space, as shown by the two large arrows.

▲ 1•24B

The picture frame.
The picture frame represents the outermost limits, or boundary, of the picture plane. These limits are represented by the edges of the canvas or paper on which the artist works, or by the margin drawn within these edges.

THE TWO-DIMENSIONAL PICTURE PLANE

There are many ways to begin a work of art. Artists who work with two-dimensional art generally begin with a flat surface. The flat surface is the picture plane on which artists execute their pictorial images. The need to somehow establish a relationship between the actual environment and the reduced size of an artist's working area, or picture plane, has had a long history. A piece of paper, a canvas, a board, or a plate may be representative of the picture plane. This flat surface may also represent an imaginary plane of reference on which an artist can create spatial illusions. The artist may manipulate forms or elements so that they seem flat on the picture plane, or extend them so that they appear to exist in front of or behind the picture plane (fig. 1.24A). In this way, the picture plane is used as a basis for judging two- and three-dimensional space. In three-dimensional art, the artist begins with the material—metal, clay, stone, glass, and so on—and works it as a total form against the surrounding space, with no limitations except for the outermost contour (see Chapter 9).

THE PICTURE FRAME

Artists from all cultures have used defined boundaries around the working area, or picture plane, which we generally call the ▪ **picture frame** (fig. 1.24B). The picture frame should be clearly established at the beginning of a pictorial organization. Once its shape and proportion are defined, all of the art elements and their employment will be influenced by it. The problem for the pictorial artist is to organize the elements of art within the picture frame on the picture plane.

The proportions and shapes of frames used by artists are varied. Squares, triangles, circles, and ovals have been used as frame shapes, but the most popular is the rectangular frame, which in its varying proportions offers the artist an interesting variety within the two-dimensional ▪ **space** (figs. 1.25, 1.26, 1.27; see fig. 2.25). Many artists select the outside proportions of their pictures on the basis of geometric ratios. (See the Proportion section in Chapter 2.) These rules suggest dividing surface areas into

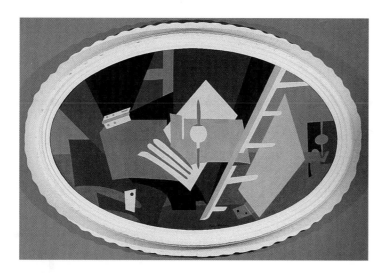

◀ 1 • 25

Esphyr Slobodkina, *Composition in an Oval,* c. 1953. Oil on gesso board, $32\frac{1}{2} \times 61\frac{1}{2}$ in. (82.5 × 156.2 cm).

Slobodkina has used an unusual frame shape to emphasize an angular abstract painting. Now used less frequently, such frame shapes were employed more often in the past with traditional religious subjects.

Grey Art Gallery. New York University Art Collection. Gift of Mr. and Mrs. Irving Walsey, 1962.

▼ 1 • 26

El Greco, *Madonna and Child with Saint Martina and Saint Agnes,* c. 1597–99. Oil on canvas, 6 ft $4\frac{1}{8}$ in. × 3 ft $4\frac{1}{2}$ in. (1.94 × 1.03 m).

The rectangular frame shape, by its proportions, offers the artist a pleasing and interesting spatial arrangement. Here, El Greco has elongated his main shapes to repeat and harmonize with the vertical character of the picture frame.

Widener Collection. © 1997 Board of Trustees. National Gallery of Art, Washington.

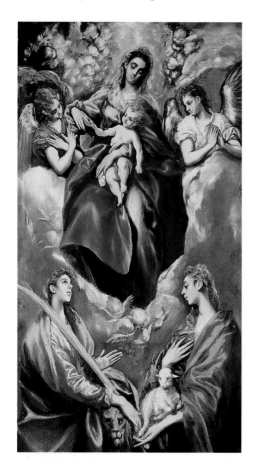

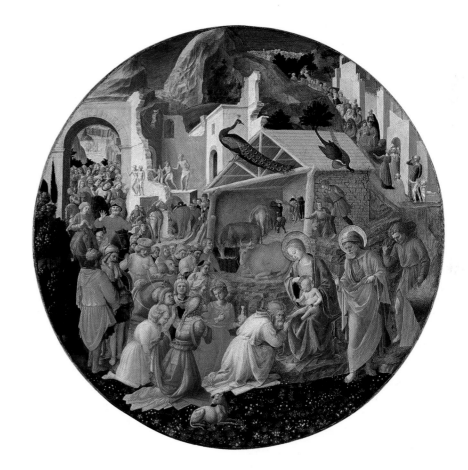

▲ 1 • 27

Fra Angelico and Fra Filippo Lippi, *The Adoration of the Magi,* c. 1445. Tempera on panel, diameter 4 ft 6 in. (1.37 m).

The artists have used figures and architecture, and the direction of the movement of the art elements, in harmonious relation to a circular picture frame.

Samuel H. Kress Collection. © 1997 Board of Trustees. National Gallery of Art, Washington.

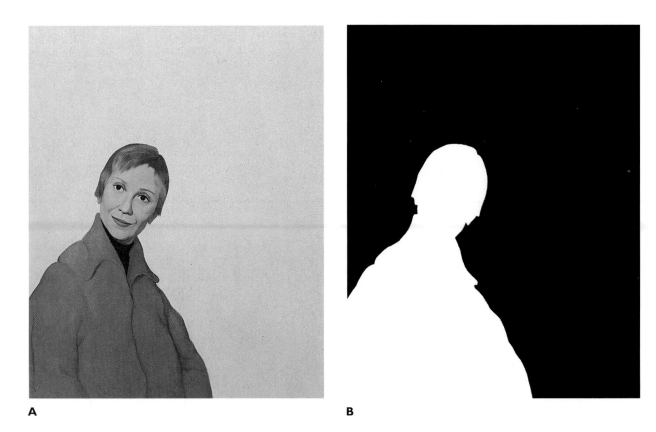

A B

▲ 1 • 28

John Currin, *The Moved Over Lady,* 1991. Oil on canvas, 46 × 38 in. (116.8 × 96.5 cm).
The subject in this painting represents a positive shape that has been enhanced by careful consideration of the negative areas, or the surrounding space. In Figure 1.28B, the dark area indicates the negative shape and the white area the positive shape.

Andrea Rosen Gallery, New York. Photograph: Fred Scraton.

odd proportions of two-to-three or three-to-five, rather than into equal relationships. The results are visually pleasing spatial arrangements. Most artists, however, rely on their instincts rather than on a mechanical formula. After the picture frame has been established, the direction and movement of the elements of art should be in harmonious relation to this shape. Otherwise, they will tend to disrupt the objective of pictorial unity.

POSITIVE AND NEGATIVE AREAS

All of the surface areas in a picture should contribute to ▦ **unity**. Those areas that represent the artist's initial selection of element(s) are called ▦ **positive areas**. Positive areas may depict recognizable objects or nonrepresentational elements. Unoccupied spaces are termed ▦ **negative areas** (fig. 1.28). The negative areas are just as important to total picture unity as the positive areas, which seem tangible and more explicitly laid down. Negative areas might be considered as those portions of the picture plane that continue to show through after the positive areas have been placed in a framed space (Fig. 1.29).

Traditionally, figure and/or foreground positions have been considered positive, and background areas have been considered negative. The term "figure" probably came from the human form, which was used as a major subject in artworks and implied a spatial relationship with the figure occupying the position in front of the remaining background (fig. 1.30; see fig. 1.28). In recent times, abstract and nonobjective painters have adopted the terms *field* to mean positive and *ground* to mean negative. They speak of a color field on a white ground, or of a field of shapes against a ground of contrasting value.

The concept of positive and negative areas is important to beginners investigating art organization, because inexperienced artists usually direct their attention to positive forms and neglect

▶ 1 • 29
Robert Motherwell, *Africa*, 1965.
Acrylic on Belgian linen, 81 × 222½ in.
In this nonfigurative or nonobjective work, some areas have been painted and others not. It is very simple, perhaps deceptively so. To the viewer, the darks seem to be the positive shapes, although after some looking, the effect may be reversed.
The Baltimore Museum of Art. Gift of the Artist. BMA 1965.012.

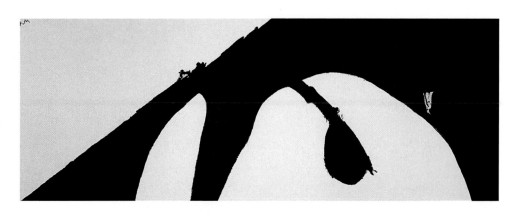

the surrounding areas. As a result, their pictures often seem overcrowded, busy, and confusing.

When the artist's tool touches the picture plane, leaving a mark, two things happen. First, the mark divides, to some extent, the picture plane. Generally the mark is seen as a positive image, leaving the remainder to be perceived as a negative area. Secondly, the mark may seem to take a position in front of, or at some distance behind, the picture plane. Each of these results will continue to be important to the artist as the work develops.

THE ART ELEMENTS

The artist employs various media to implement the art elements: line, shape, value, texture, and color. These elements are the fundamental, essential constituents of any artwork. The basic elements are thought to be so indispensable to art fundamentals that each will be examined individually in the chapters that follow.

For more information on the development of an artwork, see the accompanying CD-ROM. 🌑

▲ 1 • 30
Paul Gaugin, *Ancestors of Tehamana*, 1893.
Oil on canvas, 30⅛ × 21⅛ in. (76.3 × 54.3 cm).
Items in the foreground (generally toward the bottom of the picture plane) are traditionally considered positive areas, whereas unoccupied spaces in the background (upper) are negative areas. This traditional view does not always apply, however, as can be seen by looking at other illustrations in this book.
Art Institute of Chicago. Gift of Mr. and Mrs. Charles Deering McCormick, 1980.613. Photo © Art Institute of Chicago.

CHAPTER TWO

Form

THE VOCABULARY OF FORM

FORM AND VISUAL ORDERING

THE SEVEN PRINCIPLES OF ORGANIZATION
Harmony (1)
Variety (2)
Balance (3)
Proportion (4)
Dominance (5)
Movement (6)
Economy (7)

SPACE: RESULT OF ELEMENTS/PRINCIPLES

FORM UNITY: A SUMMARY

Ben Shahn, *Handball*, 1939. Tempera on paper over composition board, 22³⁄₄ × 31¹⁄₄ in. (57.8 × 79.4 cm).

THE VOCABULARY OF FORM

Form 1. The organization or inventive arrangement of all the visual elements according to the principles that will develop unity in the artwork. **2.** The total appearance or organization.

academic
Art that conforms to established traditions and approved conventions as practiced in art academies. Academic art stresses standards and set procedures and rules.

allover pattern
The repetition of designed units in a readily recognizable systematic organization covering the entire surface.

approximate symmetry
The use of similar imagery on either side of a central axis. The visual material on one side may resemble that on the other but is varied to prevent visual monotony.

asymmetry
Having unlike, or noncorresponding, appearances—"without symmetry." An example: a two-dimensional artwork that, without any necessarily visible or implied axis, displays an uneven distribution of parts throughout.

balance
A sense of equilibrium achieved through implied weight, attention, or attraction, by manipulating the visual elements within an artwork to achieve unity.

closure
A concept from Gestalt psychology in which the development of groupings or patterned relationships occurs when incomplete information is seen as a complete, unified whole; the artist provides minimum visual clues, and the observer brings them to final recognition.

composition
An arrangement and/or structure of all the art elements, according to the principles of organization, that achieves a unified whole. Often used interchangeably with the term *design*.

concept
1. A comprehensive idea or generalization. 2. An idea that brings diverse elements into a basic relationship.

design
The underlying plan on which artists base their total work. In a broader sense, design may be considered synonymous with the term *form*.

dominance
The principle of visual organization in which certain elements assume more importance than others in the same composition or design. Some features are emphasized, and others are subordinated.

economy
The distillation of the image to the basic essentials for clarity of presentation.

Gestalt (Gestalt psychology)
A German word for "form"; an organized whole in experience. Around 1912, the Gestalt psychologists promoted the theory that explains psychological phenomena by their relationships to total forms, or Gestalten, rather than by their parts.

golden mean, golden section
1. Golden mean—"perfect" harmonious proportions that avoid extremes; the moderation between extremes. 2. Golden section—a traditional proportional system for visual harmony expressed when a line or area is divided into two sections so that the smaller part is to the larger as the larger is to the whole. The ratio developed is 1:1.6180 . . . or roughly 8:13.

harmony
The quality of relating the visual elements of a composition. Harmony is achieved by the repetition of characteristics that are the same or similar. These cohesive factors create pleasing interaction.

interpenetration
The movement of planes, objects, or shapes through each other, locking them together within a specified area of space.

motif
A designed unit or pattern that is repeated often enough in the total composition to make it a significant or dominant feature. Motif is similar to theme or melody in a musical composition.

movement
Eye travel directed by visual pathways in a work of art.

pattern
1. Any artistic design (sometimes serving as a model for imitation). 2. A repeated element and/or design that is usually varied and produces interconnections and obvious directional movements.

principles of organization
Seven principles that guide the use of the elements of art in achieving unity: harmony, variety, balance, proportion, dominance, movement, and economy.

proportion
The comparative relationship between the parts of a whole or units as to size. For example, the size of the Statue of Liberty's hand relates to the size of her head. (See **scale.**)

radial
Emanating from a central location.

repetition
The use of the same visual effect a number of times in the same composition. Repetition may produce the dominance of one visual idea, a feeling of harmonious relationship, an obviously planned pattern, or a rhythmic movement.

rhythm
A continuance, a flow, or a sense of movement achieved by the repetition of regulated visual units; the use of measured accents.

scale
The association of size relative to a constant standard or specific unit of

measure related to human dimensions. For example, the Statue of Liberty's scale is apparent when she is seen next to an automobile. (See **proportion.**)

symmetry
The exact duplication of appearances in mirrorlike repetition on either side of a (usually imaginary) straight-lined central axis.

transparency
A visual quality in which a distant image or element can be seen through a nearer one.

unity
The result of bringing the elements of art into the appropriate ratio between harmony and variety to achieve a sense of oneness.

variety
Differences achieved by opposing, contrasting, changing, elaborating, or diversifying elements in a composition to add individualism and interest; the counterweight of **harmony** in art.

FORM AND VISUAL ORDERING

A completed work of art has three components: subject, form, and content. These components change only in the degree of emphasis put on them. Their interdependence is so great that none should be neglected or given exclusive attention. The whole work of art should be more important than any one of its components. In this chapter, we explore the component ■ form in order to investigate the structural principles of visual order (fig. 2.1).

When we see images, we take part in visual forming (or ordering). An object is reduced to elements. A chair might be seen as a shape or a group of lines, a wall as a value, and a floor as a color. In this act, the eye and mind organize visual differences by integrating optical units into a unified whole. The mind instinctively tries to create order out of chaos. This ordering adds harmony to human visual experience, which would otherwise be confusing and garbled.

Artists are visual formers with a plan. With their materials they arrange the elements—lines, shapes, values, textures, and colors for their structure.

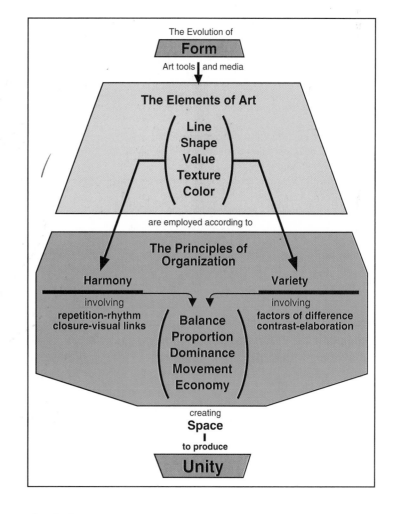

▲ **2•1**
Although this is a logical and common order of events in the creation of an artwork, artists often alter the sequence.

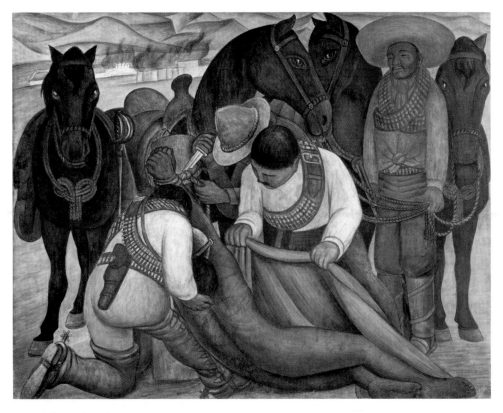

▲ **2 • 2**
Diego Rivera, *The Liberation of the Peon,* 1931. Fresco, 6 ft 2 in. × 7 ft 11 in. (1.88 × 2.41 m).
Here we see a political artist making use of appropriate and expected subject material. Without the effective use of form, however, the statement would be far less forceful.
Philadelphia Museum of Art, PA. Gift of Mr. and Mrs. Herbert Cameron Morris. © Philadelphia Museum of Art/Corbis Media. Reproduction authorized by National Institute of Fine Art and Literature of Mexico.

that follow. If the act of organization is as important as what is being organized, which should be presented first? It is the problem of the chicken or the egg. One must know about the individual elements in order to use them to harmonize a work. In the line chapter, for example, the physical properties of line include length, width, character, direction, and so on. While an artist may use line to unify a work, in this chapter, we will discover that the resulting harmony will actually be created by the "relatedness" of one or all of those properties—length, width, character, and so on. Thus, we see that the principles of organization may be applied to the individual characteristics of each element—or that the individual characteristics of each element may be subjected to the principles of organization in order to bring unity to a composition. In view of this, these principles must necessarily be reviewed after each of the following chapters to see how that element or any of its separate attributes could be used to produce space and to achieve harmony, variety, balance, proportion, dominance, movement, and economy.

THE SEVEN PRINCIPLES OF ORGANIZATION

The elements they use need to be controlled and integrated. Artists manage this through the unifying principles of organization: ■ **harmony,** ■ **variety,** ■ **balance,** ■ **proportion,** ■ **dominance,** ■ **movement,** and ■ **economy.** These principles create space and the sum total, assuming the artist's plan is successful, equals ■ **unity.** Unity in this instance means oneness, an organization of parts that fit into the order of a whole and become vital to it.

Form is the complete state of the work. The artist produces this overall condition using the elements of art structure, subject to the principles of organization. The artist's plan is usually a mix of intuition and intellect. Ideally, the plan will effectively communicate the artist's feeling, even though it may change as the work progresses. The plan can be variously termed ■ **composition** or ■ **design** (fig. 2.2).

In this chapter, we will be dealing with *how* the elements are organized. The individual characteristics of each element are so important to this organizational process that they really cannot be separated from it. But, for the sake of clarity, the elements will be discussed individually in the chapters

As explained earlier, the principles of organization—(1) harmony, (2) variety, (3) balance, (4) proportion, (5) dominance, (6) movement, and (7) economy—are only guides. They are not laws with only one interpretation or application. These principles are used to help organize the elements into some kind of action. The principles of organization may help in finding certain solutions for unity, but they are not ends in themselves, so following them will not always guarantee the best results. Artworks are the results of personal interpretation and should be judged as total visual expressions. In other words,

the use of the principles is highly subjective or intuitive.

Organization in art consists of developing a unified whole out of diverse units. This is done by relating contrasts through similarities. For example, an artist might use two opposing kinds of lines, vertical and horizontal, in a composition. Because both the horizontal and vertical lines are already straight, this likeness would relate them. Unity and organization in art are dependent on a dualism of similarity and contrast—a balance between harmony and variety (fig. 2.3).

Harmony (1)

Harmony may be thought of as a factor of cohesion—relating various picture parts. This pulling together of opposing forces on a picture surface is accomplished by giving them all some common element(s): color, texture, value, and so forth. The repetition or continued introduction of the same device or element reconciles that opposition. ■ **Rhythm** is also established when regulated visual units are repeated. Whether created by ■ **repetition** or rhythm, harmony may create the feeling of boredom or monotony when its use is carried to extremes. But, properly introduced, harmony is a necessary ingredient of unity.

We often cite music in this book because its composition is quite similar to the construction of an artwork. Harmony in music is identifiable when the component notes fit in producing a sound. Of course, sometimes composers intentionally introduce discord (not normally a pleasant listening experience) and resolve it later in the composition. Discord in art can also result when unrelated parts are put together.

Music making requires the efforts of at least two participants: the composer and the performer(s). The composer (the creator) provides the musical blueprint (the score) and the key signature (what notes go together); the performer (the interpreter) follows these guidelines, with some latitude for individual interpretation. The score indicates the placement and movement (up or down) of the notes and the rests and the degree of sound (the volume) to be produced. This is not unlike a visual art product; the artist controls eye movements in both speed and direction and provides pauses (rests) and, in a sense, the volume (loud or soft colors and clashing or more gently related lines and shapes). In the visual arts, the artist/creator lays out the guidelines, and the interpretation is in the eyes and minds of the viewers. The viewer thus shares with the artist the responsibility for the success of the artwork. Knowledgeable and sensitive viewers are a necessity.

Because relationships are essential to harmony, what would relate one part of the artwork to another or more

▲ **2 • 3**
Frank Stella, *Damascus Gate Stretch Variation*, 1968. Acrylic on canvas, 60 × 300 in. (152.4 × 763.9 cm).
Stella has harmonized the painting through his inventive use of the curve and straight-edged shapes; he has provided variety by using contrasting colors and shape sizes.

Collection Walker Art Center, Minneapolis. Gift of Mr. and Mrs. Edmond R. Ruben, 1969. © Artists Rights Society (ARS), NY.

▶ **2 • 4**
Eva Hesse, *Repetition 19 III*, 1968.
Nineteen tubular fiberglass units,
19–20¼ in. × 11–12¾ in. (48.3–51.4 cm
× 27.8–32.3 cm).
This work, as the title implies, exploits the repetitive dimensions of identical "can forms." These are then given variety by distorting the basic shapes.
The Museum of Modern Art, New York. Gift of Charles and Anita Blatt. Photo © Museum of Modern Art.

▼ **2 • 5**
Pauline Gagnon, *Secret Little Door*, 1992.
Mixed media on canvas, 48 × 72 in.
Repetition is introduced in this image by the theme of architectural surface and shape. But, by repeating those items in differing ways, variety is created and a potentially monotonous composition is greatly enlivened.
Courtesy of the artist and Jain Marunouchi Gallery.

parts? A common element or motif—a repeated color, texture, value, or a common configuration of line or shape—would be the connecting force. Rhythm is also present when regulated units are repeated. However, properly handled, harmony is a necessary ingredient in the broader coalescence of unity. In art, as in music, if the parts fit, harmony is achieved.

Repetition

Repetition, needless to say, means that certain things are repeated. In art these things will most likely be the elements of art, characteristics of those elements, or certain designs produced by a combination of the elements. The relationships created by repetitive resemblances imbue the artwork with a degree of harmony. The repetition does not require exact duplication but, instead, similarity or near likeness. Such treatment will undoubtedly hammer home, through its emphasis, a condition desired by the artist. Also, carefully handled repetition can use the similarities as links for developing

planned eye travel for the observer. When those similarities are somewhat reduced, the *least* related can also achieve emphasis, drawing attention to the dissimilarities. Emphases, of any kind, tend to hold our attention, if only briefly. Repetitive similarities are not unlike our genetic predisposition to resemble our parents, clarifying relationships. Harmonious relationships are similarly established in art through repetition (figs. 2.4, 2.5, and 2.6).

Pattern A concept that may be considered within the discussion of repetition is ▪ **pattern.** At the most elementary level, pattern may be seen as any arrangement or design and may function as the model for imitation or for making things (one or multiples). Examples are the pattern a dressmaker uses to make a skirt, the pattern a moldmaker uses for a piece of machinery, or the pattern an artist uses to create artistic designs. On the next level,

▲ **2 • 6**
Paul Manes, *Eiso*, 1995. Oil on canvas, 60 × 66 in. (152.4 × 167.6 cm).
The visual units in Manes' painting are ovoid saucer shapes. The repetition of this shape creates harmony. Variety develops out of differences in the shape's size and color.
Marisa Del Re Gallery, New York, NY.

A **B**

◄ **2 • 7**

(A) The basic pattern is the universally and immediately recognizable paisley shape (see fig. 2.9). (B) A pattern created by an arrangement of lines and positive and negative shapes based on an abstraction of tree reflections (see fig. 2.8).

pattern is usually seen as a noticeable formation or set of characteristics that is created when the basic pattern (model) is repeated.

These repetitions may be composed of arranged elements, from simple marks to more complex relationships of line, shape, value, texture, or color. They may be totally invented, as in a paisley or a geometric pattern, or suggested by objects, like tree branches and/or their spaces (figs. 2.7A, B). The generally repetitive nature of patterns can be used to create harmony and rhythm with pauses and beats that cause flow and connections between parts. They serve to direct eye movement from one part to another. The resulting organization may appear casual when the repetitions are irregular, as in the reflected tree pattern and wallcovering pattern (figs. 2.8 and 2.9), or more controlled when more regulated repetitions are used (fig. 2.10). With either approach, the individual units, patterns, or repetitions become part of a new organization creating an ▪ **allover pattern.**

▲ **2 • 8**

M.C. Escher, *Rippled Surface,* 1950.

Although the subject is trees, the distinctive pictorial characteristic of this work is the pattern produced by the rippling reflections of the trees—a pattern that is developed, though not identically, in all areas of the work, creating unity.

The Gemeentemuseum, The Hague. © 2000 Cordon Art, Baarn, Holland. All rights reserved.

▷ **2 • 9**

Paisley pattern, 1992. Wallcovering.

The paisley is repeated casually to achieve a pattern of more or less irregular design.

Courtesy of Fashion Wallcoverings, Distributors, Cleveland, OH.

Motif ▨ **Motif** is a concept closely related to pattern. Once the basic unit, cell, or original pattern (model) is created and repeated it is referred to as a motif. The smallest repeating designed unit in a roll of wallpaper is the motif. The continued repetition of this design unit tends to relate the surface of the room and creates a conspicuous allover pattern due to the size of the area covered. The motif is easy to identify in the work of Pop artist Andy Warhol, who also created allover pattern on a somewhat smaller

scale with his soup can artworks (see fig. 10.91). Allover patterns don't always have to be so predictable. An artist who doesn't want such a repetitive image might choose to create an irregular pattern design (see figs. 2.8 and 2.9). In addition, quiltmakers often rotate their motifs, changing their color, value, texture, and placement. This allows them to further accent the change and bring about a new pattern of diagonals, squares, or diamonds that seem to emerge from the allover pattern (fig. 2.10; see also fig. 7.23). In a

▲ **2 • 10**
Michael James, *Rhythm/Color: Spanish Dance*, 1985. Somerset Village, Massachusetts, machine-pieced cotton and silk, machine quilted. 100 × 100 in. (254 × 254 cm).

Using traditional quilting techniques, Michael James has repeated the basic design unit four times. However, the unusual allover pattern becomes more important than the repeating motif after changing color, value, and texture within the units to accentuate and emphasize new space relationships.

Collection of the Newark Museum, Newark, New Jersey. Photograph by David Caras.

▲ 2•11

Chuck Close, *Paul III,* 1996. Oil on canvas, 102 × 84 in. (259.1 × 213.4 cm).
A very interesting allover pattern emerges as a larger-than-life portrait. Because of the changing treatment in color and value, the allover pattern dominates the repeating motif or design unit—a diamond with a series of internal circles.

© The Cleveland Museum of Art, 2001, Mr. and Mrs. William H. Marlatt Fund, 1977.59. Photograph by Ellen Page Wilson, courtesy Pace Wildenstein.

similar manner, Chuck Close has established the repeating design unit of the diamond with a series of internal circles but, because he changes color and value in each cell, the allover pattern is one of a portrait of Paul III (fig. 2.11).

Studio artists often find the obvious and continuous repetition of a motif in an allover pattern too monotonous. For them, a subtler use of motif would treat it more like a repeated idea, theme, or pattern of notes in music. For example, the "ta–ta–ta–TUM" in Beethoven's *Fifth Symphony* is repeated but constantly changes in terms of tempo, pitch, volume, and the voice of the instrument playing it. Max Ernst, in *The Hat Makes the Man,* uses the idea of a hat in much the same way (fig. 2.12). It is

not repeated over and over exactly alike but rather is introduced as a theme, constantly changing and accented in differing ways.

Sometimes the theme develops for an artist over a long series of work. Consider 30 paintings by an artist, each dealing with a cat in some different attitude or position. In each individual painting, the cat would be the subject. But, within a consideration of the total series, the cat may be seen as the artist's repeating theme, idea, or motif. Two examples from a larger series may be seen in the Impressionist artist Claude Monet's *Waterloo Bridge* paintings (see figs. 7.24 and 7.25) and the work of Piet Mondrian (see figs. 1.3 through 1.6).

▼ **2 • 12**
Max Ernst, *The Hat Makes the Man*, Cologne, 1920. Cut-and-pasted paper, pencil, ink, and watercolor on paper, 14 × 18 in. (35.6 × 45.7 cm).
The hats in this picture represent strong motifs in a system of accents and pauses. Notice the variety of style, size, and shape contour within the repetitive order.
The Museum of Modern Art, New York. Purchase. Photo © 1998 Museum of Modern Art. © 1997 Artists Rights Society (ARS), New York/ADAGP, Paris.

▲ 2•13
Katsushika Hokusai, *Under the Wave off Kanagawa* (from the series "The Thirty-Six Views of Fuji"), 1829–33. Colored woodblock print, $10\frac{1}{2} \times 15$ in. (26.7 × 38.1 cm).
Hokusai has given us a dramatic sense of the rhythmic surging of the sea in this print.
Takahashi Collection. Sakamoto Photo Research Laboratory/Corbis Media.

Rhythm

One attribute of repetition is its ability to produce rhythm. Rhythm, in art as in music, results from repeated beats, sometimes regular, sometimes more eccentric. Walking, running, dancing, wood chopping, and hammering are human activities with recurring measures. Rhythm in art derives from reiterating and measuring similar or equal parts. This reiteration is, of course, a synonym for repetition. Consequently, the repetition of elements and motifs strategically placed and, if necessary, suitably accented, will result in rhythm (fig. 2.13). The rhythm may be smoothly flowing or less regular and even jerky in the visual movements as dictated by the artist (much like a musical composition). Repetition and rhythm can bless an artwork with both excitement and harmony depending on how they are used. A gentle rhythm, as in a quiet landscape, suggests peace, while a very active rhythm, as in a stormy landscape or riot, suggests violent action. The type of rhythm will depend on horizontal or vertical lines versus diagonal lines, regular or irregular shapes, smooth or fast transitions between optical units to where the eye is guided. Bridget Riley charges her image *Evoë 1* with obvious rhythmical order (fig. 2.14). She uses

several rhythmical measures simultaneously to create unity. She ties the picture together by repeating curvilinear shapes, relating their direction, and using colors of modified value and intensity.

In art, just as in music, variation in size (quarter or whole notes) or volume (loudness or softness) may create more interest, but there is another aspect of rhythm often overlooked by the visual artist—the intervals of silence between repeating units. This becomes apparent when a drummer taps out the old "shave and a haircut, . . . two bits." When the relative size and accent of the drum beat is made as similar as possible, the recognizable rhythmic pattern must be attributed to the variation in the negative space or intervals of silence between the beats. When this concept is applied to the visual arts, the importance of this variation in spacing can be seen in the sculpture of Alexander Calder (see fig. 9.35) or in the placement and intervals between the heads in Andrew Stepovich's *Carnival* (see fig. 5.20).

Closure or visual grouping

In the early part of the 20th century, Max Wertheimer, a German ▪ **Gestalt** psychologist, and his colleagues began to investigate how the viewer sees form, pattern, shape, or total configuration in terms of group relationships rather than as individual items. They discovered several factors, such as nearness and size, that help objects relate visually. We will be referring to the concept bringing most of these together to create pattern as ▪ **closure.** The principle of closure states that people tend to see incomplete patterns or information as complete or unified wholes. This "closure tendency" occurs when an artist provides a minimum of information or visual clues, and the observer provides the closure or imposes an understanding of the patterns with final recognition. For example, in the upper example in figure 2.15, some viewers will see an X formed by the black circles, and others will see a + created by the blue squares. By application of this principle, the four green triangles with

▽ **2 • 14**

Bridget Riley, *Evoë I*, 1999–2000. Oil on linen, 6 × 19 ft. (194 × 580 cm).
Shapes related in color, value, and curving edges create a dramatic sweep across the composition. Interest is added to the rhythmic movement and ordered beat by changing the size and type of shape and the diagonal accents.
Courtesy Karsten Schubert, London. © 2000 Bridget Riley. All rights reserved. Photograph by Prudence Cumming, London.

▲ 2•15

Examples of closure.

Top: The total configuration is more important than the individual components. An X, a central cross, and a squared outer circular shape are recognized before the individual circles used. Center and lower right: Similar shapes optically join to form a green serpentine object and a circle in a green square. Bottom left: Similar shapes help form red arrows.

concave hypotenuses would seem to create a complete circle (bottom right illustration in fig. 2.15). Cover up one triangle or move them farther apart, as in figure 2.16B, and the circle is destroyed. Admittedly, with closure there are many principles at work, like the rule of proximity (relative nearness may visually join objects) or the rule of similarity (visual elements may join optically if they resemble one another in size or shape; see illustration in fig. 2.15, bottom left). For Wertheimer, this visual ordering helped explain how artists see and create structural organization or pattern in their work. With the concept of closure, the whole (the collective pattern or organization) is greater than its individual parts. In practice, this simply means that in figs. 2.16 A, B, and C, as circles, rectangles, and triangles move closer together, it is easier to see a developing circular grouping in the upper half and a lower horizontal line. The new grouping becomes more important than any one individual triangle, circle, or rectangle (individual part). ◕

How do images interact visually as they are moved or placed closer and closer together? In the diagram shown in fig. 2.16A, when separate images are evenly spaced throughout the area, each must be experienced individually. But as we begin to pull some of those shapes nearer together, as in figure 2.16B, before they physically touch they begin to join together as visual units. As enough come together, there is a growing awareness of a circular form and a horizontal linear development. In the final image, all of the various shapes have been given a harmonious relationship by altering their spacing (fig. 2.16C). All of the individual shapes (circles, rectangles, and squares of many sizes) have become related. The cohesive or harmonizing factor may be aided by similarity of color, related surface, or shape type—though for purposes of illustration here, they are dissimilar to emphasize the importance of spacing in visually joining the units. The relationship is in fact a psychological relatedness, where all the different individual images become part of

A

B

something even greater. We see the larger group rather than the individual parts involved in its creation. By varying the negative interval between shapes, the new grouping can appear dense in one location or fade away in another. The same shapes that create a circle in one location can be made to suggest a serpentine movement in another (center example, fig. 2.15). It is not always necessary to create recognizable shapes through closure. A group of value- or color-related shapes may appear to move across a composition as its controlling value pattern (see fig. 2.54). The areas or shapes come together visually with the correct spacing or proximity to form a new grouping. Relatedness in color, value, texture, shape type, direction, linear quality, and the like can also help this happen.

In addition to positive images, closure can also make negative areas become specific identifiable forms. Notice, in the center image of figure 2.16C, how the four black triangular corner shapes cause the negative area to

become important. It is difficult to see the background only as negative area surrounding the black shapes. Instead, the missing sections of the black shapes are filled in, and we are forced to see the central area as a circle. As shapes are moved around, one should explore the relationship of their placement—the negative interval. Discover how the mind fills in missing information. Determine at what point they begin to visually join together. Can a third shape be made to join a grouping of two? Is more or less space needed between the units as a third joins the unit? Try to discover at what point in the spacing the most tension is created between members. With the correct spacing interval, unrelated elements, shapes, or images may be given a harmonious relationship as they participate in an implied grouping. ◐

Visual linking
Just as closure unifies by moving objects or shapes so close together that they

share in a new implied relationship or shape system, other ways of unifying a composition bring the elements so close together that they physically touch. When this occurs, the cohesive device or commonly held and unifying factor is the shared space itself.

Connections—shared edges
Shapes sharing a common edge (contacting, touching, butting together) are often easier to unite, because the sharing imposes other common relationships that help draw them together. For example, they tend to appear to be on the same limited space plane or share a similar spatial or pictorial depth. The cubists and some contemporary artists like Gunther Gerzso (fig. 2.17) have used this idea very successfully.

A great way to unite compositions dealing with flat or more limited space solutions is by using shapes of the same size and related color or value. This technique, however, may not always be the easiest way to develop an

C

◀ **2 • 16**
(A) Individual shapes without any implied organization. (B) Individual shapes moving closer together and beginning to establish a visual grouping. (C) Shapes close together with closure suggesting patterns of an "oval," a "circle," and a horizontal "bar." For more information see the accompanying CD-ROM. ◐

illusionistic or more three-dimensional space. It is difficult because shapes with a shared edge and contrasting values limit the ability to create a spatial reference (fig. 2.18A, left). Changing the sizes of shared shapes will make it easier to see those shapes pass behind or in front of each other (fig. 2.18A, right). ●

When shapes with a common border share a similar value level or color, the dividing edge between the shapes is often obscured if not lost altogether where they merge (visually become one new shape) (fig. 2.18B left). Further, even with

▶ 2•17

Gunther Gerzso, *Personage in Red and Blue,* 1964. Oil on fabric, 39³⁄₈ × 28³⁄₄ in. (100.33 × 73 cm).

In this painting, shapes are united by shared edges as well as similar color and textural development. Though the sense of space is shallow, it is heightened by the contrast of value.

Collection Jacques and Natasha Gelman, courtesy of Centro Cultural/Arte Contemporáneo, A. C., Mexico. Photograph: Jorge Contreras Chacel.

decorative relationships, there is a danger with sharing edges. Two shapes seem to meet best and retain their individual character when the common dividing edge is rather generic or nondescript, because when the edge begins to suggest something recognizable, the accompanying image becomes a positive shape. A specific spatial reference is created that forces the remaining shared shape to become a negative area (fig. 2.18B, right). Changes in value or texture that create differences further exacerbate the situation. M. C. Escher explored this phenomenon, using it to his advantage when he made patterns of dark ducks fly through patterns of light ducks (fig. 2.19). As the ducks fly farther away from the central part of the image, the elaboration of detail becomes more and more distinct. As that same shape system is tracked backward, it looks less and less like ducks and takes on the imagery of the landscape.

Overlapping With overlapping, the areas involved are also drawn together by a common relationship, and the shared item is a bit more involved than a simple edge; it becomes a shared area. As long as the color, value, texture, and so on are the same or related, the overlapping of the areas tends to unite the items involved (fig. 2.18C). However, the space defined may be shallow and rather ambiguous—one time the circle is seen on top, the next time the square is seen on top. The Futurists often achieved this by overlapping multiple views of the same object (fig. 8.51). Vastly unrelated objects can be harmonized in this fashion. Overlapping does not always mean limited space or cohesive relationships, because a deeper space may be caused by visual separation or difference in treatment. The object overlapped can be seen as the receding object (fig. 2.18D). ◐ Color and value choices can exaggerate or minimize the spatial effect of overlapped shapes. With a more figurative application, independent

▲ 2 • 18

(A) Shapes, which deny and imply space, are related by shared edges. (B) Dissolved and altered spatial references involving shared edges. (C) Shapes related by overlapping edges. The new shapes, defined by value change, create little spatial reference. (D) Spatial reference created by overlapping shapes. (E) Shapes related by transparency.

symbolic information can not only overlap but occur within the same shared physical space. In this manner, entirely different symbols or image areas can even be brought into a plausible harmonious context. If we study Sam Haskins's photo *Apple Face,* 1973, the face is quite believably contained within the shape of the apple (fig. 2.20).

▲ 2•19

M. C. Escher, *Day and Night,* 1938. Woodcut in two colors, 15½ × 26¾ in. (39.3 × 67.9 cm).

This is an example of shapes sharing mutual edges with one image. (light ducks) appearing to change into another (dark ducks).

The Gemeentemuseum, The Hague. © 1998 Cordon Art–Baarn–Holland. All rights reserved.

▶ 2•20

Sam Haskins, *Apple Face,* from the book HASKINS POSTERS, 1973. Photograph.

In this image, two distinctly different naturalistic images convincingly share the same shape and space.

© Sam Haskins Partnership. (Website URL: www.haskins.com)

Transparency ▮ **Transparency** is another way an artist can add harmony to images that occur in the same area. When a shape or an image is seen through another, the relating visual devices that create harmony and unite those areas include the shared area itself, the layers of space they all pass through, and the surface treatment of all the images (highlights, shading, color, and the like). Like simple overlapping, this technique tends to limit the visual depth that may be introduced and is another relating harmonious device (see figs. 2.18E and 8.9).

Interpenetration When several images not only share the same area but appear to pass through each other, they are brought into a harmonious relationship not only by the common location but also by the physical depth of the space in which they all appear (see fig. 8.10). Whether shallow or deep, or illusionistic or stylized, the space itself pulls the various images into a visual

harmony. Notice that in figure 2.21 there are two series of shapes. Some seem to plunge toward the left end and the rest toward the right end of the composition. Even though the two areas are treated in different colors, the sharing of the internal space created by ▮ **interpenetration** of shapes helps unify this work.

Extensions (Implied and subjective edges/lines/or shapes) Like the invisible lines of a surveyor that map out and organize the cities, roads, and contour of the land, the extended edges in a composition help the artist organize and bring all parts of that structure into a harmonious relationship. While we have seen harmony achieved by concepts where there are jointly shared edges, shared areas by overlapping shapes, similar transparency of surface, or even the relating of forms by making them pass through each other, these often are used to relate items relatively close to each other. However, the concept of

extensions—implied edges, lines, or shapes—provides the artist with a visual alignment system. By simply extending the edge of a shape across the composition, the artist can find a location for new objects, images, or shapes in locations some distance away. Placing new shapes along the shared extended edge provides commonalities to distant shapes, thereby harmonizing the areas. Such placement may be used to integrate all areas within the composition and create space by an implied tension between areas.

Extensions create hidden relationships. They harmonize by setting up related directional forces, creating movement, and providing a repetition of predictable spacing between units. The strong direction impulse suggested by these subjective edges (subconscious and invisible or implied extensions) provides the viewer with an expectation that something else will be discovered in a new area and helps pull or direct the eye to a new location. It can integrate a work

▶ **2 • 21**
Clouret Bouchel, *Passing Through,* 2001. Digital imagery, 7 × 10½ in. (17.8 × 26.7 cm).
This is an example of interpenetration, with lines, shapes, and planes passing through one another.
Courtesy of the artist.

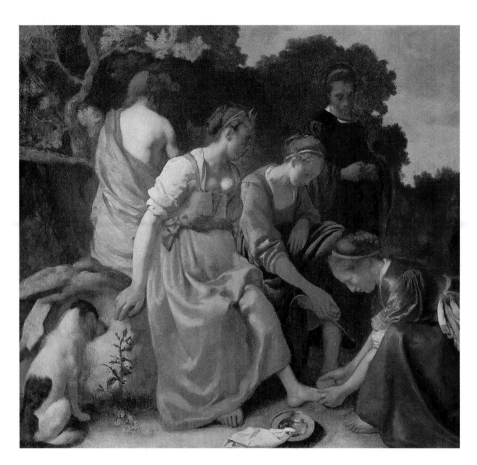

◁ **2•22A**

Johannes Vermeer, *Diana and the Nymphs,* c. 1655–56. Oil on canvas, 33½ × 41 in. (97.8 × 104.6 cm).

Here Vermeer uses extended edges to interlock the images, find the location for new forms, relate shapes, and create directional movement across the painting.

Royal Cabinet of Paintings, Mauritshuis. The Hague, Netherlands, Scala/Art Resource.

◁ **2•22B**

This overlay shows some of the extended edges by solid lines of various strengths and their extensions by dots and dashes. Notice how the implied direction is often interrupted or disguised by subtle changes.

▲ **2 • 23**

Designers often use a grid system to help with the layout and organization of text and visual information. The system can be applied to one image or made to relate a whole corporate campaign.

© Erv Schowengerdt.

as it winds through the composition along contours of information (figs. 2.22A and B). 💿

As an element in its own right, line can draw all sectors of the arrangement together (see figs. 3.9 and 3.10). This line may be clear and dominate or be less emphasized and fade away to become a lost or dissolved contour (see figs. 5.20 and 5.21). As a strong directional indicator, new lines introduced or repeated anywhere along the extension of a first may relate both by implied direction. Invisible linear extensions (subjective lines) are such a strong device for relating

compositional areas that designers also use them in the form of a grid system for the layout and organization of blocks of type, logos, and graphic information (fig. 2.23).

Like line, a shape may create a strong directional movement and, as an organizational tool, create cohesive (harmonious) relationships with other shapes. Shape can create directional force or visual movement in two ways: (1) the volume of the shape points in a general direction (for example, a long triangle points straight ahead in the general direction of the narrow end), directing the viewer across the composition to

▼ **2 • 26**

Nancy Graves, *Perfect Syntax of Stone and Air,* 1990. Watercolor, gouache, and acrylic on paper, 48½ × 48⅜ in. (123.2 × 122.9 cm).

So many colored brush strokes and black linear symbols are used that some degree of harmony is sure to exist, but variety is by far the dominant theme because of the array of colors and patterns.

Gerald G. Peters Gallery. © 1998 Nancy Graves Foundation/licensed by VAGA, New York, NY.

produces a sense of tension between the ball and the baseline of the picture plane. There is the expectation that gravity will cause that ball to drop, and when it does not fall—the tension is created (fig. 2.27A). A ball placed low or on the baseline provides a sense of peace or resolution, gravity having acted on the ball (fig. 2.27B). Our understanding of the particular image or symbol used has an effect upon its psychological weight and the resulting balance in a composition. For example, if the ball in figure 2.27A becomes a hot-air balloon, a large negative area under that shape will tend to support or balance it—we may even have the sensation of the balloon lifting up from that area (fig. 2.27C). If the image becomes a lower-positioned bowling ball, its symbolic weight seems to make the composition bottom-heavy—gravity's force seems to be pulling the bowling ball down to a still position on the lane at the picture's bottom (fig. 2.27D). What we know of the weight of actual objects (here a ball, a balloon, and a bowling ball) influences how we judge balance on a picture surface. If we were to replace the objects with nonobjective entities, their psychological weight would be created by their shape, value, and/or color, and our view of their balance again would change. Whether objective or nonobjective components are used, the potential creation of psychological weight/balance and its compositional adjustment are endless. ◐

Artists will often offset their pictorial works with a mat—an area between the picture's edge and an actual picture frame (structured of wood, metal, and so on). Even here, psychological factors can affect the visual weight and balance. If a mat with two-inch top, sides, and bottom were used, the bottom would have the illusion of being pinched or smaller than the other sides. This is an optical illusion that may make the artwork appear to be unstable or rising on the wall. To compensate, the bottom

▲ **2•27**
Balance: gravitational forces and the resulting pictorial tensions.

measurements on mats are generally made wider than the top width so they seem stabilized or balanced.

Balance is so fundamental to unity that it is impossible to consider the principles of organization without it. At the simplest level, balance implies the gravitational equilibrium of a single mark on a picture plane. Try placing a single colored shape on a white surface

anywhere *but* in the center. The final location will involve a balance between the object and the amount of open space around it. Balance can also refer to the gravitational equilibrium of pairs or groups of units (such as lines or shapes) that are arranged on either side of a central axis. This balancing is best illustrated with several different representations of weighing devices or

▽ **2·31**
Valerie Jaudon, *Big Springs*, 1980, Gold leaf and oil on canvas, 96 × 48 in. (243.8 × 121.9 cm).
The repetitious nature of this symmetrical work is counterbalanced and relieved by the active interlacing linear pattern. The composition is divided equally on either side of a subtle vertical axis.
© Valerie Jaudon/Licensed by VAGA, New York, NY.

Approximate symmetrical balance

The potentially boring qualities of symmetry can be reduced by deviations from its repetitive nature. Balance is still the goal, and the solution is similar, but the artistic components, instead of being identical, are different; they are, however, still positioned in the same manner. The apparent weights of the components must still be equal or balance out. The differences add variety, thereby producing more interest, but at the loss of some harmony. The image, though, is still fairly static. ■ **Approximate symmetry** requires more sensitivity from the artist regarding the various weights for the components cited earlier. Nevertheless, the severe monotony of pure symmetry is given relief (figs. 2.33 and 2.34).

▲ **2·32**
Chilkat Blanket, Tlingit, Northwest coast, Alaska. Dyed wool and cedar bark fibers, 69 in. (175.2 cm).
A formal, symmetrical product that relies on shape, size, and arresting imagery. The frontality of the center section draws the spectator into the composition.
Adolph Gottlieb Collection, Brooklyn Museum.

▶ 2 • 33

Ragamala, *Salangi Raga* (Three females under a tree), c. 1580–90. Indian (Deccan, probably Ahmadnagar). Colors and gilt on paper, 10^{15}/$_{16}$ × 8³/₄ in. (27.79 × 22.23 cm).

This image Gas approximate symmetry. While the format is symmetrical, the central image is rendered asymmetrical by modifying the positions of the trees, figures, and elephant. The vertical axis is still retained.

The Metropolitan Museum of Art, New York. Rogers Fund, 1972. Photo © 1998 Metropolitan Museum of Art.

◀ 2 • 34

Masoud Yasami, *Balancing Act with Stone II*, 1992. Edition of 50, Ilfochrome, 3 ft 4 in. × 5 ft (1.02 × 1.52 m).

Approximate symmetry could be said to be the subject as well as the form of this composition.

Courtesy of Masoud Yasami (American, 1949–).

◁ **2 • 35**
Fred Tomaselli, *Bird Blast,* 1997. Pills, hemp leaves, photocollage, acrylic, resin on wood panel, 60 × 60 in. (152.4 × 152.4 cm).
With radial balance, there is frequently a divergence from some (usually central) source. Here, too, the linear development of the red leaves and the birds seem to explode from the center of the composition.
The Museum of Modern Art, New York. Gift of Douglas S. Cramer. Photograph © 2001 The Museum of Modern Art, New York.

▷ **2 • 36**
Marc Chagall, *Le Pont de Passy et la Tour Eiffel,* 1911. Oil on Canvas, 23¾ × 32 in. (60 × 80 cm).
The equilibrium in this painting is centered where the radiating diagonal edges and lines come together under the railroad bridge.
Metropolitan Museum of Art, Robert Lehman Collection, 1975. (1975.1.161) Photo © 1994 Metropolitan Museum of Art © 1997 Artists Rights Society (ARS), New York/ADAGP, Paris.

Radial balance

Another type of arrangement, called radial balance, can create true or approximate symmetry. In radial balance, forces are distributed around a central point. The rotation of these forces results in a visual circulation, adding a new dimension to what might otherwise be a static, symmetrical balance. Pure radial balance opposes identical forces, but interesting varieties can be achieved by modifying the spaces, numbers, and directions of the forces (figs. 2.35 and 2.36; see also fig. 10.62). Although modified, the principle of repetition must still be stressed so that its unifying effect is utilized. Radial balance has been widely used in the applied arts. Jewelers often use radial patterns for stone settings on rings, pins, necklaces, and brooches. Architects have featured this principle in quatrefoils and rose windows, where the panes of glass are radially arranged like petals of flowers. The potter's plates and vessels of all kinds evolve on the wheel in a radial manner and frequently give evidence of this genesis. In two-dimensional work, the visual material producing the radial effect can be either nonobjective or figurative. ◐

Asymmetrical (occult) balance

Balance created through ■ **asymmetry** achieves visual control of contrasts through felt equilibrium between parts of a picture. For example, felt balance might be achieved between a small area of strong color and a large empty space. Particular parts can be contrasting, provided that they contribute to the allover balance of the total picture. There are no rules for achieving asymmetrical balance; there is no center point and no dividing axis. If, however, the artist can feel, judge, or estimate the opposing forces and their tensions so that they balance each other within a total concept, the result will be a vital, dynamic, and expressive organization on the picture plane. A picture balanced

▲ **2 • 37**
Richard Diebenkorn, *Ocean Park # 9*, 1968. Oil on canvas, 84 × 78 in. (213.5 × 198.1 cm).
Relying on a felt balance, Diebenkorn uses a large open bluish-grey area to balance smaller but more active areas at the top and side. Linear information is balanced against brush textures, and horizontals and verticals are countered by strategically placed diagonals.
Christie's Images.

by contradictory forces (for instance, black and white, blue and orange, or shape and open space) compels further investigation of these relationships and thus becomes an interesting visual experience (figs. 2.37 and 2.38). ◐

Proportion (4)

Proportion deals with the ratio of individual parts to one another. In works of art, the relationships of parts are difficult to compare with any accuracy because proportion often becomes a matter of personal judgment. Proportional parts are considered in relation to the whole and, when related, the parts create harmony and balance. The term ■ **scale** is used when proportion is related to size and refers to some gauge for relating parts to the whole. Often a "norm" or standard is

A

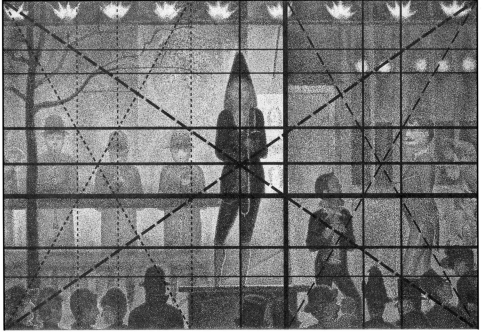

B

△◁ 2 • 46

Georges Seurat, *Circus Sideshow (La Parade)*, 1887–88. Oil on canvas, 39¼ × 59 in. (99.7 × 149.9 cm).

(B) When this Seurat painting is divided by a diagonal from upper left to lower right (large dashes), it crosses the large square where a golden rectangle would be subdivided by a heavy horizontal line. Smaller golden rectangles are created in the vertical rectangle on the right. These small rectangles may be further divided by intersecting diagonals. This could continue indefinitely. In addition, when the original square is established on the right side of the picture (small dotted lines) and a diagonal is drawn from lower left to upper right, the left side may be broken down into smaller golden rectangles that mirror those on the right side of the diagram. Notice how Seurat has used these lines and their intersections for the strategic placement of figures and imagery.

Metropolitan Museum of Art, New York. Bequest of Stephen C. Clark, 1960. Photo: Metropolitan Museum of Art/AKG, Berlin/SuperStock.

▶ **2 • 47**

Claes Oldenburg and Coosje van Bruggen, *Spoonbridge and Cherry* **(a fountain), 1985–88. Stainless steel, paint, and aluminum, 139 × 243⅓ × 63¾ in. (354 × 618 × 162 cm).**

These clearly recognizable objects far surpass the scale expected of them.

Collection Walker Art Center. Minneapolis. Gift of Frederick R. Weisman in honor of his parents, William and Mary Weisman, 1988.

▲ **2 • 48**

Jerome Paul Witkin, *Jeff Davies,* **1980. Oil on canvas, 6 × 4 ft (1.83 × 1.22 m).**

If there was ever a painting in which one subject dominated the work, this must be it. Most artworks do not need this degree of dominance, but Witkin evidently wanted a forceful presence—and he got it.

Palmer Museum of Art, Pennsylvania State University. Gift of the American Academy and Institute of Arts and Letters (Hassam and Speicher Purchase Fund).

shape is placed alongside a much smaller one in an artwork, the effect is disproportionate. A spectator may register some dismay when confronted with extreme examples of disproportionate scale. Common objects are particularly unsettling when made monumental (fig. 2.47). Most artists who make judgments in determining proportions will rely on an educated intuition and will adjust and readjust the sizes of their elements so that they seem to fill the whole work of art.

Still, many artists find a need for enlarging and/or diminishing the sizes of certain elements to aid the expression of an idea or as a means of creating emphasis or dominance. When changes in scale are used for emphasis, the artist will find that he or she can harness and sustain the observer's attention. In the Jerome Witkin painting *Jeff Davies* (fig. 2.48), the artist uses enlargement as a means of emphasizing the presence of his

figure. The subject, a large, physically imposing man, is presented with a bulky torso in simple, light values, surrounded by the darker forms of the head, arms, jacket, and pants. The artist has positioned the white torso in the center of the composition for primary attention and has sized the figure's image so that it seems to burst the limits of the painting's format. Witkin's exaggerated enlargement and relative scaling came from his perceptions of the actual figure he was to represent. The result is an overpowering portrait.

Another way artists have used inordinate proportion or scaling is to indicate rank, status, or importance of religious, political, military, and social personages. *Hierarchical scaling* is a term used to describe this system, whereby figures of greatest importance are made larger in size according to their status. In the painting *Madonna of Mercy,* Piero

The optical units that direct us contain vital visual information. In a work such as the *Mona Lisa,* the figure is such a dominant unit that little eye movement is required (although there is secondary material of considerable interest). In other works, there may be several units of great interest that are widely separated, and it thus becomes critical that the observer's vision be directed to them. There is usually some hierarchy in these units, some calling for more attention than others.

Kinetic, or moving, sculpture exists, but most sculpture and all picture surfaces are static. Any animation in such works must come from an illusion of movement created by the artist through the configuration of their parts. The written word is read from side to side, but a visual image, whether two-dimensional or three-dimensional, can be read in a variety of directions. The movement of one's eyes as dictated by the artist must ensure that all areas are exploited with no static or uninteresting parts. The movement should be self-

2 • 53
Poteet Victory, *Symbols of Manifest Destiny,* 1999. Oil and mixed media on canvas, 60 × 40 in. (152.4 × 101.6 cm).
In this work, the yellow-orange striped rectangle becomes dominant because of the contrast of light against dark and warm color against cool color.
Courtesy of the artist.

2 • 54
Giambattista Tiepolo, *Madonna of Mt. Carmel and the Souls in Purgatory,* c. 1720. Oil on canvas, 82⅔ × 256 in. (210 × 650 cm).
The movement weaves its way through this work because the lighting gives the figures dominance.
Scala/Art. Resource, New York.

renewing, constantly drawing attention back into the work (fig. 2.55; see also the "Pictorial Representations of Movement in Time" section in Chapter 8, p. 213).

Another movement in picture making is caused by the spatial positioning of the elements. Historically the illusion of spatial movement into the work has been produced by linear perspective. Although this is effective, it is not necessary. There is also "intuitive" space, which often denies perspective by using certain artistic devices covered in the chapter on space. Some art, as in sculpture, and particularly kinetic sculpture, even incorporates the element of time into its movement; there will be more on this later, as well (see the "Movement" section in Chapter 9, p. 244).

Economy (7)

Very often, as a work develops, the artist will find that the solutions to various visual problems result in unnecessary complexity. The problem is frequently characterized by the broad and simple aspects of the work deteriorating into fragmentation. This process seems to be a necessary part of the developmental phase of the work, but the result may be that solutions to problems are outweighed by a lack of unity.

The artist can sometimes restore order by returning to significant essentials, eliminating elaborate details, and relating the particulars to the whole. This is a sacrifice not easily made or accepted because, in looking for solutions, interesting discoveries may have been made. But, interesting or not, these effects must often be surrendered for greater legibility and a more direct expression. Economy has no rules but rather must be an outgrowth of the artist's instincts. If something works with respect to the whole, it is kept; if disruptive, it may be reworked or rejected.

Economy is often associated with the term *abstraction*. Abstraction implies an active process of paring things down to the essentials necessary to the artist's style of expression. It strengthens both the conceptual and organizational aspects of the artwork. In a sense, the style dictates the degree of abstraction, though all artists abstract to some extent (fig. 2.56).

Economy is easily detected in many contemporary art styles. The early modernists Pablo Picasso and Henri Matisse were among those most influential in the trend toward economical abstraction; another artist who used economy effectively was Milton Avery (fig. 2.57; see also fig. 4.7). The hard-edged works of Ellsworth Kelly, the "field" paintings of Barnett Newman and Morris Louis, and the analogous color canvases of Ad Reinhardt all clearly feature economy (see figs. 7.14, 10.76, and 10.101). Two sculptors of the Minimalist style (which itself bespeaks economy), Beverly Pepper and Donald Judd, make use of severely limited geometric forms (see figs. 9.41 and 9.42). They have renounced illusionism, preferring instead to create three-dimensional objects in actual space that excludes all excesses. The absence of

2 • 55
George Andreas, *Energy*, 1979. Oil on canvas, 31 × 54 in. (78.7 × 137.2 cm).
The swing of the circles and their subsequent rebounding generates a sweeping pendulumlike movement.
Courtesy of the artist and Andreas Galleries.

▶ **2 • 56**

Tom Wesselmann, *1960 Judy Trying on Clothes,* 1997. Alkyd oil on cut-out aluminum, 58½ × 72½ in.

Wesselmann has reduced the image to the few details he considers crucial, thereby practicing economy.

Collection of the artist. Photograph by Jim Strong, Inc.

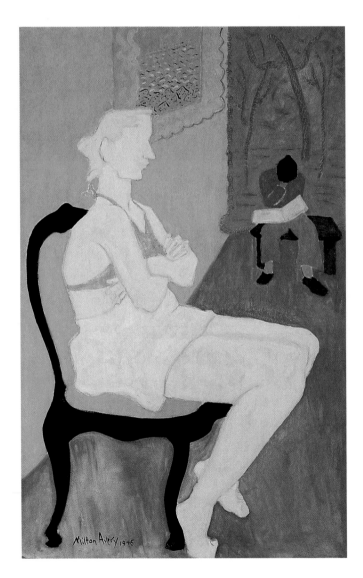

◀ **2 • 57**

Milton Avery, *Seated Blonde,* 1946. Oil, charcoal on linen, 52 × 33¾ in. (132.1 × 85.7 cm).

Avery has simplified the complex qualities of the surface structures of his two figures, reducing them to shapes and flat color. Through the use of economy, the artist abstracted the figures to strengthen their distance and isolation.

Walker Art Center, Minneapolis, MN. Gift of Mr. and Mrs. Roy R. Neuberger, New York, NY, 1952.

elaboration results in a very direct statement.

In economizing, one flirts with monotony. Sometimes embellishments must be preserved or added to avoid this pitfall. But if the result is greater clarity, the risk (and the work!) are well worth it.

SPACE: RESULT OF ELEMENTS/ PRINCIPLES

The artist is always concerned about space as it evolves in artworks. The authors have taken the position that space is not an element (that is, not one of the ▪ **principles of organization**) but a by-product of the elements as they are put into action and altered by the various principles of organization. Other people regard space as an element in its own right. However space is classified, the ▪ **concept** of space is unquestionably of crucial importance— so much so, that many chapter sections in the text and the entire contents of Chapter 8 are devoted to the subject.

If we follow the order in our diagram (see fig. 2.1), we see that a medium is necessary for the creation of an element and that, once an element (a line for example) becomes visible, it automatically creates a spatial position in contrast with its background.

An artist, when considering space in a work, should look for consistency of relationships. There is nothing that can throw an artwork so out of kilter as a jumbled spatial order. An artist who begins with one kind of space, say, a flat two-dimensional representation of a figure, should continue to develop two-dimensional concepts in the succeeding stages of the artwork. Consistency contributes immeasurably to unity.

Our familiarity with space comes, in part, from the exploration of outer space. Of course, we personally become acquainted with space, though on a less

exalted level, as we move from point to point in the performance of our normal daily duties. As we do this we are unconsciously aware of the distance between these points and even of the limit of our vision, the horizon. In transferring nature's space to the drawing board or canvas, the artist has long been faced with problems— problems that have been dealt with in various ways in different historical periods. The artist must use the art elements to produce the illusion of the spatial phenomena he or she wants represented in the artwork. Quite often the effect sought is one that has the observer viewing the frame as a window into the space, terminating at some point or continuing to infinity. Such space, in an art setting, is called three-dimensional because all of this is condensed into a drawing or painting surface. These surfaces have their natural limits, but, additionally, there is a further measurement, the illusion of depth, giving three-dimensional space.

FORM UNITY: A SUMMARY

Artists select a picture plane framed by certain dimensions. They have their tools and materials and with them begin to create elements on the surface. As they do so, spatial suggestions appear that may conform to their original conception; if not, the process of adjustment begins. The adjustment accelerates and continues as harmony and variety are applied to achieve balance, proportion, dominance, movement, and economy. As the development continues, artists depend on their intellect, emotions, and instincts. The ratio varies from artist to artist and from work to work. The result is an artwork that has its own distinctive form. If the work is successful, its form has unity—all parts belong and work together.

A unified artwork develops like symphonic orchestration in music. The musical composer generally begins with a theme that is taken through a number of variations. Notations direct the tempo and dynamics for the performers. The individual instruments, in following these notations, play their parts in contributing to the total musical effect. In addition, the thematic material is woven through the content of the work, harmonizing its sections. A successful musical composition speaks eloquently, with every measure seeming to be irreplaceable.

Every musical element just mentioned has its counterpart in art. In every creative medium, be it music, art, dance, poetry, prose, or theater, the goal is unity. For the creator, unity results from the selection of appropriate devices peculiar to the medium and the use of certain principles to relate them. In art, an understanding of the principles of form-structure is indispensable. In the first chapters of this book, one can begin to see the vast possibilities in the creative art realm. Through study of the principles of form organization, beginners develop an intellectual understanding that can, through persistent practice, become instinctive. The art elements—line, shape, value, texture, and color—on which form is based rarely exist by themselves. They join forces in the total work. Their individual contributions can be studied separately, but in the development of a work, the ways in which they relate to each other must always be considered. Because each of the elements makes an individual contribution and has an intrinsic appeal, the elements are discussed separately in the following five chapters. It is necessary to do this for ▪ **academic** reasons. As an element is studied, please keep in mind those that preceded it. At the end, all the elements must be considered both individually and collectively. This is a big task, but it is a necessary one for that vital ingredient, unity.

CHAPTER THREE

Line

THE VOCABULARY OF LINE

LINE: THE ELEMENTARY MEANS OF COMMUNICATION

THE PHYSICAL CHARACTERISTICS OF LINE

Measure
Type
Direction
Location
Character

THE EXPRESSIVE PROPERTIES OF LINE

LINE AND THE OTHER ART ELEMENTS

Line and Shape
Line and Value
Line and Texture
Line and Color

THE SPATIAL CHARACTERISTICS OF LINE

LINE AND REPRESENTATION

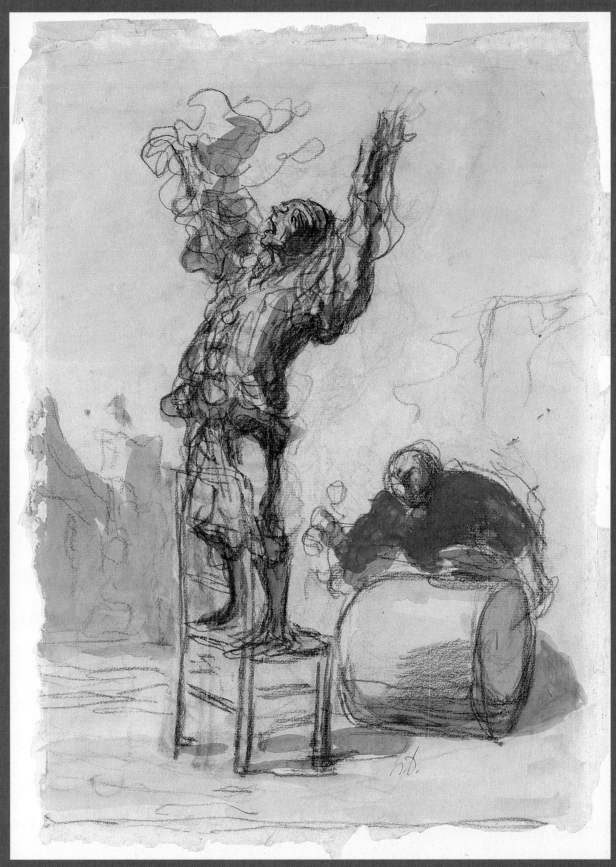

Honoré Daumier, *Street Show*, 1865–66. Black chalk and watercolor on laid paper, $14^{3}/_{8} \times 10^{1}/_{16}$ in.

THE VOCABULARY OF LINE

Line The path of a moving point that is made by a tool, instrument, or medium as it moves across an area. A line is usually made visible because it contrasts in value with its surroundings. Three-dimensional lines may be made using string, wire, tubes, solid rods, and the like.

calligraphy
Elegant, decorative writing. Lines used in artworks that possess the qualities found in this kind of writing may be called "calligraphic" and are generally flowing and rhythmical.

contour
In art, the line that defines the outermost limits of an object or a drawn or painted shape. It is sometimes considered to be synonymous with "outline"; as such, it indicates an edge that also may be defined by the extremities of darks, lights, textures, or colors.

cross-contour
A line that crosses and defines the surface undulations between, or up to, the outermost edges of shapes or objects.

expression
1. The manifestation through artistic form of a thought, emotion, or quality of meaning. 2. In art, expression is synonymous with the term *content*.

hatching
Repeated strokes of an art tool producing clustered lines (usually parallel) that create values. In "cross-hatching," similar

lines pass over the hatched lines in a different direction, usually resulting in darker values.

implied line
Implied lines (subjective lines) are those that dim, fade, stop, and/or disappear. The missing portion of the line is implied to continue and is visually completed by the observer as the line reappears.

representation(al) art
A type of art in which the subject is presented through the visual art elements so that the observer is reminded of actual objects. (See **naturalism** and **realism**.)

LINE: THE ELEMENTARY MEANS OF COMMUNICATION

Line is undoubtedly the most familiar of the art elements; we use it daily in our handwriting. In art, line is used in sketching (drawing), often in preparation for larger works. The term *line* is also used in connection with other situations: the checkout line, the prison or shopping lineup, the football line, the line of sight, the gas line, and so on. These are some of the everyday expressions that share the word *line* with our first element. These common uses of the word imply that something is strung out or stretched a certain distance. You have undoubtedly stood in line for something and found your impatience turn to relief as you reached the front. Your line may have

been a single line (narrow) or two abreast (wider). Sometimes lines become straggly—but this had better not be the case in the military, where perfectly straight alignment is enforced. Standing lines often exhibit differences in width because of the different sizes of the people in the line or because people are bunched together.

Art lines and "people lines" have things in common. Theoretically, a line is an extended dot; so, if only one person shows up, a dot is made. But, as other people are added, with their different dimensions and positions, the line's characteristics change. In art, these line variations are called "physical characteristics," and they can be used by the artist to create meanings as well as to reproduce the appearance of the artist's subjects.

Different types of lines are everywhere: the easily seen lines the

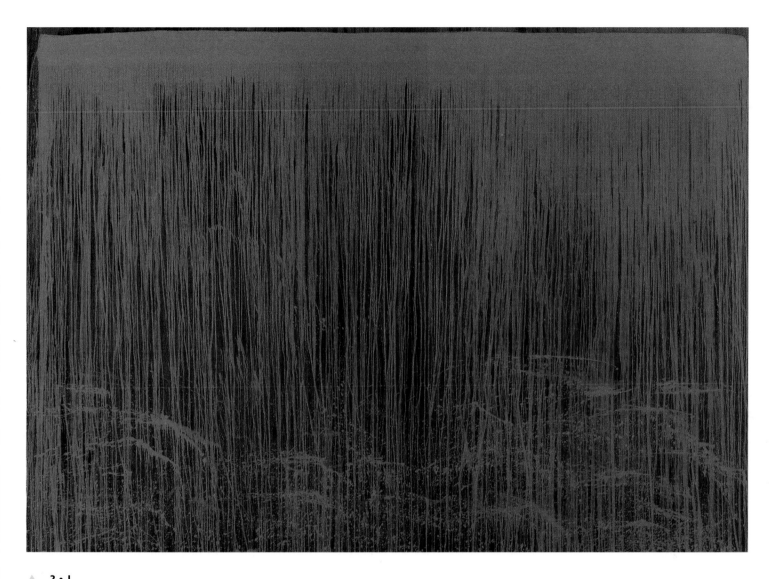

▲ **3 • 1**
Pat Steir, *Inner Sanctum Waterfall,* 1992. Oil on linen, 104 × 136.4 in. (246.4 × 346.7 cm).
Subjective in approach, Pat Steir uses line to create the waterfall's power and movement in this private place.
Courtesy of Ani and David Kasparian, New Jersey.

graphic artist makes with instruments such as crayons, pens, and pencils; the phenomena in nature that we can perceive as lines, such as cracks in a sidewalk, rings in a tree, or a series of pebbles in alignment; and the linear masses such as spider webs, dental floss, and tree limbs that may be recognized as lines.

The artist uses line as a graphic device of visual instruction or as a symbol of something observed; these observances may prompt certain reactions in the artist that can be interpreted by line (fig. 3.1). Linear designs in the form of ideograms and alphabets are used by people as a basic means of communication, but the artist uses lines in a more broadly communicative manner. Line operates in different ways in the visual arts. For example, line can describe an edge, as on a piece of sculpture; it may be a

◄ 3•5
The illustrated signatures of famous artists often have, to some degree, the character of calligraphy, perhaps due to their profession.

▲ 3•6
Wang Hsi-chih: from Three Passages of Calligraphy: "Ping-an," "Ho-ju," and "Feng-chu," Eastern Ch'in dynasty, fourth century (321–379 A.D.), *Calligraphy*, Ink on paper.
Certain meanings intrinsic to line arise from their character. These character meanings are the product of the medium, the tools used, and the artist's method of application. The example shown here of Chinese calligraphy which has historically been admired in China as an art form as valued as painting, is by a fourth century A.D. calligrapher. Always created with brush and ink on paper (the Chinese invented paper), the lively, abstract ideographs appear to leap upward and outward, "like a dragon leaping over heaven's gate," according to a later emperor.

National Palace Museum, Taipei, Taiwan, Republic of China.

■ **calligraphy** of figure 3.5 with examples of drawn figures 3.6 and 3.7, one can see the shared qualities of grace and elegance. In addition, line can perform several functions at the same time. Its wide application includes the creation of value and texture, illustrating the impossibility of making a real distinction between the elements of art structure (see figs. 3.17 and 3.19).

When lines are used to reproduce the appearance of subjects in an artwork, this appearance can be reinforced by the artist's selection of lines that carry certain meanings. In this way, the subject may be altered or enhanced, and the work becomes an interpretation of that subject. Line meanings can also be used in conjunction with the other art elements.

THE PHYSICAL CHARACTERISTICS OF LINE

The physical characteristics of line are many. Lines may be straight or curved, direct or meandering, short or long, thin or thick, zigzag or serpentine. The value of these characteristics to the artist is that they have certain built-in associations. When we say that a person is a "straight arrow," we mean that the person is straightforward and reliable; a "crooked" person, on the other hand, is devious and untrustworthy. Most of us can find adjectives to fit various kinds of lines; those meanings, deriving in part from the associations cited above, make for the possibility of subtle psychological suggestions.

MEASURE

Measure refers to length and width of line. A line may be of any length and breadth. An infinite number of combinations of long and short, thick and thin lines can, according to their use, divide, balance, or unbalance a pictorial area.

▲ **3 • 7**
Zhen Wu (attributed to), *Bamboo in the Wind,* **early 14th century hanging scroll. Ink on paper, 29⅝ × 21⅜ in. (75.2 × 54.3 cm), China, Yuan dynasty.**
Wu Zhen uses meticulous, controlled brushwork to describe the flowing linear (calligraphic) qualities of the bamboo tree.
Chinese and Japanese Special Fund. Courtesy of Museum of Fine Arts, Boston.

TYPE

There are many different kinds of line. If the line continues in only one direction, it is straight; if changes of direction gradually occur, it is curved; if those changes are sudden and abrupt, an angular line is created. Taking into consideration the characteristic of type as well as measure, we find that long or short, thick or thin lines can be straight, angular, or curved. The straight line, in its continuity, ultimately becomes repetitious and, depending on its length, either rigid or brittle. The curved line may form an arc, reverse its curve to become wavy, or continue turning within itself to produce a spiral. Alterations of movement become visually entertaining and physically stimulating if they are rhythmical. A curved line is inherently graceful and, to a degree, unstable (see figs. 3.4 and 3.25). The abrupt changes of direction in an

◄ 3•8
Clouret Bouchel, *Fight or Flight*. 9¼ × 12½ in.
The abrupt changes of direction in the diagonal angular lines on this drawing create the excitement and tension of combat.
Courtesy of the authors.

angular line create excitement and/or confusion (fig. 3.8). Our eyes frequently have difficulty adapting to an angular line's unexpected deviations of direction. Hence, the angular line is full of challenging interest.

DIRECTION

A further complication of line is its basic direction; this direction can exist irrespective of the component movements within the line. That is, a line can be a zigzag type but take a generally curved direction. Thus, the line type can

be contradicted or flattered by its basic movement. A generally horizontal direction could indicate serenity and perfect stability, whereas a diagonal direction would probably imply agitation and motion (fig. 3.9). A vertical line generally suggests poise and aspiration. The direction of line is very important, because in large measure it controls the movements of our eyes while we view a picture. Our eye movements can facilitate the continuity of relationships among the various properties of the element (fig. 3.10).

LOCATION

The control exercised over the measure, type, or direction of a line can be enhanced or diminished by its specific location. According to its placement, a line can serve to unify or divide, balance or unbalance a pictorial area. A diagonal

▼ 3•9
Mel Bochner, *Vertigo,* 1982. Charcoal, conté crayon, and pastel on canvas, 9 ft × 6 ft 2 in. (2.74 × 1.88 m).
Line, the dominant element in this work, is almost wholly diagonal, imparting a feeling of intense activity and stress.
Albright-Knox Art Gallery, Buffalo, NY. Charles Clifton Fund, 1982. © Mel Bochner.

▲ 3•10
Dorothea Rockburne, *Continuous Ship Curves, Yellow Ochre,* 1991. Fresco pigment and watercolor stick, 10 ft × 15 ft 7 in. (3.05 × 4.75 m).
The ever-changing directions of the continuous lines in Dorothea Rockburne's painting control the movement of the eye as they loop about and traverse the pictorial composition.
Courtesy of André Emmerich Gallery, a Division of Sotheby's, on behalf of Dorothea Rockburne.

line might be soaring or plunging, depending upon its high or low position relative to the frame. The various attributes of line can act in concert toward one goal or can serve separate roles of expression and design. A fully developed work, therefore, may recognize and use all physical properties, although it is also possible that fewer than the total number can be successfully used. This is true largely because of the dual role of these properties. For instance, unity in a work might be achieved by repetition of line length at the same time that variety is being created through difference in the line's width, medium, or other properties.

CHARACTER

Along with measure, type, direction, and location, line possesses character, a term largely related to the medium with which the line is created. Different media can be used in the same work to create greater interest. Monotony could result from the consistent use of lines of the same character unless the unity so gained is balanced by the variation of other physical properties. Varied instruments, such as the brush, burin, stick, and fingers, have distinctive characteristics that can be exploited by the artist (fig. 3.11). The artist is the real master of the situation, and it is the artist's ability, experience, intention, and mental and physical condition that determine the effectiveness of line character. Whether the viewer sees lines of uniformity or accent, certainty or indecision, tension or relaxation are decisions only the artist can make.

The personality or emotional quality of the line is greatly dependent on the nature of the medium chosen. In Rembrandt's sketch *Nathan Admonishing David,* the expressive qualities created by the soft brush lines of ink, juxtaposed with the precise and firm lines of pen and ink, can be clearly seen (fig. 3.12).

▲ 3•11

Jonathan Lasker, *The Artistic Painting,* 1993. Oil on canvas, 90 × 120 in. (228.6 × 304.8 cm).

The unique character of the line work in this piece is enhanced by the careful choice of tools, color, and shape.

Collection Fonds Cultural National, Luxembourg (Sammlung des zukünftigen Musée d'Art Moderne Grand-Duc Jean). Courtesy of Sperone Westwater, New York.

▲ 3•12

Rembrandt Harmenszoon van Rijn, *Nathan Admonishing David,* no date. Pen and brush with bistre, $7^{5}/_{16} \times 9^{5}/_{16}$ in. (18.6 × 23.6 cm).

The crisp, biting lines of the pen contrast effectively with broader, softer lines of the brush.

© Metropolitan Museum of Art, New York. Bequest of Mrs. H. O. Havemeyer, 1929. The Havemeyer Collection.

▲ 3 • 18
Andres Zorn, *The Toast,* 1893. Etching, 12⅝ × 10⁷⁄₁₆ in. (32 × 26.5 cm).
This work was created using hatching and cross-hatching to create degrees of value: darks where lines are densely drawn and lighter values where more paper can be seen.
Kupferstichkabinett, Staatliche Kunstsammlungen, Dresden. Photo Deutsche Fotothek, Dresden.

single lines that create areas of differing value (fig. 3.18). Sometimes, when ▪ **hatching** is used to produce value, the strokes will be made to define the direction of a surface at any given point.

LINE AND TEXTURE

Groups of lines can combine to produce textures that suggest a visual feeling for the character of the surface (fig. 3.19).

This apparent texture can result from the inherent characteristic of individual media and tools, and their distinctive qualities can be enhanced or diminished by the manner of handling. Brushes with a hard bristle, for instance, can make either sharp or rough lines, depending on hand pressure, amount of medium carried, and quality of execution. Brushes with soft hairs can produce smooth lines if loaded with thin paint and can produce thick blotted

lines if loaded with heavy paint. Other tools and media can produce similar variations of line (fig. 3.20).

LINE AND COLOR

The introduction of color to a line adds an important expressive potential. Color can accentuate other line properties. A hard line combined with an intense color produces a forceful or even harsh effect. This effect would be considerably muted if the same line were created in a more neutralized color. Different colors have come to be identified with different emotional states. Thus, the artist might use red as a symbol of passion or anger, yellow to suggest cowardice or warmth, and so forth (see the "Color and Emotion" section in Chapter 7, p. 165).

▼ **3 • 19**

Jean Dubuffet, *Urgence,* 1979. Acrylic on canvas-backed paper with collage, 22½ × 27½ in. (57.15 × 69.85 cm).

In this painting/collage, Jean Dubuffet creates diverse textures by varying his many line combinations.

Collection Donald Rubin. Courtesy of Jonathan Novak Contemporary Art, Los Angeles. © 1997 Artists Rights Society (ARS), New York/ADAGP, Paris.

▲ 3 • 20

Emile Nolde, *Fischdampfer* (Fishing Boat), 1910. Print (woodcut), 11¾ × 15⅜ in. (29.84 × 39.37 cm).

When knives and gouges are used to cut the wood, the lines and textures created are different from those produced by another medium.

Nolde-Stiftung Seebüll, Germany. Inventory number Ho41. Photograph by Kleinhempel, Hamburg.

THE SPATIAL CHARACTERISTICS OF LINE

All the physical characteristics of line contain spatial properties that are subject to control by the artist. Mere position within a prescribed area suggests space. Value contrast can cause lines to advance and recede (fig. 3.21). An individual line with varied values throughout its length may appear to writhe and twist in space. Because warm colors generally advance and cool colors generally recede, the spatial properties of colored lines are obvious. Every factor that produces line has something to say about a line's location in space. The artist's job is to use these factors to create spatial order (fig. 3.22).

LINE AND REPRESENTATION

Line creates representation on both abstract and realistic levels. In general, we have dealt primarily with abstract definitions, but it is easy to see that the

◀ 3 • 21

Zdenek Sykora, *Line No. 50,* 1988. Oil on canvas, 59 × 59 in. (149.8 × 149.8 cm).

Variations in the continuous curvilinear lines within this painting create illusions of open space. These variations include changes in the physical properties of the measure, direction, location, and character of the lines, as well as changes in value and color.

Courtesy of Prague National Gallery.

application can be observed equally in a realistic context. For example, we have discussed the advancing and receding qualities of value in a line. If a particular line is drawn to represent the contours of a piece of drapery, the value contrast, as it changes in measure and direction, might describe the relative spatial position of the folds of the drapery (fig. 3.23). An artist drawing a linear portrait of a person might use line properties to suggest a physical presence (fig. 3.24). The artist might also be able to convey—either satirically or sympathetically—much information about the character of the sitter. Thus, line in ▪ **representational art** has many objective and subjective implications. All are the direct result of the artist's manipulation of the physical properties.

In its role of signifying ideas and conveying feelings, line moves and lives, pulsating with significant emotions. In

▲ **3 • 22**
Denyse Thomasos, *Urban Jewels,* 1995, Acrylic on canvas, 10 × 16 ft (304.8 × 487.68 cm).
The spatial illusion, of such obvious importance in this example, is largely the product of the physical properties of the lines strengthened by contrasting areas of value and color.
Lennon, Weinberg, NY.

◄ **3 • 23**
J. Seeley, *Stripe Song,* 1981. Print (photo silkscreen), 22 × 30 in (81.9 × 76.2 cm).
Seeley is an acknowledged master of the high-contrast image. Combining the undeniable visual appeal of Op art with the implicit realism of the photographic image, the artist's black-and-white linear abstractions are boldly decorative, highly complex, and a delightful treat for the eye.
© 1998 J. M. Seeley/licensed by VAGA, New York, NY.

▼ 3 · 24
Juan Gris (José Victoriano González),
Portrait of Max Jacob, 1919. **Pencil on sheet,**
$14\frac{3}{8} \times 10\frac{1}{2}$ in. (36.5 × 26.7 cm).
This drawing, done entirely in line, provides
information on the physical presence as well as
the psychological character of the sitter.
The Museum of Modern Art, New York. Gift of James
Thrall Soby. Photograph © 1998 Museum of Modern Art.

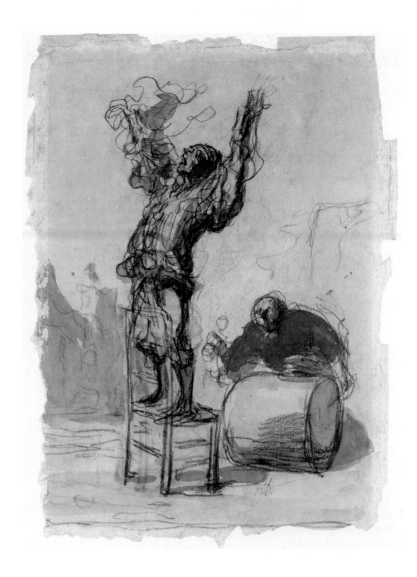

▲ 3 · 25
Honoré Daumier, *Street Show,* 1865–66. **Black chalk and watercolor**
on laid paper, $14\frac{3}{8} \times 10\frac{1}{16}$ in. (36.8 × 25.4 cm).
Though subjects are often static and immobile, Daumier used the excitement
of gestural line to interpret the gyrations of the dancer and the frenzied
beating of the drummer.
The Metropolitan Museum of Art, Rogers Fund, 1927. (27.152.2) Photograph © The
Metropolitan Museum of Art.

◄ 3 · 26
Giovanni Battista Tiepolo, *Study for Figure of Falsehood on the Ceiling*
of the Palazzo Trento-Valmarana, Vicenza, **no date. Pen and brown ink,**
$6\frac{3}{8} \times 6$ in. (16.2 × 15.4 cm).
This gestural drawing clearly illustrates the dramatic action of the activity.
Artists often try to sustain this effect beyond the initial stage of a sketch.
The Art Museum, Princeton University, NJ. Bequest of Dan Fellows Platt. Photo: Bruce
M. White.

▲ **3 • 27**
Steve Magada, *Trio,* c. 1966. Oil on canvas, size and present location unknown.
The gestural lines in this work successfully evoke the movements of the performers.
Photograph courtesy of Virginia Magada.

visual art, line becomes a means for transcribing the expressive language of ideas and emotions. It describes the edges or contours of shapes, it diagrams silhouettes, it encompasses spaces and areas—all in such a way as to convey meaning.

Line is not used exclusively to express deep emotion and experience in this manner. Often, it depicts facts alone: the lines drawn in an architect's plan for a building or an engineer's drawings of a bridge; the lines drawn on maps to represent rivers, roads, or contours; or the lines drawn on paper to represent words.

Such use of line is primarily utilitarian, a convenient way of communicating ideas to another person. In addition to its ability to describe facts with precision, line can express action in a "gestural" sense. The gesture in graphic work implies the past, present, and future motion of the drawn subject. Gestural drawing in any medium displays lines that are drawn freely, quickly, and seemingly without inhibition. If preserved in the work, this response captures the intrinsic spirit and animation seen in the subject. This spirit can pertain to both animate and

inanimate subjects—a towel casually thrown over a chair has a unique "gesture" resulting from the way it falls, its weight and texture, and the surface it contacts. Obviously this gestural concept applies even more conspicuously to those subjects that are capable of movement (fig. 3.25). Many paintings are preceded by and based on the artist's initial gestural response (fig. 3.26).

Whichever the emphasis—expression of human emotions, depiction of action, or communication of factual information—line is an important element for the artist to use (fig. 3.27).

CHAPTER FOUR

Shape

THE VOCABULARY OF SHAPE

INTRODUCTION TO SHAPE

THE DEFINITION OF SHAPE

THE USE OF SHAPES

Shape Dimensions
The Illusions of Two-Dimensional Shapes
The Illusions of Three-Dimensional Shapes
Shape and Principles of Design
Balance
Direction
Duration and Relative Dominance
Harmony and Variety
Shapes and the Space Concept

SHAPE AND CONTENT

question our first defin[...]
closure is not always a[...]
necessary condition fo[...]

There are other d[...]
we call shape that may[...]
understanding of this[...]
these are: any visually[...]
value, texture, color, o[...]
combination of these[...]
pictorial forms of art,[...]
two-dimensional. In t[...]
dimensional forms of[...]
architecture, environm[...]
so on), shapes are mor[...]
as solids, or masses. Wh[...]
dimensional artists do[...]
planning using graphic[...]
be aware that the pictu[...]
contradiction to their[...]
or plastic, intentions a[...]
only one view of the p[...]
dimensional work. The[...]
conditions the use and[...]
all shapes and other ele[...]
was already discussed a[...]
Chapter 2.

Henri Matisse, *The Burial of Pierrot*, Plate VIII from *Jazz*, 1947. Pochoir (stencil printing), $16\frac{1}{4} \times 25\frac{1}{8}$ in. (41.2 × 63.5 cm).

4 • 2

The spectator aut[...]
shapes from those [...]
lines.

4 • 3

Claude Monet, R[...]
Canvas, 39³⁄₈ × 2[...]

Had he so chosen, [...]
version of the facad [...]
interested in the ef [...]
relationships—hence [...]

Courtesy of National [...]

▲ 4 • 5

Juan Miro, *The Painting*, 1933. Oil on canvas, 68 × 77¼ in. (174 × 196.2 cm).
The shapes in this work seem to have occasional veiled references to creatures (though unlikely ones), but they certainly deserve the term *biomorphic* because of their organic configuration.

The Museum of Modern Art, New York. Loula D. Lasker Bequest (by exchange). Photograph © 2001 The Museum of Modern Art, New York.

◀ 4 • 6

Yves Tanguy, *Mama, Papa Is Wounded* (*Maman, papa est blessé*), 1927. Oil on canvas, 36¼ × 28¾ in. (92.1 × 73 cm).
Surrealists such as Yves Tanguy have given considerable symbolic significance to biomorphic shapes. These remind us of basic organic matter or of flowing and changing shapes in dreams.

The Museum of Modern Art, New York. Purchase. © 1998 Museum of Modern Art. © 1997 Estate of Yves Tanguy/Artists Rights Society (ARS), New York.

organisms encountered in biological studies (such as amoebas, viruses, and cells). Such shapes are normally referred to as organic, but, because organic shapes are often curved, the term ▣ **biomorphic** was coined in early twentieth-century art to describe the irregular rounded shapes in art that suggest life (fig. 4.5; see figs. 10.80 and 10.83).

With the great interest aroused by abstract art (from around 1910 forward), the increasing awareness of the microscopic world through science, and the growth of Freudian psychology, the biomorphic shape became a key component in ▣ **Surrealism**. Surrealist artists' interests in the mystic origins of being and in the exploration of subconscious revelations, such as in dreams, attracted them strongly to organic or biomorphic shapes (fig. 4.6). Other artists (Matisse and Braque are examples) abstracted organic forms in a less symbolic and primarily decorative manner (fig. 4.7; see also fig. 4.17).

▣ **Rectilinear** (straight-lined) shapes, called ▣ **geometric** because they are based on the standardized shapes used in mathematics, contrast with biomorphic shapes. The precisionist, machinelike geometric shapes appealed to artists working in ▣ **Cubism**, who used them in their analytical dissection and reformulation of the natural world (fig. 4.8).

From these examples, it is clear that, however shapes are classified, each shape or combination of shapes can display a particular personality according to its physical employment and our responses to it.

THE USE OF SHAPES

Shapes are used by artists for the two fundamental purposes mentioned in the preceding paragraphs: to suggest a physical form they have seen or imagined and to give certain visual qualities or content to a work of art.

Shapes in art can be used for some of the following purposes:

1. To achieve order, harmony, and variety—all related to the principles of design discussed in Chapter 2.
2. To create the illusion of mass, volume, and space on the surface of the picture plane.
3. To extend observer attention or interest span.

The last item in this list requires further clarification. While the arts of music, theater, and dance evolve in time, the visual arts are usually chronologically fixed. This means that the time of an observer's concentration on or mental unity with most works of art is by comparison usually limited. This is particularly true in the pictorial or graphic arts. It is not quite so true with one type of plastic art, ■ **kinetic** forms. Mobiles, for example, are a form of sculpture in motion; their constantly changing relationships of shapes usually hold the viewer's attention longer than immobile forms of sculpture or pictorial art.

SHAPE DIMENSIONS

We have already defined shapes as having either two- or three-dimensional identities. In order to use shape(s) successfully in works of art, we must further consider these dimensional aspects. Some people, for example, make a distinction between shape that is ■ **two-dimensional** and shape that is ■ **three-dimensional** (referred to as ■ **mass** and/or ■ **volume**) and consider them to be two separate elements. However, the authors have always considered shape, whether two-dimensional or three-dimensional, to be one element of form. For increased familiarity with the way the term *shape* is used in this context, more information about shape dimension follows.

The Illusions of Two-Dimensional Shapes

Foremost among shapes and probably the most useful is the two-dimensional ■ **plane.** As we have noted, in pictorial artworks the flat surface on which artists work is called the picture plane. In addition to being a working surface, a

▲ 4 • 8
Juan Gris (José Victoriano González), *Breakfast,* **1914. Cut-and-pasted paper, crayon, and oil over canvas, 31⅞ × 23½ in. (80.9 × 59.7 cm).**
Gris, a Cubist, not only simplified shapes into larger, more dominant areas but gave each shape a characteristic value, producing a carefully conceived light–dark pattern. He also made use of open-value composition, where the value moves from one shape into the adjoining shape, as can be seen in this example.
The Museum of Modern Art, New York. Acquired through the Lillie P. Bliss Bequest. © 1998 Museum of Modern Art.

▲ 4 • 7
Henri Matisse, *The Burial of Pierrot,* **Plate VIII from** *Jazz,* **1947. Pochoir (stencil printing), 16¼ × 25⅛ in. (41.2 × 63.5 cm).**
Matisse abstracted organic forms for the purpose of decorative organization.
Ecole des Beaux Arts, Paris, France. © Succession H. Matisse, Paris/ARS, NY. Giradon/Art Resource, NY.

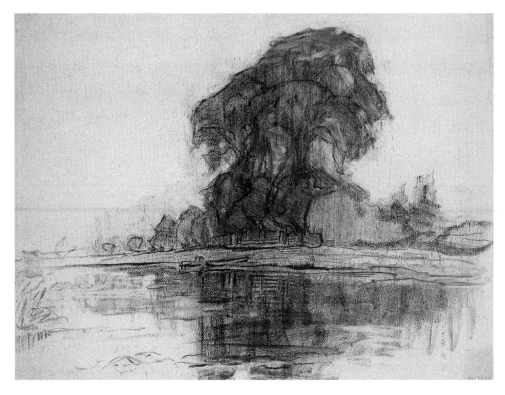

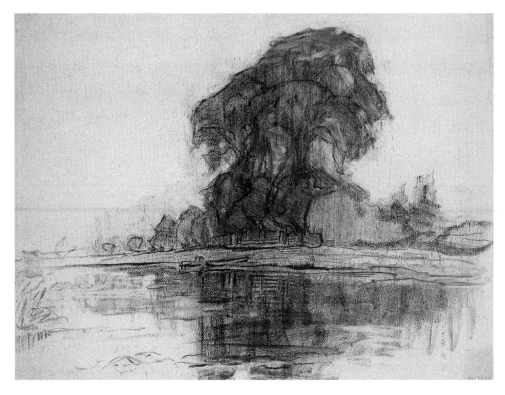
▲ 4•9
Piet Mondrian, *Trees by the River Gein,* c. 1907. Charcoal, 18⅞ × 24½ in. (48 × 62.2 cm).
In this work Piet Mondrian uses outer contours to establish the larger simplified planar shapes. They, in turn, are broken into smaller organic planes which provide more and more detail.
Edward E. Ayer Fund, 1962.105.

planar shape is often used as a device to simplify vastness and intricacies in nature. In sketching trees, for example, an artist will utilize a large, simple ▪ **planar** shape to represent the overall image of the tree. Further, individual clumps of foliage often are shown by a number of smaller varied shapes (fig. 4.9). This use of the plane creates more economical, stable, and readily ordered units that are useful to the artist not only for preliminary sketches but also for finalizing the organization of his or her work. Beyond this, planes are extremely useful in creating the illusion of three-dimensionality on the two-dimensional picture plane, whether or not they have the appearance of objects or are abstract.

The use of the plane varies from a flat or ▪ **decorative** appearance on a picture plane to one or more that appear to occupy space. Artists use all kinds of shapes, from geometric to organic, to

achieve both these effects. A rectilinear shape—that is, a geometric shape whose boundaries consist of straight lines—might appear flat when lying on the surface of the picture plane, but even a simple overlapping of two or more rectilinear shapes can give them a sense of depth. The addition of size, color, value, and texture contrasts to these planes can even more definitively establish an impression of depth (fig. 4.10).

▪ **Curvilinear** planes, those planar shapes made up of circles, ovals, or irregular organic attributes, can also create shallow effects of space or, through their curving nature, suggest movements into depth. When either curvilinear, rectilinear, or other irregular planes are given a foreshortened appearance by tilting them and making the near end look larger than the distant one, we have a much stronger visual statement of depth than in the decorative use of planes (figs. 4.11A–D).

The Illusions of Three-Dimensional Shapes

When the term *mass* is used to describe three-dimensional shapes in the picture plane, we mean that they have the appearance of solid bodies. If a three-dimensional shape is a void or an area of definable containment, it occupies a certain amount of measurable space and is called a volume. Rocks and mountains are masses, while holes and valleys are volumes; cups are masses, while the areas they contain are volumes (figs. 4.12A and B). When beginning to develop three-dimensional shapes, we should select the kind(s) of shape(s) we wish to portray—geometric, organic, or irregular—just as we did in working with their two-dimensional counterparts. Because geometric shapes, such as the square/rectangle, are the most basic two-dimensional shapes, let us look at the development or transformation into their three-dimensional equivalents—the cube/rectangular solid.

▷ **4 • 10**
Rectilinear planes can suggest the illusion of depth in a number of ways.

▷ **4 • 11**
The diagrams illustrate how differently shaped and positioned planes can create illusions of depth: (A) Curvilinear or circular planes overlapped to suggest shallow space; (B) curvilinear planes placed on edge and tilted to suggest an effect of greater depth—note how the circles become elliptical in shape; (C) straight-edged or rectilinear planes positioned so that they float in deep space (see fig. 4.10 for a shallower effect); (D) irregular shapes creating a sense of depth.

In diagrams B, C, and D, the illusion of depth is accentuated by thickening the nearest edges of the planes. Variations of value, size, texture, and color further enhance or diminish the illusion of depth.

A

B

◁ 4•12
Masses and volumes: Arches and Canyonlands National Parks, Utah.
In figure 4.12A, mountainous rock formations and their valleys represent mass and volumes. Figure 4.12B illustrates a close-up view of a gigantic rock formation (mass) with an enormous hole (volume).

Presenting the planes in this way highlights the importance of the edges' functions as the planes combine to form the illusion of mass and its depth. In figure 4.14A, the diagram shows planes that have parallel-angled edges. They establish a directional movement (usually away from a central location—an edge/corner). This combination of planes seems to provide solidity, whereas any plane on its own would appear relatively flat.

In the next example of a mass, figure 4.14B, the planes appear to tilt or tip. The planes take on an added feeling of dimension—depth illusion—as they appear to recede away from the spectator. These planes are the converging sides of the mass. When several converging planes are juxtaposed and touching, the spatial illusion of mass and depth is greater than that provided by the use of parallel-edged planes. This is because the illusion of the converging planes receding in depth more closely relates to our optical perception. Under normal conditions, one may expect the size of the planes to appear to

The illusion of masses or volumes on the picture plane is produced by arranging two or more flat or curvilinear planes in relation to one another to give them an appearance of solidity, as shown in figure 4.13. The planes that constitute the sides of these illusionary three-dimensional objects could be detached from the parent mass and tilted back at any angle. In fact, such planes do not have to be closed or joined at the corners in order to afford an appearance of solidity—the Gestalt effect again. As we can see in this diagram, there is no

limit to the number of shapes that can be shown in three dimensions, but the rectangular solid is probably the simplest. Spheres, pyramids, hexagonal, and ovoidal solids all have their counterparts in planar shapes, such as circles, triangles, hexagons, and ovoids.

The illusionary effect of juxtaposing the planes without connecting them makes the arrangement of planes seem less substantial than the mass, but it shows the development of the planes more clearly and is more flexible in the pictorial exploration of volume and space.

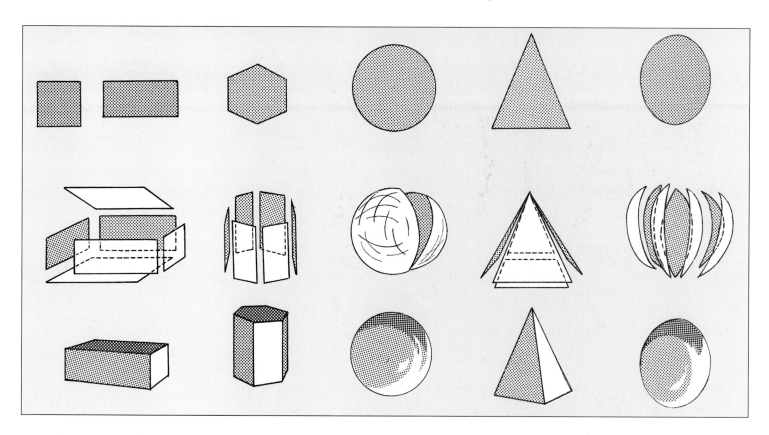

diminish as they move away from the viewer. The use of planes with converging sides is not limited to that concept and traits of depth; however, equivocal planes also occur when the traditional application is reversed, as in figure 4.14C. Equivocation means ambiguity or uncertainty. This is certainly true of ■ **equivocal space** in this example; the situation is now one in which "now you see it and now you don't," or, more accurately, "now you see it and now you see it another way." This is typical of equivocal art situations. Initially, figure 4.14C is seen as a solid block, though not in perspective. Following another inspection the white plane may be seen as an advancing "ceiling" and other planes as retreating to a corner. Such ambiguities can add challenge, spice, and interest to the viewing. This application of converging edges advancing may appear to exaggerate and distort shape definitions and impart some decorative qualities to the image; however, the individual planes in isolation remain relatively plastic.

▲ **4 • 13**
Planes and their three-dimensional equivalents.

▲ **4 • 14A**
A combination of planes that show parallel edges in depth creates the illusion of mass (shape).

▲ **4 • 14B**
A combination of planes that show converging edges in depth (moving *away* from the viewer) creates the illusion of mass (shape).

▲ **4 • 14C**
A combination of planes that show edges converging *toward* the viewer creates the illusion of mass (shape). (This is the reverse effect of the shape in figure 4.14B.)

▲ **4 • 15**

Ron Davis, *Parallelepiped Vents #545*, 1977. Acrylic on canvas, 9 ft 6 in. × 15 ft (2.90 × 4.57 m).
While the strict order of linear perspective is not observed here, a sense of space is achieved by other means under the control of the artist's instincts.
Los Angeles County Museum of Art, CA. Gift of the Eli and Edythe Broad Fund.

Review figures 4.13 to 4.14C, and you will find examples of three-dimensional shapes that have planes with parallel, advancing, and receding converging edges. Artists enjoy the freedom of creating imaginative shapes in three dimensions unencumbered by the restrictions of formulae and mechanical processes. Ron Davis, in his painting *Parallelepiped Vents #545,* employs flat planes, shapes with parallel edges, shapes with converging edges receding, and shapes with converging edges advancing (fig. 4.15). Al Held creatively employs the same types of shape-edge development in his painting *B/WX* (see fig. 8.41).

The creation of three-dimensional shapes and their depth through the use of converging edges (receding and/or advancing) preceded the development of linear perspective but is closely related to it. Because of linear perspective's importance to the creation of space it will be discussed further in Chapter 8, "Space."

The parallel-edge shape concepts that have been presented are closely related to the system of ▮ **perspective** used in mechanical drawings. Within this chapter we are primarily concerned with the illusions of shape and depth created by graphic artists. Other artists employ actual three-dimensional shapes in their art, but this is more appropriately discussed in Chapter 9, "The Art of the Third Dimension."

SHAPE AND PRINCIPLES OF DESIGN

Artists who wish to create order or unity and increase their viewers' attention spans have to conform to certain principles of order or design. In observing these principles, they are often forced to alter shapes from their natural appearance. It is in this respect that shapes can be called the building blocks of art structure. Just as in the case of line, our first element of artistic form, shapes have multiple purposes in terms of visual manipulation and psychological or emotional effects. These purposes, as suggested, vary depending on the artist and the viewer.

The principles determining the ordering of shapes are common to the other elements of form. In their search for significant order and expression, artists modify the elements until:

1. The desired degree and type of balance is achieved.
2. The observer's attention is controlled both in terms of direction and duration.
3. The appropriate ratio of harmony and variety results.
4. The space concept achieves consistency throughout.

While space is a result of the use of the elements, and harmony and variety have already been discussed (pp. 35–53), the concepts of balance, direction, and duration, as they regard shape, are important enough to warrant additional investigation.

Balance

As artists seek compositional balance, they work with the knowledge that shapes have different visual weights depending on how they are used. Although this principle of form organization was treated at some length in Chapter 2, it may be helpful to reexamine balance in particular regard to shape by reusing the example of the seesaw, or weighing scale, as depicted in figure 2.28. We see that placing shapes of different sizes at varying distances from the fulcrum can be controlled to create a sense of balance or imbalance. Because no actual weight is involved, we assume that the sensation is intuitive, or felt, as a result of the various properties composing the art elements. For example, a dark value adds weight to a shape, while substituting a narrow line for a wider line around it reduces the shape's apparent weight.

A

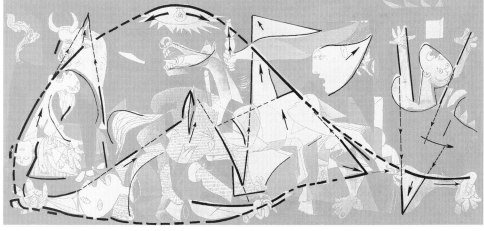

B

4 • 16

Pablo Picasso, *Guernica*, 1937. Oil on canvas, 11 ft 5½ in. × 25 ft 5¼ in. (3.49 × 7.75 m).

The linear diagram (B) overlaying Picasso's *Guernica* is one of several possible interpretations of the way shape is used as a directional device. The arrows in the middle of shapes indicate their major directional thrust. The thick solid lines show the edges where a felt direction seems to line up with a corresponding shape edge across a space (indicated by broken lines). These create the major shape directions in the overall composition. Secondary shapes, related in a similar way, are shown by middleweight lines. The lighter lines show curving shape edges counteracting the straighter and more broadly arced edges of the design.

Museo del Prado, Madrid, Spain. Photo: Centro de Arte Reina Sofia, Madrid/Giraudon, Paris/SuperStock. © 1997 Estate of Pablo Picasso/Artists Rights Society (ARS), New York.

The seesaw is an example of how a few basic elements can operate along only one plane of action. Developed artworks, on the other hand, contain many diverse elements working in many directions. The factors that control the amounts of directional and tensional force generated by the various elements are: placement, size, accents or emphasis, and general shape character (including associative equivalents to be discussed under "Duration and Relative Dominance," (p. 108). The elements are manipulated by the artist until the energy of their relationships results in dynamic tension.

Direction

Artists can use the elements of form to generate visual forces that direct our eyes as we view the work. Pathways are devised to encourage transition from one pictorial area to another. There are several ways of facilitating this; one way is to make use of shapes pointing in specific directions (shorter shapes generally obstruct the visual pathways). Secondly, artists often extend or "aim" edges so that they imply a linkage with the edges of other shapes or suggest by the direction of the edges a related movement in a certain direction (figs. 4.16A and B). A third solution is the use of intuitive space (see Chapter 8, p. 206), an implied perspective given to

4 • 17

Georges Braque, *Still Life with Fruit and Stringed Instrument,* 1938. Oil on canvas, 45 × 58 in. (114.3 × 147.3 cm).
The shapes of white line or light value define the designed pathways of eye travel. The visual tension and rhythmic movement results from the placement, size, soft accent, and general character of the shapes involved.
Gift of Mary and Leigh Block, 1988.141.6.
Photograph © 2001, The Art Institute of Chicago, All Rights Reserved.

shapes that tip them into or through the picture plane and direct our eyes along three-dimensional routes; this can be observed in figures 4.11B, C, and D. The direction of the eyes along these paths should be rhythmic, providing pleasurable viewing and unification of the work. The character of the rhythm produced depends on the artist's intentions—jerky, sinuous, swift, or slow (fig. 4.17). The control of direction helps us to see things in the proper sequence and according to the degree of importance planned for them.

Duration and Relative Dominance

The unifying and rhythmic effects provided by eye paths are modified by the number and length of the pauses in the eye journey. If the planned pauses are of equal duration, the viewing experience is more monotonous. The artist, therefore, attempts to organize pauses so that their lengths are related to the importance of the sights to be seen on the eye journey (fig. 4.18). The duration of a pause is determined by the pictorial importance of the area. Although shapes create transitions, they are very often focal points in a picture. In a work depicting the Crucifixion, for example, we would expect an artist to make the figure of Christ particularly significant (fig. 4.19). In the case of the illustration shown, this dominance is achieved by the size of the shape created by Christ's body. The effect of a shape's size can be further modified by manipulations of value, location, color, or any combination of these elements. Artists develop dominance on the basis of their feelings, and they reconcile the various demands of the design principles with those of relative dominance. The degree of dominance is usually in direct proportion to the amount of visual contrast. This is true of both representational and abstract works (see figs. 4.19 and 4.20). The idea of relative dominance is similar to the hierarchy in organizations that have a dominant figure and other members with diminishing responsibilities.

There is another aspect, association, or similarity that tends to qualify the attention given to shapes or other elements. The contrasts between Christ's T shape, the ovals in the right and left foreground, the arch tops in the background, and the differences in value and color from his figure, all afford differences that increase the dominance of it in Ismael Rodríguez's painting *El Sueño de Erasmo.* Playing a diminished role, but adding to the organized coherence of the painting, is the repetition of the similar head shapes in the figures and the touches of yellow, red, and green in parts of the painting

▲ 4•18

Sassetta, workshop of, *The Meeting of Saint Anthony and Saint Paul,* c. 1440. Tempera on panel, 18¾ × 13⅝ in. (47.6 × 34.6 cm).

In this painting by the Italian artist Sassetta, "station stops" of varied duration are indicated by contrasts of value. In addition, eye paths are provided by the edges of the natural forms that lead from figure to figure. This painting also illustrates how late-Gothic artists used shallow space in compositions prior to the full development of perspective.

Samuel H. Kress Collection. © Board of Trustees, National Gallery of Art, Washington.

▶ **4 • 19**
Ismael Rodriguez Rueda, *El Sueño de Erasmo (The Dream of Erasmus)*, 1995. Oil on canvas, 39⅓ × 47½ in. (100 × 120 cm).
The figure of Christ is made dominant by its size and centrality of location.

Courtesy of Ismael Rodriguez Rueda.

(fig. 4.19). In an abstract work of art, such as the Coleman computer-aided art (fig. 4.20), an oval shape may well receive more attention if for some reason it reminds us of a head. Artists usually would try to avoid such chance interpretations, although they cannot always be foreseen. Of course, size remains the principal device used for dominance. At other times, artists can use the innate appeal of associative factors to advantage, weighing them in the balance of relative dominance and

forcing them to operate for the benefit of the total organization.

Harmony and Variety

Harmony ensures that all things seem to belong together. Shapes and other elements achieve this by having a likeness. With repetition, those parts form a family, just as members of human families share certain characteristics. A family of shapes could be mostly rectilinear (composed of

straight edges), curvilinear (curved edges), or another similar type. The shape likeness could be additionally enhanced by sharing common applications of value, texture, or color. The likeness need not always be identical but perhaps merely enough to see their relationship. A stress on shape harmony can result in a relatively peaceful situation, but over-stressing harmony may curtail our interest.

Variety is the other side of the coin. Enough differences must exist to

◄ 4 • 20
Ronald Coleman, *Supervisory Wife II*, 1992. Computer-aided art.
The principle of relative dominance is generated in this computer print by the large size, the contrasting purple color, and the mysterious eye that peers out of the sphere. Further attention is drawn to this spherical shape by the converging front lines and side shapes that are directed to it.
Courtesy of the artist.

make for challenging viewing. These differences are attractions that grasp and hold our attention for the period thought necessary by the artist. If the artwork consists of mostly gently flowing shapes, the introduction of angular shapes will produce sharp accents and, of course, the reverse would be true. Although the presence of some differences is essential, excessive differences may be out of tune with the total concept; some reconciliation with harmony is necessary. If agitation and somewhat violent effects are sought, shape variety is the answer. Remember: repetitive shapes for harmony; contrasting shapes for variety.

Shapes and the Space Concept

Regarding space, the sculptor may have an advantage over the two-dimensional artist who is confronted with a flat working surface. The flat surface must be converted into a "window" where things

appear to be advancing and retreating. Space has been dealt with in different ways in different cultures; sometimes it has been extended, sometimes compressed. In either case, shapes are an important factor.

Shapes are often seen as planes, independent of or part of objects, tilted or upright, and often, although not always, flat. They may be seen as ground surfaces, walls, tabletops and sides, and the like. Frequently, shapes are seen in perspective as they move away from us, resulting in different depths of space. Shapes may twist and bend in space or overlap and may be seen through and penetrate each other, causing new spatial relationships.

The artist must be consistent with his or her space; a mix does not ordinarily work well. One challenge is balancing the spatial forces. In two-dimensional art, one form of balance depends on the apparent weights of the elements. In seeking an apparent three-dimensional appearance, the thrusting

and recession of the elements in space must balance; otherwise, the picture plane can appear twisted. Equalization of the spatial forces depends on adjustments in size and position and variations of strong or weak values and colors. When making these adjustments, the artist will help the shapes take their desired position in space.

SHAPE AND CONTENT

Whereas the physical effects created by artists are relatively easily defined, the qualities of expression, or character, provided by shapes in a work of art are so varied (because of individual responses) that only a few of the possibilities can be suggested. In some cases, our responses to shapes are quite commonplace; in others, our reactions are much more complex because our own personality traits can influence the shapes' character (for example, shyness,

▲ **4•21**
Francisco Goya, *The Bullfight,* c. 1824. Oil on canvas, 24¾ × 36½ in. (63 × 93 cm).
While it is a straightforward exercise to recognize the picador in this painting, this should only be a starting point for understanding the blood and tragedy that Goya found in the bull ring.
Toledo Museum of Art, Toledo, Ohio. Purchased with funds from the Libbey Endowment. Gift of Edward Drummond Libbey.

aggressiveness, awkwardness, poise, and so forth). These are just some of the meanings or content we can find in shapes. Artists, naturally, make use of such shape qualities in developing their works of art, although much of their work is instinctive.

It is hardly conceivable that an architect would use shapes in buildings to suggest natural forms. It has been done during art history, but very rarely. On the other hand, sculptors and pictorial artists have almost always used natural forms in their respective media. Yet the evidence indicates that they were not always interested in using shapes to represent known objects. Artists more often tend to present what they conceive or imagine to be real rather than what they perceive, or see objectively, to be real. This was particularly evident in the twentieth century, when whole movements were based on the nonrepresentational use of shapes—from the abstract movement of the early 1900s to the conceptual movement of the seventies and eighties.

Thus, conception and imagination have always been parts of artistic expression. It is usually a matter of degree as to how much artists use their imagination and how much they use their perceptual vision. By trying to say something through their use of subject and form, artists find that their points cannot be made without editing the

◄ **4•22**
Conrad Marca-Relli, *The Picador,* 1956. Oil and fabric collage on canvas, 3 ft 11¼ in. × 4 ft 5 in. (1.20 × 1.35 m).
Artists differ in their responses to subject matter. It is often a matter of degree as to how much artists use their imaginations and how much their visual perceptions vary. Such differences are apparent if one contrasts the use of the picador in figures 4.21 and 4.22.
Hirshhorn Museum and Sculpture Garden, Smithsonian Institution, Washington, D.C. Gift of Joseph H. Hirshhorn, 1966. Photograph by Lee Stalsworth.

elements (or "grammar") of form/expression. So while the work of those artists who are more devoted to representing actual appearances might seem to be quite natural, comparison with the original subject in nature may still show considerable disparities (figs. 4.21 and 4.22). Artists, therefore, go beyond literal copying and transform object shapes into their personal style or language of form (figs. 4.23, 4.24, and 4.25; see fig. 4.5).

Just as the configuration of a shape gives it the character that distinguishes it from other shapes, so does configuration also change a shape's content or expressive meaning. Many of the abstract artists of the twentieth century seem to have been influenced by the stylization of machinery, for example, to create pristine, clear-cut shape relationships. Our reactions to these, or the meanings we find in them, vary with our own

▼ 4 • 24

Charles Burchfield, *The Night Wind,* (Salem, Ohio, January) 1918. Watercolor and gouache on paper, 21½ × 27⅞ in. (54.4 × 55.5 cm).
The shapes used by Burchfield in this painting are partly psychological and partly symbolic. The approaching storm seems to evoke human qualities, such as the onset of depression or anger.
The Museum of Modern Art, New York. Gift of A. Conger Goodyear. Photograph © 1998 Museum of Modern Art.

▼ 4 • 25

Josef Albers, *White Line Square IX,* from the series *Homage to the Square,* 1966. Colored Lithograph, 21 × 21 in. (53.3 × 53.3 cm).
The meaning of the squares in this picture lies not in their resemblance to a real object but in their relationship to *one another.*
© 1966 Josef Albers and Gemini G.E.L., Los Angeles, CA.

▲ 4 • 23

Ernest Trova, *Untitled,* from the series *Index,* 1969. Serigraph, sheet 15 × 12½ in. (15.2 × 31.7 cm).
Ernest Trova takes the use of the human figure beyond literal interpretation. It becomes a personal symbol reinforcing the circular format as a radial design unit.
Courtesy of the artist.

▲ 4 • 26

Charles Sheeler, *Rolling Power,* 1955. Oil on canvas, 15 × 30 in. (38.1 × 72.6 cm).
While commenting upon the abstract quality of his images, Sheeler remarked, "I had come to feel that a picture could have incorporated in it the structural design implied in abstraction and be presented in a wholly realistic manner."
Smith College Museum of Art, Northampton, MA. Purchased, Drayton Hillyer Fund, 1940. Courtesy of Smith College Museum, Northampton, MA.

▲ 4 • 27

Helen Frankenthaler, *Madame Butterfly,* 2000. Woodblock print, Triptych: 41¼ × 79 in. (104.8 × 200.7 cm).
Many shapes are not meant to represent or even symbolize. Here, for example, the shape extremities, the softly changing values of the larger shapes, and the brown wood-grained ground act against the horizontal violet and white components and the outer frame shape. The artist provokes a momentary feeling of excitement within an otherwise quiet mood.
Printed and published by Tyler Graphics Ltd., 2000. © Helen Frankenthaler/Tyler Graphics Ltd. Photograph by Steven Sloman.

psychological conditioning. In figure 4.26, Charles Sheeler abstracts shadow patterns to create shapes that help establish compositional movement. While many people accept Sheeler's artworks because of their recognizability even when the abstraction is more pronounced (see fig. 1.11), some react adversely to simple abstract shapes like those in Albers' paintings (see fig. 4.25). While both artists use similar shapes, visual differences in the relationships of these shapes, change their meanings. There are differences in color and treatment of value—one flat and the other blended. In other examples, shape extremities become important; thus, the terms *soft edge* and *hard edge* are simply another way of defining shape edges as being fuzzy and indistinct as opposed to clear-cut and sharply defined (figs. 4.27, 4.28, and 4.29). In addition, colors, values, textures, and the application of particular media can affect whatever feeling or lack of it we intuit in such works of art. The student only has to glance around a class where all members are working on a similar exercise to see the variety of personal ways that the work is done; it is amazing to see the differences in style and content that can result from the same assignment. How much more can be expected, in terms of endless expressive potential, in the case of trained artists?

All the principles involved in ordering shapes are of little value until one becomes aware of the various meanings that can be revealed through relationships made possible by the language of art. Much of this awareness, of course, comes through practice, as in learning any language.

Artists usually select their shapes to express an idea, but they may initially be motivated by the psychological associations of shape, as in the Miro and Burchfield paintings (see figs. 4.5 and 4.24). Shapes suggest certain meanings, some readily recognizable, others more complex and less clear. Some

common meanings conveyed by squares, for instance, are perfection, stability, stolidity, symmetry, self-reliance, and monotony. Although squares may have different meanings for different people, many common sensations are shared when viewing them (see fig. 4.25). Similarly, circles may suggest self-possession, independence, and/or confinement; ovals might suggest fruitfulness and creation; and stars could suggest reaching out. A vast array of other shapes possess distinctive meanings as well; however, all shapes' meaningfulness depends on their complexity, their application, and the sensitivity of those who observe them (figs. 4.27 and 4.28). How different are our reactions to the biomorphic shapes favored by the Surrealists when compared to the hard-edged shapes of the geometric abstractionists (see figs. 4.5 and 4.29)? We know we are sensitive to shape meaning, as proven by the psychologist's use of the familiar Rorschach (inkblot) test, which is designed to aid in evaluating emotional stability. The evidence from these tests indicates that shapes can provoke emotional responses on different levels. Thus, the artist might use either abstract or representational shapes to create desired responses. By using the knowledge that some shapes are inevitably associated with certain objects and situations, the artist can set the stage for a pictorial or sculptural drama.

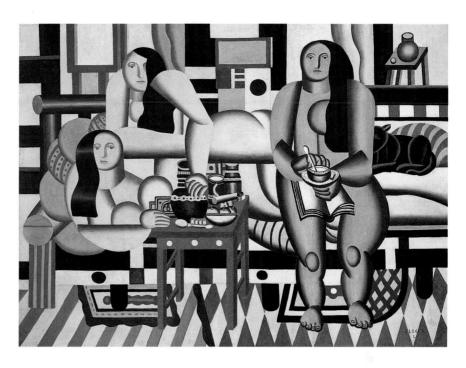

▲ **4 • 28**

Fernand Léger, *Three Women (Le Grand Déjeuner)*, 1921. Oil on canvas, 6 ft ¼ in. × 8 ft 3 in. (183.5 × 251.5 cm).

The Cubist painter Léger commonly used varied combinations of geometric shapes in very complex patterns. Here, because of his sensitive design, he not only overcomes a dominant, hard-edged feel but imbues the painting with an air of femininity.

The Museum of Modern Art, New York. Mrs. Simon Guggenheim Fund. Photo © 1998 Museum of Modern Art. © 1997 Artists Rights Society (ARS), New York/ADAGP, Paris.

▶ **4 • 29**

Dorothea Rockburne, *Mozart and Mozart Upside Down and Backward*, 1985-87. Oil on gessoed linen, hung on blue wall, 89 × 115 × 4 in. (226.06 × 292.1 × 10.16 cm).

In this painting Dorthea Rockburne is representative of the Neo-Abstractionist painters who leaned toward the geometric abstraction of the 1950s. Based on a seemingly simple scheme, upon closer examination this piece reveals a labyrinth of interlocking rectilinear shapes.

Courtesy of André Emmerich Gallery, a Division of Sotheby's, on behalf of the artist.

THE VOCABULARY OF VALUE

Value 1. The relative degree of light or dark. 2. The characteristic of color determined by light or dark or the quantity of light reflected by the color.

achromatic (value)
Relating to differences of light and dark; the absence of hue and its intensity.

cast shadow
The dark area that occurs on a surface as a result of something being placed between that surface and a light source.

chiaroscuro
1. Distribution of light and dark in a picture. 2. A technique of representation that blends light and shade gradually to create the illusion of three-dimensional objects in space or atmosphere.

chromatic (value)
The value (relative degree of lightness or darkness) demonstrated by a given color.

closed-value composition
Composition in which values are limited by the edges or boundaries of shapes (see also **decorative value**).

decorative (value)
Ornamenting or enriching but, more importantly in art, stressing the two-dimensional nature of an artwork or any of its elements. Decorative art emphasizes the essential flatness of a surface.

high-key value
A value that has a level of middle gray or lighter.

highlight
The portion of an object that, from the observer's position, receives the greatest amount of direct light.

local value
The relative light and dark of a surface, seen in the objective world, that is independent of any effect created by the degree of light falling on it.

low-key value
Any value that has a level of middle gray or darker.

open-value composition
Composition in which values cross over shape boundaries into adjoining areas.

plastic (value)
1. The use of the elements to create the illusion of the third dimension on a two-dimensional surface. 2. Three-dimensional qualities of art forms, such as architecture, sculpture, and ceramics, are enhanced by value.

shadow, shade, shading
The darker value on the surface of an object that gives the illusion that a portion of it is turned away from or obscured by the source of light.

shallow space
The illusion of limited depth. With shallow space, the imagery moves only a slight distance back from the picture plane.

tenebrism
A technique of painting that exaggerates or emphasizes the effects of chiaroscuro. Larger amounts of dark value are placed close to smaller areas of highly contrasting lights—which change suddenly—in order to concentrate attention on important features.

value pattern
The arrangement or organization of values that control compositional movement and create a unifying effect throughout a work of art.

INTRODUCTION TO VALUE RELATIONSHIPS

Value is a term often used to indicate worth, and the worth and certainly the sucess of an artwork can be greatly enhanced by an artist who makes good use of lights and darks. In art, lights and darks are referred to as ■ **value.** We experience the sensation of value in our daily life as the sun rises and sets and as we perceive the differing values of the objects that surround us. This chapter is primarily concerned with ■ **achromatic** values consisting of white, black, and the limitless degrees of gray, disregarding terms sometimes used for value such as tone, brightness, and even color.

Anyone who studies art must consider the relationship of value to the other elements of art form, all of which possess value. An examination of the value scale in figure 5.1 will indicate that there are ■ **low-key values** (middle value to black) and ■ **high-key values** (middle value to white). Many artworks lean toward low-key values (often with lighter accents), while others take the opposite path. The "key" selected usually sets the mood of the work.

For the graphic artist, the particular value of a line could be the result of the medium used or the pressure exerted on the medium by the artist. For example, the degree of value of a pencil line would be determined by the hardness of the graphite or the force with which it is used (see fig. 1.22). Value can be created by placing lines of the same or different qualities (wet or dry, pencil or chalk, or direct or blended) alongside or across each other to produce generalized areas of value. These lines may be so delicate that they are barely noticeable or so aggressive that they reveal the energy driving the artist. Value, however applied, will create distinguishable shapes (fig. 5.2). The values of line can also be used for copied (simulated) textures, including the

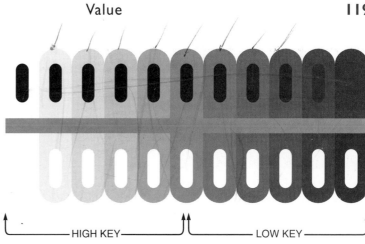

▲ **5 • 1**

This value scale shows a gradation from light to dark. The value is also seen against middle gray and black and white. Regardless of the media or technique used to create them, compositions that use values from white to middle gray are referred to as high key, while low-key images would include dark values—middle grays to black. Small amounts of contrasting value are often necessary to make either low or high key exciting.

▽ **5 • 2**

Martha Alf, *Pears Series 11 #7,* **1978. 4B pencil on bond paper, 11 × 14 in.**
A casual glance might make one think that these values were blended by rubbing drawing materials, but close examination reveals that Ms. Alf created this image using delicately drawn lines so fine that they are not recognized as individual lines. Rather, the marks combine to produce areas of strong highlights and shadow that define the pears and their surroundings. This results in crisp and sparkling surfaces.

Newspace Gallery, Los Angeles. Photograph by George Hoffman.

▲ **5•3**
Giorgio Morandi, *Large Still Life with Coffee Can,* 1934. Etching, 29.8 × 39 cm.
The degree of line concentration indicates the value of the subject; where tightly bunched shadows are suggested, the forms of the still life are defined. Though defined with strong contrasts and refined shapes, the overall darkness and minimal use of highlights creates a somber mood.
Courtesy of the Fogg Art Museum, Harvard University Art Museums. Gift of Meta and Paul J. Sachs. Photograph by Photographic Services. © President and Fellows of Harvard College Harvard University.

■ **shadows** and ■ **highlights** peculiar to a particular surface, or to produce abstract textures. The values in abstract textures depart to some degree from the values of the objects being represented and may even be totally the artist's invention.

In addition to draftsmen, most printmakers (figs. 5.3 and 5.5) have traditionally worked entirely with achromatic values to produce eminently successful works. Many artists and photographers, even today, prefer this approach. Rich darks and sparkling lights can be a visual delight.

Painters have discovered that the intoxicating effects of a particular color often blind people to the fact that color's very existence is entirely dependent upon the presence of ■ **chromatic value**—the lightness or darkness of a color. A standard yellow, for example, is of far greater lightness than a standard

violet, although both colors may be modified to a point that they become virtually equal in value. A common weakness in painting is the unfortunate disregard for the pattern created by the value relationships of the colors. Black-and-white photographs of paintings often reveal this deficiency very clearly.

DESCRIPTIVE USES OF VALUE

One of the most useful applications of value is in creating objects, shapes, and space (fig. 5.3). When artists describe images using only the naturally occurring values of those objects, they are working with ■ **local value.** Descriptive qualities can be broadened to include psychological, emotional, and dramatic expression. For centuries, artists have

been concerned with the problem of using value to translate the effect of light playing about the earth and its inhabitants. Objects are usually perceived in terms of the characteristic patterns that occur when those objects are exposed to light rays. Objects, at least normally, cannot receive light from all directions at once. A solid object gets more light from one side than another because that side is closer to the light source and thus intercepts the light and casts shadows on the other side (fig. 5.4A).

Light patterns vary according to the surface of the object receiving the light. A spherical surface demonstrates an even flow from light to dark; a surface with intersecting planes shows sudden contrasts of light and dark values. Each basic form has a basic highlight and shadow pattern. Evenly flowing tone gradation invokes a sense of a gently curved surface. An abrupt change of tone indicates a sharp or angular surface (see fig. 5.4A).

■ **Cast shadows** are the dark areas that occur on an object or a surface when a shape is placed between it and the light source. The nature of the shadow created depends upon the size and location of the light source, the size and shape of the interposed body, and the character of the surfaces where the shadows fall. Although cast shadows offer very definite clues to the circumstances of a given situation, they only occasionally give an ideal indication of the true nature of the forms (fig. 5.4B). The artist normally uses or creates shadows that aid in descriptive character, enhance the effectiveness of the design pattern, and/or contribute to the mood or expression.

Many artists use value to create representational imagery, sometimes employing chiaroscuro, giving emphasis to light and shadow. In addition, artists like Anne Dykmans and other (New) Realists (for example, painters Richard Estes and Philip Pearlstein) draw inspiration from photography and cinema for their artworks (fig. 5.5: see figs. 10.112 and 10.113). When value is used to describe

▲ **5 • 4A**
Russell F. McKnight, *Light and Dark,* 1984. Photograph.
A solid object receives more light on one side than the other because of its proximity to a light source. As the light is blocked out, shadows occur. Curved surfaces exhibit a gradual change of value, whereas angular surfaces give sharp changes. (A) Highlight; (B) Light; (C) Shadow edge; (D) Shadow core; (E) Cast shadow; and (F) Reflected light.

Courtesy of the artist.

▲ **5 • 4B**
Russell F. McKnight, *Shadows,* 1984. Photograph.
Light can cast overlapping shadows that tend to break up and hide the true character of object forms. When the shapes of shadows are not factored into the composition, results are often disorganized, as in this experiment.

Courtesy of the artist.

◀ **5 • 5**
Anne Dykmans, *Trois Fois,* 1986. Etching, mezzotint and aquatint, $13\frac{3}{4} \times 19\frac{1}{2}$ in. (34.9 × 49.53 cm).
This is fairly straightforward portrayal of the benches, including cast shadows of an undisclosed source. The background is made moody because of the shielding. One might initially expect this to be a photograph.

Courtesy Stone and Press Galleries, New Orleans, LA.

▲ **5•6**
Georges de La Tour, *The Payment of Taxes*, c. 1618-20. Oil on canvas.
In a complex composition, La Tour has used strong candlelight and its highlights and shadows to produce the atmosphere of a quiet drama. Multiple figures provide the opportunity for combining natural and invented shadows, which reinforce the structural movement.
Lviv State Picture Gallery, Ukraine/The Bridgeman Art Library.

the illusion of volume and space, it can be called ■ **plastic value.**

EXPRESSIVE USES OF VALUE

The type of expression sought by the artist ordinarily determines the balance between light and dark in a work of art. A preponderance of dark areas creates an atmosphere of gloom, mystery, drama, or menace, whereas a composition that is basically light will produce quite the opposite effect.

Artists aren't bound to an exact duplication of cause and effect in light and shadow, because this practice may create a series of forms that are monotonously light or dark on the same side. The shapes of highlights and shadows are often revised to produce desired degrees of unity and contrast with adjacent areas in the composition. In summary, lights and shadows exist in nature as the by-products of strictly physical laws. Artists must adjust and take liberties with lights and shadows to create their own visual language (fig. 5.6).

▶ 5 • 7

Giotto, *The Kiss of Judas,* Scrovegni Chapel, Padua, 1304–06. Fresco, 7 ft 7 in. × 6 ft 7½ in. (2.31 × 2.02 m).

Although line and shape predominate in Giotto's works, some early attempts at modeling with chiaroscuro value can be seen.

Photo: Arena Chapel, Cappella Degli Scrovegni, Padua/SuperStock.

▼ 5 • 8

Leonardo da Vinci, *Mona Lisa,* 1503-06. Oil on panel, 30½ × 21 in. (76.2 × 52.5 cm).

While exploring chiaroscuro, Leonardo extended the value range set by previous artists; he also developed a technique known as *sfumato,* which featured soft blending and subtle transitions from light to dark.

Louvre, Paris, France/The Bridgeman Art Library.

CHIAROSCURO

Chiaroscuro refers to the technique of representation that makes forceful use of contrasting lights and darks. The term also alludes to the way that artists handle atmospheric effects to create the illusion that the objects are surrounded on all sides by space. ■ **Chiaroscuro** developed mainly in painting, beginning with Giotto (1266–1337), who used darks and lights for modeling but expressed shape and space in terms of line (fig. 5.7). The early Florentine masters Masaccio, Fra Angelico, and Fra Filippo Lippi carried chiaroscuro a step further by expressing structure and volume in space with an even, graded tonality (see figs. 1.27 and 8.17A). Leonardo da Vinci employed a much bolder series of contrasts in light and dark but always with soft value transitions (fig. 5.8). The great Venetian painters, such as Giorgione and Titian, completely subordinated line and suggested compositional unity through an enveloping atmosphere of dominant tonality (figs. 5.9 and 5.10).

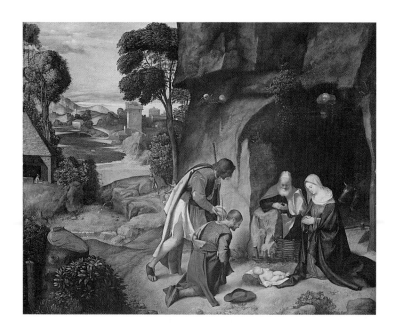

◀ **5 • 9**
Giorgione, *The Adoration of the Shepherds,* c. 1505–10. Oil on wood, 35¾ × 43½ in. (90.8 × 110.5 cm).
In Giorgione's work, line was largely disregarded in favor of atmospheric definition.
Samuel H. Kress Collection. National Gallery of Art, Washington, D.C. Photo: SuperStock.

▼ **5 • 10**
Titian (Tiziano Vecellio), *The Entombment of Christ,* 1559. Oil on canvas, 4 ft 6 in. × 5 ft 8⅞ in. (1.37 × 1.75 m).
The Venetian master Titian subordinated line (contrasting edges with value) and enveloped his figures in a total atmosphere that approaches tenebrism.
Museo del Prado, Madrid, Spain. Photo: Scala/Art Resource, NY.

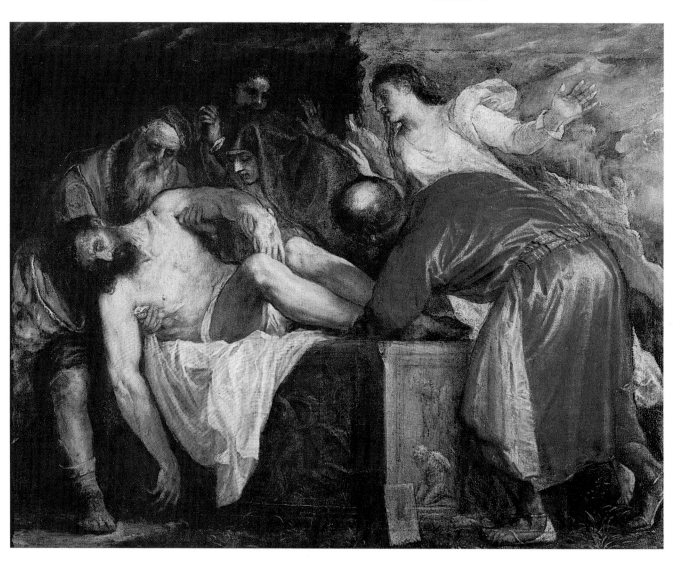

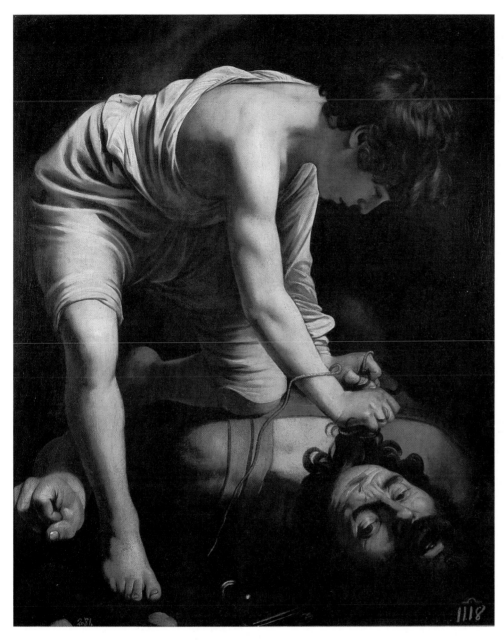

▲ **5 • 11**
Michelangelo Merisi, called Caravaggio,
David Victorious over Goliath, **1599-1600.**
Oil on canvas, 44 × 36 in. (110 × 91 cm).
Caravaggio was essentially the leader in
establishing the dark manner of painting in the
sixteenth and seventeenth centuries. Several of
the earlier northern Italian painters, however,
such as Correggio, Titian, and Tintoretto, show
a strong tendency toward compositions using
darker values.
The Prado Museum, Madrid, Spain/The Bridgeman Art
Library.

TENEBRISM

Extreme chiaroscuro is called
■ **tenebrism.** The first tenebrists were
an international group of painters who,
early in the seventeenth century, were
inspired by the work of Michelangelo
Merisi da Caravaggio (fig. 5.11).
Caravaggio based his chiaroscuro on
Correggio's work and instituted the so-
called "dark manner" of painting in
Western Europe. Rembrandt became the
technical adapter and perfector of this
dark manner, which he learned from
migratory artists of Germany and
southern Holland (fig. 5.12). The dark
manner made value an instrument in the
characteristic exaggeration of Baroque
painting. The strong contrasts lent
themselves well to highly dramatic, even
theatrical, work of this type.

Later, the dark manner evolved into
the pallid, muddy monotone that
pervaded some nineteenth-century
Western painting. The tenebrists and
their followers were very much
interested in peculiarities of lighting,
particularly the way that lighting affected
mood or emotional expression. They
deviated from standard light conditions
by placing the implied light sources in
unexpected locations, creating unusual
visual and spatial effects. In the hands of
such superior artists as Rembrandt, these
effects were creative tools; in lesser hands,
they became captivating tricks or visual
sleight-of-hand.

Printmaking Techniques
and Value

Rembrandt was a printmaker, known for
his intaglio prints or etchings, which
were achromatic but employed a strong
contrast of light and dark (see figs. 1.21A
and 1.21B). Intaglio printing involves a
metal plate that the artist has cut into or
etched using acid. Ink is rubbed into the
crevices of the plate, which is then wiped
so that only those crevices contain the
ink. Under the pressure of a press, the ink

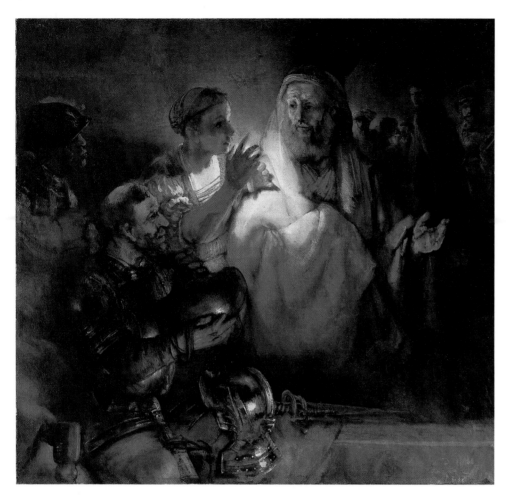

▲ 5•12

Rembrandt van Rijn, *The Denial of St. Peter,* 1660. Oil, 154 × 169 cm.
Rembrandt often used invented and hidden light sources that deviated from standard conditions to enhance the mood or emotional expression. The spotlight effect predates the invention of dramatic stage lighting.
Collection Rijksmuseum Amsterdam.

is then forced out of the plate onto the printing paper.

Woodcut or relief prints by artists from this same period were printed in black and white from single blocks cut with gouges or knives. In an attempt to achieve more subtle shading or chiaroscuro effects, artists began to explore the use of multiple blocks, printing gray tones under the final black-and-white block. However, experimentation soon began with colored blocks, and the use of color in printmaking remains popular today (see fig. 4.27).

Lithography, developed in the early nineteenth century, used achromatic values drawn by oil crayon on a slab of limestone (later replaced by metal plates). Chemically treated and washed in water, the stone would allow the application of ink in only the drawn areas. When the inked stone, which was covered with paper, passed through a press with a scraper bar, the pressure of the press forced the ink to transfer to the paper (see fig. 3.4).

Screen printing, also known as silk screen or serigraphy, became popular because of the speed of printing. It is capable of black-and-white images but has been more often used to develop colored images. With screen printing, ink is forced through a screen onto the printing paper by pressure applied to a squeegee. The preparation of the screen determines the ink pattern (fig. 2.56). Whether the artist is creating colored or black-and-white prints, the use of value to organize and create successful images has remained fundamental to all four of these basic printmaking techniques.

Many prints have used combinations of these techniques. For more information on printmaking tools and processes, see the accompanying CD-ROM. 💿

DECORATIVE VALUE

Art styles that stress ■ **decorative** effects usually ignore conventional light sources or neglect representation of light

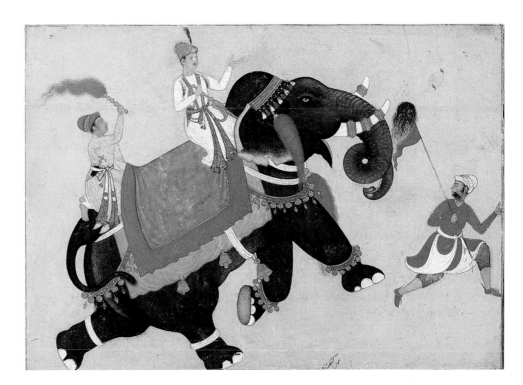

▶ 5•13
Signed: Khem Karan, *Prince Riding an Elephant,* Mughal, period of Akbar, c. 1600. Opaque watercolor and gold on paper, 12¼ × 18½ in. (31.2 × 47 cm).
Historically, South Asian artists have often disregarded the use of light (illumination) in favor of decorative value compositions.
© 1998 Metropolitan Museum of Art, New York. Rogers Fund, 1925. (25.68.4).

altogether. If light effects appear, they are often a selection of appearances based on their contribution to the total form of the work. The neglect of natural lighting, or "staged" lighting, is characteristic of the artworks of children and of primitive and prehistoric tribes, traditional East Asians, and certain periods of Western art, notably the Middle Ages. Many contemporary artworks are completely free of illusionistic lighting. An artwork that thus divorces itself from natural law is obviously based on pictorial invention, imagination, and formal considerations. Emotional impact is not necessarily sacrificed (as witness Medieval art), but the emotion speaks primarily through the forms and is consequently less extroverted.

The trend away from illumination values gained strength in the nineteenth century, partly because of growing interest in Middle Eastern and East Asian art forms (fig. 5.13). It was given a scientific, Western interpretation when the naturalist Edouard Manet observed

that multiple light sources tended to flatten object surfaces. He found that this light condition neutralized the plastic qualities of objects, thereby minimizing gradations of value (figs. 5.14A and B). As a result, he laid his colors on canvas in flat areas, beginning with bright, light colors and generally neglecting shadow (fig. 5.15). Some critics have claimed this to be the basic technical advance of the nineteenth century, because it paved the way for nonrepresentational uses of value and helped revive interest in the shallow-space concept.

COMPOSITIONAL FUNCTIONS OF VALUE

The idea of carefully controlled shallow space is well illustrated in the works of the early Cubists and their followers. In those paintings, space is given its order by the arrangement of flat planes

abstracted from the subject matter. In the initial stages of this trend, the planes were shaded individually and semi-illusionistically, although giving no indication of any one light source. Later, each plane took on a characteristic value and, in combination with others, produced a carefully conceived ▪ **shallow space.** Eventually, this shallow spatial effect was developed through attention to the advancing and receding characteristics of value (see fig. 4.8). The explorations of these early-twentieth-century artists helped focus attention on the intrinsic significance of each and every element. Value was no longer forced to serve primarily as a tool of superficial transcription, although it continued to be of descriptive usefulness. Most creative artists should think of value as a vital and lively participant in pictorial organization. An artist can strengthen underlying compositional structure by controlling contrast of value; it is instrumental in creating relative

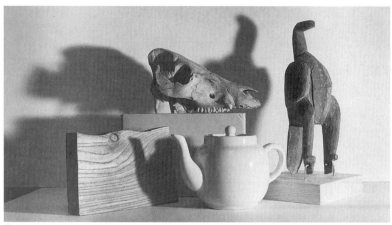
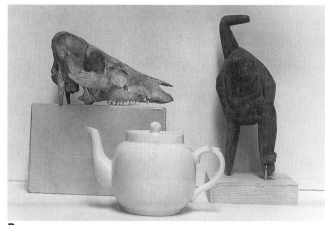

A

B

▲ 5 • 14

Russell F. McKnight, *Effect of Light on Objects*, 1984. Photograph.

Figure 5.14A demonstrates how light from one source emphasizes the three-dimensional qualities of an object and gives an indication of depth. The cast shadows also give definite clues to the descriptive and plastic qualities of the various objects. The photograph in figure 5.14B shows the group of objects under illumination from several light sources. This form of lighting tends to flatten object surfaces and produces a more decorative effect.

Courtesy of the artist.

▼ 5 • 15

Edouard Manet, *The Dead Toreador*, probably 1864. Oil on canvas, $29\frac{7}{8} \times 60\frac{3}{8}$ in. (75.9 × 153.4 cm).

Manet, a nineteenth-century naturalist, was one of the first artists to break with traditional chiaroscuro, making use, instead, of flat areas of value. These flat areas meet abruptly, unlike the blended edges used by artists previous to Manet. This was one of the great technical developments of nineteenth-century art.

Widener Collection. © 1998 Board of Trustees, National Gallery of Art, Washington, D.C.

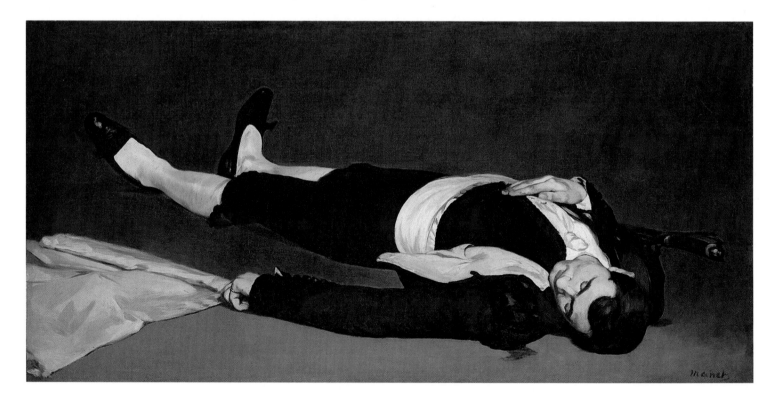

▶ **5•16**
Jisik Shin, *Lunar Image I*, 1990. Print (etching), 11⅞ × 15¾ in. (30 × 40 cm).
Absent of the need for any three-dimensional illusion of imagery, the light and dark contrasts in this etching create a dynamic two-dimensional value pattern.
Courtesy of the Artist.

dominance, indicating deep or two-dimensional space, establishing mood, and producing spatial unity (fig. 5.16).

VALUE PATTERNS

Artists have long explored possible variations for a composition's value pattern—its underlying movement and ground system—by making small studies of the value structure called thumbnail sketches. These **value patterns** may be thought of as the compositional skeleton that supports the image. When properly integrated into the final work, the movement, tension, and structure of the value pattern explored in the sketches reinforces the subject. It does not distract from the image nor separate itself as an overpowering entity or an isolated component. The advantage of small-scale preliminary value studies is that they allow an artist to quickly explore compositional variations before selecting a final solution. In figures 5.17, 5.18, and 5.19, for example, Nicolas Poussin and Barry Schactman develop large rhythmical dark shapes across the bottom, while intermingling smaller receding toned shapes in the middle areas.

Often it is difficult to relate such small studies to the final work because of scale. Small drawings may look exciting because of the way the areas of value are drawn—with rapid sketchy strokes.

▲ **5•17**
Nicolas Poussin, study for *Rape of the Sabines*, c. 1633. Pen and ink with wash, 6½ × 8⅞ in. (16.4 × 22.5 cm).
Preparatory or "thumbnail" sketches give the artist the opportunity to explore movement, ground systems, value structure, and compositional variations. In the Poussin sketch, it seems likely that the artist was striving for rhythmical movement within the horizontal thrust of the composition.
Devonshire Collection, Chatsworth, England. Reproduced by permission of the Trustees of the Chatsworth Settlement. (Photograph from Courtauld Institute of Art, London.)

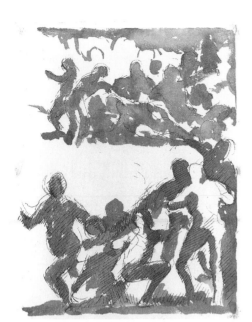

◄ **5•18**
Barry Schactman, *Study after Poussin*, 1959. Brush and ink with wash, 10 × 7⅞ in. (25.4 × 20 cm).
By using thumbnail sketches, artists can quickly position subjects in several locations before arriving at the final composition.
Collection of Yale University, New Haven, CT. Transfer from Yale Art School.

▶ **5•19**
Barry Schactman, *Study after Poussin*, 1959. Brush and ink with wash, 10 × 7⅞ in. (25.4 × 20 cm).
Loose, rapid sketches can also be used to explore value patterns, color structure, and movement.
Yale University Art Gallery, New Haven, CT. Transfer from Yale Art School.

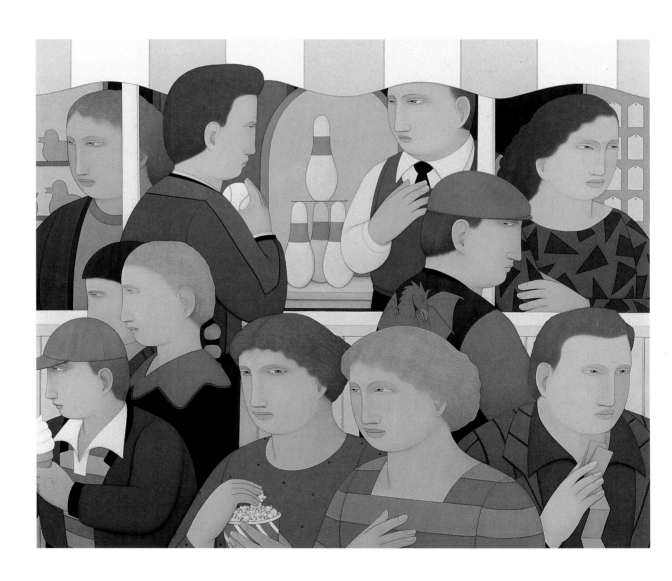

◄ 5 • 20
Andrew Steovich, *Carnival,* 1992. Oil on linen, 4 × 5 ft (1.22 × 1.52 m).
In the Stepovich painting, a closed-value composition, the color values lie between prescribed and precise limits, usually object edges or contours.
Courtesy of Adelson Galleries, New York.

◄ 5 • 21
Larry Rivers, *The Greatest Homosexual,* 1964. Oil, collage, pencil, and colored pencil on canvas, 6 ft 8 in. × 5 ft 1 in. (2.03 × 1.55 m).
In this work, values pass freely through and beyond the contour lines that normally serve as boundaries of color separation. This is an example of an open-value composition.
Hirshhorn Museum and Sculpture Garden, Smithsonian Institution. Gift of Joseph H. Hirshhorn, 1966. (Photograph by John Tennant.)
© 1998 Larry Rivers/Licensed by VAGA, New York.

When enlarged many times, small strokes become large enough to be seen as bold flat shapes that no longer have the same visual appeal. The new, enlarged shapes of value often require a refinement of detail before the proper relationship of value and mood can be established.

OPEN AND CLOSED COMPOSITIONS

While integrating the value structure and the image, the artist should be aware of two approaches for developing the value pattern—closed-value or open-value compositions. In ▪ **closed-value** compositions, values are limited by the edges or boundaries of shapes (fig. 5.20). This serves to clearly identify and, at times, even isolate the shapes (see fig. 5.16). In ▪ **open-value** compositions, values can cross over shape boundaries into adjoining areas. This helps to integrate the shapes and unify the composition (fig. 5.21; see fig. 4.8). With both open- and closed-value compositions, the emotive possibilities of value schemes are easy to see. The artist may employ closely related values for hazy, foglike effects (see fig. 4.5). Sharply crystallized shapes may be created by dramatically contrasting values (see figs. 5.2 and 5.6). Thus, value can run the gamut from decoration to violent expression. It is a multipurpose tool, and the success of the total work of art is in large measure based on the effectiveness with which the artist has made value serve these many functions.

CHAPTER SIX

Texture

THE VOCABULARY OF TEXTURE

INTRODUCTION TO TEXTURE

TEXTURE AND THE VISUAL ARTS

THE NATURE OF TEXTURE

TYPES OF TEXTURE

Actual Texture
Simulated Texture
Abstract Texture
Invented Texture

TEXTURE AND PATTERN

TEXTURE AND COMPOSITION

Relative Dominance and Movement
Psychological Factors

TEXTURE AND SPACE

TEXTURE AND ART MEDIA

Andrew Newell Wyeth, *Spring Beauty*, 1943. Drybrush watercolor on paper, 20 × 30 in. (50.8 × 76.2 cm).

THE VOCABULARY OF TEXTURE

Texture The surface character of a material that can be experienced through touch or the illusion of touch. Texture is produced by natural forces or through an artist's manipulation of the art elements.

abstract texture
A texture derived from the appearance of an actual surface but rearranged and/or simplified by the artist to satisfy the demands of the artwork.

accent
Any stress or emphasis given to elements of a composition that makes them attract more attention than other features that surround or are close to them. Accent can be created by a brighter color, darker tone, greater size, or any other means by which a difference is expressed.

actual texture
A surface that can be experienced through the sense of touch (as opposed to a surface visually simulated by the artist).

assemblage
A technique that brings together individual items of rather bulky three-dimensional nature that are displayed (in situ) in their original position rather than being limited to a wall.

atmospheric (aerial) perspective
The illusion of deep space produced in graphic works by lightening values, softening details and textures, reducing value contrasts, and neutralizing colors in objects as they recede.

collage
A pictorial technique whereby the artist creates the image, or a portion of it, by adhering real materials that possess actual textures to the picture plane surface, often combining them with painted or drawn passages.

genre
Subject matter that concerns everyday life, domestic scenes, family relationships, and the like.

invented texture
A created texture whose only source is in the imagination of the artist. It generally produces a decorative pattern and should not be confused with an abstract texture.

natural texture
Texture created as the result of nature's processes.

paint quality
The use of paint to enrich a surface through textural interest. Interest is created by the ingenuity in handling paint for its intrinsic character.

papier collé
A visual and tactile technique in which scraps of paper having various textures are pasted to the picture surface to enrich or embellish areas. In addition to the actual texture of the paper, the printing

on adhered tickets, newspapers, and the like functions as visual richness or decorative pattern similar to an artist's invented texture.

pattern
1. Any artistic design (sometimes serving as a model for imitation). 2. A repeated element and/or design that is usually varied and produces interconnections and obvious directional movements.

simulated texture
A convincing copy or translation of an object's texture in any medium.

tactile
A quality that refers to the sense of touch.

trompe l'oeil
Literally, "deceives the eye"; a technique that copies nature with such exactitude that the subject depicted can be mistaken for natural forms.

INTRODUCTION TO TEXTURE

Texture is an experience that is always with us. Whenever we touch something, we feel its texture. By concentrating on your hands and fingers holding this book, you will realize that you are experiencing ▪ **texture.** If your fingers are against the open side, they will feel the ridged effect of the stacked pages; if on the surface of a page, its smoothness. By looking around the room where you sit, you will find many textures. In fact everything has a texture, from the hard glossiness of glass through the partial roughness of a lampshade to the soft fluffiness of a carpet. If your room happens to contain a painting or art reproduction, the work most likely illustrates textures that can be seen and not felt—but that are made to look as if they could be felt.

TEXTURE AND THE VISUAL ARTS

Texture is unique among the art elements because it activates two sensory processes. It is more intimately and dramatically known through the sense of touch, but we also can see texture and thus, indirectly, predict its feel. In viewing a picture, we may recognize objects through the artist's use of characteristic shapes, colors, and value patterns. But we may also react to the artist's rendering of the surface character of those objects. In such a case, we have both visual and ▪ **tactile** experiences (fig. 6.1).

Whether the artist is working in the two-dimensional or three-dimensional field, our tactile response to the work is always a concern (fig. 6.2). Sculptors become involved with the problem of texture by their choice of material and the type and degree of finish they use. If they wish, sculptors can recreate the textures that are characteristic of the subject being interpreted. By cutting into

▲ **6 • 1**
Dennis Wojtkiewicz, *Kaleidoscope,* **1996. Oil on canvas, 40 × 60 in. (101.6 × 152.4 cm).**
The convincing effect of naturalistic still-life paintings is due, in large part, to the artist's careful simulation of object surfaces.
Courtesy of the artist, collection Mr. and Mrs. Thomas Cody, Cincinnati, OH.

▲ **6 • 2**
Andrew Newell Wyeth, *Spring Beauty,* **1943. Drybrush watercolor on paper, 20 × 30 in. (50.8 × 76.2 cm).**
Skillful manipulation of the medium can effectively simulate actual textures.
Sheldon Memorial Art Gallery, University of Nebraska, Lincoln, Nebraska. The F. M. Hall Collection 1944. H-247.

▲ 6·3

Rombout Verhulst, *Bust of Maria van Reygersberg,* Leiden, 1663. Terracotta, 45 cm high.

In this work, Rombout Verhulst has united the sober realism of the period to the skillful rendering of details such as hair and clothing. The sensitivity of his modeling of flesh brings out the expressive and malleable qualities of the clay.

Courtesy of Rijksmuseum, Amsterdam.

▲ 6·4

(A) A cross section of three materials. On the left is a hard, smooth substance; in the middle is cinderblock; and on the right is weathered wood. The texture of the three upper surfaces can be clearly seen and could be felt if stroked. (B) The same cross section showing its upper plane. The arrow indicates the light source. The texture is defined by the highlights and shadows formed by this illumination. The material to the left, being smooth, produces no shadows (if glossy, it would show reflections). In the cinderblock, shadows are cast among the small stones. The undulations in the weathered wood have shadows on the left side and highlights on the right. The nature of the texture in materials is defined by light and shadow patterns.

◄▲ 6·5

Gary Lawe, *I Remember Being Free,* 1998. Lucite, acrylic, encaustic, and nails, 24 × 30 in. (61 × 76 cm).

The admixture of nails with the varied paint media is used to create an actual textured surface that is rich in its inherent visual and tactile qualities.

Courtesy of the artist Gary Lawe and the Don O'Melveny Gallery, West Hollywood.

◀ **6 • 6**
Seo-Bo Park, *Ecriture No. 940110*, 1994. Mixed media with Korean paper, 26 × 18 in. (65.3 × 46 cm).
The massing of paint is clearly evident, particularly in the central portion. Some shapes seem to have been effected by a comblike instrument.
Courtesy of Jean Art Gallery, Seoul, Korea.

TYPES OF TEXTURE

The artist can use four basic types of texture: actual, simulated, abstract, and invented.

ACTUAL TEXTURE

Actual texture is the "real thing"; it is the way the surface of an object looks and feels. Generally, the emphasis is on the way it feels to the touch, but we can get a preliminary idea of the feel by viewing the object (fig. 6.5). Historically, ▪ **actual texture** has been a natural part of three-dimensional art, but it has rarely been present in the graphic arts. An exception might be the buildup of paint on Seo-Bo Parks' *Ecriture* or van Gogh's *Starry Night,* in which the pigment has been applied in projecting mounds or furrows for its intrinsic ▪ **paint quality** (fig. 6.6; see fig. 1.16). The usual artistic application of actual texture involves fixing a textured object or a natural texture to the working surface. When this is done, the texture simply represents itself, although a texture may sometimes be used out of context by displacing an expected texture. The adhering of textures in two-dimensional art probably began with Picasso and Braque in the early twentieth century. In 1908, Picasso pasted a piece of paper to a drawing. This is the first known example of ▪ **papier collé.** This practice was later expanded to include the use of tickets, portions of newspapers, menus, and the like.

the surface of the material, they can suggest the exterior qualities of hair, cloth, skin, and other textures (fig. 6.3).

THE NATURE OF TEXTURE

The sense of touch helps to inform us about our immediate surroundings. Our language, through such words as *smooth,* *rough, soft,* and *hard,* demonstrates that touch can tell us about the nature of objects. Texture is really surface, and the feel of that surface depends on the degree to which it is broken up by its composition. This determines how we see it and feel it. Rough surfaces intercept light rays, producing lights and darks. Glossy surfaces reflect the light more evenly, giving a less broken appearance (figs. 6.4A and B).

▲ 6 • 7
Pablo Picasso, *Still Life with Chair Caning,* 1912. Oil on pasted oilcloth, rope, oval 10⅝ × 13³/₇ in. (27 × 34.9 cm).
With this work, Picasso pioneered the development of the papier collé and collage forms—art created by fastening actual materials with textural interest to a flat working surface. These art forms may be used to simulate natural textures but are usually created for decorative purposes.
Musée Picasso, Paris, France. © Artists Rights Society, NY. Giraudon/Art Resource, NY.

▲ 6 • 8
Ilse Bing, *My World,* 1985. Mixed media, 14 × 17 × 3¾ in. (35.6 × 43.2 × 9.5 cm).
The inspiration behind the use of burlap in this artwork stems ultimately from the first collages of Picasso and Braque—then a revolutionary, but now a fairly commonplace, technique.
© Ilse Bing, courtesy of Houk-Friedman, New York.

▲ 6 • 9
***Ancestral Figure from House Post,* Maori, New Zealand, c. 118–129. Wood, 43 in. high (109.22 cm).**
The Maori shallow relief figure from New Zealand, representing a tribal ancestor, has incorporated curving or spiral bands of invented textural pattern. The decorative treatment relates to the tattooing that embellished the tribal members' bodies, including their faces. The carving functioned as one of the wall planks in their meeting house.
© Boltin Picture Library.

Papier collé soon led to ■ **collage,** an art form where actual textures, in the form of rope, chair caning, and other articles of greater substance than paper, were employed. Sometimes these were used in combination with simulated textures (fig. 6.7). The use of papier collé and collage is not always accepted easily; it leads to an uncertainty that can be perplexing. The problem created by mixing objects and painting is: What is real—the objects, the artistic elements, or both? Do the painted objects have the same reality as the genuine objects? Whatever the answers, the early explorations of the Cubists (the style of Picasso and Braque, about 1907–12) stimulated other artists to explore new attitudes toward art and made them much more conscious of surface (fig. 6.8). A concern for ■ **pattern,** arising out of interest in texture, can be found in the work of artists from every culture (fig. 6.9). In the art of today, we find many forms of surface applications. Aside from the more familiar texture of manipulated paint, we may find aggregate (sand, gravel, and so on) mixed into the paint to make the surface smoother or rougher, for whatever reason (see fig. 6.5).

Actual textures contribute to a fairly recent development called ■ **assemblage.** If there is any distinction to be made between collage and assemblage, it is that assemblages usually bring together rather bulky individual items that are displayed in different positions rather than on a wall. These objects, of course, possess actual texture in their own right (fig. 6.10; see figs. 10.89 and 10.90).

SIMULATED TEXTURE

A surface character that looks real but, in fact, is not is said to be ■ **simulated texture.** Every surface has characteristic light and dark features as well as reflections. When these are skillfully

△ **6 • 10**
Robert Rauschenberg, *Canyon,* 1959. Combine painting: oil, pencil, paper, fabric, metal, cardboard box, printed reproductions, photograph, wood and objects on canvas, with a bald eagle, cord and pillow, 81¾ × 70 in. (207.65 × 177.8 cm).
Perhaps the dividing line between collage and assemblage, as illustrated by this example, lies in the greater bulk and variety of the objects found in assemblages.
© Robert Rauschenberg/Licensed by VAGA, New York, NY.

Flemish artists produced amazing naturalistic effects in still-life and ▪ **genre** paintings. Their work shows the evident relish with which they moved from one textural detail to another. Interior designers employ this concept when painting "faux" (fake) surface treatments of imitation stone or marble-veined wall texture. Simulated textures are often associated with ▪ **trompe l'oeil** paintings, which attempt to "fool the eye" (fig. 6.11; see fig. 6.1).

Simulated texture can serve to illustrate the dual character of texture. Imagine an artist painting a picture that includes a barn door. The door is so weathered and eroded that its wood grain stands out prominently; it would feel rough if stroked. The roughness results from the ridges and valleys formed by exposure to the elements. These ridges and valleys can be felt but are visible only because they are defined by light and shadow. In rendering (or simulating) the door's texture the artist copies the highlights and shadows from a photograph (fig. 6.12) and, if performed with skill, this technique works like a feat of magic. The copied door appears to be rough, but is, in fact, smooth, as can be confirmed by stroking the surface of the work.

ABSTRACT TEXTURE

Very often artists may be interested in using texture, but, instead of simulating textures, they ▪ **abstract** them. Abstract textures usually display some hint of the original texture but have been modified to suit the artist's particular needs. The result is often a simplified version of the original, emphasizing pattern. Abstract textures normally appear in works where the degree of abstraction is consistent throughout. In these works they function in a decorative way; obviously there is no attempt to fool the eye, but they serve the role of enrichment in the same way that simulated textures do. Besides helping the artist to simplify his or her

▲ **6 • 11**
Gary Schumer, *Simulation,* 1979.
Oil on canvas, 3 ft 6½ in. × 4 ft 4½ in.
(1.08 × 1.33 m).
As the title implies, the artist is concerned with the simulation of natural textures.
Courtesy of Owens Corning Collection, Toledo, OH.

reproduced in the artist's medium (as in the case of the seventeenth-century Dutch painters), they can often be mistaken for the surfaces of real objects. Simulation is a copying technique, a skill that can be quite impressive in its own right; but it is far from being the sum total of art.

Simulated textures are useful for making things identifiable; moreover, we experience a rich tactile enjoyment when viewing them. The Dutch and

◀ **6 • 12**
A closeup of a wooden barn door shows a detailed view of its grain. The wood has been so eroded by the weather that the grain and knots stand out. If you were to touch the actual surface of the door it would feel rough, but if you stroke the surface of the photographic reproduction on this page it feels perfectly smooth. The picture is, in fact, a simulation of the textured barn door.
Courtesy of the authors.

▼ **6 • 13**
Roy Lichtenstein, *Cubist Still Life with Playing Cards,* 1974. Oil and magna on canvas, 96 × 60 in. (243.8 × 152.4 cm).
The wood grain in this work is not abstracted beyond recognition; it is clearly derived from wood, though simplified and stylized.
© Estate of Roy Lichtenstein.

material, abstract textures can be used to ▦ **accent** or diminish areas (relative dominance) and to control movement. They can be a potent compositional tool (fig. 6.13).

INVENTED TEXTURE

Invented textures are textures without precedent; they neither simulate nor are they abstracted from reality; they are purely the creation of the artist's imagination. In some settings, ▦ **invented textures** may suggest that they function as another type of texture, but such references are not generally intended by the artist. Invented textures usually appear in abstract works, as they are entirely nonobjective. It is sometimes difficult to distinguish abstracted from invented textures, because an artist with the same level of skill as the simulator (but probably with more imagination) can invent a texture and make it appear to have a precedent where none exists

CHAPTER SEVEN

Color

Charles Csuri, *Wondrous Spring,* 1992. Computer image, 48 × 65 in. (121.9 × 165.1 cm).

THE VOCABULARY OF COLOR

Color The visual response to the wavelengths of sunlight identified as red, green, blue, and so on; having the physical properties of hue, intensity, and value.

academic
Art that conforms to established traditions and approved conventions as practiced in art academies. Academic art stresses standards, set procedures, and rules.

achromatic (color)
Relating to differences of light and dark; the absence of hue and its intensity.

additive color
Color created by superimposing light rays. Adding together (or superimposing) the three physical primaries (lights)—red, blue, and green—will produce white. The secondaries are cyan, yellow, and magenta.

analogous colors
Colors that are closely related in hue(s). They are usually adjacent to each other on the color wheel.

chroma
1. The purity of hue or its freedom from white, black, or gray. 2. The intensity of hue.

chromatic
Pertaining to the presence of color.

chromatic value
The value (relative degree of lightness or darkness) demonstrated by a given color.

color tetrad
Four colors, equally spaced on the color wheel, containing a primary and its complement and a complementary pair of intermediates. This has also come to mean any organization of color on the wheel forming a rectangle that could include a double split-complement.

color triad
Three colors spaced an equal distance apart on the color wheel forming an equilateral triangle. The twelve-color wheel is made up of a primary triad, a secondary triad, and two intermediate triads.

complementary colors
Two colors directly opposite each other on the color wheel. A primary color is complementary to a secondary color, which is a mixture of the two remaining primaries.

high-key color
Any color that has a value level of middle gray or lighter.

hue
Designates the common name of a color and indicates its position in the spectrum or on the color wheel. Hue is determined by the specific wavelength of the color in a ray of light.

intensity
The saturation, strength, or purity of a hue. A vivid color is of high intensity; a dull color is of low intensity.

intermediate color
A color produced by a mixture of a primary color and a secondary color.

local (objective) color
The color as seen in the objective world (green grass, blue sky, red barn, and the like).

low-key color
Any color that has a value level of middle gray or darker.

monochromatic
Having only one hue; the complete range of value of one color from white to black.

neutralized color
A color that has been grayed or reduced in intensity by being mixed with any of the neutrals or with a complementary color.

neutrals
1. The inclusion of all color wavelengths will produce white, and the absence of any wavelengths will be perceived as black.

With neutrals, no single color is noticed—only a sense of light and dark or the range from white through gray to black. 2. A color altered by the addition of its complement so that the original sensation of hue is lost or grayed.

pigments
Color substances that give their color property to another material by being mixed with it or covering it. Pigments, usually insoluble, are added to liquid vehicles to produce paint or ink. Colored substances dissolved in liquids that give their coloring effects by being absorbed or staining are referred to as dyes.

primary color
The preliminary hues that can't be broken down or reduced into component colors. The basic hues in any color system that in theory may be used to mix all other colors.

secondary color
A color produced by a mixture of two primary colors.

simultaneous contrast
When two different colors come into direct contact, the contrast intensifies the difference between them.

spectrum
The band of individual colors that results when a beam of white light is broken into its component wavelengths, identifiable as hues.

split-complement(s)
A color and the two colors on either side of its complement.

subjective (color)
1. That which is derived from the mind reflecting a personal viewpoint, bias, or emotion. 2. Subjective art (color) tends to be inventive or creative.

subtractive color
The sensation of color that is produced when wavelengths of light are reflected back to the viewer after all other wavelengths have been subtracted and/or absorbed.

tertiary color
Color resulting from the mixture of all three primaries in differing amounts or two secondary colors. Tertiary colors are characterized by the neutralization of intensity and hue. They are found on the color wheel on the inner rings of color leading to complete neutralization.

value (color)
1. The relative degree of light or dark.
2. The characteristic of color determined by light or dark or the quantity of light reflected by the color.

THE CHARACTERISTICS OF COLOR

Color, the most universally appreciated element, appeals to children and adults instantly. An Infant will reach out for a brightly colored object, and children watch in fascination as yellow magically becomes green with the addition of blue. Even the average layperson, although frequently puzzled by what he or she calls "modern" art, usually finds its color exciting and attractive. This person may question the use of distorted shapes but seldom objects to the use of color, provided that it is harmonious in character. In fact, a work of art can frequently be appreciated for its color style alone.

Color is one of the most expressive elements because its quality affects our emotions directly. When we view a work of art, we do not have to rationalize what we are supposed to feel about its color; we have an immediate emotional reaction to it. Pleasing rhythms and harmonies of color satisfy our aesthetic desires. We like certain combinations of color and reject others. In representational art, color identifies objects and creates the effect of illusionistic space. The study of color is based on scientific theory—principles that can be observed and easily systematized. We will examine these basic characteristics of color relationships to see how they help to give form and meaning to the subject of an artist's work.

LIGHT: THE SOURCE OF COLOR

Color begins with and is derived from light, either natural or artificial. Where there is little light, there is little color; where the light is strong, color is likely to be particularly intense. When the light is weak, such as at dusk or dawn, it is difficult to distinguish one color from another. Under bright, strong sunlight, as in tropical climates, colors seem to take on additional intensity.

Every ray of light coming from the sun is composed of waves that vibrate at different speeds. The sensation of color is aroused in the human mind by the way our sense of vision responds to the different wavelengths. This can be experimentally proved by observing a beam of white light that passes through a triangle-shaped piece of glass (a prism) and then reflects from a sheet of white paper. The rays of light bend, or refract, as they pass through the glass at different angles (according to their wavelength) and then reflect off the white paper as different colors. Our sense of vision interprets these colors as individual stripes in a narrow band called the spectrum. The major colors easily distinguishable in this band are red, orange, yellow, green, blue, blue-violet, and violet (scientists use the term *indigo* for the color artists call *blue-violet*). These colors, however, blend gradually so that we can see several intermediate colors between them (figs. 7.1 and 7.2).

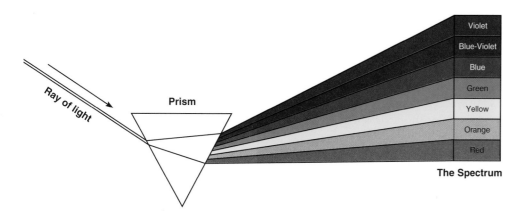

Ray of light · Prism · Violet · Blue-Violet · Blue · Green · Yellow · Orange · Red · **The Spectrum**

◀ **7 · 1**
The rays of red have the longest wavelength, and those of violet the shortest. The angle at which the rays are bent, or refracted, is greatest at the violet end and least at the red end.

◁ **7 • 2**

A beam of light passes through a triangular-shaped piece of glass (prism). The rays of light are bent, or refracted, as they pass through the glass at different angles (according to their wavelengths), producing a rainbow array of hues called the spectrum.

© David Parker, SPL/PhotoResearchers, Inc.

▲ **7 • 3**

The projected additive primary colors—red, blue (a color named by industry and scientists that is actually closer to violet), and green—create the secondary colors of cyan, yellow, and magenta when two are overlapped. When all three primaries are combined, white light is produced.

© Eastman Kodak Company.

Additive Color

The colors of the spectrum are pure, and they represent the greatest intensity (brightness) possible. If we could collect all these spectrum colors and mix them in a process reversed from the one described in the previous paragraph, we would again have white light. When artists or physicists work with rays of colored light, they are using ■ **additive color.** Some interesting things happen when rays of red, blue, or green (the additive primaries) are overlapped—the secondary colors are created. Where red and blue light overlap, magenta is produced; where red and green light overlap, yellow is produced; where green and blue light overlap, cyan is produced. Where red, blue, and green light rays overlap, white light is produced—proving that white light may be created by the presence of all color wavelengths (fig. 7.3).

The television industry uses this additive color mixing process. The modern color monitor is made up of small triplet phosphor units of red, blue, and green. Seen in 525 horizontal lines, the units are illuminated singly or in various combinations to produce the sensation of every color possible. Each image is made up of two scans of alternate lines—odd-numbered lines, then even. This takes place at a rate of 60 scans per second. At viewing distance, the lines and stripes of glowing colored phosphors cannot be distinguished as the eye merges them all together into a sharp image in full color.

Like television, the computer is another important tool that uses additive color mixing. It is employed by the artist to explore and create intense color images (fig. 7.4). In addition, computer-generated models can provide the illusion of three-dimensional space and scale. They allow the viewer to move about in the image, trying multiple spacing and color relationships. In a computer model, the artist is able to explore the additive color effects of stage lighting on characters and props before building the actual set. An old accountant's saying states, "If you want to count green pigs, shine a green spotlight upon them." With additive color stage lighting, things are not always what they may seem to be either. A reddish stage light will make the object take on that color, and if green is projected on the opposite side, interesting qualities may be created by the highlight and shadows of the natural contours. Where the two spotlights overlap, a new color (yellow tones) may be seen. Though a bit garish in this instance, additive color stage lighting that is appropriate to the image can do much to heighten the emotional response of the audience.

It is becoming increasingly more important for an artist to be familiar with the additive color system. In addition to computer art, it is used in theater, video production, computer animation graphics, the neon sign industry, slide and multimedia presentations, laser light shows, and landscape and interior lighting. In each case, artists and technicians work with light and create color by mixing the light primaries—red, blue, and green.

Subtractive Color

Because all the colors are present in a beam of daylight, how are we able to distinguish a single color as it is reflected from a natural object? Any colored object has certain physical properties, called color quality or pigmentation, that enable it to absorb some color waves and reflect others. A green leaf appears green to the eye because the leaf reflects only the green waves in the ray of light. An artist's ■ **pigments** have this property and, when applied to the surface of an object, give it the same characteristic. The artist may also alter the surface pigmentation of an object through the use of dyes, stains, and chemical washes or gases (as applied to sculpture).

Regardless of how the surface pigmentation is applied or altered, the sensation of color is created when the surface absorbs all the wavelengths except those of the color perceived. When the work is experienced through reflected light, we are dealing with ■ **subtractive color** rather than actual light rays or additive color. With an area of white, all the light wavelengths of color are reflected back to the viewer—none is subtracted by the white. However, when a color covers the surface, only the wavelengths of that color are reflected back to the viewer—all others are subtracted or absorbed by the pigment. As a result, the sensation of that specific color is experienced. The total energy subtracted (not reflected) would equal the reflected color's opposite or complement (see fig. 7.22).

Therefore, in theory, when a color (which should reflect itself and absorb all wavelengths equal to its complement) is physically mixed on the palette with its complement (which should reflect itself and absorb all wavelengths equal to its complement—the other hue), they should cancel each other out, and the mixture should successfully absorb *all* wavelengths. In theory the area should appear black—no reflected light. The

▲ **7 • 4**

Charles Csuri, *Wondrous Spring*, 1992. Computer image, 48 × 65 in. (121.9 × 165.1 cm).
In Csuri's computer-generated image, floral forms are used to explore the transparency and intensity of color as light.
Courtesy of the artist.

mixing of a color—blue—and its complement—orange (yellow and red)—involves the mixture of all three primaries. Notice that the result here is the opposite of additive color mixing, which produces white by mixing all the light primaries.

However, in actual practice on the palette, the mixture of all three primaries (a color and its complement) will not result in black but what often appears as a neutralized dark gray—hinting at some color presence but leaving the viewer uncertain and feeling it is rather "muddy." This occurs because of adulterants and imperfections in pigments, inks, and dye and the fact that the surface may not perfectly absorb all wavelengths except for those being reflected. In addition, the pigment may

reflect more than just one dominant color and/or a certain amount of white.

The theory of subtractive color, then, helps to explain how we perceive color, as an image reflects only the wavelength of the color seen, while absorbing all other wavelengths. We will see later that photographers, printers, and some artists have created a subtractive color system that uses primaries not usually known or practiced by the artist (see "The Subtractive Printing System or Process Color," p. 169). But, for the following sections when we discuss color, we will be concerned with the artist's palette of pigments and the hue made visible by subtractive color (reflected light) rather than the sensation of mixed colored light or additive color.

▲ **7 • 5**
A primary triad is shown in solid line. When the yellow, red, and blue of the primary triad are properly mixed together, the resulting color is neutralized gray. A secondary triad is connected by dotted lines. When secondary colors are also properly mixed together, the resulting color is gray. Triadic color intervals are of medium contrast.

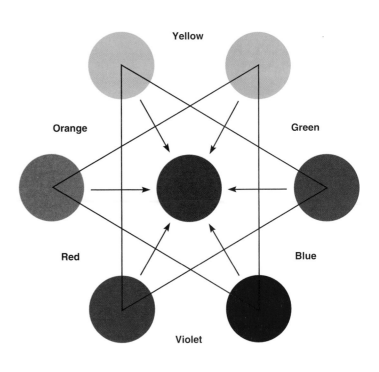

▲ **7 • 6**
Intermediate colors.
When the colors of the intermediate triads are mixed together in even proportions, the resulting color is usually a neutralized gray. Uneven mixtures produce tertiary colors, found in fig. 7.7.

ARTIST'S COLOR MIXING

As previously mentioned, the spectrum contains red, orange, yellow, green, blue, blue-violet, and violet, with hundreds of subtle color variations at their greatest intensity. This range of color is available in pigment as well. Children or beginners working with color are likely to use only a few simple, pure colors. They do not realize that simple colors can be varied. Many colors can be created by mixing two other colors.

For artists working with traditional processes, there are three colors that cannot be created from mixtures; these are the hues red, yellow, and blue, known as the ■ **primary colors** (fig. 7.5). When the three primaries are mixed in pairs, in equal or unequal amounts, they can produce all of the possible colors.

Mixing any *two* primaries in more or less equal proportions produces a ■ **secondary color:** Orange results from mixing red and yellow; green is created by mixing yellow and blue; and violet occurs when red and blue are mixed (see fig. 7.5).

■ **Intermediate colors** are mixtures of a primary color with a neighboring secondary color. Because a change of proportion in the amount of primary or secondary color used will change the resultant hue, many subtle changes are possible. For example, between yellow, yellow-green, and green, more yellow will move green toward yellow-green (fig. 7.6). If we study the theoretical progression of mixed color from yellow to yellow-green to green and so on, we discover a natural order that may be presented as a color wheel

(fig. 7.7). Our ability to differentiate subtle variation allows us to see a new color at each position. Please note that the primaries, secondaries, and intermediates are found on the outer ring with the hues at spectrum intensity.

■ **Tertiary colors** are infinite in number. They are created by mixing any two secondary colors or through the neutralization of one color by its complement. In practical terms, this involves the intermixing of all three primaries in varying proportions creating the browns, olives, maroons, and so on found on the inner rings of the color wheel. Though we have presented only two inner rings, we could have shown numerous rings as possible steps from a hue to complete neutralization in the center (fig. 7.7). This is more fully explained in the coming section on "Intensity."

The Triadic Color System

The system of ▪ **color triads** is presented in theory as a way to organize color. The color illustrations presented are created by inks and should be used as guides rather than absolutes. The actual practice of mixing pigments will reveal that each manufacturer's "red" is different and that the color of your green may depend on what you use as primaries. Lemon yellow mixed with ultramarine blue will create a different green than one that uses cadmium yellow and cobalt blue. Color mixing experiments will disclose much about opacity, staining power, and the adulterants mixed in by the manufacturers.

With the triadic color system, the three primary colors are equally spaced apart on a wheel, with yellow usually on the top because it is closest to white in value. These colors form an equilateral triangle called a primary triad (see fig. 7.5). The three secondary colors are placed between the primaries from which they are mixed; evenly spaced, they create a secondary triad composed of orange, green, and violet (see fig. 7.5). Intermediate colors placed between each primary and secondary color create equally spaced units known as intermediate triads (see fig. 7.6). The placement of all the colors results in a twelve-color wheel. The colors change as we move around the color wheel, because the wavelengths of the light rays that produce these colors change. The closer together colors appear on the color wheel, the closer are their hue relationships; the farther apart, the more contrasting they are in character. The hues directly opposite each other afford the greatest contrast and are known as ▪ **complementary colors** (see fig. 7.15).

The complement of any color is based upon the triadic system. For example, the complement of red is green—a theoretical mixture of equal parts of the remaining points of the triad, yellow, and blue. Thus, the color and its complement are made up of the three primary triadic colors; the complement of yellow is created by mixing blue and red, resulting in violet. If the color is a "mixed" secondary hue (orange, say), its complement may be found by knowing what primaries created the color (red and yellow); the remaining member of the triad (blue) will be the mixed color's complement.

Neutrals

Not all pigments contain a perceivable color. Some, like black, white, or gray, do not look like any of the hues of the spectrum. No color quality is found in these examples; they are ▪ **achromatic.** They differ merely in the quantity of light they reflect. Because we do not distinguish any one color in black, white, and gray, they are also called ▪ **neutrals.** These neutrals actually reflect varying amounts of the color wavelengths in a ray of light.

One neutral, white, can be thought of as the presence of all color, because it occurs when a surface reflects all of the color wavelengths to an equal degree.

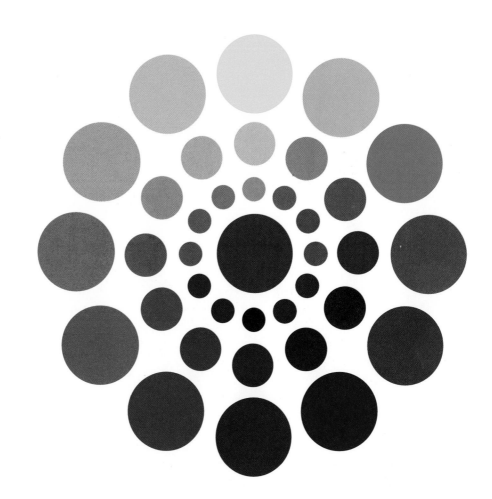

▲ **7•7**

This color wheel includes the primary, secondary, and intermediate hues, or the "standard" hues; of course, the number of possible hues is infinite. As one moves from a hue to its opposite on the color wheel, the smaller circles indicate the lessening of intensity due to the mixing of these opposites, or complementaries. The inner circles are the location of the tertiary hues—those hues result from the mixture or neutralization of one primary by its complement. This results in mixing three primaries. The features of tertiary colors are a loss of intensity and a neutralization of hue. Complete neutralization occurs in the center circle.

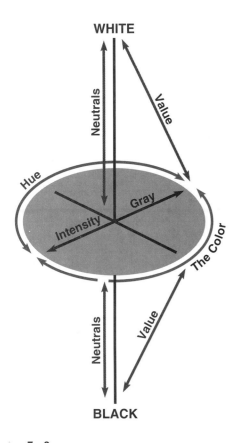

Black, then, is usually called the absence of color, because it results when a surface absorbs all of the color rays equally and reflects none of them. Absolute black is rarely experienced except in such places as deep caves, and the like. Therefore, most blacks will contain some trace of reflected color, however slight.

Any gray is an impure white, because it is created by only partial reflection of all the color waves. If the amount of light reflected is great, the gray is light; if the amount reflected is little, the gray is dark. The neutrals are indicated by the quantity of light reflected, whereas color is concerned with the quality of light reflected.

THE PHYSICAL PROPERTIES OF COLOR

Regardless of whether the artist works with ▪ **chromatic** paints, dyes, or inks, every color used must be described in terms of three physical properties: ▪ **hue,** ▪ **value,** and ▪ **intensity** (figs. 7.8 and 7.9).

Hue

Hue is the generic color name—red, blue, green, and so on—given to the visual response for each range of identifiable wavelengths in visible light (fig. 7.10; see fig. 7.1). Hue designates a color's position in the spectrum or on

▲ **7 • 8**
This diagram demonstrates the three physical properties of color. We can see all the color variations as existing on a three-dimensional solid (a double cone). As the colors move around this solid, they change in hue. When these hues move upward or downward on the solid, they change in value. As all of the colors on the outside move toward the center, they become closer to the neutral values, and there is a change in intensity (see also fig. 7.9).

▶ **7 • 9**
A three-dimensional model illustrating the three main characteristics of color (see also fig. 7.8).

Photograph courtesy of Ronald Coleman.

the color wheel. Every color actually exists in many subtle variations, although they all continue to bear the simple color names. Many reds, for example, differ in character from the theoretical red of the spectrum, yet we recognize the redness of the hue in all of them. In addition, a color's hue can be changed by adding it to another hue; this actually changes the wavelength of light. There are an unlimited number of steps (variations) that may be created by mixing any two colors—between yellow and green, for example. Yet, for the sake of clarity, artists universally recognize the hues as positioned (identified or named) on the twelve-step color wheel.

Value

A wide range of color value variations can be produced by adding black or white to a hue. This indicates that colors have characteristics other than hue. The property of color known as

■ **chromatic value** distinguishes between the lightness and darkness of colors or the quantity of light a color reflects. Many value steps can exist between the darkest and lightest appearance of any one hue. When a hue is mixed with varying amounts of white, the colors produced are known as tints. Shades are produced when a hue is mixed with black. Value changes may also

be made when we mix the pigment of one hue with the pigment of another hue that is darker or lighter; this mixing will also alter the color's hue. The only dark or light pigments available that would not also change the hue are black and white or a gray.

Each of the colors reflects a different quantity of light as well as a different wavelength. A large amount of light is reflected from yellow, whereas a small amount of light is reflected from violet. Each color at its maximum intensity has a normal value that indicates the amount of light it reflects. It can, however, be made lighter or darker than normal by adding white or black, as previously noted. We

▶ **7 • 10**

The electromagnetic spectrum.

The sun, being the most efficient source of light, sends radiation to the earth in a series of waves known as electromagnetic energy. This may be likened to throwing a pebble into the middle of a pond. Waves radiate from that point and can be measured from the crest of one ripple to the crest of the next ripple. Similarly, waves from the sun range from mere atmospheric ripples—gamma rays, which measure no more than 6 quadrillionths of an inch (.000000000000006)—to the long, rolling radio waves, which stretch $18\frac{1}{2}$ miles from crest to crest.

The wavelengths visible to the human eye are found in only a narrow range within this electromagnetic spectrum; their unit of measure is the "nanometer" (nm), which measures one billionth of a meter from crest to crest. The shortest wavelength visible to mankind measures 400 nm—a light violet. The sensations of yellow, orange, and red are apparent as the waves lengthen to between 600 and 700 nm. Contained in a ray of light but invisible to the human eye are infrareds (below reds) and ultraviolets (above violets): see figure 7.1.

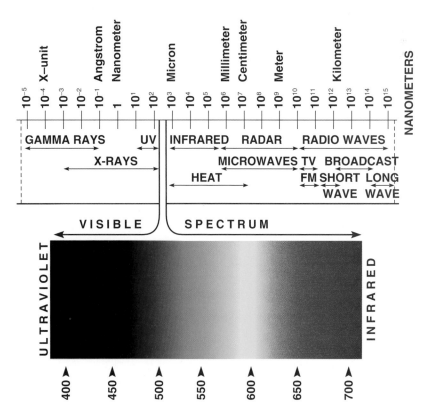

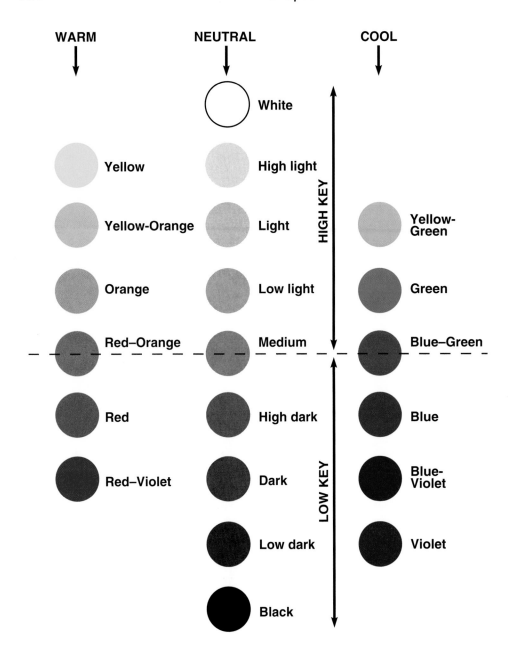

WARM　　　NEUTRAL　　　COOL

White

Yellow　　　High light

Yellow-Orange　　　Light　　　Yellow-Green

Orange　　　Low light　　　Green

Red–Orange　　　Medium　　　Blue–Green

Red　　　High dark　　　Blue

Red–Violet　　　Dark　　　Blue-Violet

Low dark　　　Violet

Black

HIGH KEY / LOW KEY

▲ 7•11
Color values.
This chart indicates the relative normal values of the hues at their maximum intensity (purity or brilliance). The broken line identifies those colors and neutrals at the middle (50 percent) gray position. All neutrals and colors above this line are high key, and any below it are low key. Warm colors are found on the yellow and red side, while cool colors are found with the greens and blues.

should know the normal value of each of the colors in order to use them effectively. This normal value can be most easily seen when the colors of the wheel are placed next to a scale of neutral values from black to white (fig. 7.11). On this scale (and in the color wheel), all colors that are above middle gray are called ▪ **high-key colors.** All colors that are below middle gray are referred to as ▪ **low-key colors.** Whether a color remains low or high key is up to the artist. As noted, a low-key violet may be lightened with white. That

adjustment may raise violet's value level until it corresponds to the value level of gray for any color along the neutral scale; violet could be made equal in value to yellow-orange by checking the gray scale. Similarly, a high-key color such as yellow may be adjusted with enough black until it has become a low-key color. Regardless of how the value level is obtained, color can be used to create a value pattern in the organization of a work. A wise artist once said, "Color gets all the glory . . . but value does all the work!" While many artists work intuitively using only color and its brillance, the most insightful also understand and employ color's value as a compositional tool.

Intensity

The third property of color, intensity (sometimes called saturation or ▪ **chroma**), refers to the quality of light in a color. Intensity distinguishes a brighter appearance from a duller one of the same hue; that is, to differentiate a color that has a high degree of saturation or strength from one that is grayed, neutralized, or less intense. The saturation point, or the purest color, is actually found in the spectrum produced by a beam of light passing through a prism. However, the artist's pigment that comes closest to resembling this color is said to be at maximum intensity. The purity of the light waves reflected from the pigment produces the variation in brightness or dullness of the color. For example, a pigment that reflects only the red rays of light is an intense red, but if any of the complementary green rays are also reflected, the red's brightness is dulled or neutralized. If the green and red rays are equally absorbed by the reflecting surface, the resulting effect is a neutral gray. Consequently, as a color loses its intensity, it tends to approach gray.

There are several ways to change the intensity of a color. To *increase* a color's intensity, an old technique involved an underpainting in the color's

complement. For example, when a red object was painted on top of a green underpainting, any green wavelengths that might have been reflected back were absorbed by the green underpainting—making the reflected red purer and more intense. Another common approach is to place one color next to its complement, which will appear to increase the color's intensity.

Other methods of change *lower* the intensity and require the mixing of pigments (fig. 7.12). This will automatically lower the intensity of the color being affected. The illustration shows the alteration of a hue (pigment) by adding a neutral (black, white, or gray). As white is added to any hue, the color becomes lighter in value, but it also loses its brightness or intensity. In the same way, when black is added to a hue, the intensity diminishes as the value darkens. We cannot change value without changing intensity, although these two properties are not the same. The illustration also shows an intensity change created by mixing the hue (pigment) with a neutral gray of the same value. The resulting mixture is a variation in intensity without a change in value. The color becomes less bright as more gray is added, but it will not become lighter or darker in value. The most efficient way to change the intensity of any hue is by adding the complementary hue. Mixing two hues that occur exactly opposite each other on the color wheel, such as red and green, blue and orange, or yellow and violet, actually results in the intermixing of all three primaries. In theory, when equal portions of the three primaries are used, a black should be created to absorb all wavelengths and not allow any colors to be reflected. However, because of impurities and an inability to absorb all the wavelengths, a neutral gray is actually produced (see "The Subtractive Printing System," p. 169). In the studio, some complements—blue to orange, for example—may give better grays than others. In addition, the gray ink in these

diagrams may appear darker and characterless compared to your experiments.

When the three primaries are used in the mixing of a new color, a tertiary color is produced and is characterized by a neutralization of intensity and hue. This occurs when complements are mixed. If the mixture has uneven proportions, the dominating hue creates the resulting color character. Though the hue's intensity has been neutralized to varying degrees relative to the amount of complement used, the resulting colors have a certain

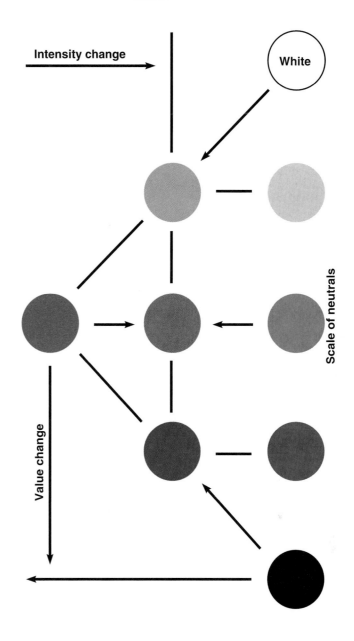

▲ **7•12**
This diagram illustrates the way neutrals may be used to change the intensity of color. As white is added to bright red, the value gets lighter, but the resulting color is lowered in intensity. In the same way, the addition of black to bright red creates a dark red closer to the neutral scale because the intensity changes. When a neutral gray is added to the spectrum color, the intensity is lowered, but the value is neither raised nor lowered.

liveliness of character not present when a hue is neutralized with a gray pigment. Hundreds of tertiary colors may be observed in a neutralization scale from one color to its complement. These show incremental steps of the change of one hue created by adding more and more of its complement until complete neutralization occurs. Tertiary colors may also be created by mixing two secondary colors (not analagous) that share a common color. For example, yellow-orange and red-violet share red as a common hue. They will have the same character and appearance as those colors created by the neutralization of a color by its complement. On the color wheel, the tertiary colors of the same degree of neutralization create inner circles and appear as the browns (neutralized oranges), olives (neutralized greens), and so on. They are characterized by a loss of intensity and a neutralization of hue. They are not to be found on the outer circle with the secondary and intermediate colors (see fig. 7.7).

This neutralization also occurs when any combination of hues are mixed that contain the three primaries. For example, yellow-orange (y+y,r) and yellow-green (y+y,b) added to red-violet (r+r,b) would actually mix four yellows with three reds and two blues—a reddish violet. Here, the resulting neutralization should have a reddish appearance.

In addition, it must be pointed out that it is difficult to change a color's intensity (by adding a little of its complement) without *also* changing its value level (fig. 7.13). A small amount of green (lighter value) was added to red (darker value), with the result being a loss of intensity and a lightening of value for the neutralized red. Conversely, when a small amount of red (darker value) was added to the green (lighter value), the green lost some of its intensity and became darker in value. This dual relationship, affecting the change of intensity and value, is perhaps more easily seen with yellow and violet. However, it occurs with every

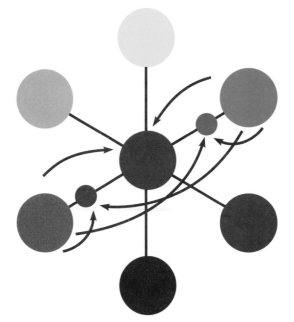

7·13
This diagram indicates change of intensity by adding to a color a little of its complement. For instance, by adding a small amount of green to red, a gray red is produced. In the same way, a small amount of red added to green results in a gray green. When the two colors are balanced (not necessarily in equal amounts), the resulting mixture is a neutral gray.

pair of complements except one—red-orange and blue-green. They are the only pair of complements that may be used to lower each other's intensity *without* changing the value level. This occurs because they begin in theory at the same value level—middle gray.

DEVELOPING AESTHETIC COLOR RELATIONSHIPS

When listening to music, we find a single note played for a long period of time rather boring. It is not until the composer begins to combine notes in chords that harmonic relationships of sound are created. All sounds work together differently; some are better than others at creating unique harmonic effects. The same is true for an artist working with color. No color is important in itself; each is always seen on the picture surface in a dynamic interaction with other colors. Combinations and arrangements of color express content or meaning. Consequently, any arrangement—

objective or nonobjective—ought to evoke sensations of pleasure or discomfort because of its well-ordered presentation (see fig. 7.40). To develop a discerning eye, study the wonderfully inexhaustible supply of exciting combinations from the extravagant color relationships of a peacock's feather to the soft muted tonality on the surface of a rock. This study should be followed by experiment and practice with these color schemes. It must be said that there are no exact rules for creating pleasing effects in color relationships, only some guiding principles.

The successful use of color depends upon an understanding of some basic color relationships. A single color by itself has a certain character, creates mood, or elicits an emotional response; but that character may be greatly changed when the color is seen with other colors in a harmonic relationship. Just as the musician can vary combined tones to form different harmonies, so too can the artist create different relationships (harmonies) among colors that may be closely allied or contrasting (fig. 7.14).

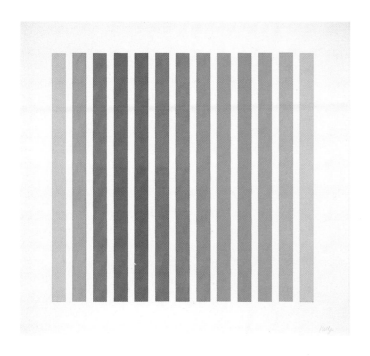

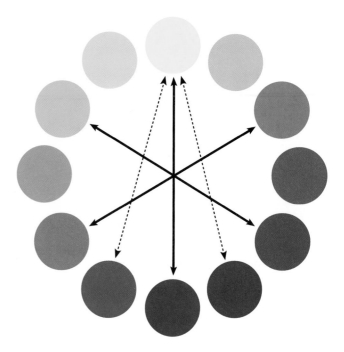

▲ 7•14

Ellsworth Kelly, *Spectrum,* 1972. Collage on paper, 45 × 48 in. (114.3 × 121.9 cm).

In this color study, Kelly has employed all the contrasting colors in the spectrum. The addition of white to each color brought them into a harmonious relationship by raising their value level and lowering their intensity.

© Ellsworth Kelly.

▲ 7•15

Complementary colors are shown connected by solid lines. They are of extreme contrast. An example of split-complementary colors (yellow, red violet, and blue-violet) is shown by dotted lines. Though yellow is used, the idea may be applied to any color and would include the color on either side of the hue's complement. Split-complements are not quite as extreme in contrast as complements.

Complements and Split-Complements

Color organizations that rely on the greatest contrast in hue occur when two colors that appear directly opposite each other on the color wheel (complementaries) are placed next to each other in the composition (fig. 7.15). When a color is seen, only that wavelength is being reflected; the wavelengths not reflected equal the color's complement. Therefore, when two complements are placed nearby, there is agitation because of the great contrast. Each color tends to increase the apparent intensity of the other color, and, when used in equal amounts, they are difficult to look at for any length of time

(see "Simultaneous Contrast," p. 162). This can be overcome by reducing the size of one of the colors or introducing changes in the intensity or value level of one or both colors.

A subtle variation with slightly less contrast would be the ▪ **split-complement** system, which incorporates a color and the two colors on either side of its complement (fig. 7.15). This color scheme provides more variety than the straight complementary system, because the color is opposed by two colors closely related to the color's complement. Even greater variety or interest may be achieved by using an intensity change or selecting variations from the complete value range of any or all of the colors in this color scheme.

Triads

A triadic color organization is based on an even shorter interval between colors, giving less contrast between the colors. Here, three equally spaced colors form an equilateral triangle on the color wheel; triads are used in many combinations. A primary triad, using only primary colors, creates striking contrasts (see fig. 7.5). With the secondary triad, composed of orange, green, and violet, the interval between hues is the same, but the contrast is softer. This effect probably occurs because any two hues of the triad share a common color: Orange and green both contain yellow; orange and violet both contain red; and green and violet both

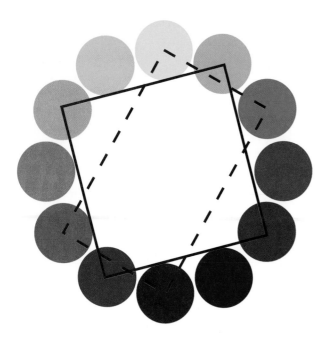

▲ **7 • 16**
Color tetrad intervals (squares and rectangles).
The color tetrad is composed of four colors equally spaced to form
a square. A more casual relationship would have a rectangle formed
out of two complements and their split complements. The rectangle
or square may be rotated to any position on the color wheel to
reveal other tetrad color intervals.

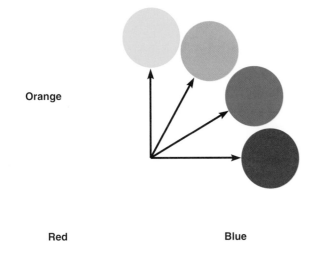

Orange

Red Blue

Violet

▲ **7 • 17**
Analogous colors (close relationships).

contain blue. Intermediate color schemes
may be organized into two intermediate
triads (see fig. 7.6). Here, too, as we move
further away from the purity of the
primaries, the contrast among the two
triads is softer.

Tetrads

Another color relationship is based on a
square rather than an equilateral triangle.
Known as a ▆ **color tetrad,** this system
is formed when four colors are used in
the organization. They are equally spaced
around the color wheel and contain a
primary, its complement, and a
complementary pair of intermediates
(fig. 7.16). A tetrad has also come to
mean, in a less strict sense, any
organization of color forming a
"rectangular structure" that could
include a double split-complement. This
system of color harmony is potentially
more varied than the triad because of the
additional colors present. Try to avoid the
temptation of using all the colors in
equal volumes, and the increased variety
will be even more interesting.

Analogous and Monochromatic Colors

▆ **Analogous colors** are those that
appear next to each other on the color
wheel. They have the shortest interval and
therefore the most harmonious
relationship. This is because three or four
neighboring hues always contain one
common color that dominates the group
(fig. 7.17). Analogous colors are not only
found at the spectrum intensity levels
(outer ring of the color wheel) but may
also include colors made by neutralization
(intensity changes) and value changes of
any of these related hues (fig. 7.18). On
the other hand, ▆ **monochromatic
color** schemes use only one hue but
explore the complete range of tints (value
levels of hue to white) and shades (value
levels to black) for that color (see fig.
7.35). Even with thousands of variations

of tints and shades of one color, this scheme is potentially the most monotonous. However, monochromatic studies are encouraged as a test of the artist's understanding of the value range of that hue.

Warm and Cool Colors

Color "temperature" may be considered as another way to organize color schemes. All of the colors can be classified into one of two groups: "warm" colors or "cool" colors. Red, orange, and yellow are associated with the sun or fire and thus are considered warm. Any colors containing blue, such as green, violet, or blue-green, are associated with air, sky, earth, and water; these are called cool. This quality of warmth or coolness in a color may be affected or even changed by the hues around or near it. For example, the coolness of blue, like its intensity, may be heightened by locating it near a touch of its complement, orange.

Plastic Colors

Colors may also be organized according to their ability to create compositional depth. Artists are able to create the illusion of an object's volume or flatten an area using color as an aid. This ability to model a shape comes from the advancing and receding characteristics of certain colors. For example, a spot of red on a gray surface seems to be in front of that surface; a spot of blue, similarly placed, seems to sink back into the surface. In general, warm colors advance, and cool colors recede (fig. 7.19). The character of such effects, however, can be altered by differences in the value and/or intensity of the color.

These spatial characteristics of color were fully developed by the French artist Paul Cézanne in the latter part of the nineteenth century. He admired the sparkling brilliancy of the Impressionist artists of the period but thought their

7•18
Lia Cook, *Point of Touch: Bathsheba,* 1995. Linen, rayon, oil paint and dyes, 46 × 61 in. (116.84 × 154.94 cm).
Lia Cook employs analogous colors, containing a common hue, to develop the illusion of hands holding folds of fabric on a pattern of changing hand images.
Collection of Oakland Museum of California. © Lia Cook.

7•19
Emily Mason, *Upon a Jib,* 1989. Oil on canvas, 54 × 52 in. (137.2 × 132.1 cm).
Like a sail filling with air, the large red and yellow shapes of this painting billow toward the viewer while the blues and greens seem to poke holes in the surface or recede.
Courtesy of the artist and M. B. Modern Gallery, New York.

7 • 20
Paul Cézanne, *Still Life with Apples*, 1875–77. Oil on canvas, 7½ × 10¾ in. (19 × 27.3 cm).
Cézanne used brushstrokes and change of color as a means of modeling form. Rather than merely indicating an adjustment in value, warm colors made the shapes come forward while cool colors forced outer edges to recede.

By kind permission of the Provost and Fellows of King's College, Cambridge, England (Keynes Collection).

work had lost the solidity of earlier painting. Consequently, he began to experiment with expressing the bulk and weight of forms by modeling with color. Previous to Cézanne's experiments, the traditional ▪ **academic** artist had modeled form by changing values in monotone (one color). The artist then tinted these tones with a thin, dry local color that was characteristic of the object being painted. Cézanne discovered that a change of color on a form could serve the purpose of a change of value and not lose the effectiveness of the expression. He modeled the form by placing warm color on the part of the subject that was to advance and adding cool color where the surface receded (fig. 7.20). Cézanne felt that this rich color and its textural application expressed the actual structure of a solid object. Later, modern artists realized that Cézanne's advancing and receding colors could also create those backward and forward movements in space that give liveliness and interest to the picture surface (see fig. 7.33). However, this is only a tool, and there is no single correct way to employ it.

Paul Gauguin, for example, often applied the same principles to *reverse* or flatten the spatial qualities in a pictorial organization. By placing cool colors in the foreground that would normally seem to advance, he made it appear to recede. He painted the background that would recede in warm colors, causing it to advance. This combination flattened the pictorial space, making it more decorative than plastic (fig. 7.21). Many abstract artists have used the relationships of balance and movement in space to give content to a painting, although no actual objects are represented (see fig. 10.76). Line, value, shape, and texture are greatly aided by the ability of color to create space and meaning.

Simultaneous Contrast

While trying to match colors, an artist may mix a color on a palette only to find that it appears entirely different when juxtaposed with other colors on the canvas. Why does a red-violet appear to change color when placed beside a violet? During the early part of the

nineteenth century, a French chemist, M. E. Chevreul, wanted to discover why the Gobelins tapestry works was having trouble with complaints about the color stability of certain blues, browns, light violets, and blacks. As Director of Tints and Dyes, Chevreul discovered that the problem was not a question of the dyestuffs but rather a phenomenon of color contrast. The color stability of these colors depended upon which color they were placed beside. These discoveries were the starting point for the *Law of Simultaneous Contrast of Colors,* published in 1839. With this publication, he became the "technical prophet" of two schools of painting that followed— Impressionism and Post-Impressionism. Both groups of painters often juxtaposed complements that increased the intensity of each through simultaneous contrast. Another early student of these principles, Eugène Delacroix, once said, "Give me mud and I will make the skin of a Venus out of it, if you will allow me to surround it as I please."

The effect of one color upon another is explained by the rule of

▲ 7 • 21

Paul Gauguin, *The Siesta*, c. 1891–92. Oil on canvas, 34¼ × 45⅝ in. (87 × 115.9 cm).
Gauguin has used the nature of plastic color to reverse the spatial effect and make it shallow. Cool blues, blue-violets, and neutralized reds, surrounded by dark greens, push the foreground back, while warm yellows and yellow-greens pull the background forward, flattening the pictorial space.
The Metropolitan Museum of Art, the Walter H. and Leonore Annenberg Collection. Partial gift of Walter H. and Leonore Annenberg, 1993 (1992.400.3). Photograph © 1994 The Metropolitan Museum of Art.

■ **simultaneous contrast.** According to this rule, whenever two different colors come into direct contact, their similarities seem to decrease, and the dissimilarities seem to be increased. In short, this contrast intensifies the difference between colors. This effect is most extreme, of course, when the colors are directly contrasting in hue, but it occurs even if the colors have some degree of relationship. For example, a yellow-green surrounded by green appears more yellow, but if surrounded by yellow it seems more strongly green. The contrast can be in the characteristics of intensity and value as well as in hue. A grayed blue looks brighter if placed against a gray background and will tend to make the gray take on an orange cast; it looks grayer or more neutralized against a bright blue background. The most striking effect occurs when complementary hues are juxtaposed: Blue is brightest when seen next to orange, and green is brightest when seen next to red. When a warm color is seen in simultaneous contrast with a cool color, the warm hue appears warmer and the cool color cooler. A color always tends to bring out its complement in a neighboring color. ● If a green rug is placed against a white wall, the eye may make the white take on a very light red

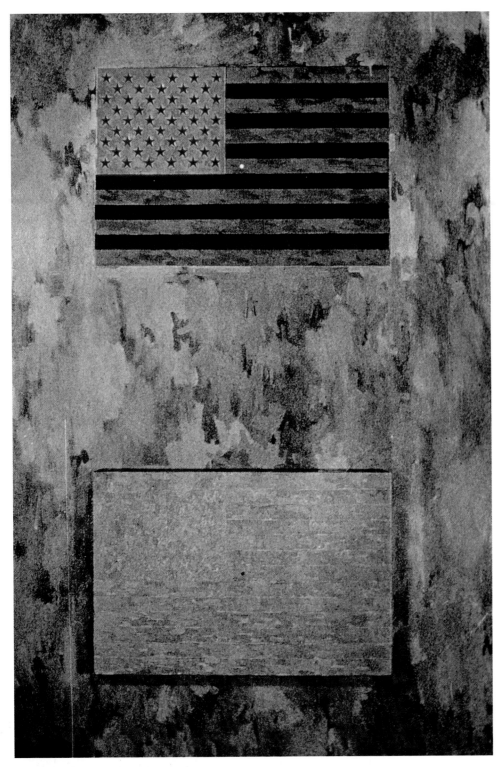

▲ 7•22
Jasper Johns, *Flags,* 1965. Oil on canvas with raised canvas, 6 × 4 ft (1.83 × 1.22 m).
With this painting, Johns wanted the viewer to experience an afterimage. This occurs when the retina's receptors are overstimulated and are unable to accept additional signals. They then project the wavelengths of the complementary color. Stare at the white dot on the upper flag for forty seconds. Shift focus to the dark dot on the lower flag, and an afterimage will be seen in red, white, and blue.

© 1998 Jasper Johns/Licensed by VAGA, New York.

or warm cast. A touch of green in the white may be necessary to counteract this. When a neutralized gray made up of two complementary colors is placed next to a strong intense color, it tends to take on a hue that is opposite to the intense color. When a person wears a certain color of clothing, the complementary color in that person's complexion is emphasized.

Some of these conditions of imposed "color" may be explained by the theory that the eye (and mind) seeks a state of balanced involvement with the three primaries. More than a psychological factor, this seems to be a physiological function of the eyes' receptors and their ability to receive the three light primaries—some combination of all three are involved in most mixed colors. And, as our eyes flash unceasingly about our field of vision, all the primaries and all receptors are repeatedly activated. The mind seems to function with less stress when all three receptor systems are involved concurrently. Within the area of vision, any combination of primaries may cause this without necessarily having to be of equal proportions.

However, if one or more primaries are missing, the eye seems to try to replace the missing color or colors because of receptor fatigue. If we stare at a spot of intense red for several seconds and then shift our eyes to a white area, we see an afterimage of the same spot in green, its complement. The phenomenon can be noted with any pair of complementary colors (fig. 7.22). Though we seem to desire the three primaries visually, our optic function may be overstimulated (or less "peaceful") under certain conditions. Large volumes of clashing full-intensity complements can make us uneasy. Museum guards at an Op Art show were said to have asked for reassignment, complaining of visual problems ranging from headaches to blurred focus. In figure 7.23 Richard

Anuszkiewicz refers in the title *Injured by Green* to the unsettling optical fatigue and pulsating colors created by simultaneous contrast.

The condition of balanced stimulation of the color receptors is much easier to experience when the three primaries are physically mixed together. The colors produced are less saturated or intense and seem easier to experience physically. This would explain why tertiary colors, neutralized—sometimes nearly to the loss of hue—are often thought of as being more universally appealing or relaxing. Hues such as blues and greens seem to be easier on the eye and mind when lightened with white; white would add more wavelengths to the reflected light and thus stimulate additional combinations of receptors. Hues that have been muted, neutralized, or lightened in value will appear to recede compared to their most saturated or intense states. Intense blue walls will not make a room appear as large as a very light tint of the same blue.

In practice, it is recommended that the student try experiments that would apply the principles of simultaneous contrast. See if the same color placed in the center of two related colors can be made to appear as two different hues, however subtle or different. Further, explore making two subtle variations in color appear to be the same by changing their surrounding colors. Investigate the eye's battle to focus or find edges when adjoining shapes or areas are closely related in value level or intensity and become difficult to see. Black lines will give greater clarity to the image but may also tend to flatten the areas. This may also work for "pulsating" edges that occur when the eye has the greatest struggle for edge definition—when complements are placed together. Greater contrast in value or intensity levels will also help with the visual problem of edge resolution or separation of image.

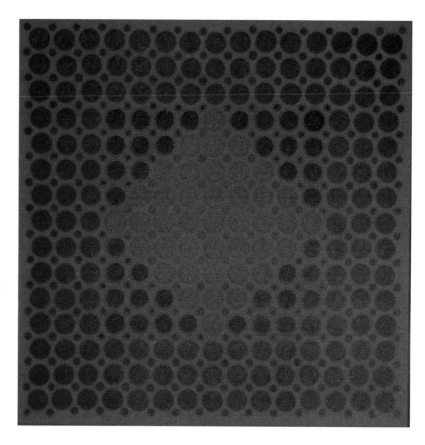

▲ **7 • 23**

Richard Anuszkiewicz, *Injured by Green,* 1963. Acrylic on masonite, 36 × 36 in. (91.4 × 91.4 cm).

This use of simultaneous contrast, using a consistent pattern of two dot sizes, builds intensity toward the center by the juxtaposition of red's complement. The central green becomes a diamond shape.

Collection of the Noyes Museum of Art, Oceanville, New Jersey.

All these changes in appearance make us realize that no one color should be used for its character alone, but each must be considered in relation to the other colors present. For this reason, many feel it is easier to develop a color composition all at once rather than try to finish one area completely before going on to another.

Color and Emotion

Color may also be organized or employed according to its ability to create mood, symbolize ideas, and express personal emotions. Color, as found upon the canvas, can express a mood or feeling in its own right, even though it may not be descriptive of the objects represented. Reds are often thought of as being cheerful and exciting, whereas blue can impart a state of dignity, sadness, or serenity. Also, different values and intensities of the hues in a color range may affect their emotional impact. A wide value range (strongly contrasting light or dark hues) can give vitality and directness to a color scheme; closely related values and low intensities help create the feeling of subtlety, calmness, and repose (figs. 7.24 and 7.25).

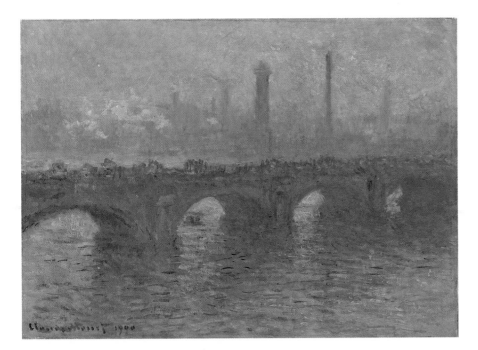

◀ **7 • 24**

Claude Monet, *Waterloo Bridge, Grey Weather,* 1900. Oil on canvas, 65.4 × 92.4 cm.

The Impressionist Monet painted almost 100 views of the Waterloo Bridge during three trips to London. Painting the view from his room in the Savoy Hotel, he studied the characteristics of light at different times of the day and in differing weather conditions. As a result, the hues, values, and intensities are markedly affected, as can be seen by comparing this painting with figure 7.25.

Gift of Mrs. Mortimer B. Harris, 1984.1173. The Art Institute of Chicago. All rights reserved.

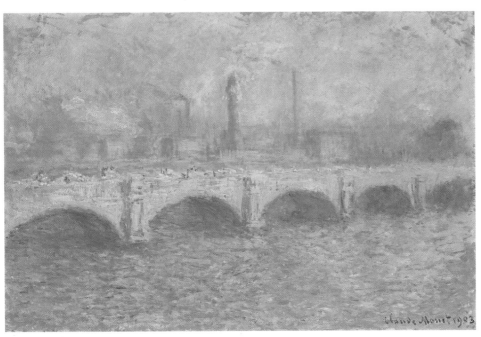

◀ **7 • 25**

Claude Monet, *Waterloo Bridge, Sunlight Effect,* 1903. Oil on canvas, 65.7 × 101 cm.

In giving the impression of a passing moment, the artist has deliberately sacrificed detailed architectural information for the effect of sunlight, color, and atmosphere playing on that form. This also applies to figure 7.24.

Mr. and Mrs. Martin A. Ryerson Collection 1993.1163. The Art Institute of Chicago. All rights reserved.

Some emotions evoked by color are personal and reinforced by everyday experiences. For example, some yellows are acidic and bitter, almost forcing a pucker, like a sour lemon. Other colors carry with them associations given by the culture. Our speech is full of phrases that associate abstract qualities like virtue, loyalty, and evil with color: "true blue," "dirty yellow coward," "red with rage,"

"seeing red," "virgin white," "pea-green with envy," and "gray gloom." In some cases, these feelings seem to be more universal because they are based on shared experiences. Every culture understands the danger of fire (reds) and the great vastness, mystery, and consistency of the heavens and the seas (blues). Blues can be used to imply reliability, fidelity, loyalty, and honesty,

while reds also suggest danger, bravery, sin, passion, or violent death. However, not all color has the same application in each culture. On many pre-Columbian artifacts, priest-kings are shown in self-bloodletting rituals, and victims are sacrificed to the sun, with red symbolizing renewal and rebirth by allowing the life of the sun to continue. For many Western cultures, green rather

than red is the sign of regeneration, hope, and life. Many color associations can be traced back historically. For example, purple has signified royalty from the early Roman civilization. Because of the rarity and expense of purple dye, only the Roman emperor could afford to wear it. However, even when dye became more affordable, the tradition (and the significance) remained. In China, ancient potters created the technology of glazing ware with very unusual glazes. Among the glazes was a very deep copper red that was so beautiful that the very best ware in every kilnload was immediately carried away to the emperor himself.

Psychological Application of Color

Research has shown that light, bright colors make us feel joyful and uplifted; warm colors are generally stimulating; cool colors are calming; while cool, dark, or somber colors are generally depressing. Medical facilities, trauma centers, and state correctional facilities are often painted in light blues or "institutional greens" because of the calming effect. Winter skiing lodges are adorned in warm yellows, knotty pine, oranges, and browns to welcome those coming in from subzero temperatures. Stories abound of the use of motivating color and sports programs. One visiting team was furious and refused to use the assigned locker room because the "powder-puff pink" walls implied they were "sissies." In another incident, the home team's locker room was painted bright red to keep them keyed up and on edge during halftime, while light blue surroundings encouraged the opponent to let down and relax. It has been shown in some work situations that bright intense colors encourage worker productivity while neutralized or lighter hues slow down the workforce.

We are continually exposed to the application of color's emotive power. In a supermarket, the meat section is sparkling white to assure us and evoke feelings of cleanliness or purity. To encourage us to purchase the product, the best steaks are garnished lavishly with parsley or green plastic trim to make them appear redder and more irresistible. Bright yellow and orange cereal boxes use contrasting lettering (often complementary) to scream for our attention. Extremely small spaces are rarely painted dark or bright warm colors that would make them feel even smaller. Instead, the space is made to appear larger by light cool colors.

With artists, an angry exchange, a love letter, a near miss in traffic may all subconsciously influence a choice of color. The power of color to symbolize ideas becomes a tool. It enriches the metaphor and makes the work stronger in content and meaning. Many artists have evolved a personal color style that comes primarily from their feelings about the subject rather than being purely descriptive. John Marin's color is essentially suggestive in character with little expression of form or solidity (see fig. 8.43). It is frequently delicate and light in tone, in keeping with the medium in which he works (watercolor). The color in the paintings of Vincent van Gogh is usually vivid, hot, intense, and applied in snakelike ribbons of pigment (see fig. 1.16). His use of texture and color expresses the intensely personal style of his work. In the work of Leon Golub, color becomes a personal symbol. It is anything but delicate and saccharin. Golub's color sets a dark and gloomy mood and helps to express his feeling of the inevitability of pain, aging, indignity, and death (fig. 7.26). The emotional approach to color appealed particularly to the Expressionistic painters, who used it to create an entirely subjective treatment having nothing to do with objective reality (see fig. 10.31). Contemporary artists like Wolf Kahn continue to interpret their environment in terms of personal color selection

▲ 7 • 26

Leon Golub, *Prometheus II,* 1998. Acrylic on linen, 119 × 97 in. (302.3 × 246.4 cm). Leon Golub often deals with psychological color, expressing personal issues through metaphors. A bloody red announces the daily vulture attack, while deep gloomy colors remind us of death and pain. Prometheus, a Titan, was chained to a rock by the Greek god Zeus for stealing fire from Mount Olympus. Courtesy of Ronald Feldman Fine Arts, New York.

(fig. 7.27). We cannot escape the emotional effects of color because it appeals directly to our senses and is a psychological and physiological function of sight itself.

THE EVOLUTION OF THE COLOR WHEEL

In this book, the circular arrangement of the color wheel is based on a subtractive system of artist-pigmented colors using red, yellow, and blue as primaries. This triadic primary system has evolved over many centuries.

▲ 7・27
Wolf Kahn, *Country Road Lined with Maples,* 1995. Oil on canvas, 52 × 66 in. (132 × 167.6 cm).
Wolf Kahn is one contemporary painter who uses his subject—landscape—as a way to express a personal joy found in color. The vibrant, even risky use of color structure is a hallmark of his later work, making it instantly recognizable.
Courtesy of the Beadleston Gallery.

The Origins of Color Systems

Sir Isaac Newton first discovered the true nature of color around 1660. Having separated color into the spectrum—red on top and violet on the bottom—he was the first to conceive of it as a color wheel. Ingeniously, he twisted what was a straight-line spectrum, joined the ends, and inserted purple, a color leaning to red-violet and not found in the spectrum. This red-violet he saw as a transition between violet and red. Newton's wheel contained seven colors, which he related to the seven known planets and the seven notes of the diatonic scale in music (the standard major scale without chromatic half-steps)—red corresponding to note C, orange to D, yellow to E, green to F, blue to G, indigo to A, and violet to B.

The Discovery of Pigment Primaries

Around 1731, J. C. Le Blon discovered the primary characteristic of the pigments of red, yellow, and blue and their ability to create orange, green, and violet. To this day, his discovery remains the basis of much pigment color theory.

The First Triadic Color Wheel

The first wheel in full color and based on the three primary system was published around 1766. It appeared in a book entitled *The Natural System of Colours* by Morris Harris, an English engraver. In the first decade of the nineteenth century, Johann Wolfgang von Goethe began placing the colors, with their triangular arrangements, around a circle. In addition,

Philipp Otto Runge created the first color solid (a three-dimensional color organization) by exploring tints, tones, and shades of color.

American Educators

In the United States, many educators advanced the red, yellow, and blue primary color wheels. Most noted among them was Louis Prang, who published *The Theory of Color* in 1876. Modern-day scholars like Johanness Itten, Faber Birren, and Joseph Albers have done much to explore the relationship between color and expression. Their research has also clarified the historical development of the triadic color system and how colors interact, each affecting the perception of the other. 🌐

The Ostwald Color System

A distinguished German chemist and physicist, Wilhelm Ostwald, developed a color system around 1916 related to psychological harmony and order. Because the system was created from pigment hues technically available at the time, it uses red, yellow, sea green, and blue, with the secondaries orange, purple, turquoise, and leaf green. The colors were placed in a circle and expanded by mixing neighboring colors into a 24-hue system—capable of further expansion. Complements were placed opposite each other—blue opposite yellow, for example. Strict rules for standardizing colors for industrial application were used. A three-dimensional model placed each color on the apex of a triangle and black and white on the other two points. The color harmonies were based upon mathematical relationships that doubled the tonal color change at each step from white to black, providing an even progression in the steps. This system concentrated on value changes, with intensity being controlled by and limited to the initial point of the triangle. The

▶ **7 • 28**

Munsell color tree, 1972. Clear plastic chart $10\frac{1}{2} \times 12$ in. (26.7 × 30.5 cm); base size 12 in. (30.5 cm) diameter; center pole size $12\frac{5}{8}$ in. (32.1 cm) high; chip size $\frac{3}{4} \times 1\frac{3}{8}$ in (1.9 × 3.5 cm).
The Munsell system in three dimensions. The greatest intensity of each hue is found in the color vane farthest from the center trunk. The value of each vane changes as it moves up and down the tree. The center trunk changes only from light to dark. The colors change in hue as they move around the tree.
Courtesy of Macbeth, New Windsor, NY.

system was never fully adopted for industrial application.

The Munsell Color System

Around 1936, the American artist Albert Munsell formulated a system to show the relationships between different color tints and shades based on hue, value, and intensity. This system was an attempt to give names to the many varieties of hues that result from mixing different colors with each other or with the neutrals. American industry adopted the Munsell system in 1943 as its material standard for naming different colors. The system was also adopted by the United States Bureau of Standards in Washington, D.C.

In the Munsell system, the five basic hues are red, yellow, green, blue, and purple (violet). The mixture of any two of these colors that are adjacent on the color wheel is called an intermediate color. For example, the mixture of red and yellow is intermediate color yellow-red. The other intermediate hues are green-yellow, blue-green, purple-blue, and red-purple.

To clarify color relationships, Munsell devised a three-dimensional color system

that classifies the different shades or variations of colors according to the qualities of hue, value, and intensity (or chroma). His system is in the form of a tree. The many different color tones are adhered to transparent plastic vanes that extend from a central trunk like tree branches. The column nearest the center trunk shows a scale of neutral tones that begin with black at the bottom and rise through grays to white at the top. The color tone at the outer limit of each branch represents the most intense hue possible at each level of value (fig. 7.28).

The most important part of the Munsell color system is the color notation, which describes a color in terms of a letter and numeral formula. The hue is indicated by the notation found on the inner circle of the color wheel. The value of the colors is indicated by the numbers on the central trunk shown in figure 7.29. The intensity, or chroma, is shown by the numbers on the vanes that radiate from the trunk. These value and intensity relationships are expressed by fractions, with the number on top representing the value and the number beneath indicating the

intensity (chroma). For example, 5Y8–12 is the notation for a bright yellow.

It is interesting to compare the Munsell color wheel with the one used in this book (fig. 7.29; see fig. 7.7). Munsell places blue opposite yellow-red and red opposite blue-green, while we place blue opposite orange and red opposite green.

The Subtractive Printing System (Process Color System)

We have already discussed how we experience color by reflected light. A colored object reflects only the wavelengths of that color while absorbing all others (see "Subtractive Color," p. 151). By taking the reflected wavelengths and passing them through specific camera filters, photographers and printers have learned how to isolate individual wavelengths and photograph them. They found that when light passed through a sheet of clear glass, all the color wavelengths passed through. When a red-colored glass was used, only the wavelengths of red were allowed to pass through, all others being absorbed; the

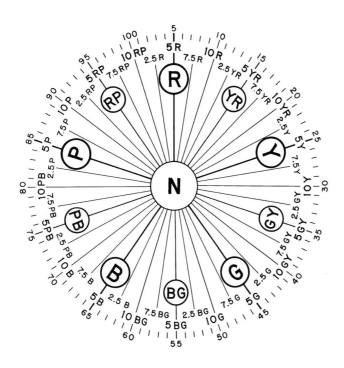

▲ **7 • 29**

Munsell color wheel.

This diagram shows the relationships of the hues on the wheel in terms of a specific type of notation (as explained in the text).

Courtesy of Macbeth, New Windsor, NY.

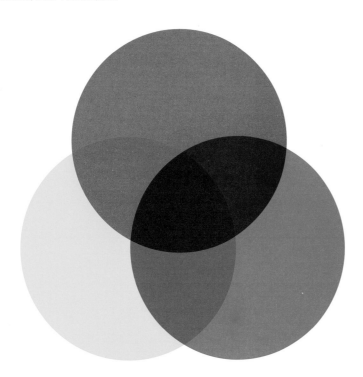

▲ **7 • 30**

The primary colors of the subtractive color system include yellow, cyan, and magenta. Where they are mixed they produce red, blue (a color named by industry and scientists that is actually closer to violet), and green. When all three are combined, they produce black. Notice that the subtractive color primaries are the additive secondary colors and that the subtractive secondary colors are the additive primary colors.

blocked wavelengths equaled red's opposite or the additive light complement of red, which was cyan. Thus, a red glass camera filter blocked all exposure on black-and-white film except for the shades of red that were recorded as gray to black shapes on the negative. The wavelengths removed by the filter (equaling red's complement cyan) were also recorded as transparent areas on the negative. When a photosensitive printing plate was exposed through the negative film, the transparent areas allowed exposure of the plate, making it printable—revealing the levels of cyan. Where the negative was opaque black (from recording the red wavelengths), the unexposed printing plate remained white and unprintable.

When this process was completed using a green filter, a printing plate for the value levels of magenta was created. Similarly, photographing through a filter named "blue"—actually on the violet side—produced a plate printing in the value ranges of yellow.

Using these techniques to produce printing plates, printers and photographers have created a special color organization with the primary colors of magenta, yellow, and cyan (fig. 7.30). Notice that these primaries are the secondary colors in the additive (light) system (see fig. 7.3), and they aren't the primary colors of red, yellow, and blue familiar to the studio artist. In this system, red is a mixed color! Artists who work with dyes, color printing for photography, transparent inks, and the printing industry will need to become familiar with the subtractive primaries of magenta, yellow, and cyan.

The printing industry has applied these subtractive primaries to the four-color printing process and has made great advances in color reproduction. Several existing techniques came together to make this process possible:

1. Monochrome photography provided images in black, white, and a full value range of unbroken grays.

2. Halftoning was invented, which allowed all the shades of gray to be printed by one shade of ink—black on white paper. This was done by translating all the grays into a network of tiny black-and-white dots of differing sizes for different values.

3. It was discovered that photographing a colored image through various colored filters and adding halftoning could create a printing plate with the proper range of value for each of the primaries—magenta, yellow, and cyan (fig. 7.31 A, B, and C).

When the printing plates for cyan, magenta, and yellow are printed together, all the colors and value ranges possible are created. Where the magenta and yellow overlap, red (a pigment primary for the artist's palette) is created as a secondary color. Where the magenta is decreased and the yellow increased, the color swings more toward orange—and so on, depending on the adjustment of the two colors. Similarly, the other subtractive color mixing secondary colors are created by overprinting the remaining primaries: Cyan plus magenta produces blue, and cyan plus yellow produces green. Overprinting cyan, magenta, and yellow creates something close to black, but that is usually heightened by printing the fourth plate in black to add definition (fig. 7.31 D, E, and F).

Color Photography

Color photographers also use magenta, cyan, and yellow. Instead of artists' pigment, they often develop color using dyes and gelatin emulsions. Colored film contains three layers of emulsion that respond to blue, red, and green light. When exposed to the image, a multilayered negative results. Light-sensitive silver halide compounds are converted to metallic compounds by the developer. In the process, they oxidize and combine with "coupler" compounds to produce dyes. Each layer forms one of the three dyes that are the subtractive

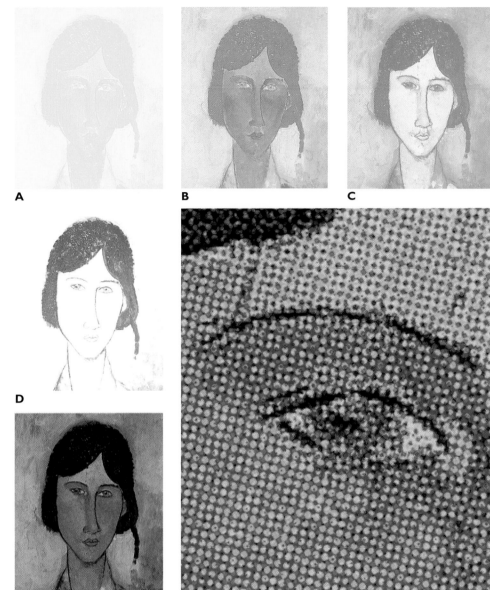

7•31

These illustrations show the yellow (A), magenta (B), cyan (C), and black (D) printing plates used in the four-color printing process. When printed together, they produce the full color image (E), a detail of Modigliani's *Gypsy Woman with Baby*. An enlargement shows the dots printed from each plate and the colors created where the yellow, magenta, cyan, and black inks overlap (F).

© National Gallery of Art, Washington/SuperStock.

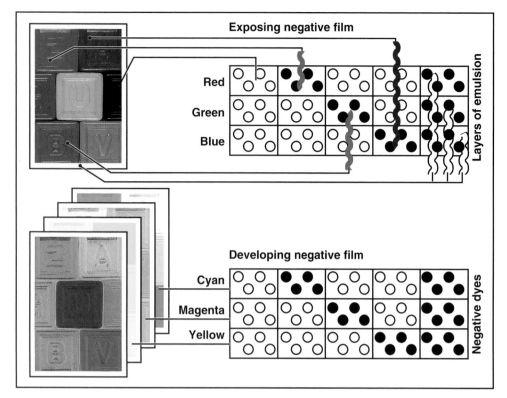

Exposing negative film

Red

Green

Blue

Layers of emulsion

Developing negative film

Cyan

Magenta

Yellow

Negative dyes

▲ **7•32**

When color negative film is exposed, the blue-, green-, and red-sensitive layers of emulsion (color spots) record latent images (gray dots) that can be developed into black-and-white negatives. Colors that are mixtures of the primaries are recorded on several layers. Blacks do not expose any of the emulsion, while white light is recorded in all layers. Each color thus leaves a corresponding negative black-and-white impression.

When exposed color negative film is developed, a black-and-white negative image is produced in each emulsion layer (black dots). During this development, a colored dye is combined with each black-and-white negative image. The dyes are cyan, magenta, and yellow. Once the silver is bleached out, the three layers (colored dots) show the subject in superimposed negative dye images.

Photograph by Bob Coyle/© McGraw-Hill Higher Education.

primaries—yellow, magenta, and cyan. A yellow image is formed on the blue-sensitive layer; a magenta image forms on the green-sensitive layer; and a cyan image is created in the red-sensitive layer. Next, the silver is bleached out of each layer, leaving only the appropriate colored dye on the correct layer. Color negatives, positive color transparencies (slides), and color printers all involve this same basic process (fig. 7.32).

Color Computer Printing

Electronic imagery, either drawn by hand, imported by scanning, or created by digital camera, requires a computer printer to produce a paper image. Most printers employ a CYMK ink system, which is an acronym for cyan, yellow, magenta (the subtractive color mixing system primaries in ink form), and black. "K" is used to denote black to avoid the confusion of black with blue. Because the computer images are created on the color monitor, each of these colors is in turn printed on paper simulating the illumination of the pixels on the monitor. The eight basic colors are produced by printing the primaries either alone or in various combinations: "black" (requiring all the primaries), red, green, blue, cyan, magenta, and yellow. "White" is a result of the color of the paper stock being used. Cyan and magenta produce "blue" (a color closer to violet); yellow and cyan produce green; and magenta and yellow produce red.

Printers now have the capacity of printing colored detail so fine that it is difficult to see without magnification. This is determined by the size of the dot pattern. Color printers are capable of more than 300 dots per inch. Hundreds of dots of varied colors can be printed in a small area. The closeness of the dots of color, the variety of colors printed, and their concentration in an area produce virtually any color and/or value the artist desires.

Many color printers now have programs that allow the artist to greatly alter the mood and appearance of the finished image. Increasing the percentage of any of the primaries or their value levels may dramatically change the intensity, mood, and spirit of the presentation. Though created using additive light, the color printer can become an interesting tool for color manipulation. The final image is printed using the subtractive printing system primaries of cyan, yellow, and magenta, followed by black.

(See the CD-ROM for illustrations using standard relationships of CYMK inks and illustrations of how the images have been affected by changing the percentages of CYMK.) ◉

The Discovery of Light Primaries

Paralleling early developments with pigment was the discovery around 1790 of the red, green, and blue light primaries. These concepts were explored by scientists Hermann von Helmholtz of Germany and James Clerk Maxwell of Great Britain. Some additive-light primary systems have been represented as circles, but they should not be confused with color systems designed for artists' pigment. Space does not permit discussion of all the color systems that have evolved.

THE ROLE OF COLOR IN COMPOSITION

The function of describing superficial appearances was considered most important when painting was seen as a purely illustrative art. For a long period in the history of Western art, color was looked upon as something that came from the object being represented. In painting, color that is used to indicate the natural appearance of an object is known as ■ **local color** (fig. 7.33). A more

▲ **7 • 33**

Frida Kahlo, *Still Life with Parrot*, 1951. Oil on masonite, 9½ × 10¼ in. (24.1 × 26 cm).

This still life is painted in local color—color that simulates the hues of the objects in nature.

Art Collection, Harry Ransom Humanities Research Center, University of Texas at Austin. Reproduction authorized by National Institute of Fine Art and Literature of Mexico.

expressive quality is likely to be achieved when the artist is willing to disassociate the color surfaces in the painting from the object to which the color conventionally belongs. An entirely ■ **subjective color** treatment can be substituted for local color. The colors used and their relationships are invented by the artist for purposes other than mere representation (fig. 7.34). This style of treatment may even deny color as an

objective reality; that is, we may have purple cows, green faces, or red trees. Most of the functions of color are subjectively applied, making an understanding of their use very important to the understanding of contemporary art.

Regardless of which system is used, color serves several purposes in artistic composition. These purposes, however, are not always separate and distinct but instead frequently overlap and interrelate.

We have seen that color can be used in the following ways:

1. To give spatial quality to the pictorial field.
 a. Color can supplement, or even substitute for, value differences to give plastic quality.
 b. Color can create interest through the counterbalance of backward and forward movement in pictorial space.

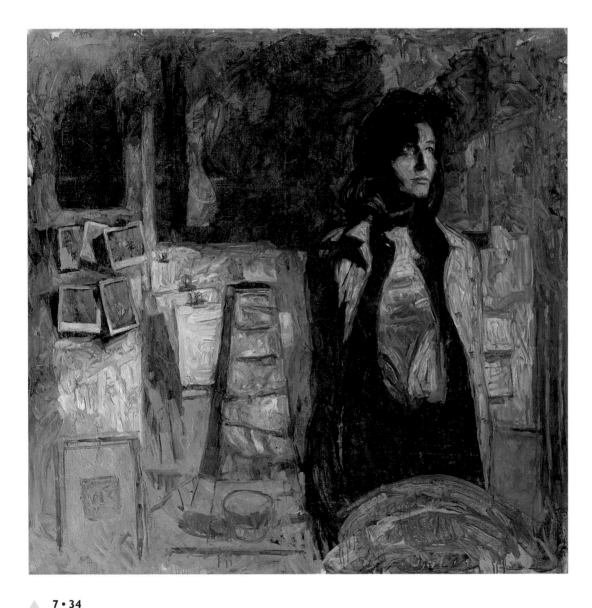

▲ **7 • 34**
Gilles Marrey, *1997*, 1998. Oil on canvas, 55 × 56 in. (140 × 142 cm).
The subjective or invented color relationships in this painting may not be as obvious as a "blue horse," but they effectively set up the mood and mystery within this painting.
© Caldwell Snyder Gallery, NY.

2. To create mood and symbolize ideas.
3. To serve as a vehicle for expressing personal emotions and feelings.
4. To attract and direct attention as a means of giving organization to a composition.
5. To accomplish aesthetic appeal by a system of well-ordered color relationships.
6. To identify objects by describing the superficial facts of their appearance.

COLOR BALANCE

Any attempt to base the aesthetic appeal of color pattern on certain fixed theoretical color harmonies will probably not be successful. The effect depends as much on how we distribute our color as on the relationships among the hues themselves. All good color combinations have some similarities and some contrasts. The basic problem is the same one present in all aspects of form organization: variety in unity. There must be harmonious relationships between the various hues, but these relationships must be made alive and interesting through variety.

COLOR AND HARMONY

Let us look first at the problem of harmonizing the color relationships. The pleasing quality of a color pattern frequently depends on the amount or proportion of color used. A simple way to create harmony and balance is by repeating similar color but in differing values and/or intensities (fig. 7.35) by controlling its placement in different parts of a composition. This one hue can also be a harmonizing factor if a little of it is mixed with every color used (see fig. 7.14). A similar effect can be created by glazing over a varicolored pattern with a single transparent color, which becomes the unifying hue. In general, equal amounts of different colors are not as

▲ 7 • 35

Ellen Phelan, *Ballerina,* 1994. Oil on linen, 27⅜ × 33⅜ in. (70 × 85 cm).

Ellen Phelan has created this close-up vision of arching blossoms by concentrating on the red color family. The artist has changed value and intensity to emphasize the developing forms and subtle spatial depth.

© 2001 Ellen Phelan/Artists Rights Society (ARS) New York.

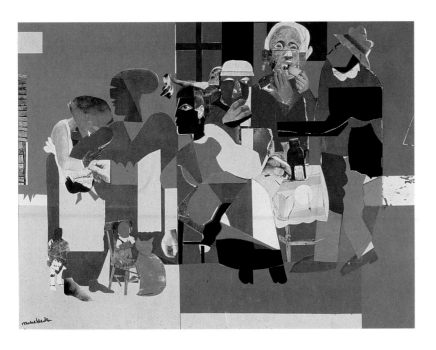

▲ **7·36**

Romare Bearden, *Family Dinner*, 1968. Collage on board, 30 × 40 in. (76.2 × 101.6 cm).

Though the analogous blues, blue-greens, and greens are the dominant hues in this painting, we understand the meaning of the work because of the contrast of the dark shapes, their symbolic character, and the recognizable human features.

Romare Beardon Foundation/Licensed by VAGA, New York, NY.

▲ **7·37**

Fernando Pomalaza, *Past and Present,* 1999. Mixed media on canvas, 18 × 26 in. (101.6 × 137.2 cm).

In this painting, the basic color unity has been established by the warm ochers and browns, but small accents of contrasting value, hue, and intensity add visual interest and prevent it from becoming monotonous.

Courtesy of the artist and Jain Marunouchi Gallery.

interesting as a color arrangement where one color, or one kind of color, predominates (see fig. 10.50). Such a unified pattern is found when all warm or all cool colors are used in combination. Again, however, a small amount of a complementary color or a contrasting neutral can add variety to the color pattern (see fig. 4.15). As a rule, where warm and cool colors are balanced against each other in a composition, it is better to allow one temperature to dominate (see fig. 7.19). The dominance of any one color in a pattern can be because of its hue, value, or intensity; when the hue intervals are closely related, as in analogous colors, greater related areas may become dominant. However, when color dominance is not enough to pull an organization together and the image is still difficult to understand, the image can be made readable by the character of the surrounding areas (fig. 7.36). A wide range of color may also be harmonized by bringing them all to a similar value level or making their intensity levels correspond. Where the basic unity of a color pattern has been established, strong contrasts of color hue, value, or intensity can be used in small accents; their size, then, prevents them from disturbing the basic unity of the color theme (fig. 7.37). Low-key or high-key compositions benefit greatly from such contrasting accents, which add interest to what might otherwise be a monotonous composition (see figs. 4.19 and 10.10).

COLOR AND VARIETY

In an attempt to become overly harmonious, we are often confused by color schemes in which all of the tones become equally important, because we cannot find a dominant area on which to fix our attention. It is sometimes necessary to develop hue combinations that depend on strong contrast and/or a variety of color (figs. 7.38 and 7.39). With this type of color scheme, the hue intervals are further apart, the greatest possible interval being that between two complementary colors. Color schemes based upon strong contrasts of hue, value, or intensity have great possibilities for expressive effect. In the contrasting color scheme, the basic problem is to unify the contrasts without destroying the general strength and intensity of expression. These contrasts can sometimes be controlled by the amount of opposing color used (fig. 7.39; see also fig. 7.20). In this situation, a small, dark spot of color, through its lower value, can dominate a large, light area. At other times, a spot of intense color, though small, can balance a larger amount of a grayer, more neutralized color (see fig. 7.34). Also, a small amount of warm color usually dominates a larger amount of cool color, although both may be of the same intensity (see fig. 7.21).

Complementary colors, which, of course, vie for our attention through simultaneous contrast, can be made

▲ 7 • 38

Joan Mitchell, *Untitled*, 1992. Oil on canvas, 110¼ × 78¾ in. (280 × 200 cm).
Characterized by aggressive brushwork, Joan Mitchell's painting has a variety of highly contrasting color and value: Large areas of dark are balanced by even larger areas of light value; blues are countered by smaller oranges, green by pink, and yellowish-white by touches of violet.
Reference MITC – 0436. Courtesy of the artist's estate and the Robert Miller Gallery.

▲ **7•39**

Norman Sunshine, *Double Fugue (diptych)*, 2000. Oil on canvas, 60 × 96 in. (152.4 × 243.8 cm).

This still-life painting presents two visual units, similar in image and shape placement. A unique vantage point is complemented by the highly contrasting use of color and value and their differing treatment in both units.

Private collection. Photograph courtesy of Neuhoff Gallery, New York. Photograph by Michael Korol.

more attractive if one of them is softened or neutralized. Another commonly used method of slightly softening exaggerated contrasts is to separate all or a part of the colors by a neutral line or area. Absolute black or white lines are the most effective neutrals for this purpose because they are so positive in character themselves. They not only tie together the contrasting hues but also enhance their color character because of value contrast. The neutral black leading between the brilliant colors of stained-glass windows is an example of this unifying character. Such modern painters as Georges Rouault and Max Beckmann found a black line effective in separating their highly contrasting

colors (see figs. 10.29 and 10.35). A similar unifying effect can be brought about by using a large area of neutral or light gray or a ■ **neutralized color** as a background for clashing contrasts of color (fig. 7.38, see fig. 2.12).

Finally, we should remember that artists frequently produce color combinations that defy these guiding principles but are still satisfying to the eye. Artists use color as they do the other elements of art structure—to give a highly personalized meaning to the subject of their work. We must realize that there can be brutal color combinations as well as refined ones. These brutal combinations are satisfying if they accomplish the artist's purpose of exciting us rather than calming us. Some

of the German Expressionist painters have proved that these brutal, clashing color schemes can have definite aesthetic value when used purposefully (fig. 7.40). There are no exact rules for arriving at pleasing effects in color relationships, but there are some guiding principles that we have discussed. With this foundation, every artist must build his or her own language of color as it is used in dynamic interaction in each work.

▲ 7 • 40

Emil Nolde, *The Last Supper*, 1909. Oil on canvas, 33⅞ × 42⅛ in. (86 × 107 cm).
The Expressionists usually employed bold, clashing hues to emphasize their emotional identification with a subject. Intense feeling is created by the use of complementary and near-complementary hues.
Courtesy of the Statens Museum for Kunst, Copenhagen.

CHAPTER EIGHT

Space

THE VOCABULARY OF SPACE

INTRODUCTION TO SPACE

SPATIAL PERCEPTION

MAJOR TYPES OF SPACE

Decorative Space
Plastic Space
Divisions of Plastic Space
Shallow Space
Deep and Infinite Space

SPATIAL INDICATORS

Sharp and Diminishing Detail
Size
Position
Overlapping
Transparency
Interpenetration
Fractional Representation
Converging Parallels
Linear Perspective

Major Systems of Linear Perspective
Perspective Concepts Applied
The Disadvantages of Linear Perspective
Other Projection Systems
Intuitive Space

THE SPATIAL PROPERTIES OF THE ELEMENTS

Line and Space
Shape and Space
Value and Space
Texture and Space
Color and Space

RECENT CONCEPTS OF SPACE

THE SEARCH FOR A NEW SPATIAL DIMENSION

Plastic Images
Pictorial Representations of Movement in Time
Motion Pictures
Television
The Computer and Art
Multimedia

Antonio Canaletto, *Campo di Rialto,* c. 1756. Oil on canvas, 119 × 186 cm.

THE VOCABULARY OF SPACE

Space. The interval, or measurable distance, between points or images.

atmospheric (aerial) perspective
The illusion of deep space produced in graphic works by lightening values, softening details and textures, reducing value contrasts, and neutralizing colors in objects as they recede (see **perspective**).

decorative (space)
Ornamenting or enriching but, more importantly in art, stressing the two-dimensional nature of an artwork or any of its elements. Decorative art (space) emphasizes the essential flatness of a surface.

four-dimensional space
A highly imaginative treatment of forms that gives a sense of intervals of time or motion.

fractional representation
A device used by various cultures (notably the Egyptians) in which several spatial aspects of the same subject are combined in the same image.

infinite space
A concept in which the picture frame acts as a window through which objects can be seen receding endlessly.

interpenetration
The movement of planes, objects, or shapes through each other, locking them together within a specific area of space.

intuitive space
The illusion of space that the artist creates by instinctively manipulating certain space-producing devices, including overlapping, transparency,

interpenetration, inclined planes, disproportionate scale, fractional representation, and the inherent spatial properties of the art elements.

isometric projection (perspective)
A technical drawing system in which a three-dimensional object is presented two-dimensionally; starting with the nearest vertical edge, the horizontal edges of the object are drawn at a thirty-degree angle and all verticals are projected perpendicularly from a horizontal base.

linear perspective (geometric)
A system used to develop three-dimensional images on a two-dimensional surface; it develops the optical phenomenon of diminishing size by treating edges as converging parallel lines. They extend to a vanishing point or points on the horizon (eye-level) and recede from the viewer (see **perspective**).

oblique projection (perspective)
A technical drawing system in which a three-dimensional object is presented two-dimensionally, the front and back sides of the object are parallel to the horizontal base, and the other planes are drawn as parallels coming off the front plane at a forty-five degree angle.

orthographic drawing
Graphic representation of two-dimensional views of an object, showing a plan, vertical elevations, and/or a section.

perspective
Any graphic system used in creating the illusion of three-dimensional images and/or spatial relationships on a two-dimensional surface. There are several types of perspective—atmospheric, linear, and projection systems.

plastic (space)
1. The use of the elements to create the illusion of the third dimension on a two-dimensional surface. 2. Three-dimensional art forms, such as architecture, sculpture, and ceramics.

shallow space
The illusion of limited depth. With shallow space, the imagery appears to move only a slight distance back from the picture plane.

three-dimensional (space)
Possessing, or creating the illusion of possessing, the dimension of depth, as well as the dimensions of height and width.

transparency
A visual quality in which a distant image or element can be seen through a nearer one.

two-dimensional (space)
Possessing the dimensions of height and width, especially when considering the flat surface or picture plane.

INTRODUCTION TO SPACE

At the mention of space, most of us think of space shuttles, a space station, the solar system, and the infinite cosmos beyond. Many artists have been interested in a seemingly unending deep space but one actually limited to the spatial atmosphere surrounding our earth. As will soon be seen, there are artistic devices that can be used to give the illusion of this kind of infinite space. On the other hand, the artist may choose to limit the degrees of space we apparently see; this kind of limit can be seen in the art of other cultures such as the Near and Far East. In the century just past, space has sometimes been shrunk almost to the level of the picture plane, but not quite, because any element placed in a pictorial area immediately takes on some apparent depth in space. All of this is, of course, pure illusion in pictorial art, but not so for the three-dimensional artists such as sculptors, jewelers, architects, and so on, who produce art objects that have their own space. ▪ **Space,** then, is a concern for all artists, and they must find ways of dealing with it in a consistent manner.

Some people consider space as a genuine element in ▪ **two-dimensional** art, while others see it as a "product" of the elements. In this text, space is conceived of as a product rather than an element, being instead created by the elements. Space, as discussed in this chapter, is limited to the graphic fields—that is, such two-dimensional surface arts as drawing, painting, printmaking, and so forth. ▪ **Three-dimensional** space concepts are discussed in Chapter 9.

SPATIAL PERCEPTION

All spatial implications are mentally conditioned by the environment and experience of the viewer. Vision is experienced through the eyes but interpreted by the mind. Perception involves the whole pattern of nerve and brain response to a visual stimulus. We use our eyes to perceive objects in nature and continually shift our focus of attention. In so doing, two different types of vision are used: stereoscopic and kinesthetic. Having two eyes set slightly apart from each other, we see two different views of the object world at the same time. The term *stereoscopic* refers to our ability to overlap these two slightly different views into one image. This visual process enables us to see in three dimensions, making it possible to judge distances.

With kinesthetic vision we experience space in the movements of the eye from one part of a work of art to another. While viewing a two-dimensional surface, we unconsciously attempt to organize its separate parts so that they can be seen as a whole. In addition, we explore object surfaces with our eyes in order to recognize them. Objects close to the viewer require more ocular movement than those farther away, and this changing eye activity adds spatial illusion to our kinesthetic vision.

MAJOR TYPES OF SPACE

Two types of space can be suggested by the artist: ▪ **decorative space** and ▪ **plastic space.**

DECORATIVE SPACE

Decorative space is the absence of real depth as we know it and is confined to the flatness of the picture plane. As the artist adds art elements to that plane (or surface), the illusion created appears flat or limited. In fact, a truly decorative space is difficult to achieve; any art element when used in conjunction with others will seem to advance or recede. The term *decorative space,* though

▲ **8 • 1**
Jasper Johns. *White Numbers,* 1955. Encaustic on linen, 28 × 22 in. (71.1 × 55.9 cm).
Though the heavy application of pigment casts shadows, in this decorative treatment there is no pictorial illusion of space, and the images appear very shallow on the picture's surface.
Private collection.

sometimes useful in describing essentially flat pictorial effects, is not accurate. Thus, decorative space for the artist is quite limited in depth (fig. 8.1; see fig. 5.15).

PLASTIC SPACE

The term *plastic* is applied to all spatial imagery other than decorative. Artists base much of their work on their experiences in the objective world, and it is a natural conclusion that they should explore the spatial resources.

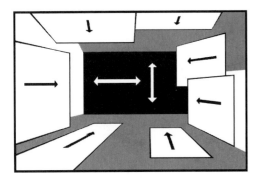

▲ **8 • 2**
Shallow space.
As a variation on the concept of shallow space, artists occasionally define the planes that make up the outer limits of a hollow boxlike space behind the picture plane. The diagram shows this concept, although in actual practice, a return to the picture plane would be made through objects occupying the space defined. The back plane acts as a curtain that prevents penetration into deep space.

▲ **8 • 3**
Jacob Lawrence, *Cabinet Makers*, 1946. Gouache with pencil underdrawing on paper, 21¾ × 30 in. (55.2 × 76.2 cm).
The use of shapes with solid colors and values, generally lacking in traditional shading, creates an overall feeling of flatness. In addition, a stagelike effect arises from the shallow space.
Hirshhorn Museum and Sculpture Garden, Smithsonian Institution, Washington, D.C. Gift of Joseph H. Hirshhorn, 1966. Photograph by Lee Stalsworth.

DIVISIONS OF PLASTIC SPACE

Artists locate their images in plastic space according to their needs and feelings, because infinite degrees of depth are possible. As a result, the categorizations of depth locations cannot be specific or fixed but must be broadened to include general areas.

Shallow Space

Concentration on the picture surface usually limits the depth of a composition. Varying degrees of limited space are possible. Limited space (or ▮ **shallow space**) can be compared to the feelings one might experience if confined to a box or stage. The space is limited by the placement of the sides or walls. For consistency, any compositional objects or figures that might appear in the boxlike or stagelike confines should be narrowed in depth or flattened (fig. 8.2). In the modern painting *Cabinet Makers* by Jacob Lawrence, the figures have been flattened and placed in a confined room (fig. 8.3).

Asian, Egyptian, and European Medieval artists used comparatively shallow space in their art. Early Renaissance paintings were often based on the shallow sculptures that were popular then. Many modern artists have elected to use shallow space because it allows more positive control and is more in keeping with the flatness of the working surface. Gauguin, Matisse, Modigliani, and Beckmann are typical advocates of the concepts of limited space (see figs. 7.21 and 4.7). For these artists, not having to create the illusion of deep plastic space allows more control of the placement of decorative shapes as purely compositional elements.

Deep and Infinite Space

An artwork that emphasizes deep space denies the picture plane except as a starting point where the space begins. The viewer seems to be moving into the far distances of the picture field. This spatial feeling is similar to looking through an open window over a landscape that rolls on and on into infinity. This infinite quality is created using spatial indications that are produced by certain relationships of art form. Size, position, overlapping images, sharp and diminishing details, converging parallels, and perspective are the traditional methods of indicating deep spatial penetration (see fig. 6.20).

▮ **Infinite spatial** concepts, allied with atmospheric perspective, dominated Western art from the beginning of the Renaissance (about 1350) to the middle of the nineteenth century. During this period, generations of artists, such as

Botticelli, Ruisdael, Rembrandt, and Bierstadt, to name only a few, developed and perfected the deep-space illusion because of its obvious accord with visual reality (fig. 8.4). Present-day art is largely dominated by the shallow-space concept, but many contemporary artists work with strongly recessed fields. Any space concept is valid if it demonstrates consistent control of the elements in relation to the spatial field chosen.

SPATIAL INDICATORS

Artistic methods of spatial representation are so interdependent that attempts to isolate and examine all of them here would be impractical and inconclusive and might leave the reader with the feeling that art is based on a formula. Thus, we will confine this discussion to fairly basic spatial concepts.

Our comprehension of space, which comes to us through objective experiences, is enlarged, interpreted, and given meaning by the use of our intuitive faculties. Spatial order develops when the artist senses the right balance and the best placement, then selects vital forces to create completeness and unity. Obviously, then, this process is not a purely intellectual one but a matter of instinct or subconscious response (see fig. 5.9).

Because the subjective element plays a part in controlling space, we can readily see that emphasis on formula here, as elsewhere, can quell the creative spirit. Art is a product of human creativity and is always dependent on individual interpretations and responses. Space, like other qualities in art, may be either spontaneous or premeditated but is always the product of the artist's will. If an artist has the impassioned will to make things so, they will usually be so, despite inconsistency and defiance of established principles. Therefore, the methods of spatial indication discussed in the following pages are those that

▲ 8 • 4

Albert Bierstadt, *View from the Wind River Mountains, Wyoming*, 1860. Oil on canvas, 30¼ × 48¼ in. (76.8 × 122.6 cm).

Nineteenth-century American landscape painting, which aimed at the maximum illusion of visual reality, emphasized the concept of infinite space. Diminishing sizes of objects and hazy effects of atmospheric perspective give the viewer a sense of seeing far into the distance.

Gift of Mrs. Maxim Karolik for the Karolik Collection of American Paintings 1815-1865, Museum of Fine Arts, Boston, MA (47.1202).

have been used frequently and that guarantee one effect of space, though not necessarily one that is always exactly the same. These traditional methods are presented merely to give the student a conception of the more conventional spatial forces (see fig. 4.15).

SHARP AND DIMINISHING DETAIL

Because we do not have the eyes of eagles, and because we view things through the earth's atmosphere, we are not able to see near and distant planes with equal clarity at the same time. A glance out the window confirms that close objects appear sharp and clear in

detail, whereas those at great distances seem blurred and lack definition. Artists have long known of this phenomenon and have used it widely in illusionistic work. In recent times they have used this method and other traditional methods of space indication in works that are otherwise quite abstract. Thus, in abstract and nonobjective conceptions, sharp lines, clearly defined shapes and values, complex textures, and intense colors are associated with foreground or near positions. Hazy lines, indistinct shapes, grayed values, simple textures, and neutralized colors are identified with background locations. These characteristics are often included in the definition of ■ **atmospheric perspective** (see fig. 8.4).

△ **8 • 5**
Winslow Homer, *Returning Fishing Boats*, 1883. Watercolor and white gouache over graphite on white paper, 13 × 19⅝ in. (40.3 × 62.9 cm).
The horizon line in this painting separates the space into a ground plane below and a sky plane above. The smaller size and higher position of the distant boats help to achieve the spatial effect.
Courtesy of the Fogg Art Museum, Harvard University Art Museums, Anonymous Gift. Photograph by Katya Kallsen. © President and Fellows of Harvard College, Harvard University.

SIZE

We usually interpret largeness of scale in terms of nearness. Conversely, a smaller scale suggests distance. If two sailboats were several hundred feet apart, the nearer boat would appear larger than the other. Ordinarily we would interpret this difference in scale not as one large and one small image (although this could play a part in our perception), but as vessels of approximately the same size placed at varying distances from the viewer (fig. 8.5). Therefore, if we are to use depth scale as our guide, an object or human figure assumes a scale that corresponds to its distance from us, regardless of all other factors (fig. 8.6; see fig. 10.22). This concept of space has not always been prevalent. In many broad periods and styles of art and in the works of children, large scale is assigned according to importance, power, and strength, regardless of spatial location (see figs. 8.12 and 2.49).

POSITION

Many artists and observers automatically assume that the horizon line, which provides a point of

◁ **8 • 6**
Jaques Callot, *The Great Fair at Imprunita*, 1620. Etching, 16¹⁵⁄₁₆ × 26 in.
In Callot's print, note how the figures gradually get smaller as they recede into the background areas. This, combined with the artist's use of linear perspective with the buildings, gives the viewer a strong sense of depth.
The Metropolitan Museum of Art, Harris Brisbane Dick Fund, 1917 (17.3.2645).

reference, is always at eye level. The position of objects is judged in relation to that horizon line. The bottom of the picture plane is seen as the closest visual point, and the degree of rise of the visual units up to the horizon line indicates subsequently receding spatial positions (see fig. 8.5). Evidence suggests that this manner of seeing is instinctive (resulting from continued exposure to the objective world), for its influence persists even in viewing greatly abstracted and nonobjective work (fig. 8.7). The alternative, of course, is to see the picture plane as entirely devoid of spatial illusion and the distances of the visual elements as actually measurable across the flat surface. It is difficult to perceive in this way even when we discipline ourselves to do so, because it requires us to divorce ourselves entirely from ingrained environmental factors.

OVERLAPPING

Another way of suggesting space is by overlapping planes or volumes. If one object covers part of the visible surface of another, the first object is assumed to be nearer. Overlapping is a powerful indication of space, because once used, it takes precedence over other spatial signs. For instance, a ball placed in front of a larger ball appears closer than the larger ball, despite its smaller size (fig. 8.8).

TRANSPARENCY

The overlapped portion of an object is usually obscured from our view. If, however, that portion is continued and made visible through the overlapping plane or object, the effect of **transparency** is created. Transparency, which tends to produce a closer spatial relationship, is clearly evident in the triangles in the painting by Leonardo Nierman (fig. 8.9). It is most noticeable in the works of the Cubists and other

△ **8 • 7**

Placement of squares.

A line across the picture plane reminds us of the horizon that divides ground plane from sky plane. Consequently, the lower shape seems close and the intermediate shape more distant, while the upper square is in a rather ambiguous position as it touches nothing and seems to float in the sky.

△ **8 • 8**

Larger objects usually advance more than smaller ones, but as an indicator of space, overlapping causes the object being covered to recede regardless of size.

◁ **8 • 9**

Leonardo Nierman, *Broken Star,* 1991. Mixed media on masonite, 32 × 24 in.

The precise, hard-edged geometric shapes in this work are a legacy of Cubism. However, notice that the implied triangular shapes overlap, remain transparent, and create a shallow space that contrasts with the deeper space behind.

Courtesy of the artist.

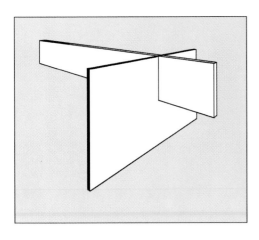

△ 8 • 10
Interpenetrating planes.
The passage of one plane or volume through another automatically gives depth to a picture.

artists who are interested in exploring shallow space (see figs. 4.8 and 10.41).

INTERPENETRATION

Interpenetration occurs when planes or objects pass through each other, emerging on the other side. It provides a very clear statement of the spatial positioning of the planes and objects involved and can create the illusion of either shallow or deep space (figs. 8.10, 8.11; also see fig. 2.21).

FRACTIONAL REPRESENTATION

Fractional representation can best be illustrated by studying the treatment of the human body by Egyptian artists. Here we can find, in one figure, the profile of the head with the frontal eye visible, the torso seen front-on, and a side view of the hips and legs. This combines the most representative aspects of the different parts of the body (figs. 8.12 and 8.13).

Fractional representation is a spatial

▷ 8 • 11
Al Held, *Quattro Centric XIII*, 1990. Acrylic on canvas, 5 × 6 ft (1.52 × 1.83 m).
The effects in this work are quite subtle and do not follow any formal technique for generating space. Areas of overlapping and interpenetration contribute strongly to the overall sense of depth.

Courtesy of André Emmerich Gallery, a Division of Sotheby's, on behalf of Al Held.

device revived in the nineteenth century by Cézanne, who used its principles in his still-life paintings (see "Plastic Images," p. 213). It was employed by many twentieth-century artists, most conspicuously Pablo Picasso. The effect is flattening in Egyptian work but plastic in the paintings by Cézanne because it is used to move us "around" the subjects.

CONVERGING PARALLELS

The space indicated by converging parallels can be illustrated using a rectangular plane such as a sheet of paper or a tabletop. By actual measurement, a rectangle possesses one set of short parallel edges and one set of long parallel

◄ **8 • 12**

Nebamun hunting birds, from the tomb of Nebamun, Thebes, Egypt, c. 1400 B.C.
This work illustrates the Egyptian concept of pictorial plasticity: Various representative views of the figure are combined into one image (fractional representation) and are kept compatible with the flatness of the picture plane. The arbitrary positioning of the figures and their disproportionate scale add to this effect.

Fragment of a fresco secco. Courtesy of the British Museum, London.

▶ **8 • 13**

This drawing illustrates the Egyptian technique of fractional representation of the human figure. The head is in profile, but the eye full-face. The upper body is frontal, gradually turning until the lower body, from the hips down, is seen from the side. This drawing combines views of parts of the body in their most characteristic or easily seen positions. In order to see all these views, one would have to move around the body.

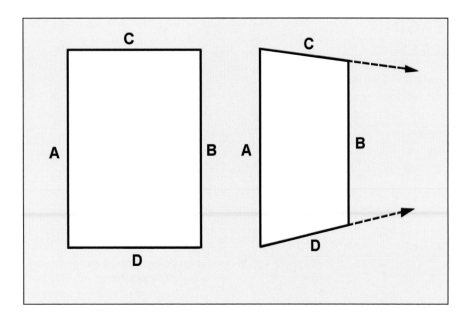

▲ 8 • 14
Converging parallels can make a shape appear to recede into the pictorial field.

▲ 8 • 15
Anselm Kiefer, *Osiris und Isis/Bruch und Einung*, 1985–87. Mixed media, 150 × 22 ½ in. (38 × 560 cm).
Kiefer uses perspective to help him intensify the viewer's confrontation with scale in his enormous canvas.

San Francisco Museum of Modern Art. Purchased through a gift of Jean Stein, by exchange, the Mrs. Paul L. Wattis Fund, and the Doris and Donald Fisher Fund.

edges (fig. 8.14). If the plane is arranged so that one of the short edges (A) is viewed head-on, its corresponding parallel edge (B) will appear to be much shorter. Because these edges appear to be of different lengths, the other two edges (C and D) that connect them must seem to converge as they move back into space. Either set of lines, when separated from the other set, would continue to indicate space quite forcefully. The principle of converging parallels is found in many works of art that do not abide by the rules of ■ **perspective.** This principle is closely related to perspective, but the amount of convergence is a matter of subjective or intuitive choice by the artist. It is not governed by fixed vanishing points and the rules governing the rate of convergence (fig. 8.15).

LINEAR PERSPECTIVE

■ **Linear perspective** is a system for converting sizes and distances of known objects into a unified spatial order. It is based on the artist's/viewer's optical perception and judgments of such specific concepts as scale, proportion, placement, and so on. Its use involves the application of such spatial indicators as size, position, and converging parallels. The general understanding of perspective occurred because of a renewal of interest in ancient Greco-Roman literature, philosophy, and art. This spirit swept many countries and sowed the seeds of the Italian Renaissance—the era that brought this spatial system to a point of high refinement. Artists focused their attention on one view, a selected portion of nature, seen from one position at a particular moment in time. The use of eye level, guidelines, and vanishing points gave this view mathematical exactitude (figs. 8.16A and 8.16B).

It has generally been agreed that perspective was developed by the early Renaissance architect Filippo Brunelleschi (1377–1446) and was

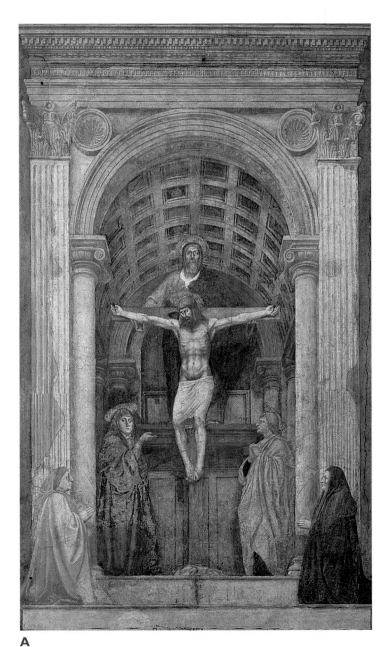

A

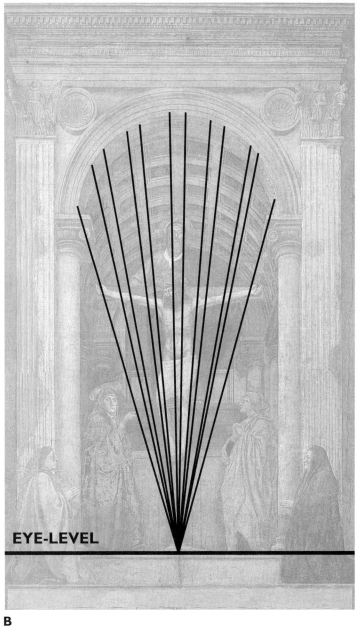

EYE-LEVEL

B

8 • 16

Masaccio, *Trinity with the Virgin, St. John and Donors*, 1427. Fresco at Santa Maria Novella, Florence, Italy, 21 ft 10 in. × 10 ft 5 in. (6.65 × 3.18 m).

According to some art history experts, Masaccio's fresco is the first painting created in correct geometric perspective. The single vanishing point lies at the foot of the cross, as indicated by the overlay in figure 8.16B.

Photo Scala/Art Resource, New York.

A

Left viewing field **Right viewing field**

SKY PLANE (ceiling)

GUIDELINES (orthogonal)

EYE-LEVEL

GROUND PLANE (floor)

B **Vanishing point (VP)** **Viewer's location point**

▲ **8 • 17**

Sandro Botticelli, *Annunciation*, c. 1490. Tempera and gold on panel, 7½ × 12⅜ in. (19.1 × 31.4 cm) (painted surface).

In the tradition of much art of the Renaissance period, perspective in the form of receding planes creates space and directs our attention to the vanishing point (see fig. 8.17B).

Metropolitan Museum of Art, New York, Robert Lehman Collection, 1975 (1975.1.74). Photo © Metropolitan Museum of Art, all rights reserved.

quickly adapted to painting by his contemporary, Masaccio (1401–28) (see fig. 8.16A). Employing their knowledge of geometry (then one of the most important elements in the classical education of every student), Renaissance artists conceived a method of depicting objects, whether animate or inanimate, in space that was more realistic than any other that had appeared in Western art since the Romans. In their concept, the perspective drawing of shapes (fig. 8.17A) makes the picture plane akin to a view through an entry window; picture framing or matting defines the window frame. In figure 8.17B, imaginary sightlines or "orthogonals," called guidelines, are extended along the edges of the room's architectural planes to a point behind the angel's head.

The guidelines converge at a point on the eye level that is called the vanishing point (infinity). The eye level is synonymous with the horizon line (where the sky and ground meet) that is often seen in landscapes (see figs. 8.4 and 8.5). While the eye level reveals the relative height of the observer's/painter's eyes, it also demarcates upper and lower divisions called ground plane (floor) and sky plane (ceiling). A vertical axis that can be seen through the vanishing point, behind the angel's head, establishes the location of the artist or viewer. This is known as the viewer's location point. Changing the latter will drastically alter the view of the room (figs. 8.18A and B).

Major Systems of Linear Perspective

There are three major systems of linear perspective: one-point, two-point, and three-point. All are relative to the way the artist views the subject or scene. Perspective is based on the assumption that the artist maintains a fixed position and, in theory, views the subject with one eye (fig. 8.19). The Renaissance painter's approach had a ray of light come from one fixed point (the artist's

eye) to every point on the object being drawn. The rays passed through a glass screen—representing the artist's canvas—placed between the artist and the image or scene. The collection of points where the lines passed through the glass achieved the naturalistic view the artist wanted to re-create on the canvas. These devices were thought of as portable camera obscuras (see the "Beginning of Photography" section in Chapter 10, p. 255).

In reality, unless immobilized by a plaster cast and fitted with blinders, most viewers will casually move either their eyes or their head as their focus moves from object to object within the image. While this may extend the viewer's ability to understand the subject, changing the point of view to some extent works against the concepts of linear perspective.

Assuming a minimum of movement, the artist can view his subjects in one of three ways:

1. By taking a position directly in front of the image, the whole front plane of the subject is made to appear flat or parallel to the picture plane (one-point);
2. By moving so that an edge—instead of the whole flat plane—is closest and centrally located, all planes will then appear to recede, because the top and bottom edges converge to vanishing points on either side (two-point);
3. Assuming a position very much above or below the subject that will make the sides as well as the top and bottom edges converge to distant points (three-point).

In each of these examples, the subject was thought of as stationary, and the artist changed position. But the same concepts can be applied to still-life material, which can be altered or repositioned; a small box could be placed in each of the three locations relative to the artist's viewpoint.

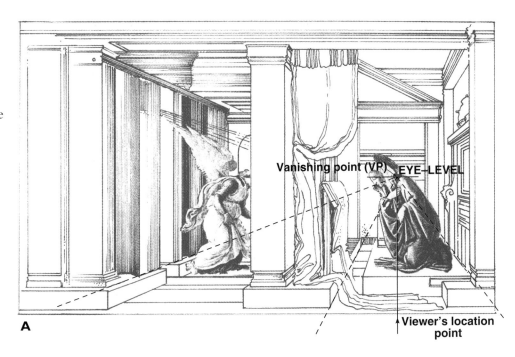

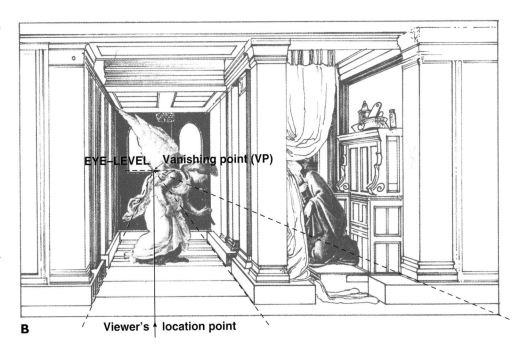

△ **8 • 18**

These illustrations show how the interior might have changed if Botticelli had moved his location point left or right and up or down (see fig. 8.17A). Figure 8.18A indicates what Botticelli would have seen by moving to the right and standing directly in front of the Madonna. Figure 8.18B depicts the view he would have had by moving to the left, past the angel, and moving up a ladder one or two steps. Notice how the architectural elements change with each view, obscuring important parts of the image.

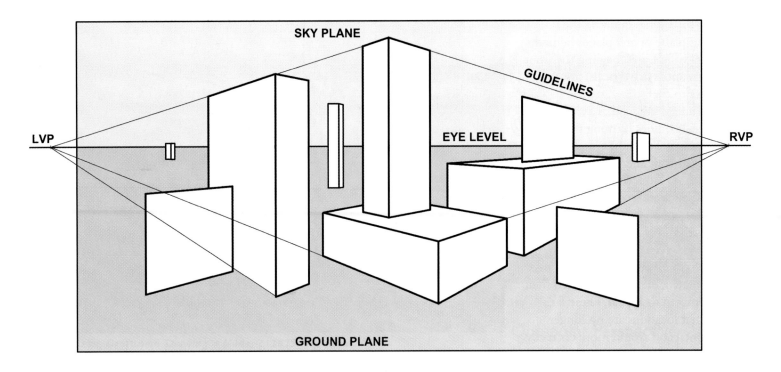

SKY PLANE

GUIDELINES

LVP

EYE LEVEL

RVP

GROUND PLANE

▲ 8 • 23

A drawing showing the essential difference between planes and three-dimensional shapes.

Planes are shapes having only two dimensions (height and width), whereas three-dimensional shapes, which are made up of planes, have the effect of solidity (height, width, and depth). The component planes (sides) of three-dimensional shapes may be detached and inclined at any angle. The drawing is also an example of two-point perspective. Object edges are shown as heavy lines, orthogonals (guidelines) as lighter lines. Vanishing points (left vanishing point and right vanishing point) show where object edges converge at the eye level or horizon line, which represents infinity. The eye level divides the picture plane into areas that stand for the ground and sky.

closest portion of the box—the vertical edge—as a vertical line. From the top and bottom corners of this vertical, guidelines are extended back to both sets of vanishing points, tentatively establishing the side, top, and/or bottom planes of the geometric solid. These planes will appear to diminish as they recede toward the vanishing points. With two-point perspective, all lines except those that are vertical will return to the vanishing points. The verticals indicate the height of the volumes, stay parallel, and are perpendicular to the ground plane. Only the verticals may be measured and never converge.

Notice in figure 8.23 that multiple solids and planes create a sense of deep space. In addition, the vanishing points are placed outside the picture plane. An artist has control over how much distortion of the objects is desired. Placing the vanishing points *inside* the edges of the picture frame will increase the exaggerated appearance of the shapes. Placing the vanishing points further apart eliminates the distortion of image that occurs when they are too close together. Unlike flies with multiple lens and 360-degree vision, our field of vision makes us specifically aware of objects in the central 60 degrees with some additional peripheral awareness of 20 to 30 degrees on either side. On the outer edges of our awareness we may only sense movement or images without color. With this in mind, the horizon line may be drawn on the paper representing the width of our visual field. The vanishing points may be placed on either side of the drawn horizon line, a distance equal to approximately one-quarter of its width. The horizon line should be extended to the vanishing points. This

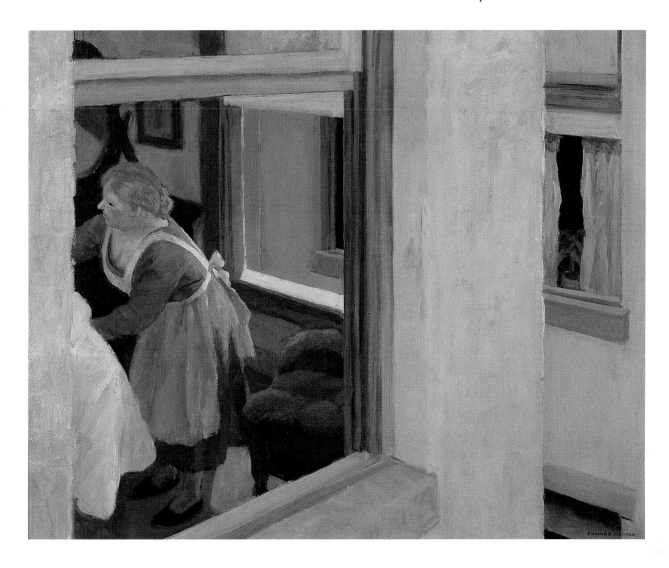

will take them outside the pictorial area and possibly off the page. For compositional reasons, an artist may choose to work with only a portion of the complete field of view. If undistorted images are desired, the relative distance between vanishing points will remain unchanged, and the section chosen will be located along that line relative to its location right or left and its width. In any case, the location of the vanishing points is only a tool and may be used to exaggerate (placed extremely close), present as observed (appropriately located), or distort by nearly eliminating the receding quality of the image (spaced extremely far apart). Each effect may be exactly what is needed at some point.

Two-point perspective is most often employed in graphic artworks when objects, usually set in architectural settings, appear to be at an angle to the lines of sight or when the artist wishes them to appear at angular positions in depth on the picture plane, as can be seen in the Hopper painting and in Callot's drawing (fig. 8.24; see fig. 8.6).

Three-point Perspective

Three-point perspective is used when an artist views an object from an exaggerated position—lying on the ground and looking up at a tree or looking down from a skyscraper into the center of the city. These are sometimes

8 • 24

Edward Hopper, *Apartment Houses*, 1923. Oil on canvas, 25½ × 31½ in. (64.8 × 80 cm).

This unusual interior with layers of space revealed through windows is painted in two-point perspective. The perspective is used to direct the viewer back and forth into the picture plane.

Pennsylvania Academy of the Fine Arts, Philadelphia. John Lambert Fund. Acc. No. 1925.5.

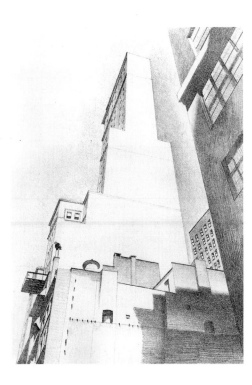

◀ **8 • 25**

Charles Sheeler, *Delmonico Building*, 1926. Lithograph, 9¾ × 6⅞ in. (24.7 × 17.4 cm).

This painting makes use of three-point perspective—a "frog's-eye view."

Fogg Art Museum. © President and Fellows, Harvard University Art Museums, Boston, MA. Gift of Paul J. Sachs.

▼ **8 • 26**

Gene Bodio, *New City*, 1992. Computer graphic created using Autodesk 3D Studio–Release 2.

This is a "bird's-eye view" generated by a computer. Though not strictly in three-point perspective, the pictue is an unusual variation in the depiction of three-dimensional objects in space.

Autodesk Inc., San Rafael, CA.

referred to as a "frog's-eye view" (fig. 8.25) and a "bird's-eye view" (fig. 8.26), respectively.

The artist begins by locating the horizon line that indicates the location of the viewer's eyes and fixing the left vanishing point (LVP) and the right vanishing point (RVP) at the appropriate location on the horizon line (fig. 8.27). Keep in mind that the closer together the vanishing points are placed, the greater will be the exaggeration or distortion of your image. Usually the horizon line will be relatively high or low on the picture plane. Next, a third point called the vertical vanishing point (VVP) is located along a vertical axis coming perpendicularly off the horizon line at a point representing the viewer's location point. The location of the VVP also controls the distortion of the

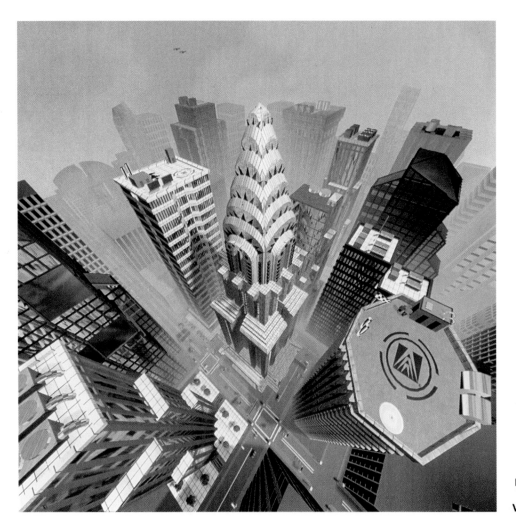

▼ **8 • 27**

With three-point perspective, a vantage point is assumed far above or below the subject. This will cause the sides, as well as the top and bottom edges, to converge to one of the three distant vanishing points.

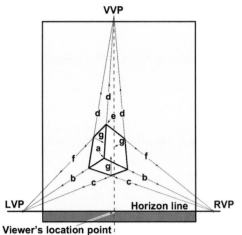

object—the further away from the horizon line the third point is located, the less exaggerated the image will be. The image is started by fixing the nearest corner (a) of what will become a rectangular solid that seems to be floating overhead. From this point, guidelines (b) are extended to the RVP and to the LVP. This locates the leading front edges of the bottom plane. The width of both edges should be indicated, and from those points new guidelines should be extended (c) again to the RVP and LVP. This completes the bottom plane and locates all four corners. The "verticals" (d) should now be drawn up and away from the three closest corners; but because there are no verticals in three-point perspective, these lines will have to converge to the VVP. Once the "verticals" are drawn, it should be decided how long the rectangular solid must be by gauging its length on the closest or center "vertical" edge (a–e). After marking this point (e), guidelines (f) are extended from it to the RVP and to the LVP. In certain cases the hidden back edges (g) could be added. This completes the drawing of the edges and fully defines the geometric solid as seen from below in three-point perspective.

Only in three-point perspective are the vertical (height) lines, as well as those receding to the left and right vanishing points, spatially indicated. All three guideline systems converge at vanishing points. They are neither perpendicular nor parallel to one another but at oblique angles (see fig. 8.25).

Perspective Concepts Applied

Whether using one-, two-, or three-point perspective, the artist is working with a system that allows the development of items of known size and their placement at various distances into the picture plane. A one-point cube, as illustrated in figure 8.28A, shows a whole flat frontal plane (the closest part) and a receding top plane. The center of any front plane—square or rectangular—may be found by mechanically measuring the horizontal and vertical lengths and dividing them in half. Lines (a) drawn from those points parallel to the verticals and horizontals will divide the plane into quarters. However, this type of measurement only works on flat, frontal planes found exclusively with one-point perspective. It will not work on any plane with converging sides—one-, two-, or three-point—because the sides get smaller as they move away from the viewer, and their changing ratio is not measurable on a ruler. Notice, on the front plane, that diagonals (b) drawn from corner to corner pass through the exact center found by mechanical measurement. The same type of diagonal lines drawn from corner to corner on the receding plane pass through the perspective center of the converging top plane. Lines drawn through this point parallel to the front edge (c) or to the vanishing point (d) create the equal division of the four edges of the receding plane. This concept of corner-to-corner diagonals may be applied to cubes or rectangles in one-, two-, and three-point perspective to locate the perspective centers on any receding plane.

Using the center point of a cube's front square, a circle can be drawn with a compass that should fit into the square perfectly (fig. 8.28B). Notice that when the diagonals are divided in thirds from the center, the circle crosses the diagonal lines on approximately the outer third mark. With a compass, try to draw a circle that fits into the top receding plane. It cannot be done, because even though we know that it is a circle, it will appear as an ellipse. The appropriate ellipse can be drawn on the top receding plane when it passes through the third marks on the diagonals and touches the square on the center points of each side. This system may be applied to any receding plane—vertical or horizontal—in one-, two-, or three-point perspective (fig. 8.28C).

Figure 8.29A shows the changing ellipses that could be located in a very tall rectangle. Occasionally, an artist must draw the appropriate ellipse for the top and bottom of anything cylindrical relative to its position above or below the horizon line. Notice that the ellipses further away from the horizon line are

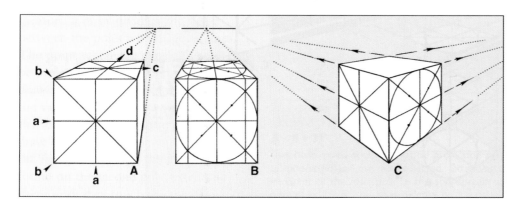

◁ **8 • 28**

Subdividing a plane.

These diagrams illustrate how to find the perspective center of a plane by crossing diagonals from corner to corner (A). To draw a circle on the same plane, divide each half of the diagonals into thirds. Draw the circle so that it passes through the outside "third" marks (closest to the corners) on the diagonals. The circle should also touch the middle points on the sides of the square. This concept may be applied to one- and two-point perspective (B and C).

INTUITIVE SPACE

Although planes and volumes play a strong part in creating illusions of space in linear perspective, they can also be used to produce ■ **intuitive space,** which is independent of strict rules and formulae. Intuitive space is thus not a system but a product of the artist's instinct for manipulating certain space-producing devices. The devices that help the artist to control space include overlap, transparency, interpenetration, inclined planes, disproportionate scale, and fractional representation. In addition, the artist may exploit the inherent spatial properties of the art elements. The physical properties of the art elements tend to thrust forward or backward; this can be used to define items spatially. By marshaling these spatial forces in any combination as needed, the artist can impart a sense of space to the pictorial image while adjusting relationships (fig.

8.37). The space derived from this method is readily sensed by everyone; although judged by the standards of the more familiar linear perspective, it may seem strange, even distorted. Nevertheless, intuitive space has been the dominant procedure during most of the history of art; it rarely implies great depth, but it makes for tightly knit imagery within a relatively shallow spatial field (fig. 8.38).

THE SPATIAL PROPERTIES OF THE ELEMENTS

The spatial effects that arise from using the elements of art structure must be recognized and controlled. Each of the elements possesses inherent spatial qualities, but the interrelationship between elements yields the greatest spatial feeling. Many types of spatial experiences can be achieved by manipulating the elements—that is, by varying their position, number, direction, value, texture, size, and color. The resultant spatial variations are endless (see fig. 3.22).

LINE AND SPACE

Line, by its physical structure, implies continued direction of movement. Thus line, whether moving across the picture plane or deep into it, helps to indicate spatial presence. Because, by definition, a line must be greater in length than in breadth (or else it would be indistinguishable from a dot or a shape), it tends to emphasize one direction. The extension of this dominant direction in a single line creates continuity, moving the eye of the observer from one unit or general area to another. Line can be a transition that unifies the front, middle, and background areas.

In addition to direction, line contains other spatial properties. Long or short,

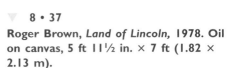

8 • 37
Roger Brown, *Land of Lincoln,* 1978. Oil on canvas, 5 ft 11½ in. × 7 ft (1.82 × 2.13 m).
Certain contemporary artists employ individualistic devices to create unusual spatial effects. This painting by Roger Brown shows multiple viewpoints that seem to project backward and forward in a scale of unusual proportions.
Courtesy of Phyllis Kind Gallery, Chicago, IL. © Guy and Helen Barbier, Geneva, Switzerland.

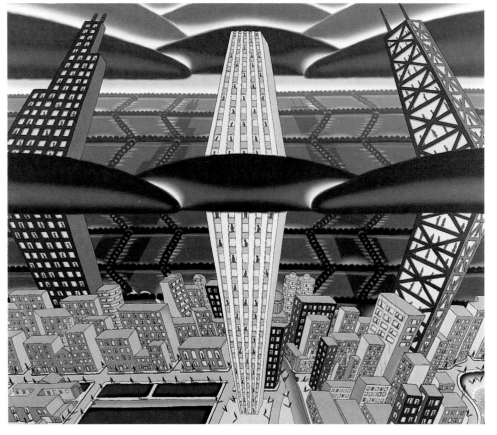

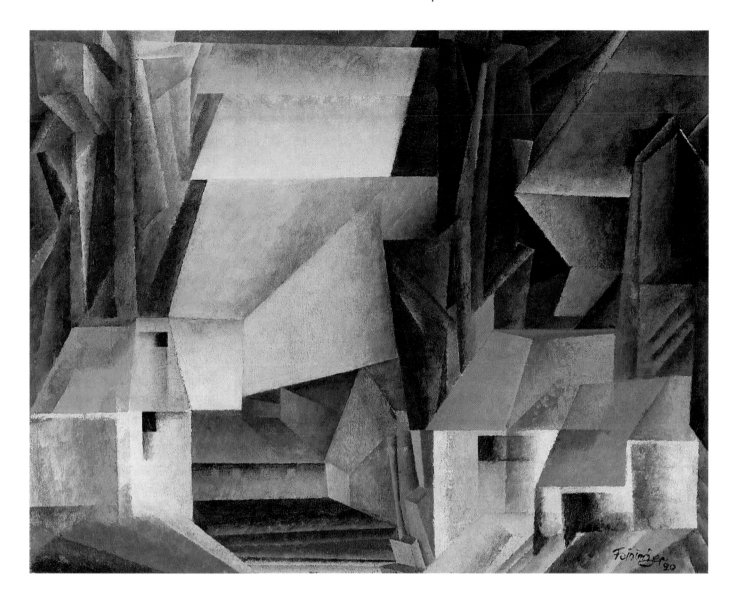

thick or thin lines, and straight, angular, or curved lines take on different spatial positions and movements in contrast with one another. The indications of three-dimensional space mentioned earlier in this chapter are actively combined with the physical properties of line. A long thick line, for instance, appears larger (a spatial indication) and hence closer to the viewer than a short thin line. Overlapping lines establish differing spatial positions, especially when they are set in opposite directions (that is, vertical against horizontal). A diagonal line seems to move from the picture plane into deep space, whereas a vertical or horizontal line generally

appears comparatively static (fig. 8.39). In addition, the plastic qualities of overlapping lines can be increased by modulating their values. Lines can be lightened to the point that they disappear or become "lost," only to reappear (become "found") and grow darker across the compositon. This missing section or implied line can also help control compositional direction or movement. The modulated plastic illusion invariably suggests change of position in space.

The spatial indication of line convergence that occurs in linear perspective is always in evidence wherever a complex of lines occurs.

▲ **8 • 38**
Lyonal Feininger, *Hopfgarten*, 1920. Oil on canvas, 25 × 32¼ in.

In this painting, the artist has used intuitive methods of space control, including overlapping planes and transparencies, as well as planes that interpenetrate one another and incline into space.

Minneapolis Institute of the Arts.

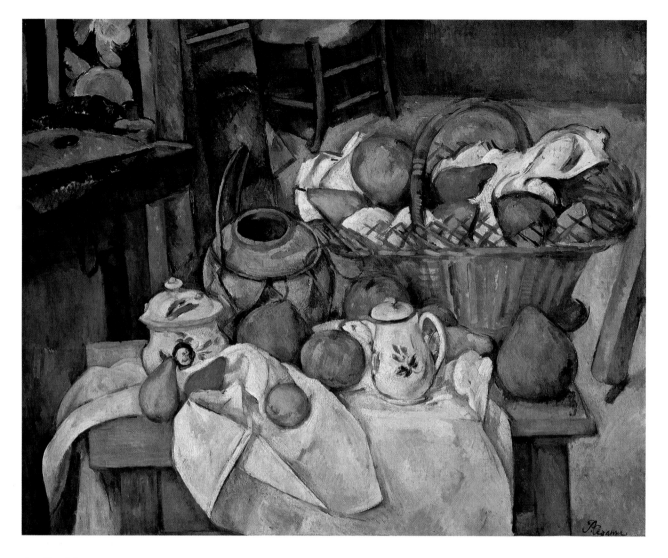

▲ 8 • 46

Paul Cézanne, *Still Life with Basket of Fruit (The Kitchen Table),* c. 1888–90. Oil on canvas, $25\frac{5}{8} \times 31\frac{7}{8}$ in. (65.1 × 81 cm).

Cézanne was concerned with the plastic reality of objects as well as with their organization into a unified design. Although the pitcher and sugar bowl are viewed from a direct frontal position, the rounded jar behind them is painted as if it were being seen from a higher location. The handle of the basket is shown as centered at the front, but it seems to become skewed into a right-sided view as it proceeds to the rear. The left and right front table edges do not line up and are thus viewed from different vantage points. Cézanne combined these multiple viewpoints in one painting in order to present each object with a more profound sense of three-dimensional reality.

Musée d' Orsay, Paris, France. Photo © Erich Lessing/Art Resource, New York.

for a new graphic vocabulary to describe visual discoveries. Because one outstanding feature of the modern world is motion, contemporary artistic representation must move, at least illusionistically. Motion has become a part of space, and this space can be grasped only if a certain period of time is allotted to cover it. Hence, a new dimension is added to spatial conception—the ■ **fourth dimension,** which combines space, time, and motion and presents an important artistic challenge. This challenge is to discover a practical method for representing things in motion from every viewpoint on a flat surface. In searching for solutions to this problem, artists have turned to their own experiences as well as to the work of others.

Plan View

Elevation View Section View

◁ **8 • 47**
**Tom Haverfield, *Kerosene Lamp,*
c. 1960. Pen and ink, 9 × 12 in.
(22.9 × 30.5 cm).**
In this work, objects are rendered in a type of orthographic drawing that divides them into essential views able to be drawn in two dimensions.
Courtesy of the artist.

▷ **8 • 48**
**Tom Haverfield, *Kerosene Lamp II,*
c. 1960. Pencil on paper, 14 × 18 in.
(35.6 × 45.7 cm).**
The juxtaposition of orthographic views illustrates all the physical attributes and different views of the object in one drawing. Such a composite drawing shows much more of an object than could normally be visible.
Courtesy of the artist.

PLASTIC IMAGES

Paul Cézanne, the nineteenth-century Post-Impressionist, was an early pioneer in the attempt to express the new dimension. His aim was to render objects in a manner more true to nature. This nature, it should be pointed out, was not the Renaissance world of optical appearances; instead, it was a world of forms in space, conceived in terms of a plastic image (fig. 8.46). In painting a still life, Cézanne selected the most characteristic viewpoint of all his objects; he then changed the eye levels, split the individual object planes, and combined all of these views in the same painting, creating a composite view of the group. Cézanne often shifted his viewpoint of a single object from the right side to the left side and from the top to the bottom, creating the illusion of looking around it. To see these multiple views of the actual object, we would have to move around it or revolve it in front of us; this act would involve motion, space, and time.

The Cubists adopted many of Cézanne's pictorial devices. They usually showed an object from as many views as suited them. Objects were rendered in a type of orthographic drawing, divided into essential views that could be drawn in two dimensions, not unlike the Egyptian technique previously cited (see "Fractional Representation," pp. 188–189, and figs. 8.12 and 8.13). The basic view (the top view) is called a plan. With the plan as a basis, the elevations (or profiles) were taken from the front and back, and the sections were taken from the right and left sides (fig. 8.47). The juxtaposition of these views in a painting showed much more of the object than would normally be visible. The technique seems a distortion to the lay spectator conditioned to a static view, but within the limits of artistic selection, everything is present that we would ordinarily expect to see (fig. 8.48).

In the works of the Cubists, we find that a picture can have a life of its own and that the creation of space is not essentially a matter of portrayal or rendering. The Cubists worked step-by-step to illustrate that the more a painted object departs from straightforward optical resemblance, the more systematically could the full three-dimensional nature of the object be explored. Eventually, they developed the concept of the "synthetically" designed picture. Instead of analyzing a subject, they began by developing large, simple geometric shapes, divorced from a model. Subject matter suggested by the shapes was then imposed or synthesized into this spatial system (see fig. 4.8).

PICTORIAL REPRESENTATIONS OF MOVEMENT IN TIME

From time immemorial, artists have grappled with the problem of representing movement on the stationary picture surface. In the works of prehistoric and primitive humans, the efforts were not organized but were isolated attempts to show a limited phase of observed movement.

▲ 8 • 50

Roger Brown, *Giotto and His Friends (Getting Even)*, 1981. Oil on canvas, 6 ft × 8 ft ³⁄₈ in. (1.83 × 2.45 m).

Contemporary artist Roger Brown has used the historical technique of segmental narrative. Each segment of the work is a portion of an unfolding story.

Private collection. Photograph courtesy of the Phyllis Kind Galleries, Chicago and New York. (Photograph by William H. Bengtson.)

▲ 8 • 49

Unknown, *David and Goliath*, c. 1250. Manuscript dimensions: 15³⁄₈ × 11³⁄₄ in. (39 × 30 cm).

The element of time passing is present here but in a conventional episodic manner. The order of events proceeds in a style similar to that of a comic strip.

Pierpont Morgan Library, New York, M.638 f.28v./Art Resource, New York.

In an early attempt to add movement to otherwise static figures, Greek sculptors organized the lines in the draperies of their figures to accent a continuous flowing direction. By following these linear accents, the eye of the observer readily moves smoothly over the figure's surface.

The artists of the Medieval and early Renaissance periods illustrated biblical stories by repeating a series of still pictures. The representation of the different phases of the narrative (either in sequence of several pictures or a

sequence within a single work) created a visual synopsis of the subject's movement, the time period, and the space covered. These pictures were antecedents of modern comic-strip and motion-picture techniques, whose individual frames, when projected at speed, provide the illusion of movement (figs. 8.49 and 8.50; see fig. 8.37).

Another representational means that has been used to suggest movement superimposes a series of views of a stationary figure or its parts within a single pictorial arrangement. This

technique in essence catalogs the sequence of position of a moving body, indicating the visible changes. Twentieth-century artists have explored the possibility of fusing these changing figure positions by filling out the pathway of its movement. Figures are not seen in fixed positions but as abstract moving paths of action. The subject in Marcel Duchamp's *Nude Descending a Staircase* is not the human body but the type and degree of energy the human body emits as it passes through space. This painting signified important progress in the pictorialization of motion, because the plastic forces are functionally integrated with the composition (fig. 8.51).

The Futurists (see the "Futurism" section in Chapter 10, p. 278) were devoted to motion for its own sake. They included not only the shapes of figures

and objects and their pathways of movement but also their backgrounds. These features were combined in a pattern of kinetic energy. Although this form of expression was not entirely new, it provided a new type of artistic adventure—simultaneity of figure, object, and environment (figs. 8.52 and 8.53). Motion pictures, which were a part of the culture during the period, almost certainly influenced these artists (see the following discussion of motion pictures). Contemporary artists continue to experiment with the concept of movement, subject, and surroundings (figs. 8.54, 8.55, and 8.56).

The exploration of space in terms of the four-dimensional space–time continuum is in its infancy. As research reveals more of the mysteries of the natural world, artists will continue to absorb and interpret them according to their individual experiences. It is reasonable to assume that even more revolutionary concepts will emerge in time, producing great changes in art styles. The important point to remember is that distortions and unfamiliar forms of art expression do not occur in a vacuum; they usually represent earnest efforts to apprehend and interpret our world in terms of the latest frontiers of understanding.

Motion Pictures

Modern scientific study of the optics of an object in motion began around 1824 and paralleled the discovery and development of photography. Among the pioneers to link photography with the study of motion were Coleman Sellers, an engineer, and the English American, Eadweard Muybridge, a photographer who used a Zoetrope, a drumlike wheel, to roll into view individual photographs that projected as animated images. Muybridge, clearly the investigative leader, was known for his photographs of animals and people in motion (fig. 8.57). He drew worldwide acclaim from his extensive public lectures and book publications. The French painter Jean Louis Meissonier was known to be one of his correspondents.

Throughout the entertainment motion picture industry, art house films have been viewed as escapism from the Hollywood-type productions. The more serious, realistic, lifelike films have come mostly from Europe. Some, like the Surrealistic film, "The Andalusian Dog" of 1929, which was created by the painter Salvador Dali and Luis Buñel, were personal and emotional accomplishments.

In 1923, Eastman Kodak developed 16-mm fireproof celluloid film, and in

▲ 8 • 51

Marcel Duchamp, *Nude Descending a Staircase, No. 2,* 1912. Oil on canvas, 58 × 35 in. (147.3 × 88.9 cm).

The subject of Duchamp's painting is not the human body itself, but the type and degree of energy a body emits as it passes through space.

Philadelphia Museum of Art, PA. Louise and Walter Arensberg Collection. Photo: Corbis Media. © 1997 Artist Rights Society (ARS), New York/ADAGP, Paris/Estate of Marcel Duchamp.

▶ 8 • 52

Giacomo Balla, *Dynamism of a Dog on a Leash,* 1912. Oil on canvas, 35³⁄₈ × 43¹⁄₄ in. (89.9 × 109.9 cm).

To suggest motion as it is involved in time and space, Balla invented the technique of repeated contours. This device soon became commonly imitated in newspaper comic strips, thereby becoming a mere convention.

Albright-Knox Art Gallery, Buffalo, NY. Bequest of A. Conger Goodyear and Gift of George F. Goodyear, 1964.

▲ 8 • 54
Renato Bertelli, *Continuous Profile of Mussolini,* 1933 (later manufactured by Ditta EFFEFFE, Milan, with Mussolini's approval). Bronzed terra-cotta, 11¾ in. high × 9 in. diameter (29.8 cm high × 22.9 cm in diameter).
Bertelli, following the influence of the Futurists, explored the concepts of simultaneity and continuous movement in portraiture. Mussolini recognized the appeal to "modernity" and organized the mass distribution of the sculpture.

Courtesy of The Mitchell Wolfson Jr. Collection, The Wolfsonian–Florida International University, Miami Beach, Florida. Photograph by Bruce White.

▲ 8 • 53
Gino Severini, *Dynamic Hieroglyphic of the Bal Tabarin,* 1912. Oil on canvas with sequins, 63⅝ × 61½ in. (161.6 × 156.2 cm).
The works of the Futurists were devoted to motion for its own sake. They included not only the shapes of figures and objects and their pathways of movement but also their backgrounds. These features were combined in a pattern of kinetic energy.
The Museum of Modern Art, New York. Acquired through the Lillie P. Bliss Bequest. Photo © 1998 Museum of Modern Art. © 1997 Artists Rights Society (ARS), New York/ADAGP, Paris.

the 1960s 8-mm film—along with portable cameras, projectors, and other user-friendly equipment—were available so that artist/designers, teachers, students, home users, and professionals of nominal means could practically view, produce, and create films. Moreover, these improvements in picture taking and viewing have expanded the use of film from a

product for the entertainment industry to one for any inspired individual.

The motion picture camera in the hands of a creative person, regardless of experience, can lead to fantastic developments. Look to the career of Steven Spielberg. He has carried the dream of a youthful film student to the dominating role of the most highly recognized motion picture

producer/director in the world. Steven Spielberg, along with George Lucas, has dazzled the public with stunts and special effects and captivated popular imagination with films like *Star Wars, Close Encounters of the Third Kind,* and *Jurassic Park.* In addition, Andy Warhol used the motion picture camera to present everyday activities, such as sleeping, in a new way. ●

▲ 8 • 55

Dan Collins, *Of More Than Two Minds*, 1994. Three-dimensional laser digitizing, cast hydrocal from CNC wax original, $3\frac{3}{4} \times 3\frac{5}{8} \times 2\frac{1}{2}$ in.

Though inspired by timeless concepts of the body in motion, current technology has opened new means of exploration and expression.

Courtesy of the artist.

▲ 8 • 56

Arman, *Lava Bike*, 1991. Bicycle, brushes, acrylic paint on canvas, 48 × 60 × $12\frac{1}{2}$ in. (121.9 × 152.4 × 31.8 cm).

Fluid motion, speed, and environment are presented in new ways with modern materials and in a new, shallow three-dimensional format.

Courtesy of the artist.

▶ 8 • 57

Eadweard Muybridge, *A Horse's Motion Scientifically Considered*. Engravings after photographs, c. 1875.

An American rancher friend and supporter of Muybridge encouraged his studies of horses in motion, which proved that at some point in midgallop all four hooves leave the ground (note the top row, numbers 2, 3, and 4). The photographer took the series with some of the earliest fast-action cameras and went on to influence Manet (see fig. 10.16), Degas, and later artistic students of motion.

Hulton Deutsch Collection/Corbis.

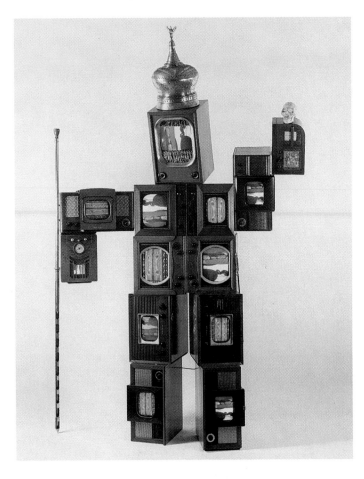

▲ 8 • 58
Nam June Paik, *Hamlet Robot*, 1996. 2 radios, 24 TVs, transformer, 2 laser disk players, laser disks, crown, scepter, sword, and skull. 144 × 88 × 32 in.
Nam June Paik's portrait of Hamlet is a video sculpture programmed with a kaleidoscopic mix of contemporary audio and visual technology.
Courtesy Carl Solway Gallery, Cincinnati, OH, from the collection of The Chrysler Museum of Art, Norfolk, VA. Photograph by Chris Gomien.

Television

Television (TV), the first of the truly electronic systems, extends the senses of vision (video) and hearing (audio). It instantaneously transmits still or moving images and the simultaneous accompanying sounds, either over electrical transmission lines or by electromagnetic radiation waves (radio waves). The most important constituent of the parts for transmission are the scanner, which breaks the image into a sequence of individual elements that can later be reassembled in their proper positions, and the picture tube, or the kinescope, which modulates the electrical impulses of the television signal into beams of electrons that strike the receiver's screen, producing light and a continuous picture. 💿

Somewhat like the motion picture camera, the television camcorder is a portable TV camera and, in addition, a videotape recorder. The camcorder has given individual artists a practical means for creating programs that offer direct action of human thoughts and movements. Art museums and galleries are currently featuring shows that have installations of TV receivers, monitors, and motion picture screens glowing with artistic images of every imaginable human expression or action. The receivers and screens are positioned for the utmost viewing and, in some installations, seemingly as if they were paintings, drawings, prints, or sculptures. Their sizes and scale are varied for compatible viewing.

The Korean-born artist, Nam June Paik, is the first artist to use television video monitors as an art form. Actually, Paik not only uses the monitor screen but the receiver's cabinet and its parts to build a sculptured form. He has produced numerous performance works, along with rewired TVs and multimonitor sculptures, in almost every possible arrangement. They include giant walls of television sets: *Information Wall* in 1992 with 429 monitors; *Megatron* in 1995 (fig. 8.58), which included 215 monitors with eight-channel color video and two-channel sound; and a blinking, flashing lights show using laser beams, TV sets, and a waterfall at the Guggenheim in 2000. They were brilliant displays!

The Computer and Art

Although name-brand computer manufacturers continually market their differences today, even the least expensive desktop computers are delivering such outstanding performance that they all seem to be more alike. On a worldwide basis, most companies manufacturing home desktop computers are producing computers with processors that use at the very least 350- to 500-MHz clock speeds, 64 MB (megabytes) of RAM, and Windows or Apple/Macintosh application operating programs. 💿

Perhaps the greatest differences may lie in the scope and quality of their multimedia technical support systems.

For instance, in order to operate some graphic programs, the computer's hard drive should be as large as 75 GB (gigabytes) and its bus circuitry an accompanying high of 133 MHz.

Multimedia

The computer has become an integral part of telecommunications. By using coaxial cable, fiber-optic cable, and twisted-pair cable, two-way transmission can take place between different computers (terminals), which in turn use the television, movie, and telephone systems. Computers have opened a new era of multimedia for communications, information gathering, and processing, which are changing the world like nothing before them. And indeed, computers have provided multimedia users access to writing processors and research and entertainment resources, as well as tools for creative artistic development, including motion explorations.

Multimedia may already be one of the most powerful educational and entertainment tools that a computer facilitates. First, as its name suggests, multimedia combines many different groups of varying media into a single unifying force. It combines such media as text, still and moving graphics (animation), and spoken and instrumental sounds into a single group. Secondly, these may be joined with the communication media: television (including cable and video), telephone (modem and Internet), and the movies (film and video).

Finally, because computers have become powerful enough to process almost any type of data that can be stored on a CD-ROM, programmers have added a seemingly endless group of program titles, among which many are available for ready use by artist/designers. This software has become more user-friendly with the means and tools for fantastic development. Some of the most

▲ **8 • 59**
Sheriann Ki-Sun Burnham, *Nomad,* **1996. Iris print, 22¼ × 22¼ in. (56.5 × 56.5 cm).** While encouraging the evolution of innovative graphic directions, the newest technology aids the artist in the investigation of texture, pattern, transparent layering, and the integration of the visual complexities within the layers.
Courtesy of the artist.

frequently used software programs include paint programs (drawing and painting), image manipulation, 3-D modeling, animation, digital video (motion sequences), and video compression. Many of the most talented artists create their own software so they can control the most implicit specialized areas.

Artists today take advantage of the many technological advances of our age. The many facets of multimedia generate images that are preparatory, simulative, or final art products. By these means, the human scene as it evolves in time, space, and action has become an inspiration for study and creativity in many exciting forms (fig. 8.59).

CHAPTER NINE

The Art of the Third Dimension

THE VOCABULARY OF THE THIRD DIMENSION

BASIC CONCEPTS OF THREE-DIMENSIONAL ART

Sculpture
Other Areas of Three-Dimensional Art
Architecture
Metalwork
Glass Design
Ceramics
Fiberwork
Product Design

THE COMPONENTS OF THREE-DIMENSIONAL ART

Materials and Techniques
Subtraction

Manipulation
Addition
Substitution
The Elements of Three-Dimensional Form
Shape
Value
Space
Texture
Line
Color
Time (the fourth dimension)
Principles of Three-Dimensional Order
Harmony and Variety
Balance
Proportion
Economy
Movement
Installations

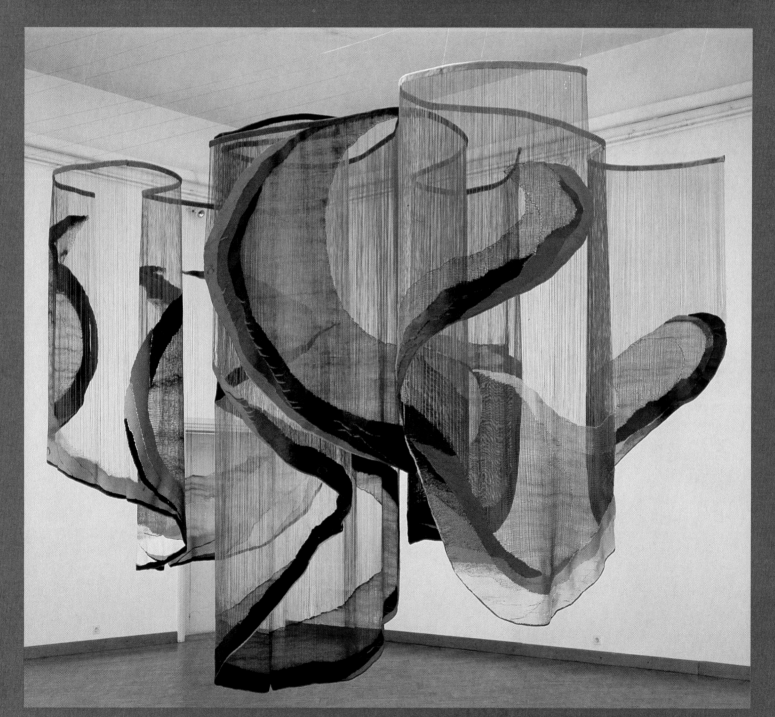

Eta Sadar Breznik, *Space*, 1995. Woven rayon, $157\frac{1}{2} \times 137\frac{7}{8} \times 137\frac{7}{8}$ in.

THE VOCABULARY OF THE THIRD DIMENSION

Three-dimensional Possessing, or creating the illusion of possessing, the dimension of depth as well as the dimensions of height and width.

addition
A sculptural term that means building up, assembling, or putting on material.

atectonic
Characterized by considerable amounts of space; open, as opposed to massive (or tectonic), and often with extended appendages.

Bauhaus
Originally a German school of architecture that flourished between World War I and World War II. The Bauhaus attracted many leading experimental artists of both two- and three-dimensional fields.

casting
A sculptural technique in which liquid materials are shaped by being poured into a mold.

glyptic
1. The quality of an art material like stone, wood, or metal that can be carved or engraved. 2. An art form that retains the color and the tensile and tactile qualities of the material from which it was created. 3. The quality of hardness, solidity, or resistance found in carved or engraved materials.

installations
Interior or exterior settings of media created by artists to heighten the viewers' awareness of the environmental space.

manipulation
The sculptural technique of shaping pliable materials by hands or tools.

mass (third dimension)
1. In graphic art, a shape that appears to stand out three-dimensionally from the space surrounding it or that appears to create the illusion of a solid body of material.
2. In the plastic arts, the physical bulk of a solid body of material.

mobile
A three-dimensional moving sculpture.

modeling
The sculptural technique of shaping a pliable material.

patina
1. A natural film, usually greenish, that results from the oxidation of bronze or other metallic material. 2. Colored pigments and/or chemicals applied to a sculptural surface.

relief sculpture
An art work, graphic in concept but sculptural in application, utilizing relatively shallow depth to establish images. The space development may range from very limited projection, known as "low relief," to more exaggerated space development, known as "high relief." Relief sculpture is meant to be viewed frontally, not in the round.

sculpture
The art of expressive shaping of three-dimensional materials. "Man's expression to man through three-dimensional form" (Jules Struppeck; see Bibliography).

shape (third dimension)
An area that stands out from the space next to or around it due to a defined or implied boundary or because of differences in value, color, or texture.

silhouette
The area between or bounded by the contours, or edges, of an object; the total shape.

substitution
In sculpture, replacing one material or medium with another (see also **casting**).

subtraction
A sculptural term meaning the carving or cutting away of materials.

tectonic
The quality of simple massiveness; lacking any significant extrusions or intrusions.

void
1. An area lacking positive substance and consisting of negative space. 2. A spatial area within an object that penetrates and passes through it.

volume (third dimension)
A measurable area of defined or occupied space.

BASIC CONCEPTS OF THREE-DIMENSIONAL ART

In the preceding chapters, our examination of art fundamentals has been limited mostly to the graphic arts. These art disciplines (drawing, painting, photography, printmaking, graphic design, and so on) have two dimensions (height and width), existing on a flat surface and generating sensations of space mainly through illusions created by the artist. This chapter deals with the unique properties of ▪ **three-dimensional** artwork and the creative concepts that evolve from these properties.

In three-dimensional art, the added dimension is that of actual depth. This depth results in a greater sense of reality and, as a consequence, increases the physical impact of the work. This is true because a graphic work is usually limited to one format plan, always bounded by a geometrically shaped picture frame, while a three-dimensional work is limited only by the outer extremities of its multiple positions and/or views. The three-dimensional format, although more complicated, offers greater freedom to the artist and greater viewing interest to the spectator.

Because actual depth is fundamental to three-dimensional art, one must be in the presence of the artwork to fully appreciate it. Words and graphic representations of three-dimensional art are not substitutes for actual experience. Two-dimensional depictions are flat, rigid, and representative of only one viewpoint; however, they do serve as a visual shorthand for actual sensory experiences. In this text, and particularly in this chapter, we use two-dimensional descriptions, by way of text and photographic reproductions, as the most convenient means of conveying the three-dimensional experience. But we

▶ **9 • 1**
Isamu Noguchi, *The Stone Within*, 1982. Basalt, 75 × 38 × 27 in. (190.5 × 96.5 × 68.6 cm).
The sculptor Noguchi has subtracted just enough stone in this work to introduce his concept of minimal form while preserving the integrity of the material and its heavy, weighty mass.
Isamu Noguchi Foundation. Photograph by Michio Noguchi.

emphatically encourage readers to put actual observation into practice.

Practicing artists and art authorities designate the three-dimensional qualities of objects in space with such terms as form, shape, mass, and volume. The term *form* can be misleading here, because its meaning differs from the definition applied in early chapters—the inventive arrangement of all the visual elements according to principles that will produce unity. In a broad structural sense, form is the sum total of all the media and techniques used to organize the three-dimensional elements within an artwork. In this respect, a church is a total form and its doors are contributing shapes; similarly, a human figure is a total form, while the head, arms, and legs are contributing shapes. However, in a more limited sense, form may just refer to the appearance of an object—to a contour, a shape, or a structure. ▪ **Shape,** when used in a three-dimensional sense, may refer to a positive or open negative area. By comparison, ▪ **mass** invariably denotes a solid physical object of relatively large weight or bulk. Mass may also refer to a coherent body of matter, like clay or metal, that is not yet shaped or to a lump of raw material that could be modeled or cast. Stone carvers,

accustomed to working with ▪ **glyptic** materials, tend to think of a heavy, weighty mass (fig. 9.1); modelers, who manipulate clay or wax, favor a pliable mass. ▪ **Volume** is the amount of space the mass, or bulk, occupies, or the three-dimensional area of space that is totally or partially enclosed by planes, linear edges, or wires. Many authorities conceive of masses as positive solids and volumes as negative open spaces. For example, a potter who throws a bowl on a wheel adjusts the dimensions of the

▶ **9 • 2**
John W. Goforth, *Untitled*, 1971. Cast aluminum, 15¾ in. (40 cm) high with base.
The volume incorporates the space, both solid and empty, that is occupied by the work.
Collection of Otto Ocvirk. Courtesy of Carolyn Goforth.

interior volume (negative interior space) by expanding or compressing the clay planes (positive mass). The sculptor who assembles materials may also enclose negative volumes to form unique relationships (fig. 9.2).

Looking more widely, most objects in our environment have three-dimensional qualities of height, width, and depth and can be divided into natural and human-made forms. Although natural forms may stimulate the thought processes, they are not in themselves creative. Artists invent forms to satisfy their need for self-expression. In the distant past, most three-dimensional objects were created for utilitarian purposes. They included such implements as stone axes, pottery, hammers, and knives, as well as objects of worship. Nearly all these human-made forms possessed qualities of artistic expression; many depicted the animals their creators hunted. These prehistoric objects are now considered an early expression of the sculptural impulse.

▽ **9 • 3**
Joan Livingstone, *Seeped*, 1997–2000. Felt, stain, resin, pigment, and steel, 112 × 36 × 96 in. (284.5 × 91.4 × 243.8 cm).
Modern sculpture exploits every conceivable material that suits the intentions of the artist.
Courtesy of the artist and the SYBARIS Gallery, Royal Oak, MI. Photograph by Michael Tropea.

SCULPTURE

The term *sculpture* has had varied meanings throughout history. The word derives from the Latin verb *sculpere,* which refers to the process of carving, cutting, or engraving. The ancient Greeks' definition of ■ **sculpture** also included the ■ **modeling** of such pliable materials as clay or wax to produce figures in relief or in the round. The Greeks developed an ideal standard for the sculptured human form that was considered the perfect physical organization—harmonious, balanced, and totally related in all parts. The concept of artistic organization was part of the definition of sculpture (see fig. 2.42).

Modern sculpture has taken on new qualities in response to the changing conditions of an industrialized age. Science and machinery have made

sculptors more conscious of materials and technology and more aware of the underlying abstract structure in their art.

Sculpture is no longer limited to carving and modeling. It now refers to any means of giving intended form to all types of three-dimensional materials. These means include welding, bolting, riveting, gluing, sewing, machine-hammering, and stamping. In turn, the three-dimensional artists have expanded their range of sculptural forms to include planar, solid, and linear constructions made of such materials as steel, plastic, wood, and fabric (fig. 9.3). The resulting sculptures are stronger (even though made of lighter materials) and more open. They also have expanded spatial relationships. Three-dimensional forms like wire constructions and ■ **mobiles** have changed the definition of sculpture that, prior to the nineteenth century, would have included only solid, heavy, and sturdy glyptic forms. Michelangelo Buonarroti, an innovative sculptor within his Renaissance time frame, thought only in terms of massive materials and heavy figures (fig. 9.4).

The diversity of newfound materials and techniques has led to greater individual expression and artistic freedom. Sculptors experiment with new theories and have found new audiences and new markets (fig. 9.5).

OTHER AREAS OF THREE-DIMENSIONAL ART

The bulk of this book has addressed works of pure or fine art that have no practical function. But sensitivity to the sculptural (and/or artistic) impulse is not confined to the fine arts; it permeates all three-dimensional structures. The same abstract quality of expressive beauty that is the foundation for a piece of sculpture can underlie such functional forms as automobiles, television receivers, telephones, industrial equipment, window and interior displays, furniture, and buildings (fig. 9.6). Artist-designers of these three-dimensional products organize elements, shapes, textures, colors, and space

9 • 4
Michelangelo Buonarroti, *The Bearded Captive,*
c. 1516–27. Marble, 8 ft 8¼ in. (2.65 m) high.
Michelangelo created heavy, massive sculpture and enlarged the sizes of human body parts for expressive purposes. The tectonic composition was in keeping with the intrinsic nature of the stone.
Accademia, Florence, Italy. © Arte & Immagine srl/Corbis.

9 • 5
Naum Gabo, *Linear Construction in Space No. 1 (Variation),*
1942–43 (enlargement 1957–58). Plexiglas with nylon
monofilament, 24¾ × 24¾ × 9½ in. (62.9 × 62.9 × 24.1 cm).
Naum Gabo was an early pioneer in the Constructivist movement. He created sculptures free of traditional figures with such new materials as the sheet plastic seen here.
Patsy R. and Raymond D. Nasher Collection, Dallas, TX. Photograph by David Heald.

▲ 9 • 6
Pontiac Protosport concept car, 2001 GM Corp. Mixed media, full scale.
New concepts in automotive design are determined by advances in technology, engineering, economics, and visual appearance. One of the stages of the design process is shown here as artisans model the basic form.
2001GM Corp. Used with permission of the GM Media Archives.

▶ 9 • 7
Armchair designed by Frank Lloyd Wright for the Ray W. Evans House, Chicago, IL, made by Neideken and Walbridge, c. 1908. Oak, $34\frac{1}{4} \times 23 \times 22\frac{1}{2}$ in. (86.9 \times 58.5 \times 57.1 cm).
To Wright, form and function were inseparable, so a chair, which functions for sitting, should be considered along with the whole architectural environment.
Art Institute of Chicago. Gift of Mr. and Mrs. F. M. Fahrenwald, 1970.435. Photo © Art Institute of Chicago. All rights reserved. © 1998 Artists Rights Society (ARS), New York/Frank Lloyd Wright Foundation.

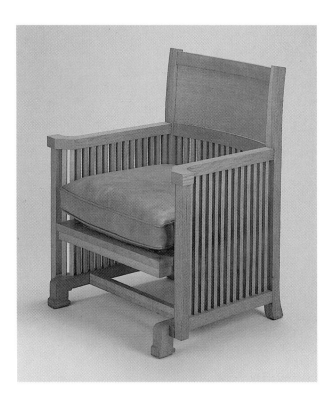

according to the same principles of harmony, proportion, balance, and variety as are used in the fine arts. Although form principles can be applied to such useful objects, the need for utility often restricts the creative latitude of the artist.

The famous architect Louis Sullivan made the oft-repeated remark that "form follows function." This concept has influenced several decades of design, changing the appearance of tools, telephones, silverware, chairs, and a vast array of other familiar and less familiar items. Sometimes this concept is misapplied. The idea of streamlining is practical when applied to the design of such moving objects as trains and cars, because it has the function of reducing wind resistance. However, streamlining has no logical application for the design of spoons and lamps. Although streamlining is helpful in eliminating irrelevancies from design, even simplification can be overdone. The ■ **Bauhaus** notion of the house as a "machine for living" helped architects rethink architectural principles, but it also produced many cold and austere structures against which there was inevitable reaction.

Contemporary designers are very aware of the functional needs of the objects they plan. Consequently, they design forms that express and aid function. However, designers also know that these objects need to be aesthetically pleasing. All of this points out that the creator of functional objects must be able to apply the principles of fundamental order within the strictures of utilitarian need. Frank Lloyd Wright, the celebrated American architect, combined architecture, engineering, and art in shaping his materials and their environment. The unity of his ideas is expressed in the chair he designed for the Ray Evans House (fig. 9.7). The sophisticated design and formal balance that Wright incorporated into this ordinary object can be seen in his highly selective repetitions, proportional relationships, and detail refinement.

The balance that exists between design, function, and expressive content within an object varies with each creator. For instance, when designing his rocking lounge chair, Michael Coffey placed strong emphasis on expressive form without totally sacrificing the function of reclining comfort (fig. 9.8). At first glance, we are drawn in by the chair's dominant outer contour and by its open shape. This unique piece of furniture resembles many freely expressed contemporary sculptures. Expressive form follows function in a new and creative way.

Tremendous developments have taken place in the general areas of three-dimensional design where works usually serve some functional purpose.

Architecture

Recent technological innovations and new building materials have given architects greater artistic flexibility. Thanks to developments in the steel and concrete industries, buildings can now be large in scale without projecting massive, weighty forms. With the advent of electric lighting, vast interior spaces can be illuminated. Because of air conditioning, buildings can be completely enclosed or sheathed in glass. Cantilevered forms can be extended into space. Sophisticated free-formed shapes can be created with the use of precast concrete. All of these structural improvements have allowed architects to think and plan more freely. Contemporary public buildings that demonstrate these developments include the National Assembly Building at Sher-e-Bangla Nagar, in Dhaka, Bangladesh (fig. 9.9); the Lincoln Center for the Performing Arts in New York; the Kennedy Center in Washington, D.C.; the Jefferson Westward Expansion Memorial in St. Louis; and the Los Angeles City Hall and Civic Center. In many ways architects today are "building sculptors," and their designs require a thorough grounding in artistic principles as well as

▲ 9 • 8

Michael Coffey, *Aphrodite* (a rocking lounge chair), 1978. Laminated mozambique, 4 ft 6 in. × 7 ft 6 in. × 28 in. (137 × 229 × 71.1 cm).
A useful household article can be transformed by the style of contemporary sculpture.
Courtesy of the artist. Photograph by Rich Baldinger, Schenectady, NY.

▲ 9 • 9

Louis I. Kahn, National Assembly Building at Sher-e-Bangla Nagar in Dhaka, Bangladesh, 1962–83. Poured concrete, wood, brick.
Louis Kahn, an American architect, shows his unique use of geometry in a simple, massive sculpturelike structure.
© Khaled Nowan/Architectural Association Slide Library, London.

▲ **9 • 10**
Frank Gehry, _Model for a New Guggenheim Museum in New York City,_ 2000.
Architect Frank Gehry proposed this free-flowing sculpturelike design to house art from the twentieth century.
Frank O. Gehry & Associates. Photograph by David Heald. © Solomon R. Guggenheim Foundation, New York.

▲ **9 • 11**
Marilyn da Silva, _The Golden Pair,_ 1996. Copper, brass, 24K gold-plate, gesso, colored pencil, (each teapot) 3½ in. h × 6 in. w × 2½ in.d (8.9 × 15.2 × 6.4 cm).
This pair of pears, as teapot dwellings, reflects the artist's use of personal symbolism in a sculptural approach to metalwork.
Courtesy of the artist. Photograph by Philip Cohen.

an understanding of engineering concepts. This may be seen in Frank Gehry's Guggenheim Museum in Bilbao, Spain, and the proposed Guggenheim South Street Seaport project (fig. 9.10).

Metalwork

Most of the changes in metalworking (jewelry, decorative and functional ware, and so on) have been in concept rather than technique. Traditional techniques are still in use, although modern equipment has made procedures simpler and more convenient. To a large degree, fashion determines the character of metalwork, but it is safe to say that contemporary work is larger and more oriented toward sculpture than most work of the past. Constant cross-fertilization occurs among the art areas, and metalwork is not immune to these influences. The metalworker benefits from studying the principles of both two- and three-dimensional art (fig. 9.11).

Glass Design

Glassworking is similar to metalworking now that modern equipment has simplified traditional techniques. Designing glass objects, however, is very much an art form of recent times. Many free-form and figurative pieces have the look of contemporary sculpture. Colors augment the designs in a decorative, as well as an expressive, sense. Thus, the principles of art structure are integrated with the craft of the medium (fig. 9.12).

Ceramics

In recent years the basic shape of the ceramic object has become more sculptural as ceramic work has become, in many cases, less functional. The ceramist must be equally aware of three-dimensional considerations and of the fundamentals of graphic art, because individual surfaces may be altered by incising, painting with colored slips, fuming, or glazing (fig. 9.13).

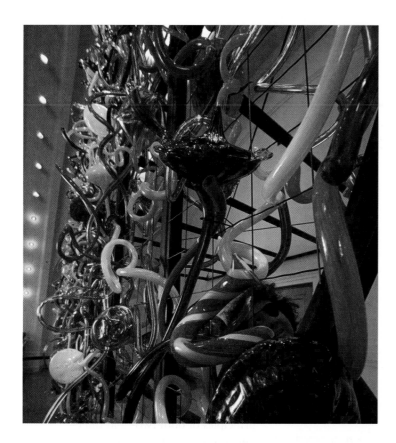

◁ **9 • 12**

Dale Chihuly, *Lakawanna Ikebana,* 1994. Blown glass, 18 ft. diameter.

These magnificent glass pieces are most unusual and creative in their scale, coloring, shape definition, and total environmental concept.

Courtesy of the artist. From the Union Station Federal Courthouse, Tacoma, Washington. Photograph by Russell Johnson © Chihuly Studio.

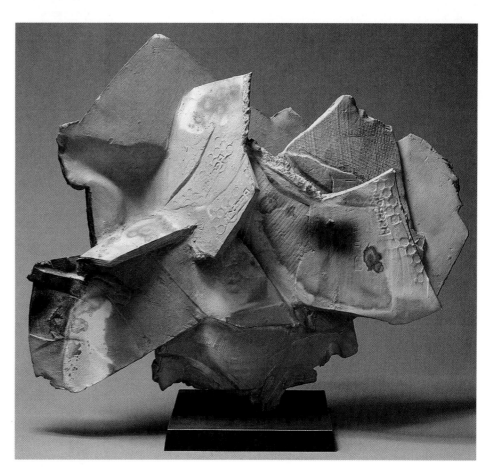

▷ **9 • 13**

Paul Soldner, *Pedestal Piece (907),* 1990. Thrown and altered clay with slips and low temperature salt glaze, 27 × 30 × 11 in. (68.6 × 76.2 × 27.9 cm).

The coloring resulting from the controlled firing process enhances the sculptural composition of the clay piece.

Scripps College, Claremont, CA. Gift of Mr. and Mrs. Fred Marer, 92.1.154.

Fiberwork

Fiberwork has undergone a considerable revolution recently. Three-dimensional forms are becoming increasingly more common, particularly as the traditional making by hand of rugs and tapestries has diminished. Woven objects now include a vast array of materials incorporated into designs of considerable scale and bulk. Traditional as well as contemporary concepts of fiberwork require an understanding of both two- and three-dimensional principles (fig. 9.14).

Product Design

A relative newcomer on the art scene, product design usually has commercial applications. The designer produces works based on function but geared to consumer appeal. To be contemporary in appearance and thus attractive to consumers, products must exploit all the design principles of our age. The designs of common objects in our daily environment are the products of the designer's training in these various principles.

▼ 9 • 14
Eta Sadar Breznik, _Space_, 1995. Woven rayon, 157½ × 137⅞ × 137⅞ in. (400 × 350 × 350 cm).
Contemporary textile design frequently goes beyond its largely two-dimensional traditions.
Ljubljana, Slovenia. Photo © Boris Gaberšček.

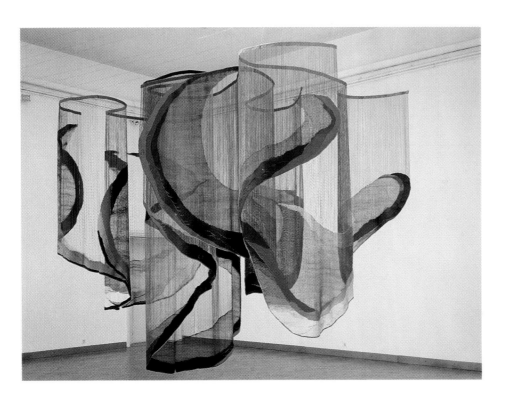

THE COMPONENTS OF THREE-DIMENSIONAL ART

Subject, form, and content—the components of graphic art—function in much the same manner in the plastic arts. The emphasis placed on each of the components, however, may vary. For example, sculptors use the components for expressive purposes. Architects, ceramists, and metalsmiths, while expressive, may also interpret form for the sake of utility and ornamentation.

Formal organization is more complex in three-dimensional art than in the graphic arts. Materials developed in actual space through physical manipulation exist in a tactile, as well as in a visual, sense. The resulting complexities expand the content or meaning of the form.

MATERIALS AND TECHNIQUES

Materials and techniques also play larger roles in three-dimensional art than in graphic art. In the last 100 years the range of three-dimensional materials has expanded from basic stone, wood, and bronze to steel, plastic, fabric, glass, laser beams (holography), fluorescent and incandescent lighting, and so on. Such materials have revealed new areas for free explorations within the components of subject, form, and content. But they have also increased our responsibilities for fully understanding three-dimensional materials and their accompanying technologies. The nature of the materials puts limitations on the structures that can be created and the techniques that can be used. For example, clay modelers adapt the characteristics of clay to their concept. They manipulate the material with their hands, a block, or a knife to produce a given expression or idea. Modelers don't

try to cut the clay with a saw. They understand the characteristics of their material and adapt the right tools and techniques to control it. They also know that materials, tools, and techniques are not ends in themselves but necessary means for developing a three-dimensional work (fig. 9.15).

The four primary technical methods for creating three-dimensional forms are ▪ **subtraction,** ▪ **manipulation,** ▪ **addition,** and ▪ **substitution.** Although each of the technical methods is developed and discussed separately in the following sections, many three-dimensional works are produced using combinations of the four methods.

Subtraction

Artists cut away materials capable of being carved (glyptic materials), such as stone, wood, cement, plaster, clay, and some plastics. They may use chisels, hammers, torches, saws, grinders, and polishers to reduce their materials (fig. 9.16). It has often been said that when carvers take away material, they "free" the image frozen in the material, and a sculpture emerges. The freeing of form by the subtraction method, although not simple, produces unique qualities characteristic of the artist's material.

Manipulation

Widely known as modeling, manipulation relates to the way materials are handled. Clay, wax, and plaster are common media that are pliable or that can be made pliable during their working periods. Manipulation is a direct method for creating form. Artists can use their hands to model a material like clay into a form that, when completed, will be a finished product. For additional control, special tools, such as wedging boards, wires, pounding blocks, spatulas, and modeling tools (wood and metal), are used to work manipulable materials (fig. 9.17).

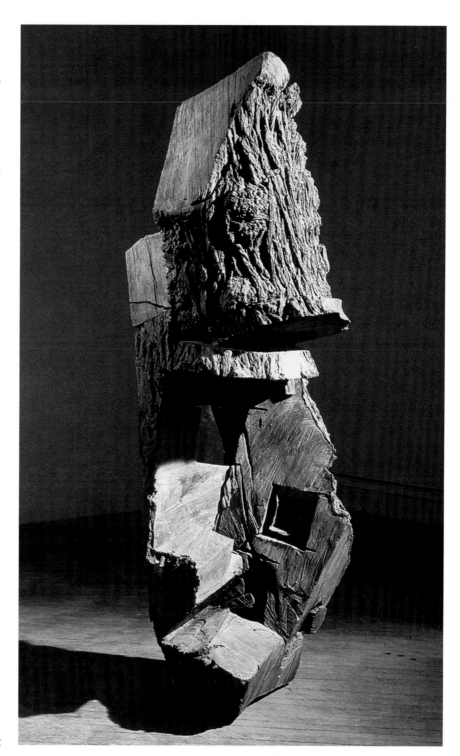

▲ **9 • 15**
Mel Kendrick, *Bronze with Two Squares,* 1989–90. Bronze (edition of three), 73 × 28 × 28 in. (185.4 × 71.1 × 71.1 cm).
This piece appears to be made of wood, but it is actually bronze that has been colored chemically to resemble weathered wood. The sculptor has to know his materials well to create this kind of *trompe l'oeil* effect.
Courtesy of John Weber Gallery, New York.

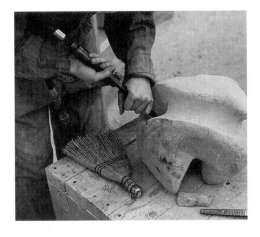

▲ 9 • 16
Subtracting stone.
In the subtractive process, the raw material is removed until the artist's conception of the form is revealed. Stone can be shaped manually or with an air hammer, as above.
Photograph courtesy of Ronald Coleman.

Manipulable materials respond directly to human touch, leaving the artist's imprint, or are mechanically shaped to imitate other materials. Although many artists favor the honest autographic qualities of pliable materials, others—especially those in business and manufacturing—opt for the economics of quick results and fast change. Techniques and materials are important because both contribute their own special quality to the final form.

Because most common manipulable materials are not durable, they usually undergo further technical change. For instance, clay may be fired in a kiln (fig. 9.18) or cast in a more permanent material like bronze.

Addition

Methods of addition may involve greater technology and, in terms of (nonfunctional) sculpture, have brought about the most recent innovations. When using additive methods, artists add materials that may be pliable and/or fluid, such as plaster or cement (see figs. 9.22B and C). They assemble materials like metal, wood, and plastic with tools (a welding torch, soldering gun, or stapler, and so on) and fasteners (bolts, screws, nails, rivets, glue, rope, or even thread) (fig. 9.19; see fig. 9.3).

Because three-dimensional materials and techniques are held in high esteem today, the additive methods, with great range, freedom, and diversity, offer solutions to many three-dimensional form challenges.

Substitution

Substitution, or ■ **casting,** is almost always a technique for reproducing an original three-dimensional model. Sometimes an artist alters the substitution process to change the nature of the cast. Basically, in this technique, a model in one material is exchanged for a duplicate form in another material, called the cast, and this is done by means of a mold. The purposes of substitution are first, to duplicate the model, and second,

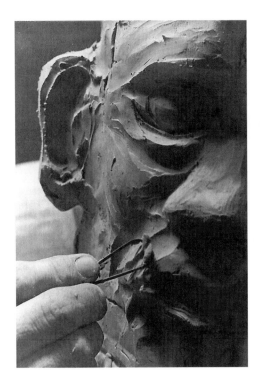

▲ 9 • 17
In this example of the manipulation technique, clay is removed with a loop tool. Clay may be applied to the surface with fingers, hands, or other tools.
Photograph courtesy of Ronald Coleman.

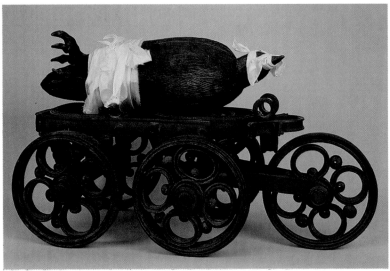

▲ 9 • 18
David Cayton, *One Dead Tern Deserves Another*, 1990. Ceramics, primitive firing, 18 in. (45.7 cm) high.
This is an example of clay that has been fired in a primitive kiln: the heavy reduction firing has caused the clay surfaces to turn black.
Courtesy of the artist. Photograph by Lynn Whitney.

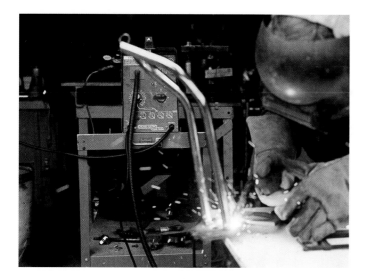

▲ **9 • 19**
Welding.
In the additive process, pieces of material are attached to each other, and the form is gradually built up. Welded pieces such as the one illustrated are often, though not always, more open than other sculptural techniques.

Photograph courtesy of Ronald Coleman.

▲ **9 • 20**
Substitution technique.
In the substitution process, molten metal is poured into a sand mold that was made from a model.

Photograph courtesy of Ronald Coleman.

to change the material of the model, generally to a permanent one. For example, clay or wax can be exchanged for bronze (fig. 9.20), fiberglass, or cement. A variety of processes (sand casting, plaster casting, lost-wax casting, and so on) and molds (flexible molds, waste molds, piece molds, and so on) are used in substitution. Substitution is the least creative or inventive of the technical methods because it is imitative; the creativity lies in the original, not in the casting process. ◉

Besides acquiring a knowledge of three-dimensional materials and their respective techniques, artists must also be aware of the elements of form.

THE ELEMENTS OF THREE-DIMENSIONAL FORM

Three-dimensional form is composed of the visual elements: shape, value, space, texture, line, color, and time (the fourth

dimension). The order of listing is different from that for two-dimensional art and is based on significance and usage.

Shape

The artist working in three dimensions instinctively begins with shape. Shape, a familiar element in the graphic arts, takes on expanded meaning in the plastic arts. It implies the totality of the mass or volume lying between its contours, including any projections and depressions. It may also include interior planes. We can speak of the overall space-displacing shape of a piece of sculpture or architecture, of the flat or curved shape that moves in space, or of a negative shape that is partially or totally enclosed. These shapes are generally measurable areas limited by and/or contrasted with other shapes, values, textures, and colors. The three-dimensional artist can clearly define the actual edges of shape borders (fig. 9.21). Ill-defined edges often lead to viewers'

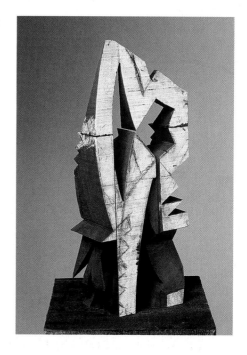

▲ **9 • 21**
**Mel Kendrick, *White Wall*, 1984.
Basswood, Japan paint, 16 × 5 × 6½ in. (40.6 × 12.7 × 16.5 cm).**
The shape of this three-dimensional piece has edges that have been clearly defined.

Courtesy of John Weber Gallery, New York.

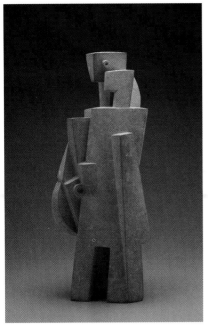

A

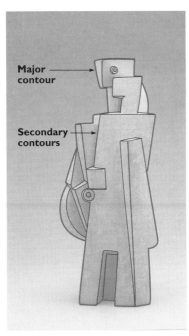

B

◁ **9 • 22**

Jacques Lipchitz, *Man with Mandolin*, 1917. Limestone, 29¾ in. high (75.6 cm).

Exploring Lipchitz's work in the round from every position reveals the changing contours and makes the three-dimensional work exciting. In figure 9.22B, an isolated view of the image, the major contour surrounds the silhouette or the total visible area of the work. Secondary contours occur on internal edges.

Yale University Art Gallery. Gift of The Societe Anonyme Collection.

◁ **9 • 23**

Ken Price, *Pacific*, 2000. Fired and painted clay, 21.5 × 11.75 × 9.5 in. (54.6 × 28.6 × 24.1 cm).

The major contour of *Pacific* is its outermost edge. Secondary contours are nonexistent or, at best, minimal.

© Ken Price, courtesy of L.A. Louver, Venice, California. Photograph by Brian Forrest.

confusion or monotony. Shape edges guide the eye through, around, and over the three-dimensional surface.

In three-dimensional art the visible shape depends on the viewer's position. A slight change of position results in a change in shape. A major contour is the outer limit of the total three-dimensional work as seen from one position (figs. 9.22A and B). Secondary contours are perceived edges of shapes or planes that move across and/or between the major contours. Some three-dimensional works are constructed so that the secondary contours are negligible (fig. 9.23).

A shape might be a negative space—a three-dimensional open area that seems to penetrate through or be contained by solid material. Open shapes can be areas that surround or extend between solids. Such open shapes are often called ■ **voids.** Alexander Archipenko and Henry Moore, prominent twentieth-century sculptural innovators, pioneered the use of void shapes (fig. 9.24, see figs 9.26 and 10.79). Voids provided new spatial extensions for these artists; they revealed interior surfaces, opened direct routes to back sides of the sculpture, and reduced excessive weight.

▲ 9 • 24

Alexander Archipenko, *Woman Doing Her Hair.* c. 1958. Bronze casting from plaster based on original terracotta of 1916, 21⅝ in. (55 cm) high.

This is a significant example of sculptural form where the shape creates negative space, or a void. Archipenko was one of the pioneers of this concept.

Courtesy of the Kunst Museum, Düsseldorf, Germany. Photograph by Walter Klein.

▲ 9 • 25

José de Rivera, *Brussels Construction,* 1958. Stainless steel, 3 ft 10½ in. × 6 ft 6¾ in. (1.18 × 2 m).

The concept of attracting observers to a continuous series of rewarding visual experiences as they move about a static three-dimensional work of art led to the principle of kinetic or mobile art, as with this sculpture set on a slowly turning motorized plinth.

Art Institute of Chicago. Gift of Mr. and Mrs. R. Howard Goldsmith, 1961.46. Photo © 1998. Art Institute of Chicago. All rights reserved.

▲ 9 • 26

Julie Warren Martin, *Marchesa,* 1988. Italian Botticino Marble, 28 × 12 × 10 in. (71.1 × 30.5 × 25.4 cm).

A piece of sculpture "paints" itself with values. The greater the projections and the sharper the edges, the greater and more abrupt the contrasts.

From the Collection of Kirby and Priscilla Smith.

Void shapes should be considered integral parts of the total form. In linear sculpture, enclosed void shapes become so important that they often dominate the width, thickness, and weight of the materials that define them (fig. 9.25).

Value

As the artist physically manipulates three-dimensional shapes, contrasting values appear through the lights and shadows produced by the forms. Value is the quantity of light actually reflected by an object's surfaces. Surfaces that are high and facing a source of illumination are light, while surfaces that are low, penetrated to any degree, or facing away from the light source appear dark. Any angular change of two juxtaposed surfaces, however slight, results in changed value contrasts. The sharper the angular change, the greater the contrast (fig. 9.26).

When any part of a three-dimensional work blocks the passage of light, shadows result. The shadows change as the position of the viewer, the work, or its source of illumination changes. If a work has a substantial high and low shape variation and/or penetration, the shadow patterns are more likely to define the work, regardless of the position of the light source. Sculptors who create mobiles typify artists interested in continuously changing light and shadow. The intensity of light markedly changes the shadow effect as the object moves.

Value changes can also be affected by painting a three-dimensional work. Light values strengthen the shadows, while

◀ **9 • 27**

Richard Lippold, *Variation within a Sphere, No. 10, the Sun,* 1953–56. 22-carat gold-filled wire, 11 × 22 × 5½ ft (3.35 × 6.70 × 1.68 m).

Development of welding and soldering techniques for use in sculpture made the shaping and joining of thin linear metals possible, as in this work by Lippold.

Metropolitan Museum of Art, New York. Fletcher Fund, 1956. Photo © Metropolitan Museum of Art, all rights reserved.

dark values weaken them. The lighter values work best on pieces that depend on secondary contours; darker values are most successful in emphasizing the major contours. Thin linear structures depend more on background contrast and appear as strong dark or light ■ **silhouettes** (fig. 9.27).

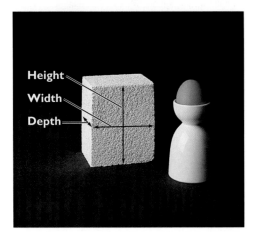

◀ **9 • 28**

The rectangular and ovoid solids are examples of two minimal objects that can be formed from displaced, boundless space. The flat and rounded planes in these positions define their special characteristics and spatial intervals.

Photograph: Lynn Whitney.

Space

Space may be characterized as a boundless or unlimited extension of occupied areas. When artists use space, they tend to limit its vastness. They may mark off extensions

▼ **9 • 29**

The figures show four bricks that have been arranged and rearranged to illustrate an increasing level of visual complexity within the third dimension—this is achieved by interactions between the *positive* objects and *negative* sculptural spaces.

(A) Stacked bricks (B) Separated bricks (C) Crooked bricks
(D) Slanted bricks (E) Crossed bricks (F) An Installation of bricks

Photographs: Lynn Whitney

A

B

C

in one, two, or three dimensions or as measurable distances between preestablished elements. Three-dimensional artists use objects to displace space and to control spatial intervals and locations. Rectangular and ovoid shapes control space effectively, because their weight is felt and established by the flat or rounded dimensions of the planes (fig. 9.28). The two shapes seen together create a spatial interval. Although the two solids illustrated are three-dimensional, their spatial indications are minimal. Greater interest and, in turn, greater spatial qualities could be added to the two shapes by manipulating their surfaces. If material were cut away, the space would move inward, and if material were added, the space would move outward.

In figure 9.29A, four bricks have been arranged in a very restricted manner to form a large, minimal rectangular solid. The individual bricks are distinguished only by the line of cracklike edges visible in the front and side planes. These linear edges are reminiscent of graphic linear renderings.

The four bricks illustrated in figure 9.29B are separated by indentations similar to the mortar joints used by masons. These gaps, although relatively shallow, nevertheless produce distinctively clearer and darker edges

▶ **9 • 30**

Giacomo Manzu, *Death by Violence*, 1950. Bronze cast from clay model, 36⅝ × 25¼ in. (93.5 × 64 cm).

This is a study for one of a series of panels for the doors of St. Peter's (Vatican, Rome). The confining spatial limitations of relief sculpture are evident. To create a greater feeling of mass, Manzu used sharply incised modeling that is similar to the engraved lines of the printmaker's plate. The crisp incising creates sharp value contrasts that accentuate movement as well as depth.

© David Lees/Corbis.

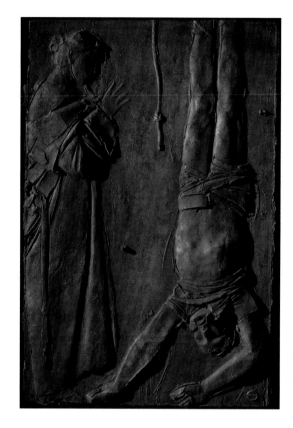

than those shown in figure 9.29A. Although the darker edges indicate greater three-dimensional variation than did the first stack of bricks shown, they still have decided spatial limitations. Many low ■ **relief sculptures** function in a similar way (fig. 9.30).

The bricks in figure 9.29C utilize even more space. They are positioned so

that the planes moving in depth are contrasted with the front and side planes, moving toward and away from the viewer. The light that strikes the grouping produces stronger shadows and more interesting value patterns. This arrangement can be compared to the qualities of high-relief sculpture. The play of deep shadows against the lights on

D

E

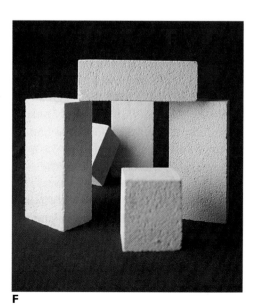

F

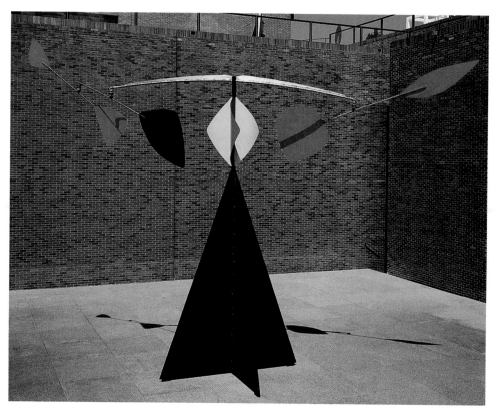

▲ 9 • 35

Alexander Calder, *The Spinner*, 1966. Aluminum, steel, paint, 235 × 351 in.

This noted artist introduced physically moving sculptures called mobiles. In this mobile-stabile, movement requires time for the observation of the changing relationships, thereby introducing a new dimension to art in addition to height, width, and space. The result is a constantly altered, almost infinite series of views of parts of the mobile.

Collection Walker Art Center, Minneapolis. Gift of Dayton Hudson Corporation, Minneapolis. © 2001 Estate of Alexander Calder/Artists Rights Society (ARS), NY.

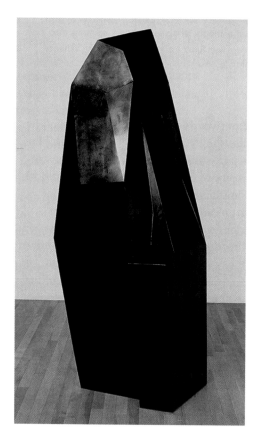

◀ 9 • 36

James De Woody, *Big Egypt*, 1985. Black oxidized steel, 72 × 30 × 30 in. (182.9 × 76.2 × 76.2 cm).

In this example of a tectonic arrangement, James De Woody has cut planes that project in and out of his surfaces without penetrating voids or opening spaces. This is sometimes referred to as "closed" composition.

Courtesy of the Arthur Roger Gallery, New Orleans, LA.

Time (the fourth dimension)

Time is an element unique to the spatial arts. It is involved in graphic arts only insofar as contemplation and reflection on meaning are concerned. The physical act of viewing a graphic work as a totality requires only a moment. However, in a plastic work, the additional fourth dimension means that the work must turn or that we must move around it to see it completely.

The artist wants the time required to inspect the work to be a continuum of rewarding visual variation. Each sequence or interval of the viewing experience brings out relationships that will lure the observer around the work, all the while extending the time spent on it.

In the case of kinetic sculpture, the artwork itself, not the observer, moves. Such works require time for their movements. Mobiles, for example, present a constantly changing, almost infinite series of views (fig. 9.35; see fig. 10.81).

PRINCIPLES OF THREE-DIMENSIONAL ORDER

Organizing three-dimensional art is the same as organizing two-dimensional art. However, three-dimensional forms, with their unique spatial properties, call for somewhat different applications of the principles.

Three-dimensional artists deal with forms that have multiple views. Composing is more complex. What might be a satisfactory solution for an arrangement with one view might be only a partial answer in the case of a work seen from many different positions. Adjustments are required in order to totally unify a piece. Compositionally, a three-dimensional work may be ■ **tectonic** (closed, massive, and simple) with few and limited projections, as in figure 9.36, or ■ **atectonic** (open, to a large degree), with frequent extensive penetrations and thin projections, as in

figure 9.37. Both tectonic and atectonic arrangements can be found in nearly all three-dimensional art, and each of these arrangements can be used individually to achieve different expressive and spatial effects.

Harmony and Variety

Harmony and variety have been cited as indispensable concerns in the creation of two-dimensional artworks; this is equally true in the realm of the third dimension, although its discernment is not always so obvious and its achievement somewhat different. In order to bring this to light we will primarily focus on sculpture because it exists in the round. One must keep in mind that in order to fully view a three-dimensional work such as sculpture, the viewer must "circumnavigate" the work, which has an almost infinite number of aspects. The interest generated by the many views under the control of the sculptor produces a degree of variety, but this must be balanced by harmony for the benefit of the work's totality.

One very important consideration in producing harmony and in leading the viewer around a sculpture piece is in "extensions." In the chapter on form, these are defined as actual and subjective lines or edges and shapes that suggest directions around the work. They imply connections with other such lines and shapes, thus creating a continuous movement encircling the work. This movement can be calculated to give a sense of rhythm that is either agitated or comparatively calm. Predictable rhythm incorporates proportional transitions that aid in giving flow to a work (fig. 9.38).

If there are areas considered significant, the sculptor may utilize closure by employing the proximity of certain shapes or lines to achieve a focus on those passages. Viewers must, however, be able to extricate themselves from these areas to facilitate the continuous movement sought. We must be reminded

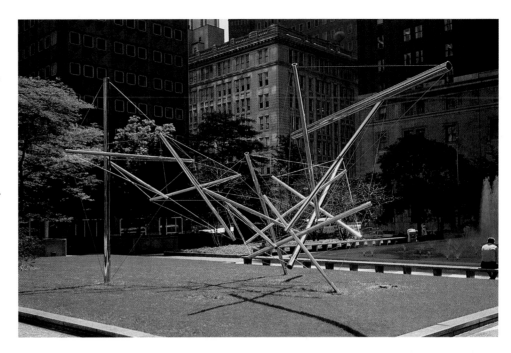

▲ 9 • 37

Kenneth Snelson, *Forest Devil*, 1977. Aluminum and stainless steel, 17 × 35 × 25 ft (5.2 × 10.6 × 7.6 m).

Kenneth Snelson has developed sculptures that are "open" or atectonic.

Collection Museum of Art, Carnegie Institute, Pittsburgh, PA. Licensed by VAGA, New York.

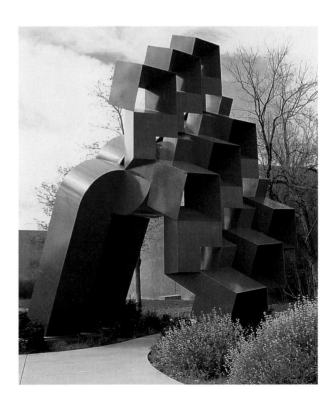

▷ 9 • 38

Sebastian, *Variacion Nuevo Mexico*, 1989. Painted steel, 27 × 24 × 24 ft

The rhythmical repetition of the stepping planes in Sebastian's sculpture creates an exciting, flowing movement.

Funded by the City of Albuquerque 1% for Art Program and The Albuquerque Museum, 1987 General Obligation Bonds. In commemoration of the Sister City relationship between Albuquerque and Chihuahua, Mexico. Photograph © 2001 Jam Photography.

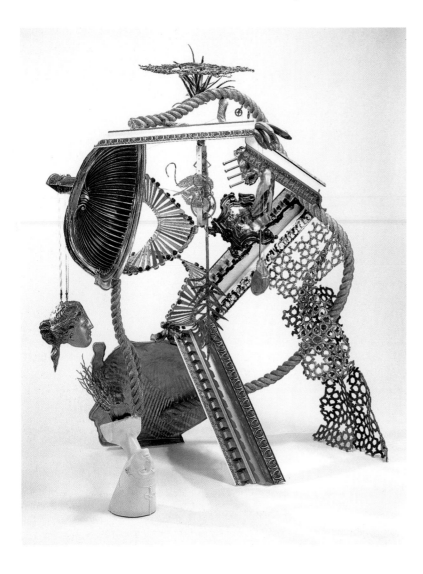

◄ **9 • 39**

Nancy Graves, *Unending Revolution of Venus, Plants, and Pendulum,* 1992. Bronze, brass, enamel, stainless steel, and aluminum, 97 × 71½ × 56½ in. (2.46 × 1.82 × 1.44 m). In this sculpture, we see a variety of form parts. We also see an excellent example of an asymmetrically balanced sculpture.

Created at Saff Tech Art. © Saff Tech Arts/Nancy Graves 1992. Photograph by Sam Kwong.

of the work. It might be added, in returning to sculpture, that such work in low relief is closely related to two-dimensional work, whereas high-relief sculpture is somewhat of a hybrid production, at times calling on some of the problems of harmony and variety encountered in sculpture in the round.

Balance

When considering balance and the extension of spatial effects in three-dimensional art, some special conditions should be examined. For example, when balancing a three-dimensional piece of work symmetrically, the added dimension of depth could change with its multiple views. While a sphere may appear symmetrical from any of its multiple views, a rectangular box could appear symmetrical only from the front and back but not from the side or top if seen in conjunction with other views. The views that are seen in depth could project other types of balance. Three types of balance are possible in actual space: symmetrical (see fig. 9.42), asymmetrical (see fig. 9.39), and radial (fig. 9.40). Of the three, symmetrical and radial balance are more formal and regular. Radial balance is spherical, with the fulcrum in the center. The parts that radiate from this point are usually similar in their formations. However, artists more commonly make use of asymmetrical balance because it provides the greatest individual latitude and variety.

that, in sculpture, shapes may be seen as well-defined edges or by cavities and bulges, whereas lines may again be edges or scratches and extended cuts.

Some sculptors make use of transparent (such as glass) rather than opaque media. The superimposition of such material will create genuine transparency, unlike the illusion of the two-dimensional artist. This would also suggest space, although usually limited. Architects, who are becoming increasingly sculptural in their vision, sometimes make use of overlapping, producing harmony in the portions of their building structures. Additionally, in sculpture there are instances of

"interpenetration" used to pull things together, notably in large metal sculpture pieces. Media that are related in color or through the painting of the surface may also assist in acquiring sculptural harmony. All of the foregoing are probably only some of the means by which the three-dimensional artist, specifically the sculptor thus far, may find harmony. Variety, as in two-dimensional work, is possible by reversing the means by which harmony is produced, the aim being to create greater interest (fig. 9.39). The ultimate goal is usually a precarious balance between harmony and variety. This goal is a concern of all three-dimensional artists whatever the nature

Proportion

When viewing a three-dimensional work, the effect of proportion (contemplating the relationship of the parts to the whole) is as crucial as it is in a two-dimensional work. Being in the presence of an actual three-dimensional work that can not only be seen but can also be touched or caressed, stood on, walked on, or passed through puts special emphasis on both the parts and the whole. Proportion is more easily realized as it applies to three-dimensional art if one actually grasps the nose or chin of a portrait sculpture while looking at it from multiple views. Similarly one could get much the same sensation by passing an arm through a void of an abstract sculpture while gripping a portion of that sculpture. Proportion is involved in determining the basic form: It sets the standard for relationships and permeates the other principles.

Scale is most dramatic when three-dimensional pieces are small enough to be held with the fingertips or when we are in the presence of gigantic architecture, landscapes, sculptures, and so forth (see fig. 9.10). The actual physical size of three-dimensional works when compared to the physical measurement of the human figure is here referred to as scale. Small jewelry and/or miniaturized models and maquettes of automobiles, architecture, landscapes, and sculpture are representative of the smaller-scaled pieces. Works designed for public places are usually of the largest scale. Religious temples, mosques, cathedrals, statehouses, malls, parks, three-dimensional commercial displays, and sculpture sites are examples of works on the largest scale possible. The spaces these pieces occupy are awe inspiring and, at the same time, mind boggling when one is in their presence (see figs. 9.10 and 9.37).

The one-on-one relationship that comes from actually experiencing a three-dimensional work brings out a special feeling for tension, balance, and scale. Proportion is involved in determining the basic form; it sets the standard and permeates the other principles. Repetition and rhythm have relationships that include proportional similarities.

Economy

Included within the group known as Primary Structurists or Minimalists are three-dimensional artists who emphasize the principle of economy in their works, because they, like their fellow painters, want to create stark, simple, geometric shapes. These Minimalists strip their shapes of any emotional, psychological, or symbolic associations and eliminate physical irrelevancies. For further emphasis, they also tend to make a feature of large size. Beverly Pepper has reduced

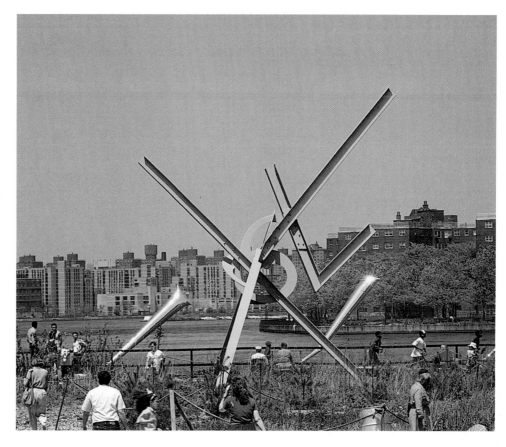

▲ 9 • 40

Mark di Suvero, *For Veronica*, 1987. Steel, 21 ft 9 in. × 35 ft.

The center of this sculpture is the fulcrum identified by the contrasting rounded, curled parts. Most of the diagonal beams radiate in outwardly thrusting directions. The exception purposefully adds variety to an otherwise formal radial balance.

The Rene and Veronica di Rosa Foundation, Napa, CA. Photograph Oil & Steel Gallery, Long Island City, NY.

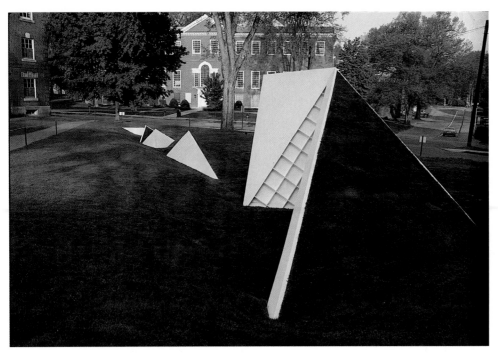

▲ 9 • 41

Beverly Pepper, *Thel,* 1977. Metal, paint, and earth, 15 ft high × 18 ft wide × 135 ft long.

Beverly Pepper has created many artworks that represent nothing more than large-scale, starkly simple geometric shapes. In this group, she has repeated shapes that interact spatially and seem to grow out of the earth. Pepper's economic means unify this interesting arrangement.

Site-specific installation at Dartmouth College. Photograph courtesy of Dartmouth College.

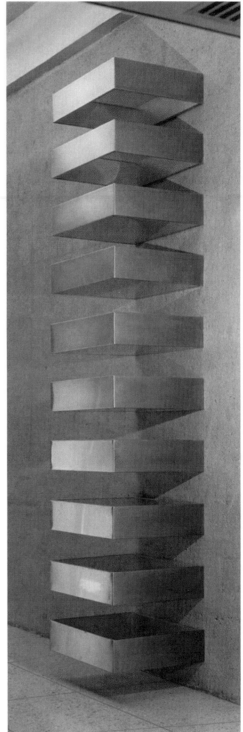

▲ 9 • 42

Donald Judd, *Untitled,* 1968. Brass, ten boxes, 6 × 27 × 24 in. (15.2 × 68.6 × 61 cm).

Judd is primarily interested in perceptually explicit shapes, reflective surfaces, and vertical interplay.

Photo: State of New York/Corbis. © 1998 Estate of Donald Judd/Licensed by VAGA, New York.

her shapes to simple geometric forms (fig. 9.41), while Donald Judd aligns his primary shapes in vertical and horizontal rows, thereby interrelating economy with repetition and rhythm (fig. 9.42).

Movement

Two types of movement are used by three-dimensional artists. Implied movement, the most common type (fig. 9.43; see fig. 9.38), is illusory, but actual movement is special and involves the total work. Actual movements that take place in kinetic art are set into motion by air, water, or mechanical devices. Alexander Calder, the innovator of mobile sculptures, at first used motors to drive his pieces but later used air currents generated by human body motion, wind, air conditioning, or heating (see figs. 9.35 and 10.81).

George Rickey, a contemporary sculptor, works with wind and air propulsion (see fig. 10.87). Water has been used as a propellant in other three-dimensional works. Jean Tinguely, Arthur Ganson (fig. 9.44), José de Rivera (see fig. 9.25), and Pol Bury (see fig. 10.86) propel their sculptures with motor drives. Computer-activated kinetics are now being marketed. The principle of movement is inherently related to the art elements of time and space.

When properly combined, the principles of order produce vibrant forms. In the three-dimensional field, new conceptual uses of time, space, and movement have changed definitions and meanings that had endured for centuries. The prevailing thought of the past, that sculpture was a stepchild of the graphic arts, need no longer be true.

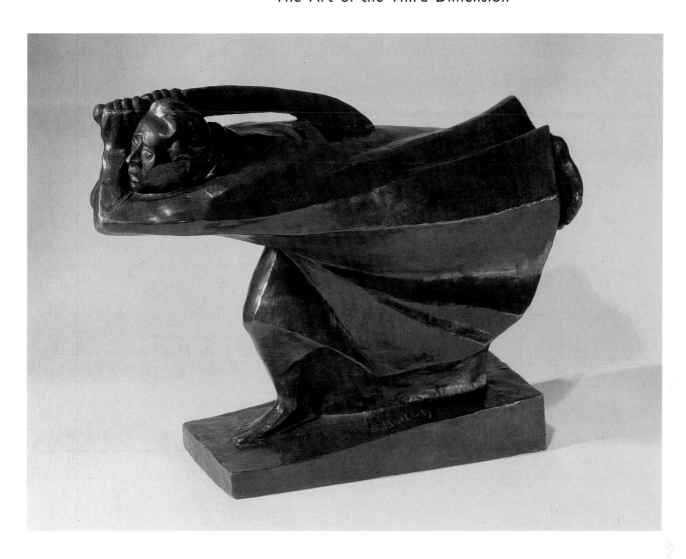

Installations

Artists turned toward ■ **installations** slightly before the fourth quarter of the twentieth century. The work that has evolved is usually, but not always, nonfigurative and ranges from the relatively small to the enormous in scale. Some materials that have been used include sheet metal, fiberglass, wood, bronze, steel, plastic, plaster, and stone: Actually any available materials are eligible, including mixed media. If placed outdoors, the installations may be simple (but frequently quite large); others, most frequently in a gallery, are many times comprised of multiple pieces, sometimes flooding the floors and/or walls. The positioning may be simply but

dominatingly placed or even seemingly haphazardly spread out. When set in an exterior setting, installations often sit in an easily viewable civic location.

One reasonable definition of an installation might be "setting in a place." This would imply that one could create an installation by setting out dinnerware, installing a battery in a car, or placing a work of art on a wall. Obviously, this would cover a limitless amount of ground, but in this case the reference is to installations produced by artists and placed in interior or exterior situations. Works of this kind are composed of any media or contrivance and of any configuration. One intention is apparently a heightened awareness of a planned alteration of indoor or outdoor environmental space.

▲ **9 • 43**
Ernst Barlach, *The Avenger,* 1914, later cast. Bronze, 17¼ × 22¾ × 8 in. (43.8 × 57.8 × 20.3 cm).
This figure is not actually moving, but it does depict a powerful forward thrust. Movement is implied by the long sweeping horizontal and diagonal directions made by the edges of the robe, the projection of the head and shoulders, and the base plane.
Tate Gallery, London/Art Resource, NY.

▲ **9 • 44**

Arthur Ganson, _Machine with Chair_ (time-lapse photograph of 1995 version), 1995. Steel (machine), fiberglass over foam (chair), motor, electronic switches and circuits, rubber. Track 30 ft long, machine 5 ft high, chair at highest point 13 ft from track.

Like Jean Tinguely, Arthur Ganson has found the machine to be an instrument for the poet/artist. He produces some machine-driven sculptures that involve kinetic ironies, mechanical awareness, and a sense of time, space, and motion.

Arthur Ganson is a sculptor at the Massachusetts Institute of Technology. Photograph by Henry Groskinsky.

Though carefully thought out, some installations have been accused by the populace of being inconsequential, dehumanized, or irrational, even provoking violent reactions. This is not surprising as installation is a new art form, and unusual styles of art have many times produced a general outcry. Richard Serra, a veteran of installations that are generally minimalist in nature, has had some of his work dismantled or defaced; his _Tilted Arc_ was removed as the result of protests. Civic leaders have been less than kind to his work, one judge equating it with "garbage, and garbage causes rats." These protestations have drawn the wrath of many artists of different artistic persuasions who feel, as most artists always have, that art should be given free rein, because of their knowledge of art forms that have produced widespread complaints in the past, only to be accepted with the passage of time.

Observers who are involved in or have a genuine interest in art are frequently accepting, whereas others may be hostile or indecisive in their response. They react in different ways, some perplexed, some overcome, some having their vision altered, and some delaying judgment. Despite the ridicule sometimes visited on them, installations are now firmly fixed on the art scene. There is little doubt that they enhance viewer involvement and produce a different outlook on the spaces on which they are placed. Among the significant artists in this area are Anne Hamilton, whose work is generally sensuous and may be monolithic; Sandy Skoglund (fig. 9.45); Roni Horn (fig. 9.46), whose work is presented in surreal architectural settings; and Richard Long, often specializing in stone arrangements.

Much of the public is curious about this kind of art; but, whatever the reactions, many artists are engaged in it. Further, installations require a great deal of sometimes very laborious effort—no doubt, to its creators, a labor of love.

▲ 9 • 45

Sandy Skoglund, *Fox Games*, 1990. Polyester resin sculptures, tables, chairs, painted tableware, painted bread, chandelier, cloth napkins and tablecloths. Approx. 30 × 30 × 12 ft high.

In this installation, Sandy Skoglund presents a personal environment of red tables and gray foxes, which confronts the viewer causing them to see the spatial setting in a new way.

This version was installed at the Denver Art Museum in Colorado in June of 1990. Denver Art Museum Collection, 1991.36. Photograph by Bill O'Connor. © Denver Art Museum.

▶ 9 • 46

Rebecca Horn, *Concert for Anarchy*, Berlin 1994. Grand piano and mixed media, variable dimensions.

Rebecca Horn's use of a piano in defiance of gravity makes the space within her installation an intimidating and overwhelming three-dimensional setting.

Photograph by Attilio Marazano. © 2001 Rebecca Horn. All rights reserved.

CHAPTER TEN

Content and Style

Faith Ringgold, *The Bitter Nest, Part V: Homecoming*, 1988. Acrylic on canvas with pieced fabric border, 76 × 96 in. (193 × 243.8 cm).

INTRODUCTION TO CONTENT AND STYLE

■ **Content** is the expression, essential meaning, significance, or aesthetic value of a work of art. Content refers to the sensory, subjective, psychological, or emotional properties we feel in a work of art, as opposed to our perception of its descriptive aspects alone. Because this chapter is concerned with the third component of a work of art, which is called content, we have brought up the definition given in the first or introductory chapter to refresh our reader's memory. This chapter is also concerned with style, defined in the introductory vocabulary, as the specific artistic character and dominant trends of form noted during periods of history and art movements. Style may also refer to artists' expressive use of media to give their works individual character.

The ■ **content,** or meaning, of works of art has constantly undergone interpretive revisions over the centuries. We now look at the arts from the past in different ways than did viewers in the past. Contemporary influences on personal experiences and thought shape the way we look at art today, just as they did in the past. Our goal, therefore, in this chapter must depend on recovering the historical influences from the past that affected artists to express their content, or what they had to say or experienced, about their times. This is as true today as in the past simply because yesterday is today's history.

Our presentation will frequently reveal the characteristics of a style or movement first, rather than the specific content of the artists involved, because we can find better clues as to why their expressive ends characterize the style. The space allotted to the chapter also necessitates that we discuss only a few artistic exponents of each style from where they were strongest during the nineteenth and twentieth centuries. It is too broad a reach for a text devoted primarily to the theory and creation of artistic form to cover the history of art either in much depth or in parts of the world other than our own. Interested individual students must do this through classes specifically devoted to these subjects or through their own endeavors. We will, however, discuss how the gradual growth of knowledge about other countries may have influenced artists in the Western countries presented in this book.

NINETEENTH-CENTURY ART

The stylistic movements of the nineteenth century in Europe contributed in some degree to the character of art in the twentieth century. On the other hand, besides being influenced by the art of the nineteenth century, the twentieth century often reacted in some degree to all art of the past. The appearance of the world around them inspired the work of painters and sculptors until about the middle of the 1800s. But the invention and development of the photographic image and camera about that time was one of the significant events that helped to change this. By the end of the nineteenth century, partly from this invention and partly from the survival of graphic techniques from the Renaissance on, the old problem of representing reality was so completely resolved that many painters, particularly, felt compelled to search for new expressive directions. Some painters turned to ancient styles or to those of the Middle Ages, for example, while others were influenced by the Middle and Far East or the arts of Africa and the Native Americans. There was a strong cult of the "noble savage," for instance, in eighteenth-century France which helped to bring about a breaking of European insularity in the nineteenth. These attitudes influenced sculptors somewhat later.

The growth of photography through the proliferation of images in popular journals and newspapers also gave artists, as well as almost everybody else, the opportunity to examine contemporary and past art in hitherto unknown or little-known places. This increasing familiarity with the arts no longer permitted the noble, the religious, and the wealthy merchant classes to be the primary proprietors of the arts. Artists, who could no longer be solely dependent on them for commissions, had to seek sources of income among the populace. So, while creating a wider audience for artists looking for new directions, the loss of such clientele forced artists to advertise and sell their art like any other public merchandise. Some, naturally, continued to satisfy the dubious tastes of the upper classes (mostly the bourgeois after the French Revolution of 1789), in order to live in the environment of the Industrial Revolution with its poor classes, slums, and injustices. But those artists who had the courage and/or means to assert their own inventiveness, daring to fight the tide of conventional popularity and prejudice, became the leaders (avant-garde). Drawing their inspiration from their surroundings and society or from subjects that seemed to have more universality, they led the way to newer styles and movements.

As we proceed, we will find that sculptors, just as painters, were affected by changes in the cultural and social values of their times that tended to associate them with the styles expressing those values.

The spirit of nineteenth-century sculpture was primarily painterly, or additive. This was partly because clay modeling, an additive rather than a subtractive process, was dominant during that time. Since sculptors have usually been used to working with materials more resistant to manipulation than pigments, painterly attitudes tended to diminish the regard for wood and stone

sculpture. Less regard for the weight and mass of such traditional materials and processes and their occupation of space led to fewer innovations in those media. A key development that occurred in sculpture as well as in painting in the 1800s was the gradual defeat of the conservative reluctance toward change caused by the continuing authoritarianism of the European academies. The lingering preference in sculpture for allegorical ideals, which use the human figure to symbolize spiritual values, whether from classical mythology and/or religion, was largely responsible. Another reason was that in the 1700s, more so than in painting, commissions to sculptors were awarded on the basis of fidelity to nature. This attitude was influenced mostly by the actual three-dimensionality of sculpture but was partly nurtured in the 1800s by the popularizing of the photographic image.

True, there were gifted sculptors who were skilled in the tools of sculpture, handling with virtuoso dexterity resistant materials like marble and creating some memorable works.

NEOCLASSICISM (c. 1750–1820)

The ▪ **Neoclassical** style originated in France, the recognized epicenter of the arts in Europe since the seventeenth century. The founding in 1648 of the French Royal Academy of Arts and Letters by King Louis XIV, promoting rules for creating "correct" works of art, was at least part of the reason for the dominance of French art. Similar government-sponsored academies soon followed in other countries. Throughout the late eighteenth and nineteenth centuries, the approval of such government-sponsored institutions continued to be a principal factor in artists' acceptance.

The characteristics of the Neoclassical style were forming by the middle 1700s,

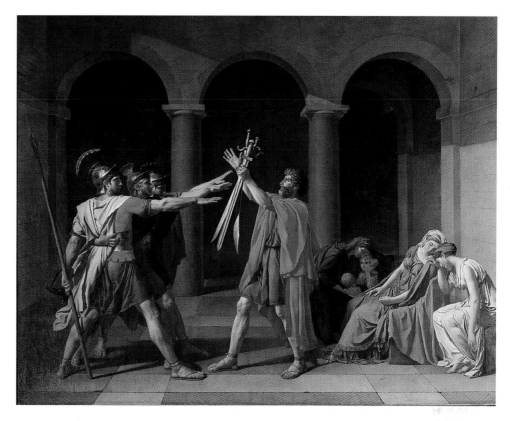

▲ 10 • 1

Jacques-Louis David, *The Oath of the Horatii*, 1786. Oil on canvas, approx. 14 × 11 ft (4.27 × 3.35 m).

A cold, formal ordering of shapes, with emphasis on the sharpness of drawing, characterized the Neoclassical form of expression. Both style and subject matter are strongly influenced by ancient Greek and Roman sculpture.

The Louvre, Paris, France. Photo: Lauros-Giraudon, Paris/SuperStock.

and the movement dated from that time until about 1820. The principal stimulus for the rise of neoclassicism was probably the discovery of the ancient Roman ruins of Herculanaeum and Pompeii (in the 1730s and 1740s) left by the eruption of the volcano Vesuvius in 79 A.D. Up to that time, Rome was the only well-known city of antiquity. Now there were other "true" ancient cities. Archaeological research at these ruins led to the New or Neoclassical architectural style that spread across Europe to the Americas.

The revival came about in the arts of painting and sculpture, of which painting remained primarily French. Another influence on Neoclassical art was the publication in 1764 of Johan Joachim

Winckelman's *The History of the Art of the Ancients*. This book was definitive in clarifying the differences between Greek and Roman art for the first time.

The principal Neoclassical painter was Jacques-Louis David (1748–1825). His severely monumental style, as in *The Oath of the Horatii* (fig. 10.1), which established the style for others in France, was founded on and expressed the current desire for moral, political, and social reforms among the masses. This attitude led to the French Revolution three years later. David's classical style resulted from his having won the Royal Academy's *Prix de Rome* (a scholarship for French artists to study in Rome), permitting him to make a closer study of Roman art. David also rebelled against

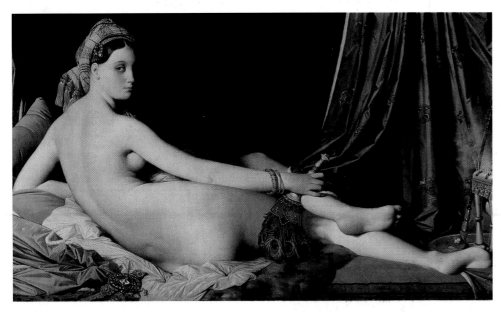

▲ **10•2**
Jean-August-Dominique Ingres, *La Grande Odalisque*, 1814. Oil, 35¼ × 63¾ in. (89.5 × 161.9 cm).
Neoclassicist Ingres, while being a doctrinaire follower of Classical expression, often tended toward romantic subjects with their attendant sensual expression of content. **Odalisque** was a term meaning harem girl, or concubine, in a Turkish seraglio.

The Louvre, Paris, France. Photo: Lauros–Giraudon, Paris/SuperStock.

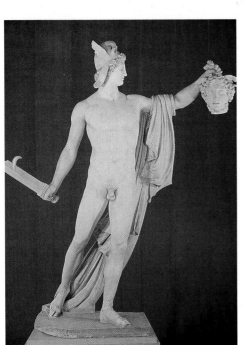

▲ **10•3**
Antonio Canova, *Perseus with the Head of Medusa*, c. 1808. Marble, 7 ft 2⅝ in. (2.20m) high.
Although he was the best of the Neoclassical sculptors, Canova's great technical facility lacked the streak of individualistic meaning that would have made his art truly outstanding. He repeated themes that were centuries old and hackneyed.

Metropolitan Museum of Art, New York, Fletcher Fund, 1967. (67,110). Photo: SuperStock.

the Rococo, the style approved by the aristocracy during his youth, finding it immoral and artificial. The clearly readable horizontal composition of *The Oath of the Horatii* is classical in its restraint and expresses nothing about the chaos and excesses of the Revolution that followed. The clarity and realistic details seem to anticipate the art of photography. The painting also strongly foreshadows the interest in the two-dimensional nature or surface of a painting, which was to be so significant in the twentieth century. David was closely connected to the Napoleonic regime after the Revolution.

Jean-Auguste-Dominique Ingres (1780–1867), a later Neoclassicist, was in essence a doctrinaire follower of the movement. In his paintings of voluptuous nudes, i.e., *La Grand Odalisque* (1814)(fig. 10.2), his compositions emphasize a somewhat softer, ornamental, linear manner, owing much to the High Renaissance manner of Raphael. He also had a romantic interest in exotic lands and people, which reflected a desire by society and artists to escape from the growing materialism of the time. This aspect of Ingres and his followers predicted the replacement of Neoclassicism by the style called Romantic art.

The Italian-born Neoclassical sculptor Antonio Canova (1757–1822) was one of the few retaining the ability to carve from hard materials, like marble, as in his statue of *Perseus with the head of Medusa* (c.1808) (fig. 10.3). Most of Canova's sculptures, as here, were based on old-fashioned mythological themes. There is little meaning for us today, since lack of familiarity with old themes tends to reduce our understanding of content. Canova, like David, worked for Napoleon after the Revolution.

ROMANTIC ART

Romantic art was an outgrowth of strong eighteenth-century literary trends that affected all European countries, called ▇ **Romanticism** or the Romantic Movement. Romanticism became a philosophy and way of life for many. The poems, novels, and prose writings of people like Shakespeare, Dante, Jean Jacques Rousseau, Thomas Gray, George Gordon, Lord Byron, Johann Wolfgang von Göethe, and Sir Walter Scott, plus the Christian Bible, were common sources of subjects for Romantic artists. Contemporary newspapers and journals were also significant sources for the dramatic and exotic subjects influencing Romantic art. The rebellion in America,

and particularly the rebellion of the Greeks against the Turks, added to the exotic flavor of the faraway in time and place, already noted in Neoclassical painting. The passionate convictions and emotionalism aroused by such events broke the existing eighteenth-century mode of intellectual certainty and formal order forever. A new age with more concern for human individuality began. The irrational, the macabre, the fantastic, the stormy and lyric moods of nature, animals, and humans became fit subjects for artistic expression. This romantic approach to art, in fact, took the emphasis somewhat away from choice of subjects, since any subject now seemed plausible to use. A new accentuation on that of form and the artist's materials (and processes) could now start, an emphasis that was ultimately to be so important in twentieth-century art.

Technically, Romantic artists exploited the exciting use of diagonal compositions and the juicy, bold textures of oil paint. The ability of paint to produce bright, exciting hues and stirring contrasts of value to express emotionalized content is typical of Romantic art. There is an obvious opposition to the Neoclassicists' more reserved use of value and color and greater insistence on linearity and formal compositions.

The important Romantic painters we will consider are the French artist Eugène Delacroix (1780–1867); the Spaniard Francisco Goya (1746–1828); and the English artist J. M. W. Turner (1774–1851).

Delacroix was the outstanding representative of Romantic painting in France. He was the leader of the faction preferring Rubens and the Venetian painters, as opposed to the Neoclassical painters who preferred Nicholas Poussin (a classical painter of the 1600s). Trained as a Neoclassicist, Delacroix created a vigorously active style that broke the formal boundaries of his background. A major example exhibiting Delacroix's

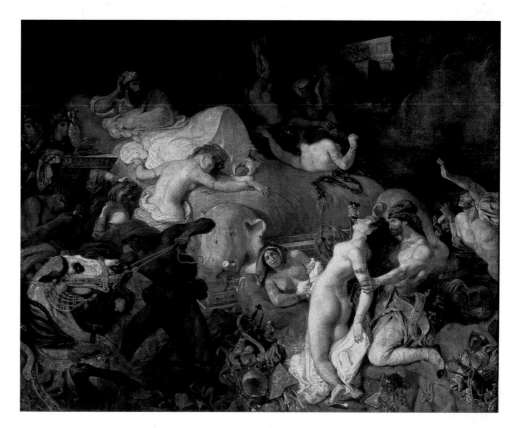

10 • 4
Eugène Delacroix, *The Death of Sardanapalus,* 1827. Oil on canvas, 145 × 195 in. (395 × 495 cm).
Subject matter most common to the Romantic movement was composed of violent action, often in foreign settings. The exaggeratedly bold expression of violence, sensuality, and death is frequently found in Delacroix's work.
Louvre, Paris, France/The Bridgeman Art Library.

expressive content is *The Death of Sardanapalus* (1827) (fig. 10.4). The exaggeratedly bold expression of violence, sensuality, and death is frequently found in his work.

The Spaniard Goya was the earliest of the nineteenth-century Romantic painters, emerging from the Spanish Rococo of the late 1700s. Of the same generation as J. L. David, he was not a Neoclassicist but went through a gamut of styles ranging from realism through the romantic to the fantastic. Goya's early work tends to be charming in its portrayal of court life, but there are hints of his psychological understanding of human follies and deeds (see fig. 4.21). After a serious illness in 1792 that left him totally deaf, Goya's content often

becomes more cruel and often uses witchcraftlike fantasies. These are found in two famous print series: *Los Caprichos* (c. 1797–99) and the *Disasters or Horrors of War* (c. 1813–1820). These etchings express, in marvelous tones of black and white, the irrational behavior of human beings under duress. War is the subject of two oil paintings, the second of which, *The Third of May* (1808)(fig. 10.5), is illustrated here. They indicate, by their form and content, the bitterness felt by the Spanish against their French invaders. In the illustrated painting, Madrid civilians are massacred by French soldiers for the civilians' part in ambushing French troops the day before. The content poignantly deals with the inhuman actions fomented by war.

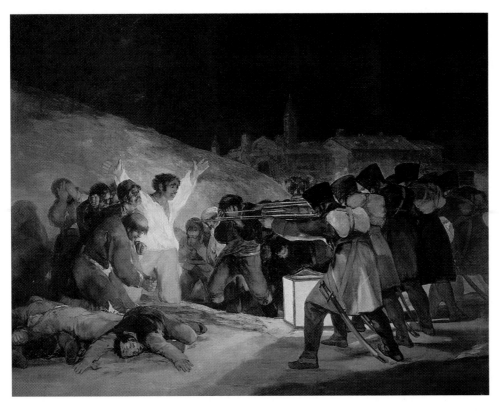

▲ 10 • 5
Francisco Goya, *The Third of May,* 1808. Oil on canvas, 8 ft 8 in. × 11 ft 8 in. (2.64 × 3.55 m).

The romanticism of Goya is displayed in both his choice of subject matter and his dramatic use of light and dark values.

Museo del Prado, Madrid, Spain. Photo: Erich Lessing/Art Resource.

▼ 10 • 6
J. M. W. Turner, *Rain, Steam, and Speed—The Great Western Railway,* 1844. Oil, 90.8 × 121.9 cm.

Historical themes and the clash of natural forces were frequently found in Turner's work. This illustration shows that Turner had ridden through a violent storm with the window open and was astonished at the power of the tempest and the speed of the new railway.

National Gallery, London. Erich Lessing/Art Resource, NY.

Turner was England's outstanding Romantic landscape painter. His early works, in the form of clear-cut landscapes, were influenced by ▪ **classical** prototypes such as Claude Lorraine (1600–1682). But as time went on, Turner became increasingly fascinated by the ability of oil paint to depict the moods and powers of nature as metaphors for human emotions (called the pathetic fallacy in literature). Mist, rain, fire, and sea foam became his favorite subjects, no matter his sources from nature. Turner's awareness of the Industrial Revolution and its effect on human beings is often hinted at, as in *Rain, Steam, and Speed—The Great Western Railway* (1844) (fig. 10.6). Here the dark mass of a locomotive pulling a line of cars gives a strong emotional feeling of Turner's own excitement about traveling at such speed as it seems to hurtle out of the fog and mist of a violent rainstorm. This work is from Turner's last decade when his style reached a peak of impressionist technical effects that he essentially passed on to artists of the Impressionist Movement, 25 years later.

French Romantic sculptor Antoine Louis Barye (1796–1875) seems to have been more imaginative than the Neoclassicist Canova in his employment of malleable materials such as clay and plaster (from which bronzes are usually cast) (fig. 10.7). Yet while Barye seems more original in his grasp of the essentially dynamic, monumental, and ferocious character of animal life, his allegorical subjects and use of additive materials conform to the traditional recommendations of the academies. Like Turner, Barye reworked an old Romantic tradition of evoking human emotions by parallels with animal nature or the vagaries of the weather, originating with the great Dutch philosopher Baruch Spinoza in the 1600s. Turner's late paintings seem more innovative in technique, and therefore more original, than Barye's sculptures,

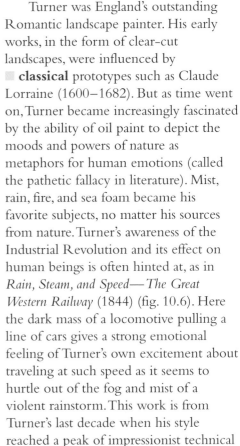

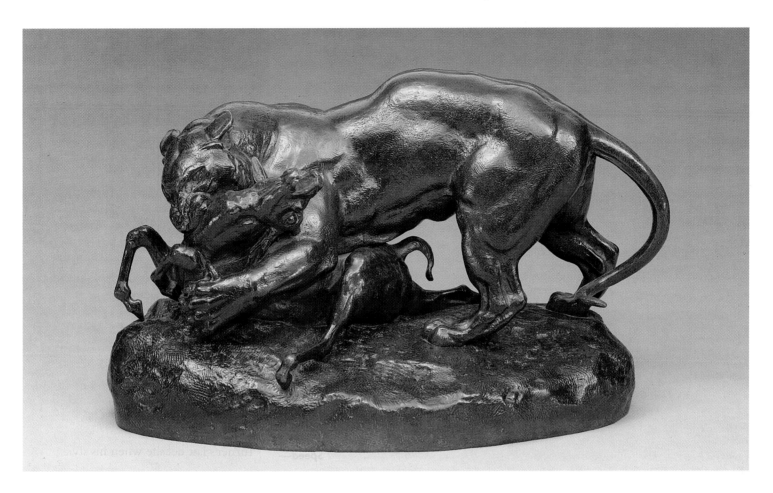

which repeat older values and ways of thinking. However, the more overt or energized expression in Romantic art, as opposed to the restraint in classical works, may improve our sense of Romantic content.

BEGINNING OF PHOTOGRAPHY

The development of the camera and the images produced by it emerged over a number of centuries. However, it was not until the mechanical inventions of the Industrial Revolution (usually dated in England around 1750–1850) had prepared the ground that the invention and use of the photographic camera could occur. We can trace the origins of the camera back to the *camera obscura* (Latin for a "dark room") in the Renaissance (although it was

already known in ancient Greece). The *camera obscura* was a lightproof room or box with a small hole in one side that could produce an inverted image of an outside scene or object on the surface opposite the hole. The example by Dürer (see fig. 8.19) shows a variation of the *camera obscura* by which artists could directly draw from the model to establish foreshortening and/or perspective. The late Renaissance artist Jacopo Pontormo (1494–1556) is believed to have added the first lenses to the *camera obscura*, providing the next step toward the picture-making camera. The final step, the process of fixing an image on a light-sensitized surface, culminated between the 1830s and 1850s, making possible the imitation of natural appearances in a permanent image—the photograph. The efforts of, particularly, Louis J. M. Daguerre (1789–1851) and Joseph N.

▲ **10 • 7**
Antoine Louis Barye, *Tiger Devouring an Antelope,* 1851. Bronze, 13 × 22½ × 11⅝ in. (33 × 57.2 × 29.5 cm).
Barye's emotionalized romantic form is similar in dynamism to the intense coloristic qualities of Romantic painters such as Delacroix and Turner.

Philadelphia Museum of Art, PA. W. P. Wilstach Collection Purchase.

▲ **10 • 8**
William Henry Fox Talbot, *Nicole & Pullen Sawing and Cleaving*, c. 1846. Salt paper print.
This is an example of a photograph by one of the medium's earliest pioneers, the English aristocrat Fox Talbot. His system, using sensitized paper negatives from which many prints could be made (calotype), was one of the key foundations of modern photography. Because of the long exposure time needed, "action" shots like this would have involved posing motionless for some minutes.
©The Royal Photographic Society of Great Britain, Bath, England.

Niépce (1765–1833) (both of France), William H. Fox Talbot (1800–1877) (of England), and others were responsible for the first photographic images (fig. 10.8). By midcentury the camera image had evolved far enough that a painting-conscious Romantic photographer like Oscar G. Rejlander (1813–1875) (fig. 10.9) could assemble a colossal, superficially romantic work out of many prints and exhibit it in the *Salon des Beaux-Arts* in 1857. This set in motion one aspect of photographical research called ■ **Pictorialism,** which was opposed by those who believed that there should be no additional manipulation of the image, either in the taking or the developing process. These were designated ■ **Straight,** or sometimes ■ **Realist,** photographers.

REALISM

The art of the Romantics had been a reaction to the pseudo-classical and pedantic formulas of Neoclassicism. The Realist movement arose about 1850, partly as a similar reaction to the favoritism shown by academic circles in accepting only those old, hackneyed themes, and partly as a reaction against the exotic, escapist, literary tendencies of Romanticism. The movement lasted until about 1870, when it was being replaced by Impressionism.

The Realists were stimulated by the prestige of science, particularly the technological revolution epitomized by photography, but opposed to the kind of superficial pictorial Romantic-Realism embraced by Rejlander. At the same

time, they avoided mere surface appearances, such as those usually provided by the camera and gave instead a philosophical or expressive quality to their art. Yet they also tried to impart a sense of the real-life immediacy they found missing in the idealistic content of Neoclassical and Romantic art. Because the Realists believed their clients shared their way of viewing the world, it might be thought that their art would have been immediately acceptable. Instead, because they often chose to depict farmers and working-class people, the Realists were often regarded as subversive by their potential, mostly urban, middle- and upper-class clientele. The most extreme form of Realist art is naturalism, a term invented by the writer Emile Zola near the end of the nineteenth century. The naturalistic artist, according to Zola, closely accepted the optical veracity of the world, much like what a photograph provided at that time. Artists of similar persuasion thought this kind of descriptive form was the way most people regarded reality. Thus they attempted to paint a visual copy of the objective world, without investing their art with the more universal meanings associated with realism. The major difference between Realistic and naturalistic art, therefore, lies in the degree of emphasis placed on the specifics of detail, location, and time (e.g., the particularizing of weather conditions).

The most important Realists were the French painters Honoré Daumier (1808–1879) and Gustave Courbet (1819–1877). Daumier, with his expressive renderings of poor city workers, actors, tradespeople, political dissidents, and refugees, best represents the Realist point of view, while Courbet represents the naturalistic approach to subject and form. Daumier managed to paint many oils during his lifetime, expressing his humanistic concerns about the meager life of the poor in strong line and values, despite the fact that he

▲ 10 • 9
Oscar J. Rejlander, *The Two Ways of Life,* 1857.
Gelatin silver print.

A photographer trained as a painter, Rejlander tried to create a great mural out of hundreds of photographs. His approach to image manipulation is a Romantic one that is called "Pictorialism" in photography.

Courtesy George Eastman House, Rochester, N.Y. © Royal Photographic Society of Great Britain, Bath, England.

labored for two Parisian journals producing hundreds of political cartoons and caricatures to earn his living (fig. 10.10). Daumier is credited with beginning the tradition of satirical political cartooning (see fig. 3.26).

Courbet was probably the most important instigator of the Realist style. He was also a political activist and believed that artists should only paint what they could see and touch. "Show me an angel and I will paint one" is his famous statement in this regard. He was a master of both the technique of oil painting and composition, creating many

▲ 10 • 10
Honoré Daumier, *The Uprising,* c. 1852–58. Oil on canvas, 34 × 44 in.

Influenced by a climate of scientific positivism, the artists of the Realist movement tried to record the world as it appeared to the eye, but they also wished to interpret it so as to record timeless truths. This painting by Daumier shows his broadly realist renderings of a political protest.

Acquired 1925. The Phillips Collection, Washington. D.C.

▲ 10 • 14
Edouart Manet, *The Races at Longchamps,* 1866. Oil on canvas, 17¼ × 33½ in. (43.9 × 84.5 cm).

The artist Manet reveals the Impressionists' concern with capturing movement realistically, as part of their desire to render perceptual reality in a new way. Photographic studies like those of Muybridge may have benefited Manet.

Art Institute of Chicago, Mr. And Mrs. Potter Palmer Collection 1922.424. Photo © 1998 Art Institute of Chicago. All rights reserved.

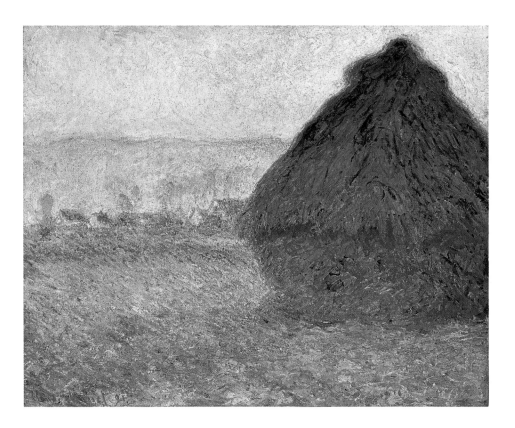

◀ 10 • 15
Claude Monet, *Haystack at Sunset,* 1880. Oil on canvas, 28⅞ × 36½ in. (73.3 × 92.6 cm).

The selection of subject in this painting is typical of the Impressionist movement. The bright weather and the blazing colors at sundown offered an opportunity to express light and atmosphere through a scientific approach to the use of color.

Juliana Cheney Edwards Collection. Courtesy of Museum of Fine Arts, Boston.

That photography had an impact on Manet and the other Impressionists is often apparent. Manet's painting of *The Races at Longchamps* (1884) (a racetrack near Paris), in which the horses almost seem to float, probably indicates his study of the stop-action photography of the Anglo-American photographer, Eadweard Muybridge (1830–1904) (fig. 10.14; see also fig. 8.57). The manner in which Manet handled the sunlight scintillating from the clothing and parasols of some the spectators shows that in his later work he had become a full-fledged Impressionist.

Claude Monet (1840–1926), Camille Pissarro, and Renoir took the lead in the Impressionist movement. Monet's painting *Impression—sunrise* (1872) gave the name to the movement. In this painting and succeeding ones, Monet (along with Manet) began to see, or paint, the world in terms of color and light rather in terms of depth and volume. The Impressionists' significant relationship to photography is signaled by the fact that their first independently arranged exhibit, in 1874, was held in the studio of the eminent Realist portrait photographer Felix Nadar (Gaspard-Felix Tournachon [1824–1910]). Outgrowing Realism, the Impressionists wanted to find their own way of painting reality. Photography taught them to do it in a new way. From the somewhat lengthy exposures required of photographs, they learned that the use of blurring and partial obscuring of objects in their paintings was similar to the strong effects that bright sunlight or other more misty weather conditions seemed to have on nature when they painted outdoors. Monet, who was one of the most consistent outdoor painters, introduced these effects in his series on haystacks (fig. 10.15), the Waterloo Bridge series (see figs. 7.24 and 7.25), and in his late garden series. In order to achieve the vibrating character of light, the Impressionists developed the techniques of juxtaposing complementary hues in large areas for greater brilliance and the interpretation of shadows as being

10 • 16
Camille Pissarro, *La Place du Théâtre Français*, 1898. Oil on canvas, 28½ × 36¼ in. (72.4 × 92.1 cm).
In this painting, the Impressionist Pissarro shows a high-angle view of a Parisian street, a technique that was influenced by both Japanese prints and photography.
Los Angeles County Museum of Art, CA. Jr. and Mrs. George Gard De Sylva Collection, M.46.3.2.
Photo: Lauros-Giraudon, Paris/SuperStock.

composed of hues opposite those of the object(s) casting shadows. They also revived the old technique of painting thick dabs that catch and reflect actual light from the surface called *tachiste* painting (from the French *la tache,* meaning "spot"). The Impressionists' use of complementary hues in the dabs of pigment, however, was the important breakthrough. When seen from a distance, these spots or dabs tend to form tones fused from the separate hues. Local color was very important to secure the effects of sunlight, shade, shadows, and all kinds of weather conditions. Landscapes painted *plein air,* or outdoors, directly from the subject to the canvas "wet-on-wet" *(alla prima),* became the Impressionists' favorite method of recording nature (see fig. 4.3).

The Impressionists also challenged traditional methods of composition. From photography they learned to often place figures and objects at random, showing them from untraditional high angles or as scenes that were cut off as if they were snapshots at a moment in a continuous event. The Impressionists' discovery of the fascinating possibilities of high or unexpected angles of composition was also aided by the introduction of Japanese block prints into France in the mid- to late 1800s. These prints often placed a dramatic decorative emphasis on high-angle views or on views looking down on landscape subjects and people. Compare, for instance, Camille Pissarro's *La Place du Théâtre Français* (fig. 10.16) to Hiroshige's

The Kintai-Kyo Bridge at Iwakuni print (fig. 10.17). Often used merely to wrap up goods being shipped to Europe, these prints were frequently cropped, resulting in curious truncated compositions. The resulting painted

10 • 17
Utagawa Hiroshige, Suö Province,
***Kintaikyō Bridge at Iwakuni (No. 52),* mid-19th century. Color woodblock print.**
The high-angle view of this bridge from the artist's series, Landscapes at Celebrated Places in the Sixty-Odd Provinces of Japan, shows one aspect of Japanese art that influenced French Impressionism and Post-Impressionism in the 1800s.
Courtesy Hiraki Ukiyo-E Foundation, Tokyo, and Hiraki Ukiyo-E Museum, Yokohama, Japan.

10 • 18
Pierre August Renoir, *Luncheon of the Boating Party,* 1881. Oil on canvas, 51 × 68 in. (129 × 172 cm).
Renoir was enchanted by the capture of vibrant light and its effects.
Acquired 1923. The Phillips Collection, Washington, D.C. © 2001 Artists Rights Society (ARS), New York/ADAGP, Paris.

views of the natural scene were almost completely different from the conventional eye-level arrangements that had been traditionally used by artists for almost 600 years.

Some of the coloristic and atmospheric effects that painters were capturing in pigments were not possible in photography as yet, but this was soon to begin changing with the invention in 1906 of the first commercially feasible color process; the color was not dependable, however, until the 1930s.

Pierre Auguste Renoir was another Impressionist master. His *Luncheon of the Boating Party* (1881) shows him at his peak (fig. 10.18). Like Monet, whose career he somewhat parallels, he was enchanted by the capture of vibrant light and its effects.

Renoir kept a more human touch than Monet and Pissarro in his figural paintings, especially his paintings of nudes dappled by sunlight and shadows. In the 1890s, however, after study in Italy and his continuing devotion to the great art of museums, he turned away from Impressionism to a firmer rendering of figures, trying to reestablish a greater monumentality.

Edgar Degas (1834–1917) is sometimes included as an Impressionist of movement or of "stop-action" painting (fig. 10.19). Degas, in fact, was well acquainted with photography, sometimes using photographs to achieve his high-angle views and the sense of motion in his ballet dancers and other subjects. He preferred working in his studio to painting out-of-doors, however. Degas also did some sculpture. His preference was for the use of clay and plaster to cast small figures in bronze (such as his dancers), which are notable for their sense of mobility and poise.

Space limitations allow only the mention of two excellent women painters connected with Impressionism. These were Berthe Morisot (1841–1895), a descendant of the eighteenth-century French court painter, Jean Honoré Fragonard (1732–1806), and the American

▲ 10 • 19
Edgar Degas, *Four Dancers*, c. 1899. Oil on canvas, 4 ft 11½ in. ×
5 ft 11 in. (1.51 × 1.80 m).
Two aspects of the Impressionist artist's recording of natural form can be found
in this painting. First, it demonstrates the customary interest in the effects of
light. Second, the painting shows a high-angle viewpoint of composition derived
either from Japanese prints or from the accidental effects characteristic of
photography.
Chester Dale Collection. © 1998, Board of Trustees, National Gallery of Art, Washington.

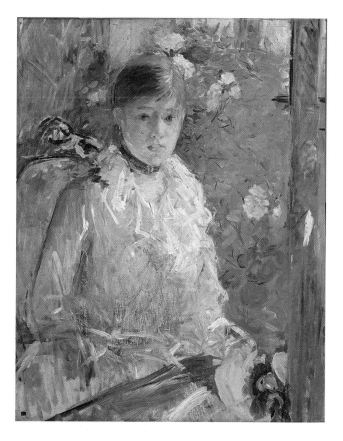

▲ 10 • 20
Berthe Morisot, *Young Girl by a Window*, 1878. Oil on
canvas, 29¹⁵⁄₁₆ × 24 in. (76 × 61 cm).
Morisot painted Impressionist figures with bold strokes and a
lively, light palette.
Musée Fabre, Montpellier, France.

Mary Cassatt (1848–1926). Cassatt studied
with Degas and concentrated on charming
figures of women and children (figs.
10.20 and 10.21).

POST-IMPRESSIONISM

By 1888, some painters associated with
Impressionism began to realize that there
were certain deficiencies in the style,
causing them to pursue individual
directions. The key innovations of the
1860s and 1870s, such as the perceptual
recording of light, color, and atmospheric
effects, were now found to be
superficially or automatically executed.
But the principal flaw, which irritated
most of these painters, was the loss of
shape and design resulting from an
acceptance of surface illusion alone. They

▷ 10 • 21
Mary Cassatt, *La Jeune Fille*,
c. 1910. Oil on canvas, 42.5 × 36.8.
Mary Cassatt was an American who
studied in Paris and was rumored to be
Degas' only student. This painting
shows one of her typical freely painted
oils of children.
Gift of Mrs. Henry C. Woods, 1964.1099, The
Art Institute of Chicago.

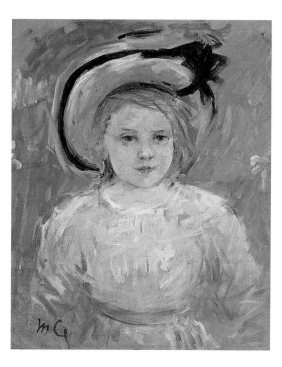

principally objected to the tendency of Impressionist paintings to dissolve shapes or objects into obscure masses of color. The ■ **Post-Impressionists,** as they were to be called, also objected to the way that outdoor lighting affected the way they saw color. In strong sunlight, it was difficult to avoid making greens too raw, and there was a tendency to overload the canvas with yellows.

The most important Post-Impressionist artists were Georges Seurat (1859–91), Paul Cézanne (1839–1906), Paul Gauguin (1848–1903), and Vincent van Gogh (1853–90). From these pioneers stem the major directions and styles of the first 60 or so years of twentieth-century art. At the same time, their styles were all individualistic and completely different from one another. The ambiguous title given to these artists—Post-Impressionists—does not indicate this, nor does it point to their significance for the future of art.

The reason they are classified together was their somewhat similar goals. They all sought such ends as: (1) a return to the structural organization of pictorial form; (2) an increased emphasis on the picture surface for the sake of pictorial unity and the unique patterns that might result; and (3) a more-or-less conscious exaggeration of natural appearances for emotionally suggestive effects. The latter is sometimes popularly called distortion. Stylistically, Seurat and Cézanne on the whole illustrate the first of these aims; Gauguin, the second; and van Gogh, the third. Each, however, incorporated some aspect of the others' objectives in his stylistic form.

In 1886, at the last Impressionist exhibit, Georges Seurat's masterpiece *Afternoon on the Island of La Grande Jatte* appeared (fig. 10.22). This painting, with its methodically dotted canvas, in many ways defines the moment when Impressionism began to be supplanted by Post-Impressionism. Although Seurat was trained in the academic manner at the École des Beaux-Arts and admired classical prototypes of the Early Renaissance, the eighteenth century, and Ingres from his own century (see fig.

10.2), he came under the influence of Impressionism in the 1880s. From these influences he developed his own style, which he called Divisionism, but which others came to call Pointillism or Neo-Impressionism. His merged style is found in the *Grande Jatte.* In its interrelationship between people and object shapes, it is Classical, while in its textured pigment and use of precisely arranged complementary colors, it is Impressionist. Seurat's sense of classical monumentality and reserve also contrasted with the lighter-hearted mood or content of Impressionism. This combination foretells much about the Abstract Art of the following century.

Like Seurat, Paul Cézanne—by general agreement, the paramount artist of the Post-Impressionist movement—remains close in spirit to classicism. He, too, sought a way out of the patently haphazard organization and ephemeral forms of the Impressionists, seeing a work of art in terms of the interrelationship of all its parts. In this, he foreshadowed the Gestalt psychologists' theories a short time later (see Chapter 4, p. 98). While retaining the individual dabs of color of the Impressionists, Cézanne used them more as building blocks in the total physical structure of his paintings while not becoming as rigidly precise as Seurat (see figs. 7.20 and 8.46).

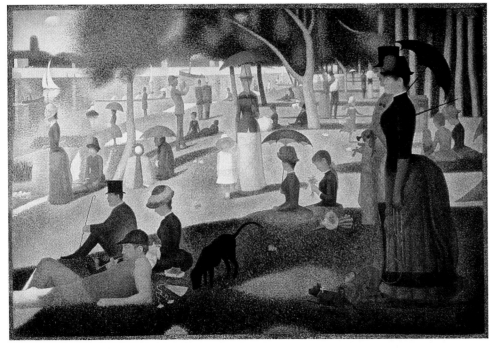

◄ **10 • 22**

George Seurat, *Sunday Afternoon on the Island of La Grande Jatte,* 1884–86. Oil on canvas, 6 ft 9 in. × 10 ft 6 in. (2.06 × 3.2 m).

Seurat is classified as a Post-Impressionist, but his technique set him apart from all other artists. He applied his color in a manner that he considered scientific, using dots of broken color that are resolved and harmonized by the eye of the observer. Though a remarkable achievement, "Pointillism" had only a brief stylistic life.

Art Institute of Chicago. Helen Birch Bartlett Memorial Collection 1926.224. Photo © 1998 Art Institute of Chicago. All rights reserved.

Apparently lacking a natural aptitude for painting, Cézanne suffered many years of abuse by critics and the public before finding his own style. But gradually he taught himself to develop the mass and space of objects (such as *Still Life with Basket of Fruit;* see fig. 8.46) and nature through the intensity of color, rather than the traditional method of dark and light values, while still respecting the flatness of his canvases. Cézanne's technique of painting thin, translucent, parallel strokes of the brush to develop form expresses in the rich sonority of hue his emotional reaction to his subjects. By his views of various objects and nature from different points in space and by using broken contours, Cézanne accounted for human eye movement, while simultaneously relating things to each other and the two-dimensional painting surface.

Thus Cézanne conceived of reality as the totality of form and expression transformed by the artist's mind and hand as it was derived from the appearance of nature. In this way Cézanne became the first artist of modern times to consider the appearance of pictorial form more important than the representation of a subject (fig. 10.23). Due to the intellectualization involved in his realizations of form, Cézanne is considered a Classicist in spirit. Nevertheless, he was the forerunner of modern Cubism as well as other intellectualized abstraction in the twentieth century.

In comparison to the classical character of Cézanne and Seurat, the works of Paul Gauguin show the invention of a vivid, symbolic world of decorative patterns (see figs. 1.30 and 7.21). The patterns owe part of their particular character to the types of expression Gauguin gleaned from Medieval carvings, mosaics, and manuscripts. He saw some of these carvings on roadside chapels while living in Brittany, France, in the 1880s. While many of his later themes (during the

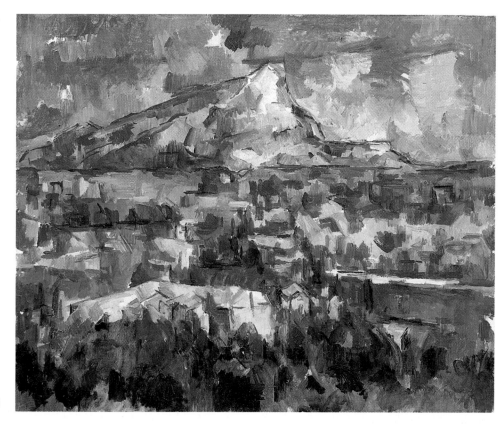

▲ **10 • 23**
Paul Cézanne, *Mount Sainte-Victoire,* 1902–04. Oil on canvas, 27 × 35 in.
Cézanne tried to show the essence of natural forms rather than describe them. This painting shows his style at its climax, in which depth is suggested but the planes into which the painting is divided tend to merge background and foreground two-dimensionally.
Acc. No. 1936-1-1. Phildelphia Museum of Art, The George W. Elkins Collection. Photograph by Graydon Wood, 1994.

1890s) were inspired by more exotic places, particularly Tahiti in the Pacific, Gauguin's work always demonstrates a sophistication and suavity typical of French art despite the mystery and underlying threat of the Tahitian native arts that he merged into his work there. The brilliant color and free patterns of his decorative style, plus the otherworldly effect, inspired not only the Symbolists at the end of the 1800s but also the early twentieth-century French Fauves.

The work of Vincent van Gogh, the fourth Post-Impressionist, represents the beginning of a new, highly charged, subjective expression that we find in

many forms of modern art. The character of Expressionism in the early 1900s owes a great deal to the impetuous brush strokes and dramatic distortions of color and objects used by Vincent van Gogh. He was mostly self-taught as an artist, having turned to art after failures at other careers. It was van Gogh's failures, however, that were the root of his impassioned style, now marked by history as one of the greatest and most distinctive. His way of vibrantly meshing his emotions with his subjects, be they portraits, landscapes, or still-life paintings, goes far beyond the perceptual starting point and final forms of the

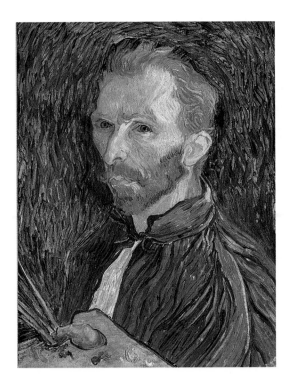

◄ **10 • 24**
Vincent Van Gogh, *Self-Portrait*, 1889. Oil on Canvas, 22 × 17 in. (56 × 43 cm).

As seen in this self-portrait, painted in the year before his death, the emotional content of Van Gogh's style becomes one with the ribboned paint texture. It was applied by brush, palette knife, and possibly fingers.

Collection of Mr. and Mrs. John Hay Whitney. Photograph © 2001 Board of Trustees, National Gallery of Art, Washington.

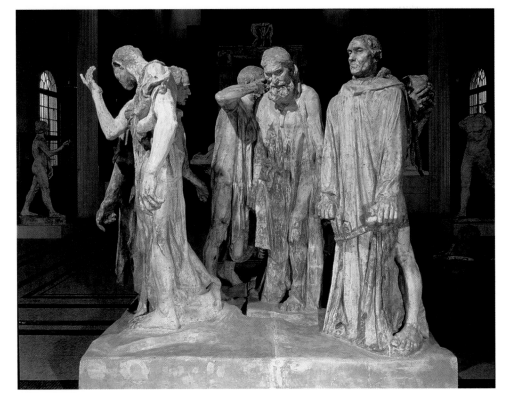

▲ **10 • 25**
Auguste Rodin, *The Burghers of Calais*, 1888. Bronze, 84 × 91 in. (213.4 × 231 cm).
The French port city of Calais commissioned this work in which the sculptor's content reaches a peak of psychological impact through gestulating figures standing on the same level as the observer. They have been mistaken for real people at night.

Musée Rodin, Paris, France. Peter Willi/The Bridgeman Art Library,

Impressionists (fig. 10.24, see also fig. 1.16).

Henri de Toulouse-Lautrec (1864–1901), a descendant of an ancient aristocratic family, seems to be classifiable as either an Impressionist of movement or a Post-Impressionist of expressive color and psychological insight. Because his growth was unfortunately stunted in childhood, Lautrec's dwarfish appearance led to his isolation from the high social strata enjoyed by his family. To find solace for his appearance, Lautrec's friends were among the outcasts of Parisian society, where, after studying art, he sought his subjects in cabaret performers, circuses, and brothels. These people were rendered in strong inquiring lines and raw color in such a way as to express Lautrec's harmonious and unquestioning acceptance of their lives. Lautrec is noted for his inventive posters advertising the cabaret entertainers' performances. Lautrec's fluid line, shape, and use of flat color capture the song and dance activities of the performers and advanced the art of color lithography immensely (see fig. 3.4).

There was no clearly defined Post-Impressionist movement in sculpture, and not until about the middle twentieth century did sculptors seek the revolutionary changes that were occurring in painting at the end of the 1800s.

Auguste Rodin (1840–1917) was the most important late nineteenth-century sculptor. He looked to the future as well as to the past, and he was the link to exploiting form, materials, and expressive content for their own inherent sake. Rodin was basically a Realist who, by embracing Romantic, Realist, and Impressionist effects, predicted the early twentieth-century Expressionists. In his search to suggest emotional states directly through sculptural form, he was a Romantic. In his attack on the medium of clay and plaster (from which his many bronzes were to be cast), the gouged, irregular surface effects are similar to

those of the Impressionists, particularly because of the way light falls on them. It is also partly from these effects that an emotional quality, something like those of the expressive Post-Impressionists van Gogh or Tolouse-Lautrec result. Rodin studied with Antoine Louis Barye but was more influenced by Renaissance sculptors Donatello (c. 1386–1466) and Michelangelo (1475–1564). Rodin highly regarded the great seventeenth-century sculptor Giovanni Lorenzo Bernini (1598–1680), and admired the carvings on Gothic cathedrals. While he was repulsed by most of the academic sculpture of his time, he did not hesitate to use similar themes, as in the *Gates of Hell* (see fig. 9.31), which contain a highly expressive content owed principally to the emotional writings of Dante and Baudelaire. Rodin also paid a great deal of attention to movement, trying to express drama and emotive effect in static sculptures, as in *The Burghers of Calais* (fig. 10.25). This commission by the port of Calais commemorated an incident in which citizens of the city offered themselves as hostages to English invaders to save the city itself. There is a tremendous psychological impact provided by actually meeting these gesturing figures on the ground level, since the traditional pedestal is no longer used. The *Gates of Hell* and *Burghers* were cast in bronze from preliminary models in clay and plaster. When Rodin worked in hard materials like marble, however, as in the *Danaide* (1885), he tried to restore sculptural values that he felt had been lost but so admirably accomplished by Michelangelo. Among other values Rodin tried to restore were the heft and texture of stone, the contrast between highly polished surfaces and unfinished roughness, and the technique of having a figure partly emerging from the block of stone. In other sketches and finished works, he created fragmentary human forms, producing an effect of humanity striving against fateful forces (see fig.

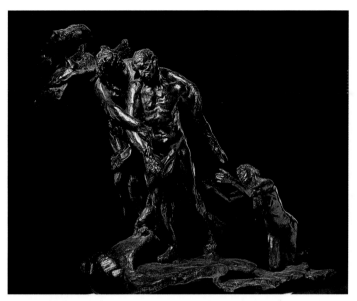

▲ **10 • 26**
Camille Claudel, *Maturity (L'Age Mûr)*, **1907. Bronze, 47⅝ × 70⅞ × 28¾ in. (121 × 180 × 73 cm).**
Sadly neglected for a half a century, this sculptress was student, assistant, model, and mistress to Auguste Rodin. Her work had a more fluid style than Rodin's.
Collection Musée Rodin, Paris. © Musée Rodin/DR. Artists Rights Society (ARS), New York/ADAGP, Paris. Photograph by Erik & Petra Hesmerg.

9.4). Moreover, it was in the unusual effects of torsion, dimension, fractional presentation, and the potency expressed in his figures that Rodin predicted the future. These effects helped pave the way to much twentieth-century sculpture.

One of Rodin's most important assistants, Camille Claudel (1864–1943), came to light a few years ago after having been forgotten. Starting as a student, she became Rodin's model and mistress. A few of her own works on display at the Rodin Museum and in private collections indicate that she was far less imaginative and monumental than Rodin but technically adept at handling similar materials (fig. 10.26).

PHOTOGRAPHIC TRENDS

In the meantime, certain Pictorialist photographers were working in an Impressionist or Post-Impressionist vein, while others were following the

■ **Symbolists,** ◍ whose style sought to achieve ultimate reality by intuitive or inward spiritual experiences of the world. Many of these artists, like their counterparts in painting, always worked directly from nature and yet, increasingly, were making perception a way of learning about composition and an evocative expression. They also seem to have been aware that there was something beyond the mere recording of a moment. Some of these Pictorialists did not approve of the fuzzy focus and film manipulation that their colleagues used to attain their effects. They began to experiment instead with the natural effects of light and atmospheric effects, as had the Impressionist painters. The fusing of experimental Pictorialism with a Realist point of view, then, seems to have been influenced by the theories of both Post-Impressionism and, to some extent, Symbolism. Many of these modernist photographers grouped together, leading to the foundation in London in 1892 of the so-called Linked

sought similar influences, searching for exciting patterns in the ancient artifacts of museums. The Fauves were inspired by the work of the Byzantines, the Coptic Christians, and archaic Greek artists, as well as by the tribal art of Africa, Oceania, and Native Americans. The influence of African masks and sculpture can be detected in the stylized, impersonal human faces found in Matisse's paintings, as well as those of numerous other early twentieth-century

artists. Behind this impersonal but enigmatic effect lies a sense of mystery or threat (see fig. 10.40).

The Expressionists Matisse and Amadeo Modigliani (1884–1920), despite their general preference for strong, vibrant color, achieved charming content within a decorative form that continued the long tradition of classical restraint found in French and Italian art. Georges Rouault (1871–1958), on the other hand, was an exception among the

French Fauve Expressionists; his work was as harsh and dramatic as that of his German counterparts. His paintings express a violent reaction to the hypocrisy and materialism of his time through characteristic use of thick, crumbling reds and blacks. His images of Christ are symbols of man's inhumanity to man, as his *Christ Mocked by Soldiers* reveals (fig. 10.29); his paintings of judges are comments on the crime and corruption of his time. Rouault's artistic comments on the French political and legislative leaders of the day were anything but complimentary.

German Expressionism

German artists of the early twentieth century felt that they, as prophets of new, unknown artistic values, must destroy the conventions that bound the art of their time. The foundation of painting in Europe for the next 50 years was partly provided by three groups of German Expressionist artists. First among these was The Bridge *(Die Brücke),* founded in Dresden at the same time as the Fauves' exhibit at the *Salon d'Automne* (1905). Ernest Ludwig Kirchner (1888–1938) was the outstanding leader of The Bridge (fig. 10.30). Another important member who joined later was Emil Nolde (1867–1957). The Bridge died out with the opening of World War I in 1914 (see fig. 3.20).

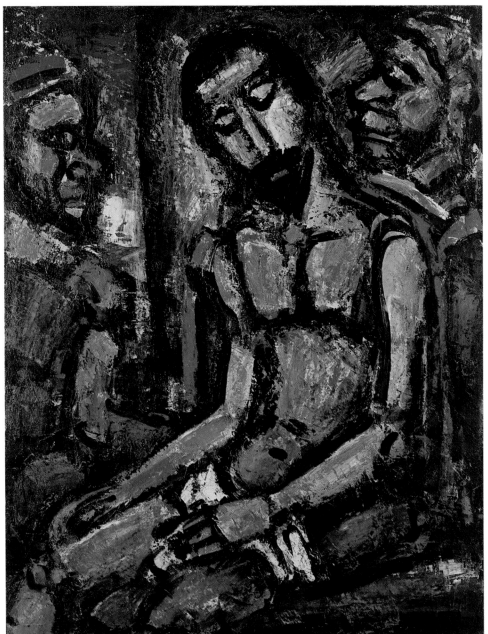

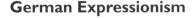

10 • 29
George Rouault, *Christ Mocked by Soldiers*, 1932. Oil on canvas, 36¼ × 28½ in. (92.1 × 72.4 cm).

In this Expressionist contrast of clashing complements, the pattern is stabilized by heavy neutralizing lines of black reminiscent of Medieval stained glass.

The Museum of Modern Art. New York. Given anonymously. Photo © 1998 Museum of Modern Art. © 1997 Artists Rights Society (ARS). New York/ ADAGP. Paris.

10 • 30
Ernst Ludwig Kirchner, *The Street,* 1909. Oil on canvas, 4 ft. 11 ¼ in. × 6 ft. 6⅞ in. (1.5 × 2 m).
While creating a world of emotional intensity, bright colors and wraith or ghostlike figures without any apparent gravity show Fauve and some Cubist impact on this artist.
The Museum of Modern Art, New York. Purchase. Photograph © 2001 The Museum of Modern Art, New York.

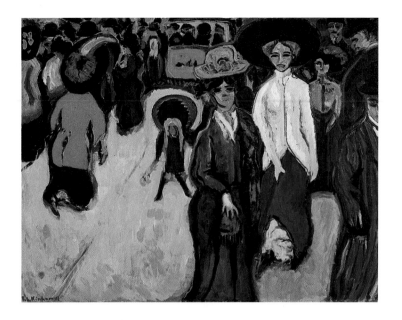

The Blue Rider *(Der Blaue Reiter),* a second group founded in Munich, Germany, in 1911, was as much abstract as Expressionist in style, and its primary artist was Wassily Kandinsky (1866–1944), whom we will consider later under European Abstraction.

The New Objectivity *(Die Neue Sachlichkeit)* was the third group of Expressionists and was founded after World War I. Its artists, including George Grosz (1893–1959) and Otto Dix (1891–1969), chose as their principal themes the corruption and chaos left in Germany by the World War I, the succeeding Weimar Republic, and the rise of Hitler's National Socialist regime resulting in World War II.

The Expressionism of the Bridge group was the most typical of the German Expressionists. Its artists created images that had a vehemence, drama, gruesomeness, and fanaticism never completely captured by the rationality of French art. They frequently identified with the religious mysticism of the Middle Ages, with the tribal arts of Oceania and Africa, and with the psychotic expression of the mentally ill. Some followed the manner of children, with a naive but direct emotional identification with the environment. For example, the art of Emil Nolde (1867–1956) is similar in feeling to the mystic art of the Middle Ages (see figs. 3.20 and 7.40). The Norwegian Edvard Munch (1863–1944), a pioneer of Expressionism living in Germany, was introducing a style of emotional instability based on his own tragic childhood (fig. 10.31). Munch was also partly influenced

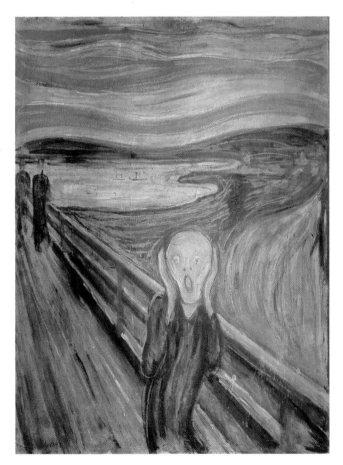

10 • 31
Edvard Munch, *The Scream* or *The Cry,* 1893, Oil and tempera on board, 35¼ × 28 in. (89.5 × 73.7 cm).
The angst-ridden life of this artist is reflected in his emotional and distorted pictures. Childish terrors and medieval superstitions are interwoven in a form of frightful conditions.
National Gallery, Oslo, Norway. Photo: Bridgemen Art Library, London/SuperStock. © 2001 The Munch Museum/The Munch-Ellingsen Group/Artists Rights Society (ARS), New York.

▲ 10 • 42
Paul Strand, *Abstraction, Porch Shadows, Twin Lakes, Conn.,* 1916. Satista print, 13 × 9 in. (33.2 × 23 cm).
In this high-angle close-up, Paul Strand has created a handsome abstract shadow photograph with rich darks and brilliant whites.
Art Institute of Chicago. The Alfred Stieglitz Collection, 1949.885. Photo © 1997 Art Institute of Chicago, all rights reserved. © 191 Aperature Foundation, Inc/Paul Strand Archive.

◀ 10 • 43
Alvin Langdon Coburn, *Portrait of Ezra Pound,* 1916. Photograph.
Strongly influenced by Cubism, the diversely talented photographer Coburn produced this multiple image of the poet Ezra Pound.
Courtesy George Eastman House, Rochester, NY.

multiple effects to produce decoratively formal photographic images. These photographers later explored more abstract imagery, with Coburn going through a Futurist phase as well.

Futurism

Futurism was a movement in painting, sculpture, and literature that refashioned Cubism in light of its own beliefs in portraying the dynamic character of twentieth-century life, glorifying war and the machine age, while favoring the political aims of Fascism. Certain Italian artists training in Paris during the excitement caused by the new artistic ventures of Picasso and Braque formed Futurism between 1909

and the end of World War I. Like Cubism, Futurism remained a submovement within the overall field of abstraction. Among the most important of these Italian artists was Gino Severini (1883–1966), who was instrumental in getting a French journal (*Figaro,* Paris, 1909) to publish the poet/critic Tommaso Marinetti's "Futurist Manifesto," which initiated the movement.

The most important artists in this movement, besides Severini (see fig. 8.53), were Giacomo Balla (1871–1958) and Umberto Boccioni (1882–1916) (fig. 10.44). Balla was the oldest Futurist and seems to have inspired the others to follow his style (fig. 10.45; see fig. 8.52). The Futurist painters tried to express the ceaseless activity of modern machinery, the speed and violence of contemporary life, and the psychological effects of this ferment on humanity by using sheaves of lines, faceted planes, and multiple brilliant colors. The activity and beauty of modern machinery at work appealed to them, as well as attempts to interpret contemporary incidents of violence—such as riots, strikes, and wars—and their effects for the future. These representations of forms in motion influenced many painters, including Marcel Duchamp (1887–1968). Futurism also counterinfluenced Cubism and had an impact on Russian Constructivism.

Arguably, however, the fervor of the Futurists does not really match up to their artistic contributions. They merely energized the somewhat static geometry of Cubism and brought back richer coloring. Perhaps the group's attention to the machine was its most important contribution, because other artists and the public became more aware of the growing mechanization of their society for good or bad. Again it appears that photography and the other graphic arts had a mutual impact on one another. In Italian Futurism, for example, the influence of early photographers such as

▲ 10 • 44
Giacomo Balla, *Speeding Automobile*, 1912. Oil on wood, $21\frac{7}{8} \times 27\frac{1}{8}$ in. (55.6 × 68.9 cm).
This artist's handling of the image of a speeding machine is characteristic of the Futurist idiom. Incorporated into the dynamic form is a sense of the hysteria, violence, and sheer tension in modern life.
The Museum of Modern Art, New York. Purchase. Photo © 1998 Museum of Modern Art. © 2001 Artists Rights Society (ARS), New York/SIAE, Rome.

▲ 10 • 45
Umberto Boccioni, *Unique Forms of Continuity in Space*, 1913. Bronze (cast 1931), $43\frac{7}{8} \times 34\frac{7}{8} \times 15\frac{3}{4}$ in. (111.4 × 88.6 × 40 cm).
Boccioni was a leading founder and member of the Futurist group. An accomplished painter and sculptor, he was preoccupied for much of his career with the dynamics of movement.
The Museum of Modern Art, New York. Acquired through the Lillie P. Bliss Bequest. Photo © 1998 Museum of Modern Art.

▶ 10 • 46
Anton Giulio Bragaglia, *Salutando (Greeting)*, 1911. Fotodinamica. From Fotodinamismo Futurista Sedici Tavole, 1911.
Within the milieu of Italian Futurist painting. Bragaglia made this time exposure of a man in the midst of greeting someone with a broad gesture. He coined the term "photo-dynamic" to describe pictures of this kind.
Centro Studi Bragaglia, Rome. Collection of Antonella Vigiliani Bragaglia.

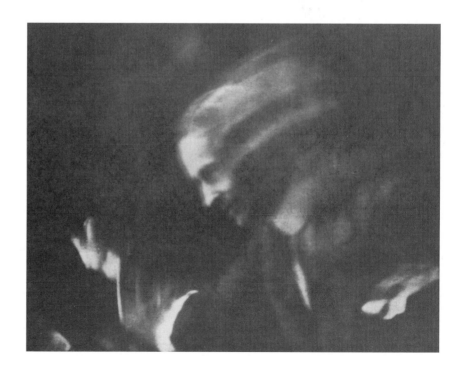

the Englishman Eadweard Muybridge is implicit, not only on painters such as the Frenchman Marcel Duchamp (1887–1968) (see figs. 8.51 and 8.52) and the Italian Giacomo Balla, but on Italian photographers like Anton Giulio Bragaglia (1889–1963) (fig. 10.46).

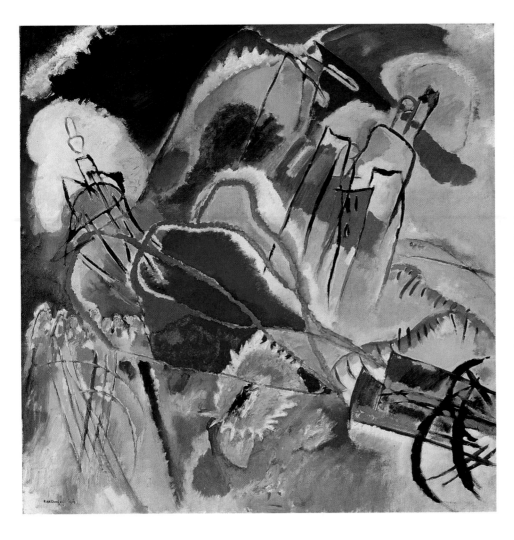

▲ 10 • 47
Wassily Kandinsky, *Improvisation 30 (Cannons)*, 1913. Oil on canvas, 3 ft 7 in. × 3 ft 7¼ in. (1.09 × 1.10 m).
About 1910, the Russian Wassily Kandinsky began to paint freely moving biomorphic shapes in rich combinations of hues. His characteristic early style can be seen in this illustration. Such an abstract form of expression was an attempt to show the artist's feelings about object surfaces rather than to describe their outward appearances.
Art Institute of Chicago. Arthur Jerome Eddy Memorial Collection, 1931.511. Photo © 1998 Art Institute of Chicago. All rights reserved.

ABSTRACT ART

Abstract Art in Europe

During the period from 1910 to 1918, the chief motivation of many artists throughout Europe was to completely eliminate nature from art. When abstract art began, however, the starting point was still in reference to visible matter and was inspired primarily by the Fauves and Cubists, particularly Picasso. As artists explored more and more toward totally nonrepresentational form, they took two main directions. Some, like the Russian Wassily Kandinsky (1866–1944), preferred, as in his early abstractions, an emotional, sensuous, expressionist quality, which later influenced American Abstract Expressionist painting. Perhaps

Kandinsky's best works were these early abstractions with their powerful rhythms, biomorphic shapes, and sense of great spontaneity (fig. 10.47). In 1919, however, after joining the German Bauhaus as a faculty member, Kandinsky's style became more geometrically abstract and more reserved in feeling.

Others, like Piet Mondrian (1872–1944), the leader of the Dutch Abstract group ■ **De Stijl,** preferred Geometric Abstraction with its colder precision and reserve, which inspired Hard-Edge Abstraction in the United States later. He was the most representative exponent of Geometric Abstraction in the early stages of Abstract Art (fig. 10.48). Like Kandinsky, while starting from nature, Mondrian eventually dealt with the most basic elements of form; but, unlike Kandinsky, he purged them of any perceivable emotional qualities (see figs. 1.3–1.6). In such work, meaning or content is inherent in the precise relationships established between the horizontal and vertical lines creating rectilinear shapes and the sole use of primary colors. This direction seemed sterile and shallow to both other artists and critics when it first appeared. That it was, instead, momentous and rich in possibilities is proven by its tremendous impact on hundreds of artists. Believers were soon finding metaphysical and mystical content in the purely optical harmonies of Geometric Abstraction, and the critics who were ridiculing Modrian's art were soon in the minority.

The Abstract Art discussed so far in this chapter originated from nature. There is another aspect to abstraction called *nonobjective art,* where the form originates from the imagination, or within the mind, of the artist. The difference between these two approaches to abstraction is of theoretical interest only, so the term *abstract* is the only one used today for all nonfigurative or nonrepresentational

art. The use of the elements of form, unencumbered by recognizable objects, became the basis for the work of hundreds of artists. A certain amount of abstract art lacks originality, of course, because although it is easy to produce synthetic (or academic) Abstract art as an end in itself, this art may truly have no meaning. However, where abstraction is genuinely a part of the creative process, great powers of thought and expression are required of the artist.

Many elements of the twentieth-century world derived their personality from the continuing influence of abstraction. Modern architects and designers readily assimilated abstract theories of form in buildings (the International Style of architecture), furniture, textiles, advertising, and machines, for example. The gap between fine art and art of a commercial or industrial nature has gradually narrowed. This may be because abstract art developed out of an environment where the practical function of the machine had become both an implicit and a conscious part of life. In a sense, the abstract artist created a machine-age aesthetic. From the late 1900s into the new millennium artists have frequently sought a more humanized content, or expression, again.

The outstanding representatives of the nonobjective concept were the Russian ■ **Constructivists,** artists who were part of a movement founded by Vladimir Tatlin between 1913 and 1922 devoted to Geometric Abstraction. Since Constructivism was primarily associated with three-dimensional spatial concepts, or sculpture, it is discussed under that heading later. There were Russian painters at the time with constructivist leanings worth mentioning, however. Principal among these was Kasimir Malevich (1878–1935), who called himself a Suprematist. In 1913 he exhibited a pencil drawing of a black square on a

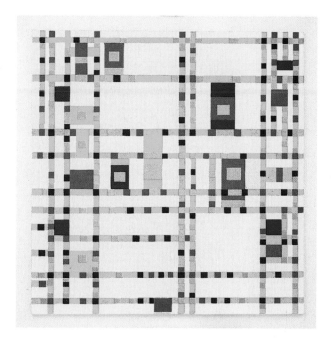

◄ **10 • 48**
Piet Mondrian, *Broadway Boogie Woogie*, 1942–43. Oil on canvas, 50 × 50 in. (127 × 127 cm).
Though some may consider Mondrian's style sterile, this work with its bright colors and sometimes unexpected shape placements probably reflects the artist's interest in popular music.

The Museum of Modern Art, New York. Given anonymously. Photograph © 2001 The Museum of Modern Art, New York.

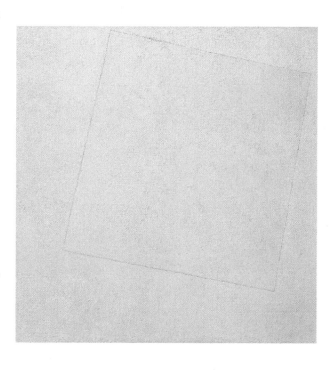

◄ **10 • 49**
Kasimir Malevich, *White on White*, 1918. Oil on canvas, 31¼ × 31¼ in. (79.4 × 79.4 cm).
The "suprematist" Malevich was possibly the first Geometric Abstract or Non-objective painter. He had begun with a black square drawn on a white ground in 1913. This later painting followed his earlier drawing reversing the square to white on white.

The Museum of Modern Art, New York. Acquisition confirmed in 1999 by agreement with the Estate of Kasimir Malevich and made possible with funds from the Mrs. John Hay Whitney Bequest (by exchange). Photograph © 2001 The Museum of Modern Art, New York.

white ground. This appears to have been the first Geometric Abstract art work (compare fig. 10.49).

In Weimar, Germany, the Bauhaus (an architectural training school) also favored Constructivism. Among the

faculty, including painters and sculptors, was the Abstract painter Joseph Albers (1888–1976), one of many who were forced to come to the United States with the closing of the Bauhaus by the Nazis in 1933 (see fig. 4.25).

▲ 10 • 50
**Georgia O'Keeffe, *Canna Red and Orange,*
1922. Oil on canvas, 10 × 16 in. (50.8 ×
40.6 cm).**
Inspired by light, this "Precisionist" artist
stripped away most features of reality to create
her colorful, semiabstract images.
Private Foundation.

Abstract Art in the United States

Abstract art was slow in coming to America. The New York Armory Show in 1913 revealed to American audiences for the first time many of the important avante garde artists of Europe. Some of the Americans who were to proceed in creating an American Abstract movement, out of which others would sprout, were

also exhibited. Meanwhile, between 1905 and 1917, primarily under the aegis of Alfred Stieglitz, the New York–based 291 gallery became a meeting place for American and international pioneers of avant-garde photography, painting, and sculpture. Among the painters and sculptors introduced by the gallery were Cézanne, Rodin, Matisse, Toulouse-Lautrec, Constantin Brancusi, Picasso, and Marcel Duchamp, along with American artists such as John Marin and Georgia O'Keeffe (whom Stieglitz married). These events encouraged the earliest experiments of Americans with abstraction. Shortly after World War I, a coterie of pioneer abstractionists appeared. Some, like Marin, Weber, and Burchfield, remained close to Expressionism (see figs. 8.43 and 4.24); others, called the Precisionists, similarly kept a basically representational form while stripping away so much detail that the impact of their forms is nearly abstract. The founders and principal artists in the group were probably Georgia O'Keeffe (1887–1986) and Charles Sheeler (1883–1965). O'Keeffe and Sheeler both felt the influence of photography. While O'Keeffe painted buildings, flowers, and cow skulls in a semiabstract manner that was notable for its clarity, poise, and harmony, Sheeler concentrated mainly on different kinds of buildings in a somewhat similar style (fig. 10.50; see figs. 1.11, 4.26 and 8.25). It took a while longer before total abstraction gathered momentum in the United States. It was evolving in the 1930s but didn't mature until the 1940s. The influence of European emigré artists was an important factor in this development. Most outstanding among these artists were Hans Hofmann (1880–1966) and Joseph Albers. We saw that Albers was active at the Bauhaus before coming to the United States, and Hofmann taught in his own school in Germany before leaving for the United States in the 1930s. Hofmann's teaching in this country and his loose, abstract,

brilliantly colorful style helped establish the ■ **Abstract Expressionist** style. Albers was a student and teacher at the Bauhaus before he came to America and the earliest immigrant artist to import Bauhaus ideas. He was also a Constructivist. His forte was to experiment with the related phenomenon of color next to color within shapes (usually squares) (see figs. 8.44 and 4.25).

Abstract Sculpture

Picasso's Cubist collages and constructions of 1912–14 opened the way for a wide range of abstract sculptural forms. Perhaps the most important early abstract sculptor was the Franco-Romanian Constantin Brancusi (1867–1957). As early as 1913, he chose to free sculpture from mere representation. Such works as the *Bird in Space* of 1928 reveal an effective and sensuous charm through their flowing, geometrical poise and emphasis on beautifully finished materials. Brancusi usually preferred to work in a semiabstract mode but always considered the shape, texture, and handling of materials to be more significant than the representation of subject (fig. 10.51).

Another pioneer Abstract sculptor, the Russian-born Alexander Archipenko (1887–1964), like Brancusi, belonged to the so-called School of Paris during the Cubist period of Picasso and Braque. His significant contribution was the use of negative space (the void) in sculpture, as in *Woman Doing Her Hair* (in which a hollow replaces the face). Archipenko also explored the use of new materials and technology, occasionally incorporating machine-made parts into his work (see fig. 9.24).

The same Cubist intellectual and artistic ferment that led Archipenko to explore human-made materials and Brancusi to pioneer the use of power tools also led the Russian brothers Naum Gabo (1890–1977) and Antoine Pevsner

▶ **10 • 51**
Constantin Brancusi, *Bird in Space*, 1228. Bronze (unique cast), 54 × 8½ × 6½ in. (137.2 × 21/6 × 16.5 cm).
Brancusi abstracted down to essential forms and showed great concern for the properties of his medium.
The Museum of Modern Art, New York. Given anonymously. Photo © 1998 Museum of Modern Art, © 1997 Artists Rights Society (ARS), New York/ACAGP, Paris.

(1882–1962) to develop their important Constructivist concepts. The Constructivist movement, although founded by Vladimir Tatlin, is most closely associated with these brothers due to their proclamation in a 1920s manifesto that total abstraction was the new realism in art. Gabo was the more exciting of the two, inventing both nonobjective and nonvolumetric forms (three-dimensional forms that do not enclose space but interact with it) (see fig. 9.5). Pevsner worked more with solid masses, nearer to sculpture of a traditional kind. The common denominator in the work of all Abstract sculptors during the period of 1900–30 was an approach that emphasized materials and blurred the division between the fine arts and the functional arts. This was essentially the point of view held by both the Constructivists and the Bauhaus movement.

Abstract and Realist Photography

Abstract art was also making its influence felt in the experimental work of photographers. So photography, too, began to be freed from its former role as a recorder of reality and to explore a whole new language of patterned design. We saw this process beginning to some extent with photographers inspired or stimulated by Cubist and Futurist painting, such as Paul Strand (see fig.

10.42) and Alvin Langdon Coburn (see fig. 10.43). These artist-photographers had been determined to work in the Realist or Straight tradition without manipulating focus, negatives, or the process of development. Coburn's image in figure 10.52 illustrates how he achieved his more abstract manner by inventing a system of multiple, three-mirror image reflections of his subjects. Under the backing of Stieglitz, we have also seen how European and American artists were often first exhibited in this country at 291 Fifth Ave., New York (pp. 268 and 282). Among the earliest group of photographers exhibited at 291 were Edward Steichen, A. L. Coburn, and Stieglitz's protégé Paul Strand. In the

▲ 10 • 63
Salvador Dali, *Persistence of Memory*, 1931. Oil on canvas 9½ × 13 in. (24.1 × 33 cm).
A naturalistic technique combined with strange abstractions gives a nightmarish mood to this painting. The limp watches may be a commentary on the unreliability of our sense of time.
The Museum of Modern Art, New York. Given anonymously. Photo © The Museum of Modern Art. © Demart Pro Arte (r), Geneva/Artists Rights Society (ARS), New York.

Surrealism were a continuation of the counterattack, begun by the Romantics in the nineteenth century, against an increasingly mechanized and materialistic society. Sigmund Freud's theories of dreams and their meanings lent strong credence to Surrealist beliefs. While Freudian psychology was not well understood, Surrealist writers and artists nonetheless tried to create a new pantheon of subconscious imagery based on its theory, claiming the results to be more real than those generated by activities and behavior on the conscious level. The Surrealists believed that only in dreams, which arise in the mind from below the conscious level, could humans retain their personal liberties. In their art, the Surrealists cultivated images that arose ostensibly unbidden from the mind. These images were recorded

through automatic techniques of drawing and painting. Such images bring to attention the arbitrary way that our senses construct reality, by exploring incongruous relationships of normal objects in abnormal settings and vice versa. The Surrealists juxtaposed commonsense notions of space, time, and scale in unfamiliar ways.

The first Surrealist exhibit, held in 1925, included works by Max Ernst (1891–1976), Arp, de Chirico, Klee, Man Ray (1890–1976), Joan Miró (1893–1983), and Picasso. Obviously, not all were associated with the Surrealist movement. There were others not represented in the exhibit but who joined later, such as Yves Tanguy (1900–1955) and Salvador Dali (1904–1989).

Ernst, a German painter associated with Dada and a founder of Surrealism,

invented several devices in exploring his fantastic concepts (see figs. 10.58 and fig. 2.12). His Frottages (invented about 1925) employed the Surrealist technique of shutting off the conscious mind. Frottages were rubbings made on rough surfaces with crayon, pencil, or similar media. In the resulting impressions, the artist would search for a variety of images while in a state of feverish mental intoxication. A process bordering on self-hypnosis was embraced to arrive at this heightened state. No doubt some artists used drugs and alcohol. The Spanish painter Salvador Dali (1904–1989) affected a creative fever similar to that of Ernst while creating his improbable, weird, and shocking images. He used an impeccably meticulous, naturalistic technique to give authenticity to them (fig. 10.63).

Yves Tanguy, a French merchant seaman who took up painting Surrealistically after seeing a painting by Georgio de Chirico, the Italian Fantasist, employed a method similar to that of Ernst. Allowing his hand to wander in free and unconscious doodlings, he created strange landscapes consisting of nonfigurative objects that suggested life. Tanguy's pictorial shapes have the appearance of perceptive, alien organisms living in a mystical twilight land (fig. 10.64; see fig. 4.6). There were many Surrealists, but Ernst, Dali, and Tanguy were the most influential, thanks to their unflagging invention of arresting images.

René Magritte (1898–1967) was the hidden artist among the Surrealists, always preferring anonymity to fame. Like Tanguy, he was so shocked by the sight of a work by de Chirico that he also embraced the Surrealist style. Magritte based his shock values on the ordinary turned strangely evocative in terms of space and the ordinary handled in an unordinary manner. Born in Brussels, he could not stand the frenetic and polarized atmosphere of Paris art circles and returned to his birthplace in 1930 for the rest of his career. In spite of being out of

the mainstream, his style of Magic Realism, as it was known in the 1940s, began to slowly be widely recognized. His *Portrait* of 1935 shows a realistic glass, bottle of wine, silverware, and plate, all everyday in appearance; but an obviously human eye peers up at us from the food on the plate. This captures the essence of Magritte's style in juxtaposing commonplace objects with elements or situations that are abnormal (see fig. 8.45).

Even when other artists did not hold with the strictures of André Breton's *Surrealist Manifesto,* they fell under the sway of its ideas. But among those so influenced were some who began to merge it with other more Expressionist and Abstract directions already prevalent during the early part of the 1900s.

Surrealist Sculpture

The effect of Surrealism on the work of many artists was variable. Certainly, not many twentieth-century sculptors were pure Surrealists when we consider the character of their work. Generally, however, the trends of the first two decades merged to such an extent that classification into specific categories is rarely possible. This tendency increased after the middle of the century and led to the complex, interwoven movements of the second half of the twentieth century.

Alberto Giacometti (1901–66), a Swiss sculptor and painter who spent much of his career in France, was perhaps one of the greatest Surrealist artists of the century. The evolvement of his personal style was affected by such diverse influences as the mildly Expressionist sculptors, Cubism, and Constructivism. Giacometti was fascinated not only by the effects of new materials on form but by the effect of light and space. By 1934 he had reached his mature style of elongated, slender figures pared away until almost nothing remained of substantial form. In their arrested movement, these figures suggest poignant sadness and isolation (fig.

▲ 10 • 64

Yves Tanguy, *Multiplication of the Arcs,* 1954. Oil on canvas, 3 ft 4 in. × 5 ft (1.02 × 1.52 m).

Working with nonfigurative objects in a polished technique, the Surrealist Tanguy invents a world that appears to be peopled by lifelike gems..

The Museum of Modern Art, New York. Mrs. Simon Guggenheim Fund. Photo © Museum of Modern Art © 1997 Estate of Yves Tanguy/Artists Rights Society (ARS), New Your/ADAGP, Paris.

▶ 10 • 65

Alberto Giacometti, *Three Walking Men* 1948/49. Bronze, 29½ in. (74.9 cm) high.

Giacometti emphasizes the lonely vulnerability of humanity by reducing his figures to near invisibility and by emphasizing the spaces between them.

Art Institute of Chicago. Edward E. Ayer Endowment in memory of Charles L. Hutchinson, 1951.256. Photo © Art Institute of Chicago. All rights reserved. © 1997 Artists Rights Society (ARS), New York/ADAGP, Paris.

10.65). Giacometti's indirect method of approaching content came from Surrealism and was related to the stream-of-consciousness theory supported by early twentieth-century psychologists.

Another Surrealist, the Spaniard Julio González (1876–1942), was the first sculptor to explore direct metal sculpture, or welding. In the late 1920s, under the influence of Picasso, González

LATE TWENTIETH-CENTURY ART

ABSTRACT-EXPRESSIONIST PAINTING

Beginning about 1940, a host of artists began mixing certain aspects of the major movements of the early twentieth century. By the late 1940s, this new stylistic category was being called Abstract Expressionism, a name derived from Alfred Barr's description in 1929 of the more romantic early versions of Kandinsky's abstractions. (Barr was the first curator of the Museum of Modern Art in New York City, which also opened in 1929).

Generally speaking, the artists grouped as Abstract Expressionists had found pure abstraction too impersonal, mechanical, and dehumanizing. On the other hand, they felt that Surrealism disregarded the desire for order that was traditionally fundamental to most art. Abstract Expressionism was actually a coalescence of the three major movements that had peaked by the 1930s: Expressionism, Abstraction, and Surrealism. Some deeper roots can also be traced to the influence of Post-Impressionism.

The leaders of Abstract Expressionism were Europeans, some of whom (Albers, Hoffmann, and Mondrian) we met under Abstract art. Others, such as Arshile Gorky (1904–1948) of Armenia, Joan Miró (1893–1983) of Spain, and Willem de Kooning (1904–1997) of Holland, had a more Surrealist Abstract or Expressionist inclination (figs. 10.70, 10.72, see fig. 4.5). These artists helped to pioneer what seemed to be the first wholly American art movement but is now interpreted by some critics as fundamentally derived from Europe due to the arrival of these émigré artists in the late 1930s and early 1940s.

Two Latin American artists important to the movement in its early stages were Rufino Tamayo (1899–1991) of Mexico and Roberto Matta Echaurren (Roberto Sebastian; b. 1912) of Chile (fig. 10.71, see fig. 4.1).

Essentially the Abstract Expressionists wanted to state their individual emotional and spiritual state of being without necessarily referring to representational form, but it should also be stressed that Abstract Expressionism was a movement without a common style: Each artist expressed his or her experiences independently. With the exhibit in 1951 of *Abstract Painting and Sculpture in America,* at New York's Museum of Modern Art, the arrival of the new movement was made official. Although the founders of Abstract Expressionism were primarily concentrated in New York City at first and were, therefore, often referred to as the New York School, by the mid-1950s there were artists working in this manner throughout the United States, Latin America, and Western Europe. As the movement developed, it divided roughly into two groups with some overlapping between them. The "Action" or "Gestural" group had a generally active, external expression of their emotions achieved by spontaneous drippings, splashings, sprayings, and rolling of paint on the canvas. Most of them had gone through earlier phases of their careers as Expressionists, Dadaists, or Surrealists. Thus they tended to find their origins in the works of such artists as van Gogh

▲ **10 • 70**
Arshile Gorky, *Agony,* 1947. Oil on canvas, 3 ft 4 in. × 4 ft 2½ in. (1.02 × 1.28 m).
A combined engineering and artistic background in his student days, plus the stimulation of Surrealism's unconscious imagery, led this artist into the emotionalized phase of Abstract Expressionism. Gorky's career followed a downward spiral of bad luck and tragedy, which seems to be mapped out in his work. His early paintings are precise and stable, gradually becoming more unsettled and unsettling in the later work. Gorky was an important influence on the younger generation of American Abstract Expressionists.

The Museum of Modern Art, New York. A. Conger Goodyear Fund. Photo: The Museum of Modern Art/SuperStock. © 2001 Artists Rights Society (ARS), New York/ADAGP, Paris.

▶ 10 • 71

Roberto Sebastian Antonio Matta Echaurren, *Listen to Living (Écoutez vivre),* 1941. Oil on canvas, 29½ × 37⅜ in. (74.9 × 94.9 cm).

Within the limits of the human mind's ability to conceive such things, Matta Echaurren has given us a vision of a completely alien milieu. Work like this by an Abstract Surrealist artist was a profound influence on the Abstract Expressionist Action artists who followed.

The Museum of Modern Art, New York. Inter-American Fund. Copyright 1998 Museum of Modern Art. ©1997 Artists Rights Society (ARS), New York/ADAGP, Paris.

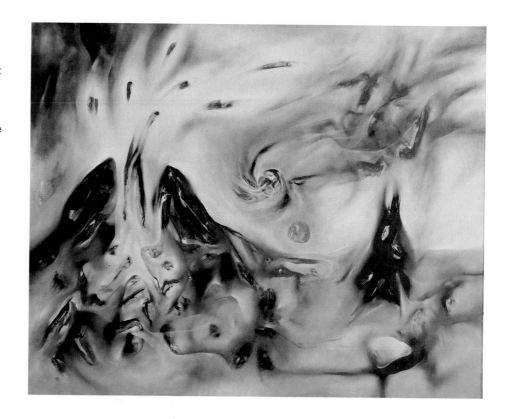

(see figs. 1.16 and 10.24) and Matisse (see figs. 3.24, 4.7, and 10.28), in Wassily Kandinsky's biomorphic abstractions (see fig. 10.47), and in the "automatic" techniques of the Dadaists and Surrealists. All had felt the influence of Picasso and the dream imagery of the Surrealists.

The second group, usually called the "Color Field" painters, were more closely allied to pre-World War II Geometric Abstraction. Their overriding influences came from the Geometric Abstract artists cited above, e.g., Piet Mondrian (see fig. 1.3), Hans Hofmann (see fig. 8.44), and Joseph Albers (see fig. 4.25). This group was indifferent to the impromptu looseness or "painterliness" of the Action painters, preferring large, flat planes painted in a more traditional manner, and therefore are sometimes labeled the ■ **Post-Painterly Abstractionists.**

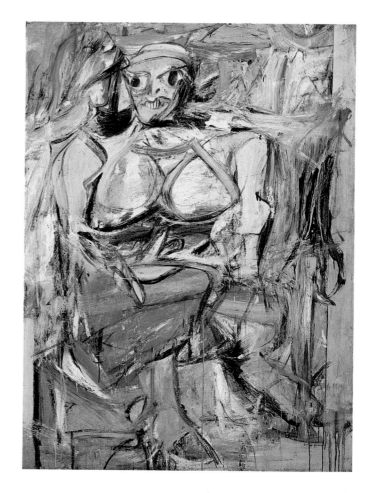

▶ 10 • 72

Willem de Kooning, *Woman, I,* 1950-52. Oil on can 6 ft 2⅞ in. × 4 ft 10 in. (1.90 × 1.47 m).

This artist summarized most aspects of the romantic, or Action, group of Abstract Expressionism: revelation of the ego through the act of painting; neglect of academic or formal organization in favor of bold, direct, free gestures are instinctively organized; and willingness to explore unknown and indescribable effects and experiences. Even though de Kooning's subject was ostensibly the figure, its representational value was subordinated to the motivating activity of pure painting.

The Museum of Modern Art, New York. Purchase. Photograph © 1998 The Museum of Modern Art, New York/Willem de Kooning Revocable Trust/Artists Rights Society (ARS), New York.

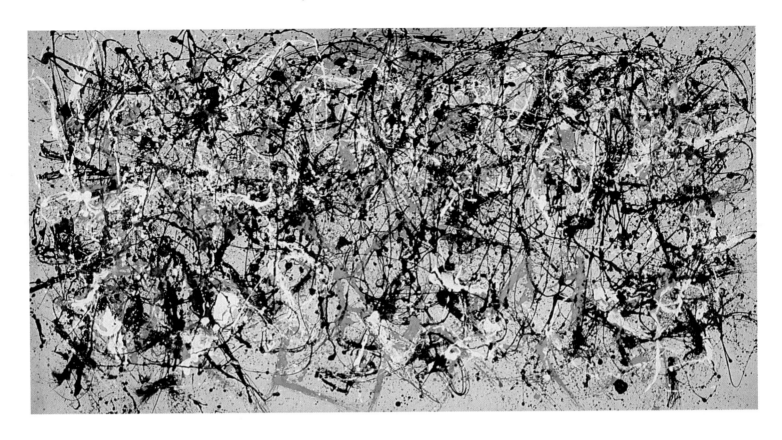

▲ 10 • 73
Jackson Pollock, *Autumn Rhythm*, 1957. Oil on canvas, 8 ft 9 in. × 17 ft 3 in. (2.67 × 5.26 m).
This artist is considered the prime example of youthful Abstract Expressionist Action painters in the late 1940s. He is noted primarily for creating swirling nonrepresentational images in linear skeins of fast-drying paint that are dripped directly onto canvases through controlled gestures of his tools.
The Museum of Modern Art, New York. George A. Hearn Fund, 1957. © 1997 The Pollock-Krasner Foundation/Artists Rights Society (ARS), New York.

Jackson Pollock (1912–56), Franz Kline (1910–62), and Helen Frankenthaler (b. 1928) are some of the significant artists of the Abstract Expressionist Action group. They worked in a way that was reminiscent not only of Surrealism and Kandinsky's pre–World War II biomorphic expressionism, but their paint application techniques also remind people of Impressionism. Confusion, fear, and uncertainty about humanity's place in a world threatened by thermonuclear holocaust may have led such painters to reject most previous forms of twentieth-century art. As a

kind of personal catharsis, they seemed to want to express their belief in the "value of doing" at the expense of other more traditional forms of expression. Pollock, for example, originated the "gesture," or the use of arm and hand movements to drop fast-drying pigments directly on the canvas in linear skeins. This is the important technique on which ■ **Action painting** was founded (although Navajo sand painting is said to have been a strong influence on him, because it also requires the use of hand and arm to apply colored sand directly to the surface). Pollock's swirling,

nonrepresentational images created in this manner expressed, through the direct act of creation, the reality of self or what the artist was experiencing as he worked (figs. 10.73 and 10.74).

Franz Kline followed a slightly different course but with a similar intention of expressing himself through direct contact with the forms created. His drawings were made with brush gestures on newsprint, then cut up and reassembled to provide a sense of power, movement, and an intensified personal rapport. Kline used these "sketches" as guides and enlarged them with loaded brushes on large canvases without directly copying them. Applied with a housepainter's brush, his savage slashings in black and white, or sometimes color, became monumental projections of inward experiences (fig. 10.75).

Helen Frankenthaler (b. 1928), a younger Abstract Expressionist, is still actively at work after benefiting from some of the older members. She developed a method of staining

▲ 10 • 74
Navajo dry or sand painting, July, 1957. Photograph.

This kind of painting used by the Navajo for religious and symbolic healing powers is said to have influenced the gestural style of Jackson Pollock. Medicine men and their helpers crushed sandstone, pollen, and charcoal. The works are temporary, needing to be destroyed by sunset to avoid evil spirits. This example depicts the sun god and the sacred eagle.

© Charles W. Herbert/National Geographic Image Collection.

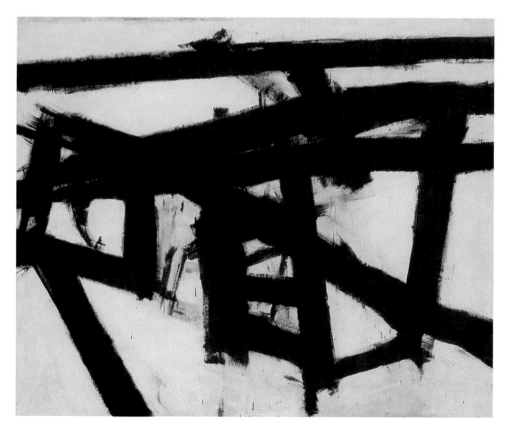

▶ 10 • 75
Franz Kline, *Mahoning,* 1956. Oil and paper collage on canvas, 6 ft 8 in. × 8 ft 4 in. (2.03 × 2.54 m).

The artist was more interested in the actual physical action involved in this type of expression than in the character of the resulting painting.

Collection of the Whitney Museum of American Art, New York. Purchase, with funds from the Friends of the Whitney Museum of American Art. 57.10. © 2001 The Franz Kline Estate/Artists Rights Society (ARS), New York.

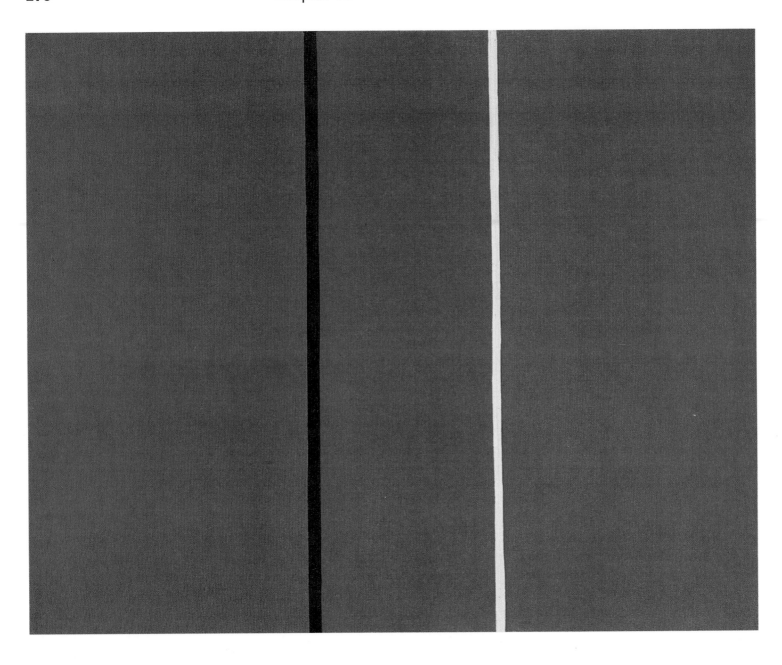

▲ 10 • 76
Barnett Newman, *Covenant*, 1949. Oil on canvas, 3 ft 11¾ in. × 4 ft 11⅝ in. (1.21 × 1.51 m).
This example is characteristic of Newman, an early Color Field painter. Such works generally feature carefully placed stripes superimposed on a flat color.
Hirshhorn Museum and Sculptue Garden, Smithsonian Institution, Washington D.C. Gift of Joseph H. Hirshhorn, 1972. Photo: Lee Stalsworth. © 1997 Barnett Newman Foundation/Artists Rights Society (ARS), New York.

unprimed canvases with pure, thinned layers of acrylic paint, depending on the bright colors and fast-drying nature of these recently innovated synthetic pigments to apply unmixed layers to achieve the brilliant density and depth of her paintings. Some of her paintings seem to become more planar, moving closer to the Color Field category. Frankenthaler is said to have been influenced, in developing her novel staining approach, by witnessing Jackson Pollock pour thinned black paint on raw

canvas. She used oil paint in this technique until acrylics became popular (see fig. 4.27).

The second category of Abstract Expressionist painting, mentioned above, called the ■ **Color Field** painters, were contemporary to the Action Group. This group was also sometimes referred to as Hard-Edge painters, since they all owed a debt to early twentieth-century Geometric Abstract works, particularly that of Josef Albers. His series called *Homage to the Square* (see fig. 4.25) had a

particularly strong influence. In this series, Albers' interest in Gestalt psychology is expressed through the effects of optical illusion. He created passive, free-floating square shapes that had just enough contrast in value, hue, and intensity with surrounding colors to be able to emerge slightly from the background. Albers' successors, Color Field painters like Barnett Newman (1905–70) and Ellsworth Kelly (b. 1923), stress definition of edges or shapes that are set off more explicitly than others in the color field (fig. 10.76; see also fig. 7.14). The paintings of this band were generally more classically restrained in content than those of the Action painters. They explored extremely large-scale, unified color fields of personally conceived shapes or signs concerned primarily with provoking sensations of ritual, tragedy, mythology, and the like.

Other noteworthy artists in Color Field painting were Kenneth Noland (b. 1924) (fig. 10.77) and Frank Stella (b. 1936). Frank Stella is of interest because of the excitement evoked by his tremendously enlarged, shaped canvases (see fig. 2.3). More recently he has also turned to large-scale sculpture. Most of the Color Field painters used stripes or bands of color moving in different directions, like Noland and Stella, while others used spots and shapes of various kinds—specific combinations of these were trademarks of their individual styles. Many, like Stella, from either branch of Abstract Expressionism have changed their styles and/or mediums in more recent times. One of the most interesting of the Color Field painters, Mark Rothko (1903–70), is said to have been inspired by the emotional and spiritual qualities of expression he found in primitive and archaic art. He also believed in the flatness of the picture plane and large rectangular shapes to express "complex ideas simply" (fig. 10.78). Rothko was noted for his nontypical color field use of softly blurred or less sharply defined looming shapes, which throughout his career became

increasingly more melancholic externalized expressions of his internal feelings of social and artistic rejection.

Because Action and Color Field painters were contemporary to one another, they often had similar goals, such as wanting to enwrap the spectator and make him or her a part of the painting through shared sensation. That they were not entirely successful in this pursuit is proved by the styles that succeeded them from about 1960 on.

ABSTRACT-EXPRESSIONIST SCULPTURE

Many sculptors worked in forms allied to Surrealism but with a greater degree of formality. These ranged from the organically sleek figures of the Englishman Henry Moore (1898–1986) to the built-up, open-wire, and welded sculptures prefigured by the forms of González and Picasso in the 1930s. Among those influenced by wire or linear sculpture was the maker of mobiles, Alexander Calder (1898–1976). González, as the pioneer of welded sculpture, must also be credited with influencing a younger generation of sculptors, most important of whom was David Smith (1906–65).

Henry Moore merged the vitality and expressive potential of González and Arp with such older traditions as Egyptian, African, and pre-Columbian sculpture, which he had discovered as a student. Moore's objective over the years was to create lively, though not lifelike, forms. His sculptures emphasize the natural qualities of the selected materials; only secondarily do they resemble human forms. In this respect, his frequently repeated theme of the reclining nude seems to retain in stone a geologically inspired character and in wood a sense of organic growth and an emphasis on the natural grain. Moore was primarily responsible for

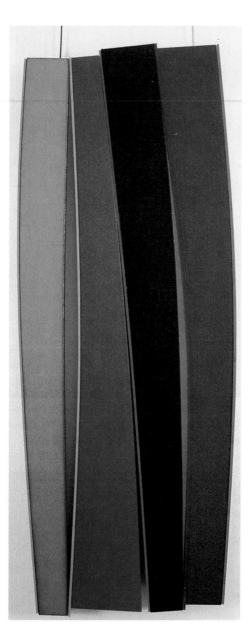

▲ 10 • 77

Kenneth Noland, *Flares: Storm Gray*, 1991. Acrylic on canvas mounted on canvas, with plexiglass, 61¾ × 24⅜ in. (156.8 × 61.9 cm).

Along with Newman, Kelly, and other Color Field painters, Noland conceived shapes or signs meant to evoke emotional response. But their approach seems more cerebral than the Action or Gestural Group. The size of such works of the 1960s and 1970s has a riveting impact. More recently, in the 1990s, Noland turned to more shaped canvases.

Kenneth Noland/Licensed by VAGA New York, NY.

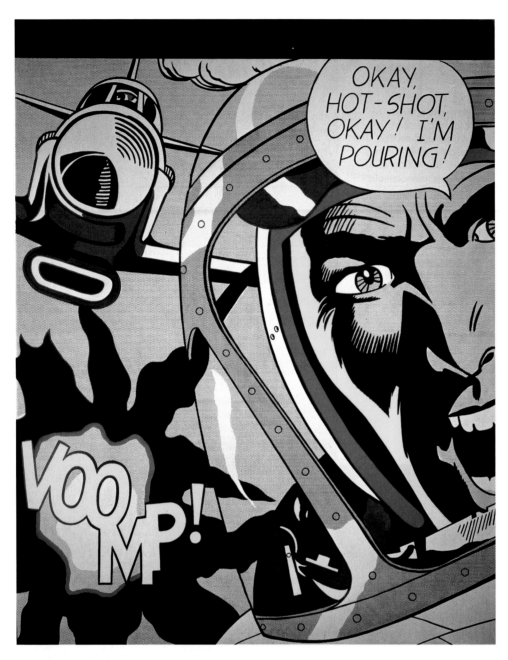

▲ 10 • 92
Roy Lichtenstein, *Okay, Hot Shot,* 1963. Oil and magna on canvas, 80 × 68 in. (203.2 × 172.7 cm).
Lichtenstein's use of magnified comic-strip heroes and heroines was typical of Pop art's playful treatment of popular culture.
© Roy Lichtenstein.

visually exploring the daily images and objects of American culture.

Claes Oldenburg (b. 1925) and George Segal (1924–2000) were two more artists significant to Pop, besides Warhol and Lichtenstein. These two were sculptors or assemblers, fields in which Pop Art made as much progress as it did in painting (figs. 10.93 and 10.94). Oldenberg, one of the most imaginative of the Pop artists, through playing on the contradiction of scale and commonly accepted reality (like the Dadaists and Surrealists) has gone through various phases of good-humored work, ranging from edibles in painted plaster to others in soft materials. Later, he also treated telephones and toilets in a similar way. Finally, he made colossal lipstick tubes, clothespins, and the like out of metal. These invade the environment monumentally and are featured in public places (see fig. 2.47). The environmental concept was an important development in the 1960s. We shall see it continued into the 1970s and 1980s with renewed vigor.

In the late fifties and sixties, at about the same time as the tongue-in-cheek irony and humor of Pop Art's new look at rampant consumerism in the United States, came another unique way of looking at American life through photography. It was introduced by a Swiss-born American, Robert Frank (b. 1924), in his photographic journal entitled *The Americans* (1959). Created in a style reminiscent of the candid social commentary of the Farm Security Administration photographers during the Depression, the journal is a photographic record of Frank's automobile travels throughout the country on a Guggenheim fellowship. Frank apparently took candid shots of people engaged in mundane tasks. They seem to say "this is life" . . . sometimes rough, sometimes sad, often suggesting, through almost empty rooms and vast uninhabited landscapes, the isolation of individuals from one another. There are people from all walks of life with "good buddy" politicians and movie

▷ 10 • 93
Claes Oldenburg, *Shoestring Potatoes Spilling from a Bag,* 1966.
Canvas, kapok, glue, acrylic, 9 ft × 3 ft 10 in. × f ft 6 in. (2.74 ×
1.17 × 106.7 m).

Pop artists generally disregarded all form considerations, which they believed created a barrier between the observer and the everyday objects that served as subjects. Pop Art was an art rooted in the present.

Collection of the Walker Art Center, Minneapolis, MN. Gift of the T. B. Walker Foundation, 1966.

▽ 10 • 94
George Segal, *Walk, Don't Walk,* 1976. Plaster, cement,
metal, painted wood, and electric light, 8 ft 8 in. × 6 ft ×
6 ft (2.64 × 1.83 × 1.83 m).

In 1961, this artist began to win fame for his plaster casts of living people. Dressing them in ordinary clothing and placing them in everyday situations, Segal was able to break down the barriers between life and art—a familiar preoccupation with Pop artists.

Collection of the Whitney Museum of American Art, New York. Purchased with funds from the Louis and Bessie Adler Foundation, Inc., Seymour M. Klein, President, the Gilman Foundation, Inc., the Howard and Jean Lipman Foundation, Inc., and the National Endowment for the Arts. 79.4. Photograph © 2001 Whitney Museum of American Art. © The George and Helen Segal Foundation/Licensed by VAGA, New York, NY.

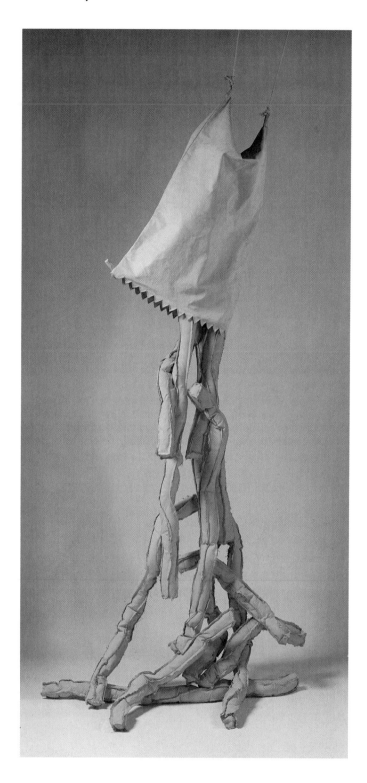

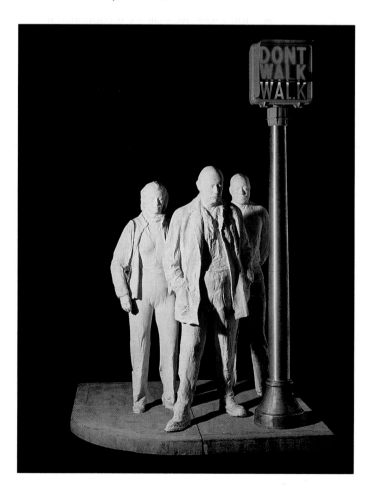

Joseph Beuys, *Rescue Sled*, 1969. Wood, metal, rope, blanket, flashlight, wax, 13¾ in. (35 cm).

Process artists such as Joseph Beuys believe that the ideas behind and production of an artwork are more important than its medium or form. His commonplace objects often entail a complex symbolism springing from personal experiences.

Art Institute of Chicago. Twentieth Century Purchase Fund, 1973.56. Photo © Art Institute of Chicago. All rights reserved. © 1997 Artists Rights Society (ARS), New York/VG Bild-Kunst, Bonn.

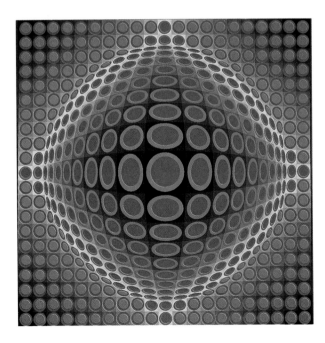

◄ **10 • 99**
Victor Vasarely, *Vega Per*, 1969. Oil on canvas, 64 × 64 in.

This painting is typical of Op art in its predilection for creating unusual visual effects. In this case, Vasarely is obviously concerned with a three-dimensional illusion.

Honolulu Academy of Arts. Gift of the Honorable Clare Boothe Luce, 1984 (5311.1). © 2001 Artists Rights Society (ARS), New York/ADAGP, Paris.

Op artists: Victor Vasarely (b. 1908), Richard Anuszkiewicz (b. 1930), and Bridget Riley (fig. 10.99; see also figs. 2.25 and 7.23). Flourishing in the mid-1960s, these artists employed precise shapes and/or lines (sometimes wavy, as in Bridget Riley's work) or concentric patterns that have a direct impact on the physiology and psychology of vision (fig. 10.100; see also fig. 2.14). They explored the kinds of abstract patterns that seem dedicated more to the scientific investigation of vision than to its evocative expression in art, as they disrupt the normal way we see.

MINIMALISM

The ■ **Minimalists** were a group of painters and sculptors who appeared in art circles from the 1960s to 1970s, although the movement also affected music (Riley, Adams, Glass), dance, poetry, and fiction. In painting there were precedents for the style in early-twentieth-century nonobjective abstraction. In fact, the painting branch grew out of Color Field paintings by such artists as Nolan, Newman, and Rothko. The painters Ad Reinhardt (1913–67) and the Canadian Agnes Martin (b. 1912) were key figures of the late 1950s, in predicting the arrival of Minimalism on the scene in the 1960s. Reinhardt, a Color Field painter obviously influenced by Constructivist painters like the Russian Malevich (see 10.49), painted pictures in such close values that only after intense concentration could the spectator determine that any shapes or lines or other elements of form were present at all (fig. 10.101). Martin in turn was most likely informed by the Color Field painters cited to present only pure forms, relying on the basic elements for meaning, without any trace of the artistic process that became the goal of Minimalism. She had also absorbed much from the spirit of Paul Klee and old Chinese landscape painting (fig. 10.102).

Among important Minimalist sculptors were Donald Judd (1928–94),

▶ **10 • 100**
Bridget Riley, *Drift No. 2*, 1966. Acrylic on canvas, 7 ft 7½ in. × 7 ft 5½ in. (2.32 × 2.27 m).
Op artists generally use geometric shapes, organizing them into patterns that produce fluctuating, ambiguous, and tantalizing visual effects very similar to those observed in moiré patterns, such as in door or window screens.
Albright-Knox Art Gallery, Buffalo, NY. Gift of Seymour H. Knox. 1967.

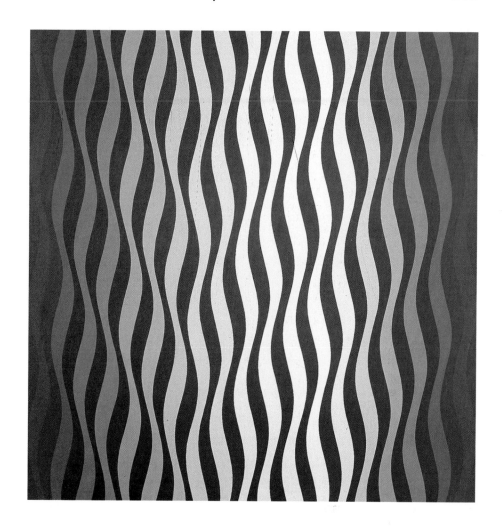

▲ **10 • 101**
Ad Reinhardt, Abstract Painting, *Blue 1953*, 1953. Oil on canvas, 50 × 28 in. (127 × 71.1 cm).
This Reinhardt work is an example of Minimalist painting, in which the values are so close that only intense scrutiny can reveal differences of shape within.
Collection of the Whitney Museum of American Art, New York. Gift of Susan Morse Hilles 74.22 © 1997 Estate of Ad Reinhardt/Artists Rights Society (ARS), New York.

◀ **10 • 102**
Agnes Martin, *Untitled # 9*, 1990. Synthetic polymer and graphite on canvas, 6 × 6 ft.
A Canadian artist who studied in the United States, Martin worked with people like Reinhardt and Albers. Her early work was usually in the form of a linear grid in graphite revealing metaphysical meanings. More recently, in the 1990s, she replaced the grids with bands of color. She remains close to the Minimalist attitude in most of her work.
Whitney Museum of American Art. Gift of the American Art Foundation 92.60. Photograph © 2001 Whitney Museum of American Art.

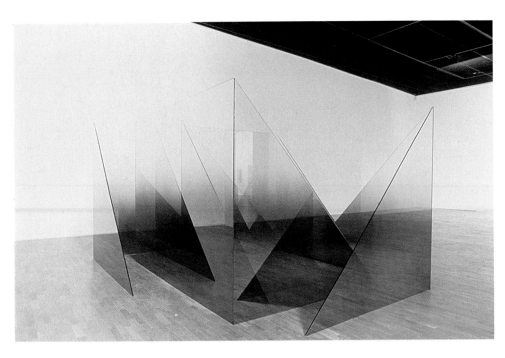

▲ 10 • 103
Larry Bell, *First and Last,* 1989. Two glass rectangles, 6 × 8 ft, eight glass triangles 6 × 6 ft, coated: nickel-chrome.
The Minimalists make use of simple monumental forms exploiting a wide variety of materials.
Musée d'Art Contemporain, Lyon, France. © Larry Bell. Photograph courtesy of the artist.

▼ 10 • 104
Dan Flavin, *Untitled* (in memory of my father, D. Nicholas Flavin), 1974. Daylight fluorescent light (edition of three), 8 × 48 ft (2.44 × 14.63 m).
One of the Minimalist artists who has devoted much of his career to light sculptures or assemblages, Dan Flavin represents a branch of artists working with static assemblies of fluorescent lights.
Courtesy Leo Castelli Gallery, New York. © 1997 Estate of Dan Flavin/Artists Rights Society (ARS), New York.

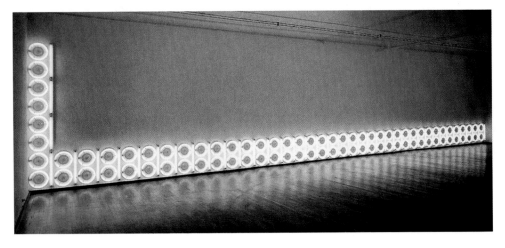

Larry Bell (b. 1939), and Dan Flavin (1933–96). They transformed the late mechanomorphic cubes of David Smith into blunt sculptures of simplified geometric volumes that, like the painters, seem stripped of all psychological or symbolic content. For their minimal presentation of nonobjective forms, the Minimalist sculptors were sometimes labeled Primary Structurists and ABC artists. Quite often they rejected metal and welding for materials hitherto uncommon in sculpture, such as cardboard, masonite, plywood, plastics, and glass. Donald Judd constructed repeated sequences of loaf-shaped boxes hung on a wall, relief fashion (see fig. 9.42). Later he turned to making sculptures of identical large, open-centered concrete boxes. Whether repeated either in the same or in different materials, Judd's and other Minimalists' sculptures were often laid out in rows or stacked up vertically. In the 1970s, when a considerable number of such "repeats" were laid out on the floor of galleries, museums, warehouses, or other open spaces (they had to be large-enough areas to contain them), they were labeled siteworks or Site Art, terms that more recently have been replaced by the term ■ **Installations.** This subject will be discussed later in the chapter.

While a few artists preferred the appearance at least of an abstract mass or solid, most of the Minimalists actually wanted to obliterate the core, creating simple volumes of enclosed space or opening up numerous voids. Some of these pieces are merely boxes of gigantic size. (Large size is a characteristic of much twentieth-century sculpture and painting.)

Some, like Larry Bell (b. 1939), used hard sheet plastic (Plexiglas) or tinted glass to create transparent volumes that enclose space (fig. 10.103). Other Minimalist sculptors or assemblers such as Dan Flavin formed lighted objects, often on the order of large room

installations, while sometimes combining them with movement and electronically produced sounds to create kinetic fantasies. Artists who create light sculptures usually use neon light in their assemblages (fig. 10.104).

There are some Minimalists who preferred to produce open spatial forms creating large simplified voids, which might look closed from one point of view and open from another. Examples of this trend can be found in Lila Katzen's (b. 1932) large, open-rolled, sheet-metal forms (fig. 10.105).

A few of the open boxes, and occasionally some of the enclosed rectilinear sculptures, stress brightly colored surfaces, while others are neutral or devoid of color. Without doubt, many of these monumental forms make a powerful impact on the observer as they are come upon in public places, but most of them transmit a feeling of sameness or monotony. In addition, they also seemed to lack content to a younger generation of artists coming to maturity in the 1960s and 1970s. Minimal forms began to be rejected in favor of more realism and observable meanings again. Obversely, the lack of content in Minimalist art was most likely a reaction to the psychologically suggestive meanings generally found in Abstract Expressionist art. On the other hand, the rejection of Minimalism was in line with or a continuation of the reaction that had brought about Pop Art a bit earlier.

ENVIRONMENTAL ART AND INSTALLATIONS

Environmental Art and Installations tend to take their names from their locations, outdoors or inside. Both forms are meant to surround the spectator and make him or her a part of the experience. The artwork becomes an artificial slice of life that is completed by spectators because of the stress placed on the details of the created forms around

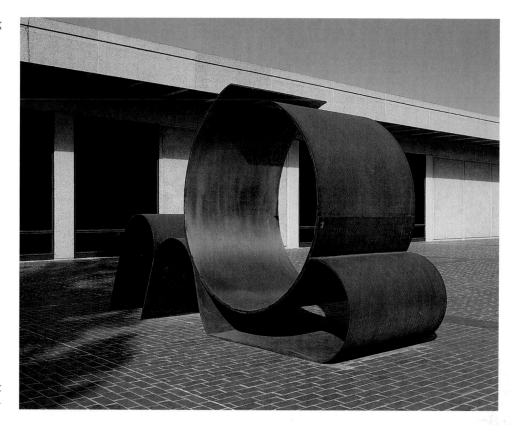

▲ 10 • 105
Lila Katzen, *Oracle*, 1974. Corten and stainless steel, 11 × 17 × 5 ft (3.35 × 5.18 × 1.52 m).
These flowing sheet-metal forms, set in outdoor space, are typical of the works of Katzen.
University of Iowa Museum of Art. Purchased with funds from National Endowment for the Arts and matching funds contributed by Mr. and Mrs. William O. Aydelotte, Edwin Green, Sylvia and Clement Hanson. Mr. and Mrs. Melvin R. Novick, and William and Lucile Jones Paff, 1976.88. © Estate of Lila Katzen/Licensed by VAGA, New York, NY.

them. Both types of art came out of Pop, Assemblage, Performances, and Minimalism. Installation artists believe that not only should the spectators' vision be engaged in works of art but also their whole bodies, including the senses of touch, smell, and hearing. Dadaists like Kurt Schwitters (1887–1948), an important German artist who created his own version of Dadaist works called "Merz," and Marcel Duchamp created the first twentieth-century Installations. The Pop artists must be credited with renewing the Installational form of art in the 1960s and 1970s. While Lucas Samaris (b. 1936) was primarily a Pop artist, his *Mirrored*

Room is also a good example of an Installation (fig. 10.106), due to its indoor location and space-filling size.

When Installations were first exhibited, being arranged on the floors or walls or from the ceilings of a gallery or another large inside location, they were named Scatterworks, Floorworks, Siteworks, or by the general term Environments. With the growing size and popularity of the installment idea, however, the relative meaning of these categories seems to now require separate emphasis pertaining particularly to the location of each. The term *Installations* should probably be used primarily to designate interiors where it is the

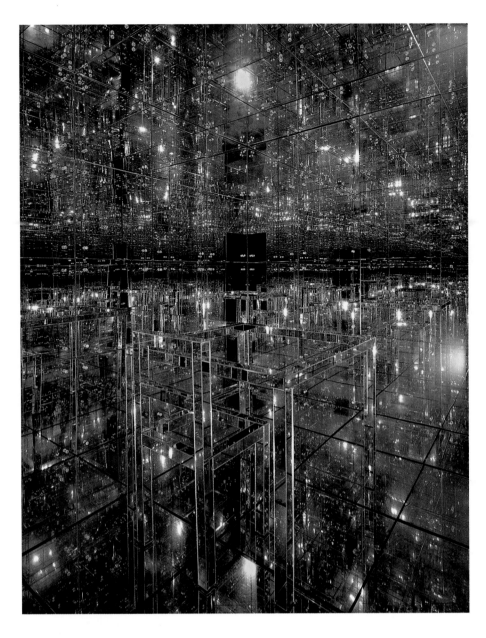

apparent intention of recent installers at least, to fill up a fairly large volume of space with their sculpture or assemblage. The term *Environments,* on the other hand, should probably be used to indicate something in the way of a structure or assemblage primarily, or solely, in an outdoors location.

Another artist producing a slightly different kind of lighted, sculptural Installation is the Korean artist, Nam June Paik, who began his career in Germany as an electronic musician and composer and then realized the possibilities of expressing himself through video or TV assemblages. Video gave him the ability to exert his domination over the mass-media field. He thus became famous as the first artist to display video ensembles (fig. 10.107; see also fig. 8.58). He now has several followers, although it is difficult to be original after Paik's example.

Judy Pfaff (b. 1946), an English artist who was trained in the United States, is a good example of what is now meant by

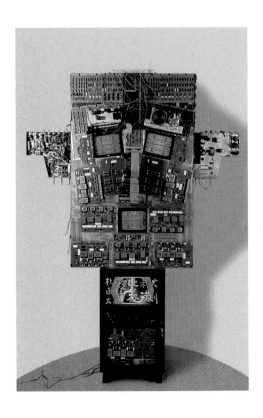

▲ 10 • 106
Lucas Samaris, *Mirrored Room,* 1966. Mirrors on wooden frame, 9 × 9 × 120 ft (2.44 × 2.44 × 3.05 m).
This is an example of Environmental Art, which, by its size and structure, may actually enclose the observer within the form of the work.

Albright-Knox Art Gallery, Buffalo, NY. Gift of Seymour H. Knox, 1966.

▶ 10 • 107
Nam June Paik, *Descartes in Easter Island,* 1993. Video sculpture, 94 × 68 × 30 in.
Process, Conceptual, and Performance Art are closely related and often overlapping art forms. The Korean American artist Nam June Paik, who mostly produces video installations—which he pioneered—bridges the slight differences between the forms. He has several followers who also explore the impact of technology on modern society.

HSG# NJP-0361. Reproduction permission courtesy Nam June Paik and Holly Solomon Gallery, New York.

an Installation artist in the locational sense, since she makes her creations site-specific. She began as an Abstract Expressionist painter of huge canvases but turned to experimenting with small sculptural Installations in the 1970s. She is now primarily known for her incredibly huge, rambling, and soaring Installations of various materials such as wires, glass, plastics, and metals (fig. 10.108).

Ann Hamilton (b. 1956), an American artist from Ohio, who trained at the universities of Kansas and Yale, is an Installment artist of imaginative, strangely moving, sensuous forms (fig 10.109). She appears to be very concerned with the direct bodily sensations provided by experiencing her works. This aspect of her content is found in the strange world of copper, animal pelts, or penny-covered floors (along with other materials) that she creates with numerous dedicated assistants. The walls and ceilings are also often subtly modified, but are unified with the building or fabric of the location. Barely heard sounds from the outside and recordings usually accompany the Installation, becoming a total part of the experience. An attendant, often Hamilton herself, is seen seated at a table burning paper, sewing, erasing, or chewing some substance. This presence is meant to make spectators feel as though they are participants as well as sensors of the experience. Hamilton's strange interior worlds seem meant to cause the observer to respond to natural and innately

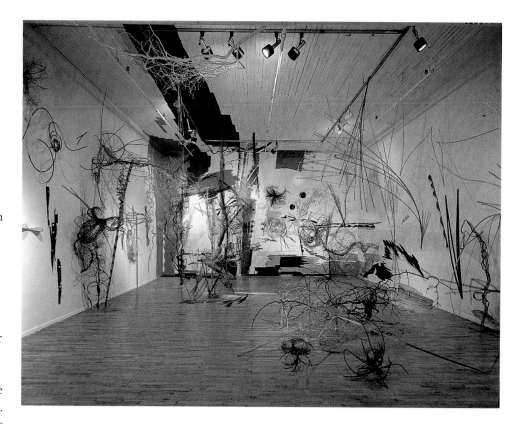

▲ 10 • 108
Judy Pfaff, *Deepwater,* Installation view, 1980. Organic matter (roots and branches), balsa and veneer plywood, wire, various plastics, oil and latex paint.
As can be seen from this illustration, Installations can be composed of virtually any kind of materials.
Courtesy of the artist and Holly Solomon Gallery, New York.

▶ 10 • 109
Ann Hamilton, *Tropos,* 1993 Installation.
Hamilton's installments seem to provide an imaginative, strangely moving, sensuous world beyond verbal or logical apprehension. Instead they offer a direct bodily sensation or experience that is at the core of human instincts, as the title in this work implies.
Courtesy of the artist and Dia Center for the Arts. Photograph Thibault Jenson.

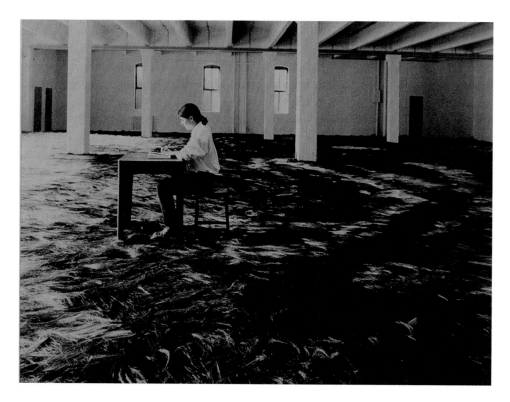

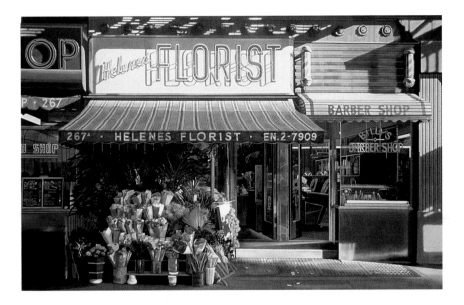

▲ 10 • 112
Richard Estes, *Helene's Florist,* 1971. Oil on canvas, 4 × 6 ft (1.22 × 1.83 m).
The meticulously rendered images of Richard Estes attempt to reach the degree of reality found in photography.
Toledo Museum of Art, Toledo, OH. © Richard Estes/Licensed by VAGA, New York/Courtesy Marlborough Gallery, NY.

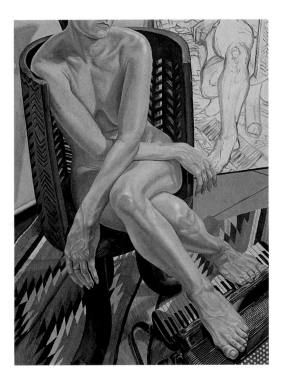

▲ 10 • 113
Philip Pearlstein, *Chevrons #2,* 1996. Oil on canvas, 48 × 36 in. (121.9 × 91.4 cm).
This New Realist painter uses a kind of descriptive lighting to represent human figures.
Courtesy of Robert Miller Gallery, New York.

consequent political upheavals, attest to the depth of the turmoil, which artists who were growing up witnessed. Other events that they were cognizant of were the dislocations and problems caused by racial prejudice, unequal treatment of women, the uneven distribution of income, and the somewhat bitter partisanship in politics. Most of these were still with us as we entered the new millennium, and, as a reflection of our world, all the arts have been affected. Due to such conditions in our social and cultural environment, all art of the last 40 years in which artists appear to be looking either for a new means of expression or for a new kind of figurative form, can be said to lie within the Postmodern sphere. However, some critics see Postmodernism in the context of a normal historical rejection of the pedantic or haughty "control" of the arts that has always accompanied the "approved" forms or styles in the past, not a radically new phase of art (or of

history). For centuries such control was waged by religion, then by government academies, and since the nineteenth century by galleries, critics, museums, and in our country by governing bodies or officials, once again.

Most of this art is the expression of individuals. Yet some of them reject the notion of individualism and want to return art to the anonymity that dominated most historical styles before the Renaissance. In the context of art today this is most likely impossible. Other notable characteristics of Postmodernism were the reintroduction of decoration, such as can be found in Islamic manuscripts (perhaps an influence from Matisse); a diversity of novel techniques, as required by new media; and even a return to literary sources, a procedure adopted before by the nineteenth-century

Romantics. From early modernism there has been a constant switching back and forth between styles and media, so that it is difficult today to coin specific names for groups or categories of artists. Because of this, it would make no sense to say that Postmodernism means that all the practices of early modernism were abandoned; thus, the term is loosely used to encompass all the styles that have come into being as reactions to some of the early modern (particularly, Abstract) "dogmas." In the case where there has been a decided return to, or continuation of, abstraction, Postmodernism has taken on a new or different meaning. The artists try to present their forms in such a way that a reference to content beyond or in back of the work seems apparent. Therefore, Postmodernism no longer depends on a "worship" of total form "for its own sake" as it did before.

NEW REALISM (PHOTOREALISM)

New Realism was the first art to use the human figure and portraiture extensively since the early part of the twentieth century. A general trend from the 1960s through the 1970s, it was, in a sense, a new kind of Pop Art that dealt for its style in almost absolute similitude, but of a more matter-of-fact kind having little of the wit, humor, and sly jibes of Pop. For most of the century, representation was anathema to abstract artists. Their values had been based on the rejection of anything suggesting an objective mapping of reality. Now representation, or realism, had returned with a vengeance. Important painters in the movement were Richard Estes (b. 1936), Chuck Close (b. 1940), and Philip Pearlstein (b. 1924) (figs. 10.112 and 10.113; see also fig. 2.11). The example by Duane Hanson (1925–96) (fig. 10.114) indicates that, like Pop Art, New Realism extended into sculpture.

The New Realists were also sometimes referred to as New Illusionists, Photorealists, and Superrealists. They depended on both photography and images taken from commercial advertising to gain their meticulous artistic ends, although some, like Pearlstein, maintain that they do not paint from projected images, or photographs, but rely upon painstaking observation of their model(s). By and large, however, all the New Realists show average people involved in everyday activities; there is little or no evocative content. Many feature photolike renditions of city streets, storefronts, and similar structures.

The New Realists were preceded, clearly, by the continuing high level of interest in realistic art throughout the twentieth century, particularly in the United States. This can be witnessed not only in the unabated popularity of Andrew Newell Wyeth (b. 1917) but also in the recurring interest in artists like

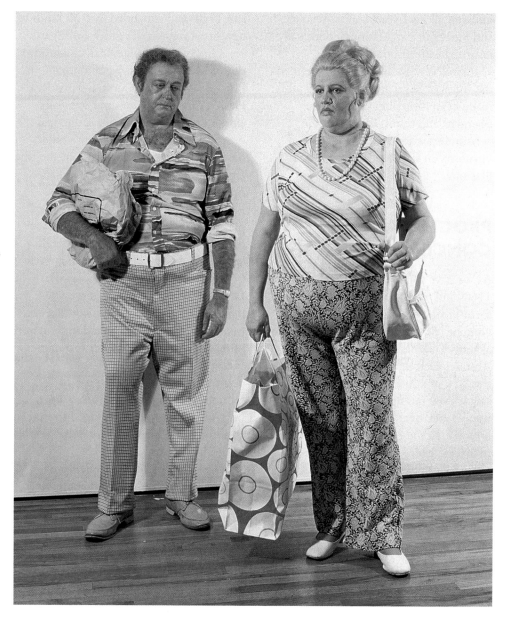

Edward Hopper (1882–1967), Charles Sheeler (1886–1965), and Ben Shahn (1898–1969) from the earlier part of the century (see figs. 6.2, 8.24, 1.11, 4.26, 8.25, and 2.30). On occasion, nineteenth-century Realism, from the Pre-Raphaelites (an English nineteenth-century Realist movement based on Proto-Renaissance and Early Renaissance "primitives" before Raphael) to the Impressionists, has also returned to favor. Even Picasso, that towering genius of the century, in the

▲ 10 • 114
Duane Hanson, *Couple with Shopping Bags,* 1976. Polyvinyl/polychromed in oil, life size.

This work belongs in the context of photorealist painting, but it incorporates more illusions than any painting could, Duane Hanson's three-dimensional, lifelike, life-sized figures are cast in colored polyester resin and fiberglass to look like real skin and are clothed in real garments. His human reproductions are so meticulously detailed that one reacts to them first as real people and only later as sculpture.

© Estate of Duane Hanson/Licensed by VAGA, New York, NY.

◄ 10 • 116
Enzo Cucchi, *Paesaggio Barbaro*, 1983. Oil on canvas, 4 ft 3 in. × 5 ft 2¾ in. (1.30 × 1.59 m).
The Italian Neo-Expressionist Enzo Cucchi paints heavily pigmented canvases contrasting living creatures with symbols of death, abandonment, and decay.
Private Collection. Photograph courtesy of the Sperone Westwater Gallery, New York. Courtesy Gallery Bruno Bischofberger, Zurich.

NEO-EXPRESSIONISM

So far, the longest-lasting and seemingly strongest movement of the new figurative approach to art in the last quarter-century has been that of the ■ **Neo-Expressionists.** There was such a widespread desire among the general populace for a return to figurative art and for a more personalized expression that it seemed for a time in the early 1980s that these artists were being deliberately forced on the public for commercial purposes. In hindsight, however, it has become evident that Neo-Expressionism had deeper roots, and the values it expressed were those genuinely being sought by a new generation of artists. One method conceived to satisfy the growing appetite for recognizable images and an art with newly meaningful content was a return to monumentally dramatic figures with broad gestures, painted in broad brushstrokes.

Some of the conditions and the questions they raised were responsible for the work of artists representing Neo-Expressionism, such as the Italian Enzo Cuchi (b. 1950), the American Julian Schnabel (b. 1951), and the German Anselm Kiefer (b. 1945). Enzo Cucchi and Anselm Kiefer were chief among the European Neo-Expressionists, while the Texan Julian Schnabel was the first American to take up the style. A common denominator of style, of course, was a reawakening of the emotional fervor of early-twentieth-century Expressionism, often updated with modern techniques and themes. Late Renaissance Mannerism; the later phases of Giorgio de Chirico's classicizing style, which had been declared as decadent after his earlier near-Surrealist fantasies; and the more representational styles of Picasso— all were sources for the Neo-Expressionists.

Enzo Cucchi (fig. 10.116) has remained on his native soil near the seaport of Ancona on the east coast of Italy. It is a land of sudden cataclysms caused by landslides. The animal and human life on his family farm and the abruptness with which tragedy can appear have fed his art. Cucchi's heavily pigmented canvases, sometimes mixed with powdery materials like earth and coal dust, express through their contrasts of living creatures and bony skulls his sense of death, abandonment, and decay.

Anselm Kiefer (b. 1945) was born amidst the expiration of Hitler's regime at the end of World War II; this German artist has given that country a new, monumental, dramatically mythic style. He expresses, by symbolic means, an apology for Germany's past sins against humanity, while providing more hopeful signs for the future by recalling the country's more noble, courageous, and/or heroic moments. Like Cucchi, Kiefer uses many materials formerly considered inappropriate for painting. Some of these are old photographs, metal, and straw. The far-reaching symbolic meanings in this artist's works are difficult to completely explore in so few words. He is well worth further study. In the painting *Osiris and Isis* for example, Kiefer's symbology implies that the modern magic of technology can bring about a rejoining of today's spearated nations just as Isis, the sister-wife of Osiris, was able to work her wizardry to reunite Osiris' body parts

▶ **10 • 117**
Julian Schnabel, *Affection for Surfing*, 1983.
Oil, plates, wood, and bondo on wood, 108
× 228 24 in. (274.3 × 579.1 × 61 cm).
Julian Schnabel, one of the Neo-Expressionists of the early 1980s, uses size and bulky collage to symbolize the discarded materials of a dying civilization.
Courtesy of Pace Wildenstein.

after he was slain and dismembered by his brother Set. Modern technology is symbolized by the video or computer board at the top of the pyramid from which wires emanate, while the tale of *Osiris and Isis* comes from Egypto-Roman mythology and is symbolized by the pyramid and stormy sky. Pyramids were fairly common ancient structures for rituals or worship of various kinds.

Though he is a commentator on modern life, many of Schnabel's themes are gleaned from the Old and New Testaments. A notable feature of his work, like that of the other Neo-Expressionists, is the use of unusual materials, ranging from canvases made of velvet and other fabrics to broken bits of china adhered to the picture plane (fig. 10.117). By and large, these Neo-Expressionists were rejecting what the mainstream avant-garde establishment had dictated as acceptable subjects for art in the modern age.

FEMINIST ART

It is an indisputable fact that women have always played some role as artists in the past. The significance or extent of that contribution at specific times was usually inhibited by male domination over social behavior, taste, and value. So although individual women have contributed a great deal to the history of art, they have also usually suffered undeserving neglect of their accomplishments. With the

freeing of women politically through suffrage and the consequential progress made in accessing other formerly male domains, such as business and sports, they are being recognized for the quality of their art along with that of male artists. The early phases of this recognition took the form of appreciating women's domestic arts on as high a level as that of the graphic, sculptural, and architectural arts. Exhibits in museums, galleries and private spaces helped to accomplish the assessment of women's domestic arts as "fine art." Now, as a matter of course, they are accepted and recognized in all media by the quality of their creations. Judy Chicago (née Cohen) (b. 1939) and Miriam Shapiro (b. 1923) were the two important cofounders of the Feminist Art Movement (1960s) in San Diego. Also we should note here that the African American artist Faith Ringgold (b. 1934) (fig. 10.118) helped not only to bring women's domestic arts to the level of high

art recognition with her narrative quilts but also brought more attention to the historical creations, and those presently being created, by all African Americans.

Miriam Schapiro was a New York–based Abstract Expressionist Field painter before she moved for a number of years to Southern California in the late 1960s to teach art at the University of California, San Diego. While she and Judy Chicago were teaching there, they helped female students to restructure an old house into a completely feminine environment. These artist-teachers' interests had been aroused by the long history of women's beautiful and often intricate designs or patterns for domestic applications, such as sewing, weaving, and crocheting. Wanting to bring attention to this long-neglected domestic art tradition, Schapiro began to make abstract and semirepresentational collages of women's craft and needlework materials. She called these *femmages*

▲ 10 • 118
Faith Ringgold, *The Bitter Nest, Part V: Homecoming*, 1988. Acrylic on canvas with pieced fabric border, 76 × 96 in. (193 × 243.8 cm).
This African American artist, through her narrative painting/quilts, helped to bring women's domestic arts to the level of "high" or "fine" art recognition. This also brought about a consequent renewed appreciation of all African American art from the period of slavery to the present.
Courtesy of the artist.

▲ 10 • 119
Miriam Schapiro, *I'm Dancin' as Fast as I Can*, 1985. Acrylic and fabric on canvas, 7 ft 6 in. × 12 ft (2.29 × 3.66 m).
This artist became well known in the late 1960s for her *femmages*, which incorporate collage, sewing, and quilting materials and techniques. Using the same basic techniques, she has recently propelled her work in a figurative direction, though the content remains disturbing and ambiguous. Her work is a good example of recent Postmodernist directions in art.
Collection of Dr. and Mrs. Harold Steinbaum. Courtesy of the Steinbaum Krauss Gallery, New York.

(fig. 10.119). These works, beyond their qualities as art, may be interpreted as analogies or symbols of the long-devalued role of women's arts in general. Schapiro continued through the 1980s and 1990s to create lively, colorful images, usually with discernible but sometimes ambiguous content. Many are related to searches for self-identity and melancholy at the gradual dissolution of the Women's Movement using metaphorical images of other female artists of the past such as Mary Cassat, Berthe Morrisot, and the Mexican artist Freda Kahlo, along with her own.

Judy Chicago meanwhile went in a somewhat more assemblage or sculptural direction in her art to emphasize specific feminine meanings. Chicago's most exciting work to express these views is undoubtedly *The Dinner Party* installation of 1974–79 in which she used painted ceramics, embroidery, needlepoint, and other women's crafts to form symbolic place settings at a giant triangular table for famous women of history and the arts. The place settings depict women's genitalia, while the triangular shape of the table is symbolic of women as well as of the Christian trinity. The installation also had correspondences to Renaissance artist Leonardo da Vinci's *Last Supper*. Though it is difficult to find sources for her work since the 1970s because reviews appear mostly in newspapers, women's journals, and crafts magazines rather than in art magazines, she has continued to work diligently in her efforts to bridge the dichotomy between women's crafts and fine art. Chicago has done this as much through her writing as her projects incorporating feminine helpers. She has written about eight books on these themes, four alone on *The Dinner Party* (fig. 10.120). She also brings knowledge about the significance of women's art to a nonart careerist audience, such as homemakers and working-class women through her project assistants. Chicago's

▲ 10 • 120
Judy Chicago, *The Dinner Party,* 1974–79. Mixed media, each side 48 feet (14.63 m).
Created by one of the important founders of the feminist movement in art, this work is undoubtedly one that well expresses the movement's and artist's views. Chicago required the assistance of many others to create this sculpture or assemblage dedicated in shape and through the use of place settings to famous women and female artists of history.
© 2001 Judy Chicago/Artists Rights Society (ARS), New York. Photograph by Donald Woodman.

▲ 10 • 121
Cindy Sherman, *Untitled,* 1989. Color photograph, 7 ft 6 in. × 5 ft (2.29 × 1.52 m).
Sherman, like other Postmodernist artists, focuses her creative energies on many of the environmental and social problems of our times. She deals, in particular, with the various trite ways in which women are viewed by society and through the visual media. Her photographs generally take the form of theatrical self-portraits that parody female stereotypes. More recent images, as found here, are often more abstract and sometimes grotesque.
Courtesy of the artist and Metro Pictures.

most recent cooperative project, called *Resolutions (for the millennium), A Stitch in Time,* consisting of needlepoint, embroidery, applique, and acrylic paint, opened in May 2000 at the New York City American Craft Museum.

Cindy Sherman (b. 1954), originally a photographer working in a Neo-Expressionist idiom, has become well known for her self-portraits. These show her dressed in all kinds of costumes, modern and historical, and serve as metaphysical scrutiny of her own person and reminder that all photographic reality is in some way a staged fable. They are also commentaries on the visual clichés that the motion-picture industry, in particular, uses to promote stereotypes of women. In the late 1980s, Sherman's work became more abstract; her images were sometimes very grotesque and sinister and were probably meant to make statements about the power men have held over women through their physical and sexual vulnerability (fig.

10.121). This has become even more obvious in recent work, where she uses plastic mannequin body parts of women to suggest rape and other horrors forcefully imposed.

Kiki Smith's (b. 1954) sculptural forms of "body art" appear to owe influences partly to precedents in Happenings and Performance Art but are addressed with particular reference to more recent feminist concerns such as AIDS, gender, battered women, and racial origins. Her particular concern with such social issues led to her own unique iconography using the female body to express her views. Sometimes Smith shows the inner workings of women on the surface to make askew reference to how such feminist views affect the body politic. In other sculptures, often with historical associations, as in the bronze *Mary Magdalene* (of which she created three versions), she may refer to the mistreatment of women, either physically or mentally (fig. 10.122).

OTHER TRENDS: NEO-ABSTRACTION, FILM STILLS, NEW NEW PAINTING

Neo-Abstraction

At the same time that the Neo-Expressionists were making themselves known in the 1980s and beyond, some young artists were retaining a more abstract style. Even some Neo-

◄ 10 · 122
Kiki Smith, *Mary Magdalene*, 1994. Silicon bronze and forged steel, edition 2 of 4, $59\frac{7}{8} \times 20\frac{1}{2} \times 21\frac{5}{8}$ in. (152 × 52 × 55 cm).

Smith is a sculptress who has expressed through her Body Art a unique content often specializing in feminine concerns with the prevalence of AIDS, gender, battered women, origins, and rape.

Courtesy Anthony d' Offay Gallery, London.

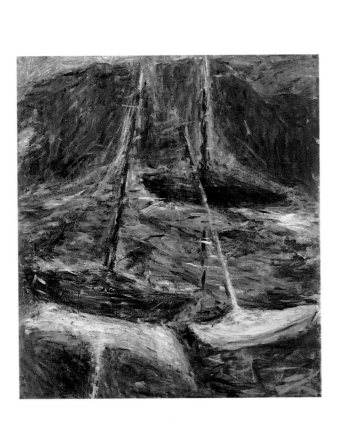

◄ 10 · 123
Susan Rothenberg, *Reflections*, 1981. Oil on canvas, 3 ft 8 in. × 3 ft 4 in. (1.12 × 1.02 m).

The Postconceptual work of this artist has run the gamut from simple, heavily pigmented canvases of horses to expressionistic and abstract seascapes, such as this.

Collection of Mr. and Mrs. Robert Lehrman, Washington, D.C. Photograph courtesy of the Greenberg Gallery, St. Louis, MO. Courtesy of Sperone Westwater, New York on behalf of the artist. © 2001 Susan Rothenberg/Artists Rights Society (ARS), New York.

Expressionists were showing this tendency in the late 1980s. None of these artists is exactly alike, so again, any abstract work created through the 1990s and in the first years of the twenty-first century should be seen as a part of the flux of many styles. All art today seems to be a loose affiliation of many individual artists and groups of artists working together but not a part of any particularly distinct movements. Hence, ■ **Neo-Abstraction** must merely be seen as one of the many trends in the arts of recent times.

Susan Rothenberg (b. 1934), a painter, became known for her heavily impastoed, monochromatic horse paintings in the 1970s. These retained a sense of the flat painting surface through the use of a slashing diagonal or vertical across the canvas, which split the shallow space and horse into two uneven, but visually balanced, parts. By the mid-1980s she was painting other subjects, including the human figure, that were partially blurred into the deeper space provided. Her images of this kind became increasingly Expressionist and abstract (fig. 10.123; see fig. 3.16).

Lynda Benglis (b. 1941) was trained as a painter but began to be fascinated by sculpture in the early 1970s when she was considered a Process artist. She developed a method of adding beautiful colors to different plastics in their molten state. After allowing the plastics to flow freely onto the floor, she shaped them into large insectlike creatures, which were then usually mounted on a wall. She has also created mock videos and advertisements of herself, aiming to satirize normally hackneyed representations of women in these media and in society. In recent work, Benglis has turned to shaping knots, bows, and more insectlike, pleated sculptures in shiny metal (fig. 10.124) that suggest a connection with the feminine world beyond them.

Another example of abstraction is found in the art of the African American

◀ **10 • 124**
Lynda Benglis, *Tossana*, 1995–96. Stainless steel, wire mesh, zinc, aluminum, and silicone bronze, 49 × 63 × 14 in. (1.24 × 1.6 × .36 m).
This artist began as a painter, then moved over to Process Art using heated, free-flowing plastics that were shaped before the material had set. Recently she has switched to working in shiny metals, forming knots, bows, and insectlike pleated sculptures.
© Lynda Benglis/Licensed by VAGA, New York, NY.

Martin Puryear (b. 1941). Born in Washington, D.C., Puryear began as a Realist but discovered the "magic" or "sense of life" evoked by primitive African forms while serving with the Peace Corps in Sierra Leone during the mid-1960s. He became particularly fond of woodworking techniques applied to sculpture, which he studied in Scandinavia and Japan as well as in Africa. From this background, Puryear developed an organic Abstract style that goes beyond some Minimalist leanings in the animistic sensitivity to woodcraft and meanings inferred beyond the object itself. Some works hint at nature-based sources and content in their flowing, stretching effect. They also have tension between parts wanting to project into space while remaining rooted to the ground. Some volumes remain more closed but suggest, through their refined craftsmanship and attention to handsome surface detail, Puryear's study of cabinetry, joining, boat building, and traditional Japanese architecture. These latter works especially make the observer search for an implicit utilitarian use beyond their actual presence (fig. 10.125).

Finally, in concluding our survey of the Neo-Abstract style, we look at a painter who represents her own kind of

▲ **10 • 125**
Martin Puryear, *Thicket*, 1990. Basswood and cypress, 76 × 62 × 17 in. (170.1 × 157.5 × 43.1 cm).
This African American artist demonstrates the influences that African tribal art and his worldwide study of woodcraft techniques had in the development of his mature work.
The Seattle Art Museum, gift of Agnes Gund. Photo: Paul Macapia. © Martin Puryear/McKee Gallery.

Geometric Abstraction: Dorothea Rockburne.

Canadian-born Dorothea Rockburne (b. 1934) had her training at Black Mountain College in North Carolina, where she became acquainted with, or was taught by, modern artists like Rauschenberg, Kline, Guston, and others. She also studied dance with Merce Cunningham and knew the highly inventive American composer, John Cage. She began to find her style, a vibrant color palette dominated by reds, yellows, blues, and greens translucently filling overlapping geometric shapes, in the late 1960s. Rockburne's abstractions have always had a similarity, or continuity, in terms of the shapes from her earliest large sheets of paper folded in near-Minimalist abstract monochromes to the present time diagonals used in large murals. Another continuous quality is her lack of overt emotional expression in her forms. But unlike the emphasis on the object, as in Minimalist art, Rockburne's paintings have a metaphysical quality that links past and present in a way that makes her audience search for meaning beyond their presence. The technical control in her shapes, colors, and linear, looping arabesques cannot be doubted either. The lines especially add a feeling of lightness, almost joyfulness, to the otherwise hard-edge geometry of shapes (see figs. 3.10 and 4.29).

Film Stills

The theory that photography should be Straight or a one-to-one copy of reality and not staged or manipulated to obtain better results in a Pictorialist sense has been a long-standing issue in photography. This theory, like those of other disciplines in recent art, is undergoing a Postmodern revision, especially in this dawning computer age. Among Straight photographers there is a fear that their photographic art will no longer be needed, since computers, digital cameras, scanners, and so forth can reproduce and alter any photographic image on any scale, while twisting and tweaking an image to eliminate undesirable features or improve the photograph. Even the notion that photographs should not be staged or manipulated in any way has often proved throughout time to be untrue. From the beginning of photography, when long poses were necessitated by the available cameras, chemicals, and surfaces, staged scenes have been employed. Oscar Rejlander's *The Two Ways of Life* of 1857 (see fig. 10.9) further demonstrated that certain artists would always defy the notion that photographs should only portray unadulterated reality. More recently, as with Cindy Sherman's satires on media dishonesty and sexist stereotypes, other photographers are using more elaborate staging techniques for their pictures. Using specialized lighting, staged sets, or natural settings given eerie effects by lighting and film alteration they are creating surrealist-like photographs of all sorts of phantasmagoria. Some of these film still photographers may act as their own directors and hire lighting and staging specialists and actors and actresses to play parts in their photographs. Others may play the part of director/picture producer alone, dressing in costume or employing especial locations, or staging, for their creations. There are a number of women engaged in making film stills as well as men, living and working internationally. Not content with film stills, some are branching over into making movie films. Most are very talented in other art media besides photography.

An interesting photographer who doesn't exactly fit the film still category but shows the variety of talent working in photography today is Vera Luter. She reverses the usual method of making a photograph by eliminating the camera. Instead she exposes interior locations, such as factories, directly to giant pieces of photographic paper, creating eerie negative images.

New New Painting

A group of international artists who are inclined to promote painting in a new direction call themselves the New New Painters. They came into sight in the late 1990s, but there is not much to be determined about their art due to a lack of exhibits and review material. They consist apparently of both men and women who shun generic activism, use synthetic materials to build up relief and three-dimensional paintings, and seem to believe they are generating the future direction of painting.

This brings us to the conclusion of our analysis of content and style in Western art during the last two centuries. There seems to be little reason to alter our conclusion in the previous edition of *Art Fundamentals* that there are very many outstanding artists working today or to alter the statement that a text of this nature could never hope to cover, let alone do justice, to the majority of them. Perhaps the most pertinent concluding statement that can be made—and that should be obvious to most—is that years are required to reveal the most durable artists and styles of the late modern and Postmodern eras. In the years ahead, historians will be able to make clearer judgments on such matters.

Chronological Outline of Western Art

PREHISTORIC ART (c. 35,000–3000 B.C.)

35,000 B.C.	**Upper Paleolithic: Late Old Stone Age.** Stone Tool Industries.
28,000	Art begins: Cave painting and fertility gooddesses (Europe).
10,000	**Mesolithic: Middle Stone Age.** End of last Ice Age.
6000	**Neolithic: New Stone Age.** Begins Middle East; spreads to
3000	Europe. Settled agricultural communities; pottery, architecture begins.

ANCIENT ART (c. 4000 B.C.–A.D. 146)

4000 B.C.	**Egyptian Art:** Old Kingdom.
3000	**Sumerian Art:** Iraq. Invention of writing.
2800	**Aegean Art:** Isle of Crete. Minoan I & II.
2300	**Akkadian Art:** Syria and Iraq.
2000	**Aegean Art:** Mycenaean Age; Greece. Minoan III; Crete.
1700	**Babylonian Art:** Syria and Iraq.
1600	**Egyptian Art:** New Empire.
1500	**Neolithic:** Ends in Europe.
1100	**Aegean Art:** Homeric Age, Greece, Turkey.
	Etruscan Art: Italy.
1000	**Egyptian Art:** Decadence.
900	**Assyrian Art:** Middle East.
750	**Greek Art:** Archaic Age; Greece and South Italy.
	Etruscan Art: Northern Italy.
600	**Neo-Babylonian Art:** Middle East.
550	**Achaemenid Persian Art:** Iran / Middle East.
470	**Greek Art:** Classical Age; Greece.
330	**Greek Art:** Ptolemaic Age, Egypt.
320	**Greek Art:** Hellenistic Age, Greece and Middle East (Seleucid Empire).
280	**Roman Art:** Roman Republic, Italy.
140	**Graeco-Roman Art:** Italy to Greece and Middle East.
30 B.C.–A.D. 146	**Imperial Roman Art:** Italy, parts of Europe and Middle East.
c. 6 B.C.	**Jesus Christ born.**

EARLY CHRISTIAN AND MEDIEVAL ART (c. 200–1300 A.D.)

500 B.C.–A.D. 400	**Migratory Period Art in Europe:** Celts, Goths, Slavs, Scandinavians.
200	**Iranian (Persian) Art:** Sassanid Empire.
	Late Imperial Roman Art and **Early Christian Art:** Italy and Europe.
330	**Early Byzantine Art:** Centers at Constantinople (Istanbul), Turkey and parts of Middle East.
	Coptic Christian Art: Egypt.
	Early Christian Art: Western Europe and Italy.
476	**Roman Art ends.**
493	**Early Byzantine Art:** Introduced at Ravenna and Venice.
570–632	**Mohammed** founds **Islamic religion.**
650	**Islamic Art:** Beginning in Syria, Palestine, and Iraq.
760	**Carolingian Art:** France, Germany, and North Italy.
800	**Developed Byzantine Art:** Middle East, Greece, Balkans, and parts of Italy.
950	**Ottonian Art:** Mostly in Germany.
1000	**Romanesque Art:** France, England, Northern Spain (Moslems in South), Italy, and Germany.
1150	**Gothic Art:** France, Italy, Northern Spain, Germany, and England.

RENAISSANCE ART (c. 1300–1600)

*From here on, indicated artists are painters unless otherwise indicated in parenthesis.

1300	**Proto-Renaissance Italy:** Duccio, Giotto, Pisano (sculptor).
1400	**Early Renaissance Italy:** Donatello (sculptor), Masaccio, Francesca, Fra Angelico, Fra Filippo Lippi, Brunelleschi (architect), da Vinci.
	Early Northern Renaissance (modified by vestiges of Medievalism): **Netherlands:** van Eyck, van der Goes, van der Weyden; **France:** Limbourg brothers, Fouquet; **Germany:** Lochner, Moser, Witz, Pacher, Schongauer (printmaker).
1500	**High Renaissance Italy:** Giorgione, Titian, Raphael, Michelangelo (sculptor), Tintoretto.
	High Renaissance in Western Europe (affected by Italy): **Netherlands:** Bosch, Breughel; **Germany:** Dürer (printmaker), Grünewald; **France:** Master of Moulins. **Spain:** El Greco.
1520	**Mannerism and Early Baroque Italy:** Caravaggio, Bernini (sculptor).

BAROQUE AND ROCOCO ART (c. 1600–1800)

1600	**Baroque Art in Europe: Netherlands (Belgium, Holland):** Rubens, van Dyck, Hals; **France:** Poussin, Claude; **Spain:** Ribera, Velasquez.
	Early Colonial Art in the Americas: Primarily limners (or primitive portraitists) in English colonies. Church or cathedral art in Latin Americas.
1700	**Rococo Art:** Primarily French but spreads to other European countries: **France:** Watteau, Boucher, Chardin, Fragonard; **Italy:** Canaletto, Guardi, Tiepolo; **England:** Gainsborough, Hogarth, Reynolds.
	Colonial Arts and Early Federal Art in U.S.: Copley, Stuart, West.

NINETEENTH-CENTURY ART (c. 1780–1900)

c. 1780	**Neoclassicism: France:** David, Ingres; **Italy:** Canova (sculptor).
1820	**Romanticism: France:** Barye (sculptor), Delacroix, Géricault,
1826	Niépce (first permanent camera image); Daguerre (photographic process), Rejlander (painter and photographer); **Spain:** Goya; **England:** Turner, Fox Talbot (photographic process); **United States:** Ryder.
1850	**Realism (and Naturalism): France:** Daumier, Courbet; Rodin and Camille Claudel (Romantic Realist Sculptors); **England:** Constable; **United States:** Eakins, Homer, Brady, Gardner, Jackson and O'Sullivan (photographers).
1870	**Impressionism: France:** Monet, Pissarro, Renoir, Degas (some sculpture), Morisot; **England:** Sisley; **United States:** Cassat, Hassam, Twachtman, Muybridge (Anglo-American photographer); **Italy:** Medardo-Rosso (sculptor).
1880	**Post-Impressionism: France:** Cézanne, Gauguin, Seurat, Toulouse-Lautrec; **Holland:** van Gogh; **Symbolism: France:** Bonnard.

EARLY TWENTIETH-CENTURY ART (1900–c. 1955)

†artists often change styles and mediums since some names appear under more than one category. Note Pablo Picasso particularly!

1900	**Sculpture in the Early 1900s: France:** Maillol; **United States:** Lachaise; **Germany:** Lehmbruck, Kolbe.
1902–1907	Stieglitz and Steichen found **291 gallery** in New York City to advance acceptance of photography and avant-garde art.
	Expressionism: France: Les Fauves (Wild Beasts): Dufy, Matisse, Modigliani **(Italian),** Vlaminick, Rouault, Utrillo, Pablo Picasso.† **(Spanish:** Blue, Rose, and Negro periods).
1902–1913	**German Expressionism: Die Brücke (The Bridge):** Kirchner, Munch **(Norwegian),** Nolde, Schmidt-Rotluff; **Der Blaue Reiter (The Blue Rider):** Jawlensky, Kandinsky†, Macke, Kuehn (photography).
c. 1918/19–1924	**Die Neue Sachlichkeit (The New Objectivity):** Dix, Grosz, Heckel, Schlemmer Sander (photographer); **Independent German Expressionists:** Beckmann, Kokoschka† **(Austrian).**
	Expressionist Sculpture: England: Epstein; **Italy:** Marini; **United States:** Zorach.
1906	**Cubism: France:** Picasso (**Spanish** painter, sculptor, potter)†, Braque, Leger, Gris **(Spanish).**
	Futurism: Italy: Balla, Severini, Carra, Boccioni (painter and sculptor), Bragaglia (photographer); **France:** Marcel Duchamp†.
1910–1920	**Abstract Art: Germany:** Albers†, Hofmann†, Kandinsky **(Russian)†,** Archipenko (**Russian** sculptor); Feininger **(American);**
1913–1922	**Russia: Constructivism:** Tatlin, Malevitch, Larionov, Gabo, and Pevsner (sculptors); **Holland:** Piet Mondrian; **France:** Delaunay, Brancusi (**Romanian** sculptor), Arp (**French** sculptor)†; **England:** Nicholson; **United States:** Dove, Marin, O'Keeffe, Sheeler, Davis. Stieglitz (photographer), Steichen (**German** photographer), Strand (photographer), Coburn (**English** photographer).
	Fantasy in Art—Individual Fantasists: France: Chagall **(Russian),** Henry Rousseau (primitive painter); **Italy:** de Chirico; **Germany:** Schwitters†, Klee **(Swiss).**

1913	**Armory Show, New York:** Helps introduce avant-garde art to United States.
1914	**Dadaism: France:** Arp†, Marcel Duchamp†, Picabia; **Germany:** Schwitters†, Ernst†; **United States:** Man Ray (photographer, painter).
c. 1920–1930	**Later Expressionism: France:** Soutine, Buffet, Balthus, Dubuffet; **U.S:** Avery, Baskin, Broderson, Lawrence, Levine, Shahn, Weber; **Mexico:** Kahlo, Orozco, Rivera, Sigueiros†.
1924	**Surrealism: France:** Arp (sculptor)†, Cartier-Bresson (photographer), Delvaux, Magritte **(Belgian)**, Masson, Miró **(Spanish)**, Picasso **(Spanish)**, Tanguy, Gonzáles **(Spanish** sculptor); **Switzerland:** Giacometti (sculptor, painter); **England:** Bacon; **Germany:** Ernst†; **United States:** Dali **(Spanish** painter, Surrealist cinemas with Luis Buñuel), Man Ray (photographer, painter).
1930–40	**Realist Painting and Photography (Straight) in United States:** Wyeth, Wood, Benton, Burchfield; **F-64 group of photographers:** Weston, Adams, Cunningham.

LATE TWENTIETH-CENTURY ART

c. 1951–1965	**Abstract Expressionist Painting:**
	Action or Gestural Group (predecessors from abroad): Albers† **(German)**; de Kooning **(Holland)**; Gorky **(Turkey)**; Hoffmann **(Germany)**; Matta **(Chile)**; Mondrian† **(Holland)**; Tamayo **(Mexico)**.
	U. S. New York School: Frankenthaler, Kline, Louis, Mitchel, Pollock, White (photographer).
	Color-Field Painting Group (Hard-Edge): United States: Diebenkorm, Callahan (photographer), Kelly, Newman, Noland, Stella, Rothko **(Russia)**.
	Painters elsewhere similar to Abstract Expressionism: France: Mathieu, Manessier, Soulages; **Portugal:** Vieira da Silva; **Spain:** Tapies; **Japan:** Okidata.
	Surreal Abstract or Abstract Expressionist Sculpture: England: Moore, Hepworth, Chadwick; **France:** Richier, Lipchitz **(Latvia)**; **United States:** Calder†, Smith, Noguchi.
1920s–1950s	**Kinetics and Light Sculpture: France** (early 1900s examples): Marcel Duchamp† (1920s); **United States:** Calder† **(United States** wire Circus, c. 1928). **United States.:** Wilfred (Clavilus color organ, 1930–63).
1960s–1970s	**United States.:** Rickey, Bury **(Poland)**; Chryssa, Flavin, Lippold **(England)**; Samaris and Takis **(Greece)**; Tinguely **(Switzerland** 1930–63).
c. 1958–1965	**Pop Art & Assemblage:**
	Predecessors: England: Tom Hamilton; **United States:** Jasper Johns, Robert Rauschenberg†, Chamberlain (assembler), Dine, Frank **(Swiss** photographer), Friedlander (photographer), Hockney **(England)**, Indiana, Kienholz (assembler), Kitaj **(England)**; Lichtenstein, Marisol **(Venezuela**—sculptor or assembler), Nevelson (sculptor or assembler), Oldenburg† (sculptor or assembler), Samaris† **(Greek**—assembler), Segal (sculptor), Stankiewicz, (assembler), Warhol, Wesselman, Winogrand (photographer).

c. 1958–1970	**Happennings, Performance or Action Art:** **United States.:** Kaprow (earliest Happening 1958), most POP artists involved; **Germany:** Beuys.
c. 1964–70s	**Op Art:** (Extremely limited Abstract style depending primarily on the observer's visual perception for content. Derives from earlier scientific investigations into color theory). **France:** Vasarely; **United States.:** Anuskiewicz; **England:** Riley.
c. 1964–75	**Minimalism:** (Climax of Abstract/nonobjective art, informed by Color-Field painting and all types of Abstract Sculpture). **United States:** Bell (sculptor assembler), Flavin† (light sculptor assembler), Judd (sculptor),Katzen (sculptor), Lewitt, Agnes Martin, Pepper (sculptor), Reinhardt†, di Suvero (sculptor), Caro and Tony Smith (**England**—sculptors).
1965–1990s 1920s	**Environmental and Installation Art:** **Forerunners:** Kurt Schwitters† **(German),** and Marcel Duchamp† **(French).** **Environmental Art: United States:** Christo and Jeanne-Claude; Oldenburg†, Smithson, Heizer, Samaris† **(Greek).** **Installation Art:** Anne Hamilton, Nam June Paik **(Korean),** Pfaff **(England),** Skoglund.
c. 1965–1990s	**Postmodernism:** Reactions to Abstract art and dogma (especially to Minimalism and the International Style in architecture), the increasing financial disparity between rich and poor, cynicism about politics and society (some of which resulted from the Vietnam War and Watergate), etc., in art resulted in the reintroduction of the human figure, decoration, literary subjects, the appropriation of earlier artists' work or parts thereof, the reuse of older media, and mixed techniques along with newer methods. Introduction of Computer Art in the 1980s.
1960s–1980s	**New Realism (Photorealism): United States:** Estes, Fish, Pearlstein, Close, Hanson (sculptor).
c. 1965–1980s	**Process and Conceptual Art: Germany:** Beuys†; **United States**: Hess **(German),** Early exemplers—1965: Kosuth, Robert Morris.
1960s–1980s	**Feminist Art Movement:** Historical precedents. Begins in acknowledgment of women's domestic arts as significant artistic achievements. Role of Judy Chicago and Miriam Schapiro. Faith Ringgold (African American achievements), Cindy Sherman's influence.
1980s–1990s	**Neo-Expressionism: Germany:** Kiefer, Baselitz, Fetting; Italy: Cuchi, Chia; **U.S.:** Schnabel, Rothenberg†, Sherman† (photographer-painter).
1980s–2000s	**Other Trends:**
c. mid 1980s–2000s	**Neo-Abstraction: United States:** Benglis (sculptor-painter), Graves (sculptor), Marden (sculptor-painter), Puryear (sculptor), Jensen, Scully (Irish), Rockburne **(Canadian),** Rothenberg†.
late 1990s–2000s	**Film Stills (Pictorialism in Photography):** Use of staging, including special lighting effects, with photographic artists often acting or directing. Not enough historical perspective to ascertain importance of artists and quality of their images. Both men and women photographers included. Strong influence of movies and Cindy Sherman†. Photographic method. **New-New Painters:** Use of synthetic materials to produce three-dimensional paintings. Information unavailable yet. No historical perspective established.

Glossary

abstraction
A term for the visual effects derived by the simplification and/or rearrangement of the appearance of natural objects, or nonrepresentational work arranged simply to satisfy artists' needs for organization or expression. Abstraction is present in varying degrees in all works of art, from full representation to complete nonobjectivity.

Abstract Art
One of the major forms of nonrepresentational and semi-representational art of the twentieth century. It began with Cubism in the second decade of the twentieth century and reached a peak about the middle of the century.

Abstract Expressionism
An American style of painting that developed in the late 1940s, sometimes called "Action" or "Gestural" painting. It was characterized by a nonrepresentational style that stressed psychological or emotional meaning.

abstract texture
A texture derived from the appearance of an actual surface but rearranged and/or simplified by the artist to satisfy the demands of the artwork.

academic
Art that conforms to established traditions and approved conventions as practiced in art academies. Academic art stresses standards, set procedures, and rules.

accent
Any stress or emphasis given to elements of a composition that makes them attract more attention than other features that surround or are close to them. Accent can be created by a brighter color, darker tone, greater size, or any other means by which a difference is expressed (see **dominance**).

achromatic (color, value)
Relating to differences of light and dark; the absence of hue and its intensity.

Action/Gestural Painting
An Abstract-Expressionist style that involves dripping, spraying, and brushing techniques in the application of pigment to the painting surface. Dribbled lines, roughly textured surfaces, and interwoven shards of color were meant to carry the emotional message to the spectator without reference to anything in the objective world.

actual shape
Clearly defined or positive areas (as opposed to an implied shape).

actual texture
A surface that can be experienced through the sense of touch (as opposed to a surface visually simulated by the artist).

addition
A sculptural term that means building up, assembling, or putting on material.

additive color
Color created by superimposing light rays. Adding together (or superimposing) the three physical primaries (lights)—red, blue, and green— will produce white. The secondaries are cyan, yellow, and magenta.

aesthetic, aesthetics
The theory of the artistic or the "beautiful"; traditionally a branch of philosophy, but now a compound of the philosophy, psychology, and sociology of art. As such, aesthetics is no longer solely confined to determining what is beautiful in art, but attempts to discover the origins of sensitivity to art forms and the relationship between art and art to other aspects of culture (such as science, industry, morality, philosophy, and religion). Frequently, aesthetics is used in this book to mean concern with artistic qualities of form, as opposed to descriptive form or the mere recording of facts in visual form. (See **objective**.)

allover pattern
The repetition of designed units in a readily recognizable systematic organization covering the entire surface.

amorphous shape
A shape without clarity or definition: formless, indistinct, and of uncertain dimension.

analogous colors
Colors that are closely related in hue(s). They are usually adjacent to each other on the color wheel.

approximate symmetry
The use of similar imagery on either side of a central axis. The visual material on one side may resemble that on the other but is varied to prevent visual monotony.

art
The formal expression of a conceived image or imagined conception in terms of a given medium. (Sheldon Cheney)

assemblage, Assemblage (art style)
A technique that brings together individual items of rather bulky three-dimensional nature that are displayed *in situ* in their original position rather than being limited to a wall. As a style it is associated with artists like Rauschenberg and Kienholz.

asymmetry
Having unlike, or noncorresponding, appearances —"without symmetry." An example: a two-dimensional artwork that, without any necessarily visible or implied axis, displays an uneven distribution of parts throughout.

atectonic
Characterized by considerable amounts of space; open, as opposed to massive (or tectonic), and often with extended appendages.

atmospheric (aerial) perspective
The illusion of deep space produced in graphic works by lightening values, softening details and textures, reducing value contrasts, and neutralizing colors in objects as they recede (see **perspective**).

balance
A sense of equilibrium achieved through implied weight, attention, or attraction, by manipulating the visual elements within an artwork to achieve unity.

Bauhaus
Originally a German school of architecture that flourished between World War I and World War II. The Bauhaus attracted many leading experimental artists of both two- and three-dimensional fields.

biomorphic shape
Irregular shape that resembles the freely developed curves found in live organisms.

calligraphy
Elegant, decorative writing. Lines used in artworks that possess the qualities found in this kind of writing may be called "calligraphic" and are generally flowing and rhythmical.

casting
A sculptural technique in which liquid materials are shaped by being poured into a mold.

336

cast shadow
The dark area that occurs on a surface as a result of something being placed between that surface and a light source.

chiaroscuro
1. Distribution of light and dark in a picture. 2. A technique of representation that blends light and shade gradually to create the illusion of three-dimensional objects in space or atmosphere.

chroma
1. The purity of hue or its freedom from white, black, or gray. 2. The intensity of hue.

chromatic
Pertaining to the presence of color.

chromatic (value)
The value (relative degree of lightness or darkness) demonstrated by a given color.

Classical
Art forms that are characterized by a rational, controlled, clear, and intellectual approach. The term derives from the ancient art of Greece in the fourth and fifth centuries B.C. The term *classical* has an even more general connotation, meaning an example or model of first rank or highest class in any kind of form, literary, artistic, natural, or otherwise. Classicism is the application of, or adherence to, the principles of Greek culture by such later cultural systems as the Roman and Renaissance civilizations and the art of the Neoclassical movement in the early nineteenth century.

closed-value composition
Composition in which values are limited by the edges or boundaries of shapes.

closure
A concept from Gestalt psychology in which the development of groupings or patterned relationships occurs when incomplete information is seen as a complete, unified whole; the artist provides minimum visual clues, and the observer brings them to final recognition.

collage
A pictorial technique whereby the artist creates the image, or a portion of it, by adhering real materials that possess actual textures to the picture plane surface, often combining them with painted or drawn passages.

color
The visual response to the wavelengths of sunlight identified as red, green, blue, and so on; having the physical properties of hue, intensity, and value.

Color Field Painting
A branch of Post-Painterly Abstraction; a style closely related to Geometric Abstraction. It is also called Hard Edge Painting. The artists filled extremely large canvases with bright color meant to involve the viewer psychologically. They created unified shapes, fields, and/or symbols of

their personal feelings. The fields of color were flat in technique and bonded or integral to the surface.

color tetrad
Four colors, equally spaced on the color wheel, containing a primary and its complement and a complementary pair of intermediates. This has also come to mean any organization of color on the wheel forming a rectangle that could include a double split-complement.

color triad
Three colors spaced an equal distance apart on the color wheel forming an equilateral triangle. The twelve-color wheel is made up of a primary triad, a secondary triad, and two intermediate triads.

complementary colors
Two colors directly opposite each other on the color wheel. A primary color is complementary to a secondary color, which is a mixture of the two remaining primaries.

composition
An arrangement and/or structure of all the art elements, according to the principles of organization, that achieves a unified whole. Often used interchangeably with the term *design*.

concept
1. A comprehensive idea or generalization. 2. An idea that brings diverse elements into a basic relationship.

Conceptual art
The most significant concern of Conceptual art is the "idea," often denying the use of art materials and form in preference to conveying a message or analyzing an idea through photography, words, and "found" objects of human construction. At the extreme, all that is needed is an idea or concept. It first appeared in the 1960s.

conceptual perception
Creative vision derived from the imagination.

Constructivism
Pre-communist movement founded in Russia by Vladimir Tatlin that proclaimed total abstraction as the new realism in art in 1920. It had much to do with the assembly and new use of contemporary materials and application of traditional materials in both painting and sculpture.

content
The expression, essential meaning, significance, or aesthetic value of a work of art. Content refers to the sensory, subjective, psychological, or emotional properties we feel in a work of art, as opposed to our perception of its descriptive aspects alone.

contour
In art, the line that defines the outermost limits of an object or a drawn or painted shape. It is sometimes considered to be synonymous with "outline"; as such, it indicates an edge that also may be defined by the extremities of values, textures, or colors.

craftsmanship
Aptitude, skill, or quality workmanship in the use of tools and materials.

cross-contour
A line that crosses and defines the surface undulations between, or up to, the outermost edges of shapes or objects.

Cubism
The name given to the painting style invented by Pablo Picasso and Georges Braque between 1907 and 1912, which used multiple views of objects to create the effect of their three-dimensionality while acknowledging the two-dimensional surface of the picture plane. Signaling the beginning of Abstract Art, it is a semiabstract style that continued the strong trend away from representational art initiated primarily by Cézanne in the late 1800s.

curvilinear
Stressing the use of curved lines; as opposed to **rectilinear,** which stresses straight lines.

Dada
A nihilistic, antiart, antieverything movement resulting from the social, political, and psychological dislocations of World War I. The movement, which literally means "hobbyhorse," is important historically as a generating force for Surrealism. The Dada movement began in Zurich, Switzerland, in 1916.

decorative (art, line, shape, color, space, etc.)
Ornamenting or enriching but, more importantly in art, emphasizing the two-dimensional nature of an artwork or any of its elements. Decorative art emphasizes the essential flatness of a surface.

descriptive (art)
A type of art that is based upon adherence to actual appearances.

design
The underlying plan on which artists base their total work. In a broader sense, design may be considered synonymous with the term *form*.

de Stijl
A Dutch form of art featuring primary colors within a balanced structure of lines and rectangles. It was a style meant to perfectly express the higher mystical unity between humankind and the universe. Translated as "the Style," it was the form of abstraction developed by Piet Mondrian and Theo van Doesburg about 1914–17.

dominance
The principle of visual organization in which certain elements assume more importance than others in the same composition or design. Some features are emphasized, and others are subordinated.

economy
The distillation of the image to the basic essentials for clarity of presentation.

elements of art
Line, shape, value, texture, and color—the basic ingredients the artist uses separately or in combination to produce artistic imagery. Their use produces the visual language of art.

Environmental Art
A form of art taking its name from the fact that it surrounds and affects the spectator like the environment. Derived primarily from Assemblage and Pop Art, it is now generally called Site and Earth Art.

equivocal space
A condition, usually intentional on the artist's part, in which the viewer may, at different times, see more than one set of relationships between art elements or depicted objects. This may be compared to the familiar "optical illusion."

expression
1. The manifestation through artistic form of a thought, emotion, or quality of meaning. 2. In art, expression is synonymous with the term **content.**

Expressionism
A form of art in which there is a desire to express what is felt rather than perceived or reasoned. Expressionistic form is defined by an obvious exaggeration of natural objects for the purpose of emphasizing an emotion, mood, or concept. It can be better understood as a more vehement kind of Romanticism. The term is best applied to a movement in art of the early twentieth century, encompassing the Fauves and German groups, although it can be used to describe all art of this character.

Fantastic Art
Not a particular style or movement, but a term used to describe the kind of art that arose as a reaction to the machine cult in Abstract Art and the bloodshed in World War I. It extolled artistic freedom to reemphasize the emotional and intuitive side of creativity.

Fauves (Fauvism)
A name (meaning "wild beasts") for an art movement that began in Paris, France, about 1905. It was expressionistic art in a general sense, but more decorative, orderly, and charming than German Expressionism.

form
1. The organization or inventive arrangement of all the visual elements according to the principles that will develop unity in the artwork. 2. The total appearance or organization.

four-dimensional space
A highly imaginative treatment of forms that gives a sense of intervals of time or motion.

fractional representation
A device used by various cultures (notably the Egyptians) in which several spatial aspects of the same subject are combined in the same image.

Futurism
A submovement within the overall framework of abstraction adopted by many twentieth-century artists. The imagery of Futurist artists was based on an interest in time, motion, and rhythm, which they felt were manifested in the machinery and human activities of modern times and their extension into the future.

genre
Subject matter that concerns everyday life, domestic scenes, family relationships, and the like.

geometric shape
A shape that appears related to geometry; usually simple, such as a triangle, rectangle, and circle.

Gestalt (Gestalt psychology)
A German word for "form;" an organized whole in experience. Around 1912, the Gestalt psychologists promoted the theory that explains psychological phenomena by their relationships to total forms, or Gestalten, rather than by their parts.

glyptic
1. The quality of an art material like stone, wood, or metal that can be carved or engraved. 2. An art form that retains the color and the tensile and tactile qualities of the material from which it was created. 3. The quality of hardness, solidity, or resistance found in carved or engraved materials.

golden mean, golden section
1. Golden mean—"perfect" harmonious proportions that avoid extremes; the moderation between extremes. 2. Golden section—a traditional proportional system for visual harmony expressed when a line or area is divided into two sections so that the smaller part is to the larger as the larger is to the whole. The ratio developed is 1:1.6180 . . . or roughly 8:13.

graphic art
1. Two-dimensional art forms, such as drawing, painting, making prints, etc. 2. The two-dimensional use of the elements of art. 3. May also refer to the techniques of printing as used in newspapers, books, magazines, etc.

Happenings
A form of participatory art in which artists and spectators were engaged. Sometimes called "assemblages on the move." It stemmed from Dada and came into being with Pop Art in the mid- to late 1950s. Being ephemeral, Happenings are recorded by photographers and cinema makers. Now, Performance Art is the more popular term (see **Performance Art**).

harmony
The quality of relating the visual elements of a composition. Harmony is achieved by the repetition of characteristics that are the same or similar. These cohesive factors create pleasing interaction.

hatching
Repeated strokes of an art tool producing clustered lines (usually parallel) that create values. In "cross-hatching," similar lines pass over the hatched lines in a different direction, usually resulting in darker values.

high-key color
Any color that has a value level of middle gray or lighter.

high-key value
A value that has a level of middle gray or lighter.

highlight
The portion of an object that, from the observer's position, receives the greatest amount of direct light.

hue
Designates the common name of a color and indicates its position in the spectrum or on the color wheel. Hue is determined by the specific wavelength of the color in a ray of light.

illusionism
The imitation of visual reality created on the flat surface of the picture plane by the use of perspective, light-and-dark shading, and the like.

illustration(al)
An art practice that stresses anecdotes or story situations.

implied line
Implied lines (subjective lines) are those that dim, fade, stop and/or disappear. The missing portion of the line is implied to continue and is visually completed by the observer as the line reappears.

implied shape
A shape suggested or created by the psychological connection of dots, lines, areas, or their edges, creating the visual appearance of a shape that does not physically exist. (See **Gestalt.**)

Impressionism
A movement of the late nineteenth century primarily connected with such painters as Claude Monet and Camille Pissarro. A form of realistic painting based on the way in which changing aspects of light affect human vision, it challenged older modes of such representation.

infinite space
A concept in which the picture frame acts as a window through which objects can be seen receding endlessly.

installations
Interior or exterior settings of media created by artists to heighten the viewers' awareness of the environmental space.

intensity
The saturation, strength, or purity of a hue. A vivid color is of high intensity; a dull color is of low intensity.

intermediate color
A color produced by a mixture of a primary color and a secondary color.

interpenetration
The movement of planes, objects, or shapes through each other, locking them together within a specific area of space.

intuitive space
The illusion of space that the artist creates by instinctively manipulating certain space-producing devices, including overlapping, transparency, interpenetration, inclined planes, disproportionate scale, fractional representation, and the inherent spatial properties of the art elements.

invented texture
A created texture whose only source is in the imagination of the artist. It generally produces a decorative pattern and should not be confused with an abstract texture.

isometric projection (perspective)
A technical drawing system in which a three-dimensional object is presented two-dimensionally; starting with the nearest vertical edge, the horizontal edges of the object are drawn at a thirty-degree angle and all verticals are projected perpendicularly from a horizontal base.

Kinetic art
From the Greek word *kinesis,* meaning "motion," art that involves an element of random or mechanical movement.

kinetic assemblage
An assemblage that moves, a mobile, for example (see **assemblage**).

line (actual)
The path of a moving point that is made by a tool, instrument, or material as it moves across an area. A line is usually made visible because it contrasts in value with its surroundings. Three-dimensional lines may be made using string, wire, tubes, solid rods, and the like.

linear perspective (geometric)
A system used to develop three-dimensional images on a two-dimensional surface; it develops the optical phenomenon of diminishing size by treating edges as converging parallel lines. They extend to a vanishing point or points on the horizon (eye level) and recede from the viewer (see **perspective**).

local (objective) color
The color as seen in the objective world (green grass, blue sky, red barn, and the like).

local value
The relative light and dark of a surface, seen in the objective world, that is independent of any effect created by the degree of light falling on it.

low-key color
Any color that has a value level of middle gray or darker.

low-key value
Any value that has a level of middle gray or darker.

manipulation
The sculptural technique of shaping pliable materials by hands or tools.

mass
1. In graphic art, a shape that appears to stand out three-dimensionally from the space surrounding it or that appears to create the illusion of a solid body of material. 2. In the plastic arts, the physical bulk of a solid body of material. (See **plastic, three-dimensional,** and **volume.**)

medium, media (pl.)
The material(s) and tool(s) used by the artist to create the visual elements perceived by the viewer.

Minimalism
Abstract art forms reduced to the barest essentials that reveal very little variation in the use of elements.

mobile
A three-dimensional moving sculpture.

modeling
A sculptural technique of shaping a pliable material.

modern art, modernism
The term *modern art* is applied to almost all progressive or avant-garde phases of art from the time of the Impressionists in the late 1880s to the growth of Postmodernism in the 1960s. Modernism is usually associated with the nonrepresentational, formally organized kinds of modern art, as opposed to its organic and/or fantastic branches.

moments of force
Direction and degree of energy implied by the art elements in specific compositional situations; amounts of visual thrust produced by such matters as dimension, placement, and accent.

monochromatic
Having only one hue; the complete range of value of one color from white to black.

motif
A designed unit or pattern that is repeated often enough in the total composition to make it a significant or dominant feature. Motif is similar to theme or melody in a musical composition.

movement
Eye travel directed by visual pathways in a work of art.

naturalism, Naturalism (art style)
The approach to art that is essentially a description of things visually experienced. Pure naturalism would contain no personal interpretation introduced by the artist. As a style, Naturalism is associated with artists like Courbet and Meissonier.

natural texture
Texture created as the result of nature's processes.

negative area(s)
The unoccupied or empty space left after the positive elements have been created by the artist. However, when these areas have boundaries, they also function as design shapes in the total structure. (See **positive area.**)

Neo-Abstraction
Within the umbrella of Postmodern art there exists a hard core of artists who have chosen to remain within the abstract manner. Most of them are influenced by the rich color work of such artists as Frank Stella or Al Held.

Neoclassicism
A style, initiated in the late 1700s in France, which centered upon a reintroduction of Classical Greek and Roman forms of art, as then understood. It became the basis for the "approved" or official art of the French government until about the middle of the nineteenth century. The main exponents were Jacques-Louis David and Jean-Auguste-Dominique Ingres.

Neo-Expressionism
Dating from the early 1980s, this style reaffirmed the psychic emotionalism of early twentieth-century Expressionism. It became perhaps the most distinctive direction in Postmodernism.

neutralized color
A color that has been grayed or reduced in intensity by being mixed with any of the neutrals or with a complementary color.

neutrals
1. The inclusion of all color wavelengths will produce white, and the absence of any wavelengths will be perceived as black. With neutrals, no single color is noticed—only a sense of light and dark or the range from white through gray to black. 2. A color altered by the addition of its complement so that the original sensation of hue is lost or grayed.

nonobjective, nonrepresentational (art)
A type of art that is entirely imaginative and not derived from anything visually perceived by the artist. The elements, their organization, and their treatment by the artist are entirely personalized and, consequently, not associated by the observer with any previously experienced natural objects.

objective (art, shape)
A type of art or shape that is based, as nearly as possible, on physical actuality or optical perception. Such art tends to appear natural or real.

oblique projection (perspective)
A technical drawing system in which a three-dimensional object is presented two-dimensionally, the front and back sides of the object are parallel to the horizontal base, and the other planes are drawn as parallels coming off the front plane at a forty-five degree angle.

Op Art
A form of Abstract Art that has a direct impact on the physiology and psychology of vision or sight; began in the late 1950s.

open-value composition
Composition in which values cross over shape boundaries into adjoining areas.

optical perception
A way of seeing in which the mind has no other function than the natural one of providing the visual sensation of object recognition.

organic unity
A condition in which the components of art— that is, subject, form, and content— are so vital and interdependent that they may be likened to a living organism. A work having "organic unity" is not guaranteed to have "greatness" or unusual merit.

orthographic drawing
Graphic representation of two-dimensional views of an object, showing a plan, vertical elevations, and/or a section.

paint quality
The use of paint to enrich a surface through textural interest. Interest is created by the ingenuity in handling paint for its intrinsic character.

papier collé
A visual and tactile technique in which scraps of paper having various textures are pasted to the picture surface to enrich or embellish areas. In addition to the actual texture of the paper, the printing on adhered tickets, newspapers, and the like, functions as visual richness or decorative pattern similar to an artist's invented texture.

patina
1. A natural film, usually greenish, that results from the oxidation of bronze or other metallic materials. 2. Colored pigments and/or chemicals applied to a sculptural surface.

pattern
1. Any artistic design (sometimes serving as a model for imitation). 2. A repeated element and/or design that is usually varied and produces interconnections and obvious directional movements.

Performance Art
A type of art derived from Happenings in which the action is performed by a single artist. It consists of mixed-media performances of painting, music, theatrics, kinetics (see **Happenings**).

perspective
Any graphic system used to create the illusion of three-dimensional images and/or spatial relationships on a two-dimensional surface. There are several types of perspective—atmospheric, linear, and projection systems.

photogravure
The process of printing a photographic image from an etched plate.

Pictorialism
A branch of photography dating from the early nineteenth century. Pictorialist photographers were opposed to the dreary predictability of Realist (or Straight) photography and to the academic, artificial Pictorialism of Rejlander. They believed in the possibility of a personal expression of order and beauty in which science and art would combine in photographic imagery. Many Pictorialists turned to manipulating focus and film development in an attempt to arrive at this result. Pictorialism has become one of the favored forms of photography.

picture frame
The outermost limits or boundary of the picture plane.

picture plane
The actual flat surface on which the artist executes a pictorial image. In some cases, the picture plane acts merely as a transparent plane of reference to establish the illusion of forms existing in a three-dimensional space.

pigments
Color substances that give their color property to another material by being mixed with it or covering it. Pigments, usually insoluble, are added to liquid vehicles to produce paint or ink. Colored substances dissolved in liquids that give their coloring effects by being absorbed or staining are referred to as dyes.

planar (shape)
Having to do with planes.

plane
1. An area that is essentially two-dimensional, having height and width. 2. A flat or level surface. 3. A two-dimensional surface having a positive extension and spatial direction or position.

plastic (art, line, shape, color, space, value, etc.)
1. The use of the elements to create the illusion of the third dimension on a two-dimensional surface. 2. Three-dimensional art forms, such as architecture, sculpture, and ceramics. (See **mass, three-dimensional,** and **volume.**)

Pop Art
The name given to the form of art that uses, often satirically, the mundane products of mass popular culture, such as magazine, newspaper, billboard, and television advertising; comic strips and books, supermarket shelves; and so on, as its subject matter. It derived from certain early modern art forms and ideas, especially from Marcel Duchamp's "ready-made" and "found" objects of the 1920s through 1950s. It began to take shape in England in the late 1950s and spread quickly during the 1960s in the United States, where it was most widely accepted.

positive area(s)
The state in the artwork in which the art elements (shape, line, etc.), or their combination, produce the subject—nonrepresentational or recognizable objects. (See **negative area.**)

Post-Impressionism
The name applied to a few artists at the end of the nineteenth century who sought to restore formal organization, decorative unity, and expressive meaning to art. The most important were Paul Cézanne, Georges Seurat, Paul Gauguin, and Vincent van Gogh. These artists believed that the qualities cited above had been lost in Contemporary Art, particularly by the Impressionists. Post-Impressionism began the strong divergence from Representational Art that was to occupy such a strong place in twentieth-century Abstract Art.

Postmodernism
It began to seem in the 1970s that the dominant styles of art—Minimalism and Conceptualism— no longer fitted a world struggling with such rising social problems as drugs, crime, divorce, and commercial greed. As a result, a plurality of styles developed as a reaction to these worsening circumstances. Other Postmodernists, however, more forcefully expressed a desire to do away with art that seemed to have no meaningful content, and began to turn back to figurative art and the establishment of meaning. Still other forms of Postmodernism extend modern art in new ways by appropriating earlier styles, with minor or major modifications, and pastiching them. Due to the sheer variety of sources and styles in Postmodernism, it has been difficult to categorize such artists with the same ease as those of earlier styles or movements.

Post-Painterly Abstraction
This category of painting has also been called "Hard-Edge" and "Color Field." Painters were closely related to early twentieth-century Geometric Abstraction.

principles of organization
Seven principles that guide the use of the elements of art in achieving unity: they are harmony, variety, balance, proportion, dominance, movement, and economy.

primary color
The preliminary hues that cannot be broken down or reduced into component colors. The basic hues in any color system that in theory may be used to mix all other colors.

Primitive Art
The art of a people with a tribal social order or an early (though complex) stage of culture. The art of such people is often characterized by a heightened emphasis on form and a mysterious or vehement expressive content. Modern Primitive Art, like that of Henri Rousseau in France and Grandma Moses in the United States, is mostly the work of untrained or slightly trained artists. This kind of recent Primitive Art shows a naïveté of form and expression closely related to the untrained but often sensitive imagery of Folk Art. Early twentieth-century artists such as the Expressionists and the Cubists were influenced by Primitive Art.

proportion
The comparative relationship between the parts of a whole or units as to size. For example, the size of the Statue of Liberty's hand relates to the size of her head. (See **scale.**)

radial
Emanating from a central location.

realism, Realism (art movement)
A style of art that retains the basic impression of visual actuality without going to extremes of detail. In addition, realism attempts to relate and interpret the universal meanings that lie beneath surface appearances. As a movement, it relates to painters like Honoré Daumier in nineteenth-century France and Winslow Homer in the United States in the 1850s.

Realist (or Straight) photography
The branch of photography opposed to the "false" imagery of the Pictorialists who believed primarily in the honest use of available materials and technology to provide a photographic image, as opposed to the blurry, altered images of the Pictorialists, which amounted to an attempt to "enhance" content.

rectilinear shape
A shape whose boundaries usually consist entirely of straight lines.

relief sculpture
An art work, graphic in concept but sculptural in application, utilizing relatively shallow depth to establish images. The space development may range from very limited projection, known as "low relief," to more exaggerated space development, known as "high relief." Relief sculpture is meant to be viewed frontally, not in the round.

repetition
The use of the same visual effect a number of times in the same composition. Repetition may produce the dominance of one visual idea, a feeling of harmonious relationship, an obviously planned pattern, or a rhythmic movement.

representation(al) art
A type of art in which the subject is presented through the visual art elements so that the observer is reminded of actual objects. (See **naturalism** and **realism.**)

rhythm
A continuance, a flow, or a sense of movement achieved by the repetition of regulated visual units; the use of measured accents.

Romanticism
In the visual arts, the romantic spirit is characterized by an experimental point of view and extols spontaneity of expression, intuitive imagination, and the picturesque rather than a carefully organized, rational approach. Romanticism, a movement of nineteenth-century artists, such as Delacroix, Géricault, Turner, and others, is characterized by just such an approach to form. (See **classical.**)

scale
The association of size relative to a constant standard or specific unit of measure related to human dimensions. For example, the Statue of Liberty's scale is apparent when she is seen next to an automobile. (See **proportion.**)

sculpture
The art of expressive shaping of three-dimensional materials. "Man's expression to man through three-dimensional form" (Jules Struppeck, see Bibliography).

secondary color
A color produced by a mixture of two primary colors.

shadow, shade, shading
The darker value on the surface of an object that gives the illusion that a portion of it is turned away from or obscured by the source of light.

shallow space
The illusion of limited depth. With shallow space, the imagery moves only a slight distance back from the picture plane.

shape
An area that stands out from the space next to or around it because of a defined or implied boundary or because of differences of value, color, or texture.

silhouette
The area between or bounded by the contours, or edges, of an object; the total shape.

simulated texture
A convincing copy or translation of an object's texture in any medium.

simultaneity
In art, the use of separate views, representing different points in time and space, that are brought together and sometimes superimposed to create one integrated image.

simultaneous contrast
When two different colors come into direct contact, the contrast intensifies the difference between them.

space
The interval, or measurable distance, between points or images.

spectrum
The band of individual colors that results when a beam of white light is broken into its component wavelengths, identifiable as hues.

split-complement(s)
A color and the two colors on either side of its complement.

style
The specific artistic character and dominant trends of form noted during periods of history and art movements. Style may also refer to artists' expressive use of media to give their works individual character.

subject
1. In a descriptive approach to art, subject refers to the persons or things represented, as well as the artists' experiences, that serve as inspiration. 2. In abstract or nonobjective forms of art, subject refers merely to the visual signs used by the artist. In this case, the subject has little to do with anything experienced in the natural environment.

subjective (art, shape, color, etc.)
1. That which is derived from the mind reflecting a personal viewpoint, bias, or emotion.
2. Subjective art tends to be inventive or creative.

substitution
In sculpture, replacing one material or medium with another (see also **casting**).

subtraction
A sculptural term meaning the carving or cutting away of materials.

subtractive color
The sensation of color that is produced when wavelengths of light are reflected back to the viewer after all other wavelengths have been subtracted and/or absorbed.

Surrealism
A style of artistic expression, influenced by Freudian psychology, that emphasizes fantasy and whose subjects are usually experiences revealed by the subconscious mind through the use of automatic techniques (rubbings, doodles, blots, cloud patterns, and the like). Originally a literary movement and an outgrowth of Dadaism, Surrealism was established by a literary manifesto written in 1924.

Symbolism/Symbolists
A literary movement that spread to painting in the 1880s. Symbolists tried to grapple with the notion of subjective ideas, stating that the senses are inseparable from human emotions and that people and objects are, therefore, merely symbols of a deeper existence beyond that of the everyday. It was not a style as such and merely set a goal for artists to reach in a number of ways. The painters Odilon Redon and Pierre Bonnard, among others, are associated with the movement, and Paul Gauguin is considered a father figure.

symmetry
The exact duplication of appearances in mirrorlike repetition on either side of a (usually imaginary) straight-lined central axis.

tactile
A quality that refers to the sense of touch.

technique
The manner and skill with which artists use their tools and materials to achieve an expressive effect. The ways of using media can have a strong effect on the aesthetic quality of an artist's total concept.

tectonic
The quality of simple massiveness; lacking any significant extrusions or intrusions.

tenebrism
A technique of painting that exaggerates or emphasizes the effects of chiaroscuro. Larger amounts of dark value are placed close to smaller areas of highly contrasting lights—which change suddenly—in order to concentrate attention on important features.

tension
The manifested energies and forces of the art elements as they pull or push in affecting balance or counterbalance.

tertiary color
Color resulting from the mixture of all three primaries in differing amounts or two secondary colors. Tertiary colors are characterized by the neutralization of intensity and hue. They are found on the color wheel on the inner rings of color leading to complete neutralization.

texture
The surface character of a material that can be experienced through touch or the illusion of touch. Texture is produced by natural forces or through an artist's manipulation of the art elements.

three-dimensional
Possessing, or creating the illusion of possessing, the dimension of depth, as well as the dimensions of height and width.

transparency
A visual quality in which a distant image or element can be seen through a nearer one.

trompe l'oeil
Literally, "deceives the eye"; a technique that copies nature with such exactitude that the subject depicted can be mistaken for natural forms.

two-dimensional
Possessing the dimensions of height and width, especially when considering the flat surface or picture plane.

unity
The result of bringing the elements of art into the appropriate ratio between harmony and variety to achieve a sense of oneness.

value
1. The relative degree of light or dark. 2. The characteristic of color determined by light or dark or the quantity of light reflected by the color.

value pattern
The arrangement or organization of values that control compositional movement and create a unifying effect throughout a work of art.

variety
Differences achieved by opposing, contrasting, changing, elaborating, or diversifying elements in a composition to add individualism and interest; the counterweight of **harmony** in art.

void
1. Areas lacking positive substances and consisting of negative space. 2. A spatial area within an object that penetrates and passes through it.

volume
A measurable area of defined or occupied space.

Bibliography

ADAM, MICHAEL, *Womankind*. New York: Harper and Row, 1979.

ADAMS, LAURIE SCHNEIDER, *Art Across Time;* 2 vols. New York: McGraw-Hill (College), 1999.

AGOSTON, GEORGE A., *Color Theory and its Application in Art and Design*. Berlin, Heidelberg, New York: Springer Verlag, 1987.

ALBERS, JOSEF, *Interaction of Color*. New Haven, Conn.: Yale University Press, 1963.

ARMSTRONG, TOM, *200 Years of American Sculpture*, catalog for Whitney Museum of American Art. Boston, Mass.: The Godine Press, 1976.

ARNASON, H. H., *History of Modern Art*. Englewood Cliffs, N.J.: Prentice-Hall, 1986.

ARNHEIM, RUDOLPH, *Art and Visual Perception*. Berkeley, Calif.: University of California Press, 1966.

ART IN AMERICA (periodical). 575 Broadway, New York, New York.

ART NEWS (periodical). W. 38th Street, New York, New York.

BATCHELDER, ANN; and ORBAN, NANCY, *Fiberarts Design Book Five*. Asheville, North Carolina: Lark Books, 1995.

BATES, KENNETH F., *Basic Design: Principle and Practice*. New York: Funk & Wagnalls, 1975.

BETHERS, RAY, *Composition in Pictures*. New York: Pitman Corporation, 1956.

BETTI, CLAUDIA; and SELE, TEEL, *A Contemporary Approach*: Drawing. New York: Holt, Rinehart & Winston, 1980.

BEVLIN, MARJORIE E., *Design through Discovery*. New York: Holt, Rinehart & Winston, 1980.

BINDMAN, DAVID, *William Blake*. Thames and Hudson, 1982.

BIRREN, FABER, *Color Perception in Art*. New York: Van Nostrand Reinhold, 1976.

___, *Creative Color*. New York: Van Nostrand Reinhold, 1961.

___, *Principles of Color*. New York: Van Nostrand Reinhold, 1969.

BLOCK, JONATHAN, et al., *Understanding Three Dimensions*. Englewood Cliffs, N.J.: Prentice-Hall, 1987.

BLOOMER, CAROLYN M., *Principles of Visual Perception*. New York: Van Nostrand Reinhold, 1976.

BRO, L. V., *Drawing: A Studio Guide*. New York: W. W. Norton, 1978.

BUENDIA, J. R., et al., *Paintings of the Prado*, Boston: Little, Brown and Company, 1994.

CANADAY, JOHN, *What Is Art?* New York: Alfred Knopf, 1980.

CARPENTER, JAMES M, *Visual Art: An Introduction*. New York: Harcourt Brace Jovanovich, 1982.

CHAET, BERNHARD, *The Art of Drawing*. New York: Holt, Rinehart & Winston, 1970.

CHEATHAN, FRANK R.; CHEATHAN, JANE HART; and OWENS, SHERYL HATER, *Design Concepts and Applications*. Englewood Cliffs, N.J.: Prentice-Hall, 1983.

CHEVREUL, M. E., *The Principles of Harmony and Contrasts of Colors and Applications to the Arts*. New York: Van Nostrand Reinhold, 1981.

CHILVERS, IAN; OSBORNE, HAROLD; and FARR, DENNIS, *The Oxford Dictionary of Art*. New York: Oxford University Press, 1988.

CLEAVER, DALE G., *Art: An Introduction*. New York: Harcourt Brace Jovanovich, 1972.

COLEMAN, RONALD, *Sculpture: A Handbook for Students*. Dubuque, Iowa: Wm. C. Brown, 1990.

COLLIER, GRAHAM, *Form, Space and Vision*. Englewood Cliffs, N.J.: Prentice-Hall, 1972.

COMPTON, MICHAEL, *Pop Art*. London: Hamlyn, 1970.

CRAWFORD, WILLIAM, *The Keepers of the Light: A History and Working Guide to Early Photographic Processes*. New York: Dobbs Ferry, 1979.

DANTZIC, CYNTHIA MARIS, *Design Dimensions*. Englewood Cliffs, N.J.: Prentice-Hall, 1990.

DAVIS, PHIL, *Photography*. Dubuque, Iowa: Wm. C. Brown, 1990.

DIAMOND, DAVID G., *Art Terms*. Boston, Mass.: A Bulfinch Press Book, Little, Brown, 1992.

EDWARDS, BETTY, *Drawing on the Right Side of the Brain*. Los Angeles: Tarcher, 1979.

ELIOT, ALEXANDER, *Myths*. New York: McGraw-Hill, 1976.

ELSEN, ALBERT E., *Origins of Modern Sculpture*. New York: George Braziller, 1974.

ENSTICE, W.; and PETERS, M., *Drawing*. Englewood Cliffs, N.J.: Prentice-Hall, 1996.

FAINE, BRAD, *The Complete Guide to Screen Printing*, Cincinnati: Quartu Publishing, 1989.

FAULKNER, RAY; SMAGULA, HOWARD; and ZIEGFELD, EDWIN, *Today: An Introduction to the Visual Arts*. New York: Holt, Rinehart & Winston, 1987.

GARDNER, HELEN, revised by Tansey, Ricnard G., and Kleiner, Fred S., *Art through the Ages*. (volume II, Renaissance and Modern Art). New York: Harcourt Brace, 1996.

GILBERT, RITA; and McCARTER, WILLIAM, *Living with Art*. New York: Alfred Knopf, 1988.

GOLDSTEIN, NATHAN, *The Art of Responsive Drawing*. Englewood Cliffs, N.J.: Prentice-Hall, 1977.

HAMMACHER, A. M., *The Evolution of Modern Sculpture*. New York: Hary N. Abrams, Inc.

HARLAN, CALVIN, *Vision and Invention: A Course in Art Fundamentals*. Englewood Cliffs, N.J.: Prentice-Hall, 1970.

HARTT, FREDERICK, *History of Italian Renaissance Art*, New York: Harry N. Abrams.

HELLER, NANCY, *Women Artists: An Illustrated History*. New York: Abbeyville Press, 1981.

HIBBARD, HOWARD, *The Metropolitan Museum of Art*. New York: Harper & Row, 1980.

HUNTER, SAMUEL, *American Art of the 20th Century*. New York: Harry N. Abrams, 1972.

ITTEN, JOHANNES, *The Art of Color*. New York: Van Nostrand Reinhold, 1970.

___, *Design and Form*. New York: Van Nostrand Reinhold, 1975.

JENKINS, DONALD, *Images of a Changing World*. Portland Oregon: Portland Art Association, 1983.

KISSICK, J., *Art Context and Criticism*. Madison, Wisconsin: Brown and Benchmark, 1993.

KNAPPE, KARL-ADOLF, *Dürer*. New York: Harry N. Abrams, 1965.

KNOBLER, NATHAN, *The Visual Dialogue*. New York: Holt, Rinehart & Winston, 1980.

KUEPPERS, HARALD, *The Basic Law of Color Theory*. New York: Barron's Educational Series, 1982.

___, *Color Atlas*. New York: Barron's Educational Series, 1982.

LANE, R., *Images from the Floating World*. Secaucus, N.J.: Cartwell Books, Inc., 1978.

LAUER, DAVID, *Design Basics*. New York: Holt, Rinehart & Winston, 1989.

LERNER, ABRAM, et al., *The Hirshhorn Museum and Sculpture Garden*. New York: Harry N. Abrams, 1974.

LEWIS, R. L.; and LEWIS, S.I., *The Power of Art*. Orlando, Florida: Harcourt Brace, 1994.

LOCKER, J. L., *The World of M. C. Escher*. New York: Harry N. Abrams, 1971.

LOWE, SARAH M., *Frida Kahlo*. New York: University Publishing, 1991.

LUCIE-SMITH, EDWARD, *Late Modern: The Visual Arts Since 1945*. New Praeger, 1969.

___, *The Thames and Hudson Dictionary of Art Terms*. New York: Thames and Hudson, 1984.

MACAULAY, DAVID, *The Way Things Work*. Boston: Mifflen, 1988.

MEISEL, L. K., *Photorealism Since 1980*. New York: Harry N. Abrams, 1993.

MENDELOWITZ, DANIEL M.; and WAKEMAN, DUANE A., *A Guide to Drawing*. Orlando, Fla.: Harcourt Brace Jovanovich, 1993.

MYERS, JACK FREDRICK, *The Language of Visual Art*. Orlando, Fla., New York: Holt, Rinehart & Winston, 1989.

NATIONAL GALLERY OF ART, *Johannes Vermeer*. Washington, D.C., 1995.

POIGNANT, R., *Oceanic Mythology*. London: Paul Hamlyn, 1967.

PREBLE, DUANE, *We Create, Art Creates Us*. New York: Harper & Row, 1976.

___, *Art Forms*. New York: Harper & Row, 1989.

RICHARDSON, J. A., *Art: The Way It Is*. Englewood Cliffs, N.J., Prentice-Hall/Harry N. Abrams, 1986.

RICHARDSON, JOHN ADKINS, et al., *Basic Design*. Englewood Cliffs, N.J.: Prentice-Hall, 1984.

RUBIN, W., *Primitivism in 20th Century "Art."* New York: Museum of Modern Art, 1984. 2 vols.

RUSSELL, STELLA PANDELL, *Art in the World*. Orlando, Fla.: Holt, Rinehart & Winston, 1989.

SAFF, DONALD; and SACILOTTO, DELI, *Printmaking*. New York: Holt, Rinehart & Winston, 1978.

SIMMONS, SEYMOUR, III; and WINER, MARC, S. A., *Drawing: The Creative Process*. Englewood Cliffs, N.J.: Prentice-Hall, 1977.

SMITH, B.; and WENG, W., *China—A History in Art*. New York: Harper and Row, 1972.

SMITH, BRADLEY, *Mexico—A History in Art*. New York: Doubleday, 1968.

SPARKE, PENNY; HODGES, FELICE; DENT, EMMA; and STONE, ANNE, *Design Source Book*. Secaucus, N.J.: Chartwell, 1982.

STRUPPECK, JULES, *The Creation of Sculpture*. New York: Henry Holt, 1952.

SUTTON, P., *Dreamings: The Art of Aboriginal Australia*. New York: George Braziller, 1988.

TERUKAZU, AKIYAMA, *Japanese Painting*. New York: Rizzoli International Publications, 1977.

THORP, R. L., *Son of Heaven: Imperial Arts of China*. Son of Heaven Press, Printed by Nissha Printing Co., Ltd., 1988.

VERITY, ENID, *Color Observed*. New York: Van Nostrand Reinhold, 1980.

WALKER ART CENTER, *Painting and Sculpture from the Collection*. Walker Art Center and Rizzoli International Publications, Inc., 1990. Subsequent editions probable.

WAX, CAROL, *The Mezzotint*. New York: Harry N. Abrams, 1996.

WEISS, HILLARY, *The American Bandanna*. San Francisco: Chronicle, 1990.

WILLIAMS, RICHARD L., Series Editor, *Life Library of Photography*. New York: Time-Life, 1971.

WINGLER, HANS M., *The Bauhaus*. Cambridge, Mass.: First M.I.T. Press Paperback, 1986.

WONG, WUCIUS, *Principles of Color Design*. New York: Van Nostrand Reinhold, 1987.

___, *Principles of Form and Design*. New York: Van Nostrand Reinhold, 1993.

___, *Principles of Three-Dimensional Design*. New York: Van Nostrand Reinhold, 1977.

YENAWINE, PHILIP, *How to Look at Modern Art*. New York: Harry N. Abrams, 1991.

ZELANSKI, PAUL, et al., *Shaping Space*. New York: Holt, Rinehart & Winston, 1987.

Index

Blue entries refer to media used